Art, Culture, and Ethnicity

Edited by

Bernard Young

D0143799

National Art Education Association
1916 Association Drive
Reston, Virginia 22091-1590

1990

About NAEA . . .

Founded in 1947, the National Art Education Association is the largest professional art education association in the world. Membership includes elementary and secondary teachers, art administrators, museum educators, arts council staff, and university professors from throughout the United States and 66 foreign countries. NAEA's mission is to advance art education through professional development, service, advancement of knowledge, and leadership.

Cover: *The Libraries are Appreciated*, by Jacob Lawrence, 1943. Gouache on watercolor on paper. Courtesy of Philadelphia Museum of Art: The Louis E. Stern Collection.

Acknowledgements: This publication was supported in part by a generous grant from the Longview Foundation for Education in World Affairs and International Understanding.

ISBN 0-937652-54-7

Contents

Foreword

Bernard Young

Editor

This book offers new perspectives on the understanding of school, artistic, aesthetic, cultural, and historical achievements about people of color. The materials gathered here have an ethnological orientation that presents propositions and approaches to expressive research that have a great deal of variance in character. The original intention of this book was to create a text on research in art education written by or about ethnic minorities. This is an area of study that has sporadically been written about by scholars in related disciplines but never studied with a concentrated effort. For art educators, the development of such a text is clearly "an important ground breaking experience," according to Dr. Thomas Hatfield, executive director of the National Art Education Association (NAEA). It is hoped that this collected body of knowledge will be ground breaking in several areas, including: the importance of minority researchers, teachers, and professors doing what we are enthusiastic about doing, that is, conducting research and teaching, two activities that we must pursue with vigor. Doing research is at least a part of our job. It's an intellectual charge and a basic responsibility. This is also in alliance with NAEA's mission to advance art education through professional development, service, advancement of knowledge, and leadership. Researching areas of art education that concern minorities should be done for its own sake, to generate new knowledge and to deal with real-life problems and conditions. Today's research in art education should be concerned with having what is often referred to as "ecological validity." Art education programs across this nation that choose not to relate to or deal with the growing cultural diversity in our schools today are ignoring an entire range of natural subject matter. Our search for knowledge must be applicable to our natural situations.

We should mention and express gratitude to individuals who were intensely involved in the early talks at NAEA meetings over the past three years that helped to create the conditions to make a publication like this possible. William Harris, at the time, was the chair of the Committee on Minority Concerns (COMC), and Sandra Epps was the chair-elect. Both had the

insight and vision to support this project and see the long-term benefits for the profession.

Professor emeritus Eugene Grigsby, Jr., of Arizona State University, posed an important question when this project was first suggested and raised the question again recently in a personal conversation. "Where will the next generation of minority art educators come from? And where will the next generation of nonminority art educators come from who are concerned with art and ethnicity issues and social issues?" His question touches on a larger problem concerning the general issue of the decreasing number of minority educators in America today, and, specifically, he addresses the even smaller number of minority educators who are going into the arts. In the general field of teaching, it is predicted from the Census Bureau's Current Population Surveys that Black representation in the teaching force will be reduced to less than 5% in 1990, down from 8.6% in 1980. This situation is potentially harmful to all youth, but particularly to Black youth and other minorities. Mexican Americans, Puerto Ricans, and Cubans, among others, constitute the fastest growing ethnic group in the nation. Hispanics also have an extremely high school dropout rate (Valverde, 1987). The nation has a serious problem in the education of its minority groups. The development and severity of the problem have been increasing for a number of years.

We hope this publication will encourage young and experienced art educators to join our efforts. Appropriate role models are needed, and new models need to be created in the field. I hope this publication, in some measure, will contribute to a better understanding of the aesthetic, art, and culture values of people of color. It is literally impossible to predict the results of today's efforts, but it's not such a difficult task to imagine the state of art and education for future minority children if bold efforts are not put forth today.

We are fortunate to be able to stay with some of our original plans by having some very talented young writers with whom you may not be familiar and others you will know immediately, who have made many important contributions to the field over the years.

I am indebted to the authors who made this anthology what it is, and especially to Vesta A. H. Daniel for accepting the task of writing the introduction for the text. I am sure this ensemble of writings will greatly interest you, and I hope it will lead you to further studies in this area.

Reference

Valverde, S. A. (1987). A comparative study of Hispanic high school dropouts and graduates — Why do some leave school early and some finish? *Education and Urban Society, 19*(3), 320-329.

Acknowledgments

For suggestions about the shape and content of this ensemble of writings, I am grateful to suggestions from the writers, my wife, Debb, and my research assistant, Carole Seldin. Special thanks to Leonard Lehrer, director of the School of Art, Arizona State University, for research support. I am grateful to Mrs. W. L. Brittain and Dr. Rogena M. Degge, editor of the *Journal of Multi-Cultural and Cross-Cultural Research in Art Education,* for granting us permission to print the late Dr. Brittain's article. Thanks also to the little Youngs for their patience.

Introduction

Vesta A. H. Daniel

The ideas expressed in this collection will be a beginning for many readers. The varying perspectives provided on the concepts of multiculturalism, multiethnicity, and global literacy may be provocative in that they require educators to question how prepared they are to meet the future. Schwartz and Exter (1989) predict that by the year 2000, 34% of children under the age of 18 in the U.S. will be Black, Hispanic, Asian, or other "minorities." This proportion will rise by the year 2010, resulting in minority children becoming the majority in the largest states — California, New York, Texas, and Florida. Concurrently, minority teachers are predicted by *NEA Today* (1989) to decrease from the 1980 proportion of 1 in 8 to the year 2000 proportion of 1 minority teacher in 20.

Given the changing face of America and the increased probability of interacting with people from diverse cultural and ethnic backgrounds, this country is faced with an educational imperative: Children whose ethnic and cultural histories do not coincide with the Eurocentric, middle-class, mainstream standard must not be miseducated. Specifically, curricula in art must be corrected to include the diverse cultural, ethnic, contextual, and historical content that contributes to a more truthful and comprehensive art education for all children.

Corrected art curricula will assist children in determining their relationship to people representing diverse histories who share similar humanistic concerns. The mode of expression may reflect similar or different aesthetic systems. However, these are the distinctions that vivify the processes of perception and appreciation.

The goal of scholars contributing to ethnic education such as James Banks and Geneva Gay is to reach a level of global competency or global literacy. At this level, according to Banks (1987), individuals possess skills and attitudes that enable them to function well with ethnic cultures within their own and other nations. Their global literacy also includes "universalistic ethical values and principles of humankind" (Banks, 1987, p. 65) that they can act upon competently.

The importance of this anthology is that it provides philosophic, ethno-graphic, empirical, and pedagogical paradigms for the improvement of art curricula that incorporate multiethnic content. Within this framework there are ideas and questions that may help to guide the reader through the various levels of concern characterizing multiethnic art education. For example, how do the notions of multiculturalism, multiethnicity, global literacy, cultural continuity, and Eurocentrism contribute to a viable curriculum in art education? What are the implications of the question of a "Black aesthetic" for the study of world art and for establishing standards for aesthetic value? How do teachers' individual ideologies affect the opportu-nity to learn for all children?

Murry N. DePillars addresses one of the above issues by asking whether educational institutions are ready for multiculturalism. His question is based on a review of formal art history (i.e., popular art history texts) and curricula in art education. These disciplines, he maintains, have systemati-cally miseducated future art educators through the omission and distortion of facts related to the art of non-European populations and their descendants in the diaspora. He asserts that the "dis-Africanization" of history and culture is the antithesis of multiculturalism. Furthermore, he views the art profession as resistant to the inclusion of historically accurate information. Consequently, children of non-European ancestry are disenfranchised by being separated from their history, and their self-concepts are negatively affected. Thus, the charge given to curriculum developers is to create materials that will close the culture and information gaps and establish the self-identity of culturally and ethnically diverse learners.

Like DePillars, Lee A. Ransaw attests to the social-cultural power of art. His study reviews the depiction of Black people in the past 300 years of paintings by European masters contained in three major art museums in Europe and the United States. In his reflections on the Eurocentric notion of beauty, he urges educators to encourage the appreciation and contempla-tion of the images of Black people as an aesthetic experience that must extend beyond the Black community to the community that is the human race.

Members of this race have been categorized typically by their ethnic heritage and valued for their mainstream cultural "advantages." But who are the culturally disadvantaged in America? They are, according to Eugene Grigsby, Jr., members of the White ghetto, who, like the victims of the discussions by DePillars and Ransaw, are being miseducated. In his view, the impact of lack of interaction with the richness of varied cultural and ethnic groups produces a narrow visual perspective among mainstream

cultures. Judith Mariahazy reemphasizes this perspective in her reflections as a student on the educational deprivation inherent in an art education curriculum devoid of the nuances characterizing multicultural and multi-ethnic art.

The concerns expressed above address the educational need to employ "multiculturalism" at a national level. However, "multiethnic" art education assumes the world view. Specifically, the world view of art, culture, and ethnicity emphasizes the importance of education that provides exposure to and understanding of diverse realities throughout the world. On this point, Vesta A. H. Daniel questions how art and technology can be coupled to encourage an international movement toward transglobal communication. Daniel cautions that an unjust imposition of Eurocentric, Western world standards may be at hand if contextual relevance (i.e., cultural setting) does not remain the uppermost concern of technologically aggressive cultures affecting the evolution and creative efforts of human beings. Moreover, the question of what technology does to or for traditional or culture-based art should be an issue in valuing art from world cultures. Regarding the world view, Bradley Smith calls for soul searching and reflection on the present and future of a world characterized by cultural dichotomies and suggests that a change in the "world curriculum" will expand educational boundaries.

Further explication of the world view is provided by several authors focusing on the important concept of a "Black aesthetic." Their diverse analyses of this topic have in common the discussion of an organizing and motivating factor in the creation of visual art by persons of African descent.

Robert L. Adams organizes the principles characterizing the Black aesthetic with a review and analysis of the ideas advanced by Alain Locke, a significant contributor to the Harlem Renaissance. As an important spokes-man for African American humanist values, Locke investigates the existence of a singular *raison d' etre* for African American artists. The reader may want to focus on the question of whether the artist of African descent applies a different set of aesthetic principles than those exercised by other artists. As Adams points out, Locke's aesthetic position is based on considerable knowledge of formal aesthetics, which Adams applies to the analysis of aesthetic theories such as instrumentalism and expressionism and their interaction with culturally particular art.

The empirical studies conducted by Adrienne Walker Hoard and Oscar L. Logan on the nature of the Black aesthetic are highly significant to the development of a disciplined approach to the broader study and application of culture based aesthetic content.

Hoard's respondents attend to abstract paintings (which are ostensibly unencumbered by subjective, political content) yielding aesthetic response patterns that Hoard terms a "felt" reality, "aesthetic instinct," or expressions of "ethnic consciousness." Logan questions the extent to which the concepts and values of Black art and Black aesthetics are transmitted to students in historically Black colleges and notes the importance of the triad of Black culture, Black aesthetics, and Black art. Moreover, he investigates the significant cultural question of the perceived efficacy of the body of information addressing Black art/aesthetics by art instructors in general and their related willingness to transmit this information.

In an ethnographic study conducted by Pamela Gill Franklin and Patricia Stuhr, the responses of African American adults to representational paintings by African American artists and examples of West African art raise several questions: What is the role of Black artists (e.g., freedom of expression versus universalism)? Can non-Black artists capture the essence of African art, for example, what about Picasso and other Modern painters? Can the ethnicity of an artist be determined absent the variables of political content and shared cultural history within the artwork?

By generalizing such questions to other cultural and ethnic groups, teachers may find it easier to structure inquiries into the relationship between mainstream and nonmainstream art.

One of the premises that organizes this anthology is that the art education community must recognize and make functional the interrelationship of pedagogy and social-cultural realities. Specifically, the development and application of viable multiethnic curricula is a function of this interrelationship.

One of the social realities addressed by Bernard Young is the impact of the low-income, ethnic-minority family on the quality of education received by children in the family. He maintains that the educational system is ineffective for these children because the standards of behavior are Eurocentric and middle class. Consequently, Young suggests some strategies for parents functioning outside of this standard. He emphasizes that parents must counteract unfair school policies, which limit a child's acquisition of personal power, through their involvement with the schools. Given the continual increase in diverse populations in American schools, Young asks who will accommodate these students? How can ethnic-minority group members be encouraged to become art educators if their learning potential and artistic achievements have been minimized by a culturally myopic educational system?

References

Banks, J. A. (1987) *Teaching strategies for ethnic studies*. Boston: Allyn & Bacon.
NEA Today, May/June 1989.
Schwartz, J., & Exter, T. (1989, May). *American Demographics*.

1

Teaching Art to Disadvantaged Black Students: Strategies for a Learning Style

LEO F. TWIGGS

Stanback Museum and Planetarium, and
South Carolina State College

> *Disillusion is the word,*
> *that's used by me*
> *when I'm not heard.*
> *I just go through life,*
> *with my glasses blurred.*
> *It's like that,*
> *and that's the way it is!*
>
> Run D. M. C. (1984)

Teaching art to Black disadvantaged students from low socioeconomic backgrounds is a shattering experience for many art teachers. For the unprepared, even the first day can be devastating. Black teachers who may have grown up in the same kinds of neighborhoods as these students find out quickly how out of touch they are. But for White teachers from middle-class backgrounds, the classroom can become an arena of nasty confrontations that slowly but eventually deteriorates into a hopelessness affecting both the teacher and the students in a negative way.

The hopelessness that many teachers, both Black and White, feel in attempting to teach art to Black disadvantaged students is similarly felt by teachers in other disciplines. But I believe that art, by its very nature, offers a unique opportunity to reach these students in a special way and even serve as an example for teachers in other disciplines. What, then, is the nature of the art experience that can provide the art teacher with this unique opportunity for Black disadvantaged students?

Figure 1.1 Children and Instructor working with clay

At the outset, I believe that the teacher must come to understand art as a humanistic endeavor, not an entity separate and apart from life itself. For such a teacher, all art is about the human condition — coming into the world, growing up, being happy, sad, disillusioned, living, dying, thoughts of the afterlife, and so forth. All of these are legitimate feelings shared by all humans, whether Black or White, whether of comfortable means or disadvantaged. This is the "stuff" that drives all of us, and it is no less important to Black disadvantaged students and teachers.

The role of art as an extension of life experiences is well documented in the literature. Dewey's (1934) *Art as Experience* and Sir Herbert Read's (1945) *Education Through Art* are familiar examples. Edmund Feldman's (1970) more recent work also adds greatly to the body of supporting literature.

Of course, one might argue that art as an extension of life experiences can be the basis for teaching art to all students, not only those who are Black and disadvantaged. There is no intent to argue that point here. Rather, I believe that disadvantaged Black students from low socioeconomic backgrounds may perceive the art experience as the only thing of value in an otherwise hostile and alien environment.

The intent of this chapter, then, is to explore, to some extent, the plight of Black disadvantaged students, investigate their learning styles, and offer some suggestions as to how art teachers can perform more effectively in the classroom.

The Students

The term *disadvantaged* is applied most often to a group that is in an unfavorable, inferior, or prejudicial relationship with another group. This relationship can exist because of race, sex, ethnic origin, religion, or economic condition. Poor socioeconomic condition, however, is perhaps the most telling and prevalent characteristic of the group.

Many books and articles about the disadvantaged tend to use the term *minority* when referring to them, even though the information presented primarily describes the Black disadvantaged population. Often the reader is confused by statistics that include several groups and make generalizations about the Black population from them.

In order to establish who Black disadvantaged students are, we must be careful to separate them from the myriad of statistics and be more specific

in our descriptions. As a result, teachers will be better equipped to develop activities to meet the needs of these students.

The largest group of Black disadvantaged students reside in the ghettos of our major cities, but there are many such students who live in rural areas. Some teachers have hinted that the rural disadvantaged seem to be more manageable and less likely to be overly aggressive and violent than their streetwise city counterparts. Perhaps the crowded conditions of ghetto living provide more opportunities for city Blacks to "get into things."

Whatever the difference, both groups share some rather disturbing statistics; the socioeconomic changes that have occurred over the past 5 years have eroded their relatively poor economic condition. As a result, many are lagging behind in school, and as they progress through school they get even further behind. Often, as many as one half of those who enter eventually drop out.

Another equally disturbing fact is that almost half of these disadvantaged Black students come from homes with no fathers, and female-headed households which tend to remain poor. There is an alarming disparity between the family incomes of these single-parent households and those in which both parents work.

I should note that the lack of a father in the home of many disadvantaged Black students is not solely due to Black men's so-called irresponsibility or "psychological difficulties." Many Black males are in prison, and there are about a million and a half more Black females than males. The foregoing explanation notwithstanding, a large number of Black fathers, after extended periods of unemployment and a loss of self-esteem in a society that champions the man as a breadwinner, walk away. Given this backdrop, by the time many Black disadvantaged students enter school they are already behind other students, and the school becomes another place that reminds them of what they do not have.

American schools are products of a middle-class culture and, as such, expound the values and mores of the middle class. Watson (1962), in his preface to Reissman's book, *The Culturally Deprived Child*, explains:

> *The American school is a curious hybrid. It is managed by a school board drawn largely from upper class circles; it is taught by teachers who come largely from middle class backgrounds; and it is attended mainly by children from working class homes. These groups do not talk the same language. They differ in their*

Figure 1.2 *Instructor prepares for a teaching demonstration*

manners, power and hierarchies of value. (p. x)

You can see that Black disadvantaged students who enter this environment from the low end of the working class face numerous difficulties, not the least of which are the cultural differences they bring with them. Such differences include traditions, values, institutions, and organizational methods.

These differences in culture and socioeconomic status result in Blacks feeling alienated. The "in-placeness," neatness, and regimentation of the school operation add to the strangeness.

Asa Hilliard (1974) points out that the school environment may be oppressive to many poor Black students because the rules of the game favor the other culture most of the time. He believes this indifference to the students' culture may precipitate aggressive behavior by Black students toward both real and imagined tormentors. What Hilliard alludes to here is a feeling of powerlessness on the part of many Black students in the school environment.

One way the disadvantaged Black student seeks to cope with the environment is by assertive behavior. Such behavior may include lashing out with verbal abuse, being mischievous, trying to manipulate the teacher or fellow students, and playing a game of willpower with the teacher.

Needless to say, this belligerence by Black disadvantaged students militates against an enthusiastic reception by teachers. Below I explore how teachers view these students and how many of them seek to cope.

The Teachers

The teacher's negative expectations and stereotypical thinking about Black people in general and Black students in particular can set off aggressive counterbehavior by students. Many teachers overtly or covertly tend to characterize all Black disadvantaged students as boisterous, unruly, lazy, inferior, and dumb. They expect little from them, and they are convinced that these students are not going anywhere. Black males, especially, bear the brunt of this negative attitude. They are often labeled in early grades as troublemakers and may be targeted for suspension as they progress through school.

Teachers who are more familiar with nice, neatly dressed, middle-class

Figure 1.3 *Children working in clay.*

students prefer not to work with poor Black students. Research has shown that teachers are less favorably inclined toward deprived children even when their school achievements are good.

The difficulties teachers have with Black disadvantaged students do not occur primarily with White teachers. Black teachers, too, experience some of the same feelings about how these students behave. Many Black teachers come from middle-class homes where such things as floppy, untied shoe-laces, boom boxes, and loud boisterous behavior were frowned upon. Often they were encouraged not to "act colored," and this kind of behavior by Black students becomes embarrassing to them.

To this juncture, I have attempted to establish the plight of Black disadvan-taged students and how many teachers perceive them in the schools. Using this knowledge of teachers and students, I turn now to the art experience.

The Art Experience

At the outset, I stated that I believe art, by its very nature, offers a unique opportunity for art teachers to reach Black disadvantaged students in a special way, but it can occur only if teachers begin to perceive art as a humanistic endeavor. By humanistic I mean the affective qualities of mind and feeling. Creativity and innovation are stressed instead of tried and proven methods of doing. "Feeling" is solicited instead of logic, synthesiz-ing is stressed instead of analyzing, and hypothesizing is encouraged instead of memorizing.

If art is to be taught so that it becomes a humanistic endeavor, an extension of the student's life experiences, teachers must become genuinely interested in what their students care about. They must talk to students, listen to their music, visit their neighborhoods, and learn about their fears and desires. In other words, they must begin to see these students as fellow human beings. The assumptions that they do not care and that they have no aspirations are false. The rap songs of the street may tell teachers more about these students than they can learn otherwise. These "rappings," in many instances, embody the frustration, anger, and hope of ghetto youths and rural Black students as well.

One thing I know,
is life is short.
Listen up homeboy,
give this a thought

8

Next time someone's teaching,
why don't you get taught.
It's like that,
and that's the way it is!

(Run D. M.C., 1984)

Art teachers must also become familiar with the culture of Black students. Such qualities as the need to be strong and to endure life's hardships, and other factors, such as the role of the church, the extended family tradition, and the strong mother image in the family, must be considered when designing any art activity.

Black students' attitudes toward art must also be considered. Many disadvantaged students think of art as an unmanly activity.

In my view, the most important quality that both the art teacher and the Black student can achieve is mutual respect. But in both instances it must be achieved the old fashioned way, to paraphrase a popular television commercial — each must earn it. The art classroom can become a place where the teacher and student earn each other's respect.

Although there are cultural differences, some of which I have explained, Black disadvantaged students have many of the same fears and anxieties all students feel when facing new and alien situations for the first time or while growing up in the world. What do they think about their school? How does being there make them feel? If they could change anything about their lives, what would they change? If they could make a place for themselves where they could go to feel free, what would it look like? All of these questions solicit legitimate feelings that art teachers can have students explore when composing artworks.

I have posed questions that relate to the students' own feelings. By investigating the student's culture and background, the teacher should be able to fashion such questions. The success of this endeavor depends on the teacher's skill in developing questions that are thought provoking and that direct student activity.

The art experience should always be one of posing questions and finding answers. For instance, the teacher could suggest that the student connect a color to a feeling. Can a color express a feeling? Why does the rock star Prince use purple to suggest a mood in his movie and song, *Purple Rain*? Why *purple* rain? How does this differ from a television commercial about

9

a shampoo called "White Rain"?

Such questioning by the teacher can lead students down a path of self-discovery. The art room now becomes a "what if" place where students can explore their innermost feelings and where they can establish a dialogue between their feelings and their work. When art is taught this way, art activity is no longer an exercise for girls or unmanly boys but a place where ideas are developed and explored.

Black disadvantaged teenagers are particularly interested in style; it may be in developing a particular swagger in their walk or the way they shake hands. In any case, they know it is not what they do, but the way they do it.

Research has shown that many Black disadvantaged students have a particular learning style as well. For instance, they seem to approach learning in a slow, but deliberate fashion. This slowness should not be construed as slow learning but as a different approach to learning. Time is seldom a factor to the disadvantaged.

Also, they tend to be more pragmatic and to express themselves better in situations that are not overly structured. They can be introspective when stimulated by activities relating to qualities they feel very deeply about and are interested in learning by hands-on experience.

Such a style meshes very well with the humanizing role of art I offered earlier. But, more important, it suggests that the humanizing role of art also can be used to enhance the disadvantaged student's learning style.

What is important in the questioning activity that I mentioned is not so much what was done, but the way it was done. Whether discussing their own artworks or those done by other artists, disadvantaged students should be taught the procedure of inquiry — the encounter with art as a way they can use the experience they bring to the classroom. In a class in art appreciation, for example, instead of giving students information about an artwork the teacher can allow students to discover for themselves what is in the work.

Works for such a project must be selected carefully. For Black students, the teacher should select works with Black people as subjects or works that relate to the students' background and experience.

First, students can be asked to describe what they see in the work and how the formal elements fit together. In this phase, the teacher's role is to keep students' descriptions focused on what they actually see in the work so that they will not try to jump to conclusions about meaning.

Figure 1.4 *A young artist reflecting on his painting.*

The second phase in this type of inquiry is interpretation — what does it mean? Using the information gathered in describing the work and how the parts fit together, students are now asked to develop several hypotheses about meaning. Here the teacher's role is like that of a facilitator, keeping students focused, suggesting alternatives, and offering means to deeper levels of intuitive involvement.

For instance, if Jacob Lawrence's painting *Tombstones* is used, the teacher might ask: "Is there a relationship between the store selling tombstones in the basement and the people who live in the stories above?" "Does this relationship suggest anything to you about your own feelings?" "What do you think the painting is about?"

One can see that if works that relate to the students' background are featured, then they can use their experience to fashion questions and seek solutions. It is this process of inquiry that is important — the process of gathering information and making decisions about what it all means.

The process of inquiry can be used while making art objects as well. During a critique of students' work, the same technique mentioned above can be employed so that students become conscious of a procedure that can be practiced in any art activity.

It is not possible to explore all of the possibilities of this process here, but I believe the blueprint presented can serve as a guide for teachers of Black disadvantaged youth.

I hasten to add that the quality of the artwork should not suffer in the process. Quite the contrary, aesthetic concerns are the basis of the procedure. Students' skills in using color, value, intensity, line, and composition are the foundation of what they must draw upon to make statements about their feelings and perceptions in the artworks they compose.

Conclusion

There are no simple solutions to the frustrations and anxieties many art teachers experience in their encounters with Black disadvantaged students. Some teachers learn to adjust to the needs of these students and develop into excellent teachers. For those who still struggle with a feeling of inadequacy and genuinely want to reach them, I hope that I have offered something of value.

Perhaps most important is that the qualities these students bring to the classroom be used to tailor a process of inquiry. If this is done successfully, then the teacher will provide disadvantaged Black students with some important assets — how to learn, how to think critically and perceptively, and how to pursue knowledge. This "how to" experience can be applicable not only to art but to other subjects as well. Most important, it can be applied to situations in life itself.

References

Davidson, H., & Lang, G., (1960). Children's perception of their teachers' feelings toward them related to self-perception, school achievement and behavior. *Journal of Experimental Education, 1960, 28*, 107-118.
Dewey, J. (1934). *Art as experience*. New York: Putman Books.
Feldman, E. B. (1970). *Becoming human through art*. Englewood Cliffs, NJ: Prentice-Hall.
Hilliard, A. (1974). Restructuring education for multicultural imperatives. In William A. Hunter (Ed.) *Multicultural education through competency-based teacher education* (pp. 40-55). Washington, DC: American Association of Colleges for Teacher Education.
Read, H. (1945). *Education through art*. New York: Pantheon.
Reissman, F. (1962). *The culturally deprived child*. New York: Harper & Row.
Run D. M. C. (1984). *Hard times*. New York: Profile Records, Inc.
Watson, G. (1962). Foreword. In F. Reissman, *The culturally deprived child* (p. x). New York: Harper & Row.

Additional Resources

Leavy, W. (1986, August). Fathers who walk away. *Ebony* (Special issue: "Crisis of the Black family"), p. 61.
Pousaint, A. (1986, August). Save the fathers. *Ebony* (Special issue: "Crisis of the Black family"), p. 43.
Twiggs, L. (1986, September/ October). On art and testing in a period of educational reform. *Design for Arts in Education*, pp. 51-54.

2

Ancestry and Aristocracy: Indigenous Art of the Northwest Coast

BARBARA LOEB

Oregon State University

In 1980, Nuu-Chah-Nulth[1] carver and printmaker Art Thompson issued a special lithograph (Figure 2.1) that he modeled after a dance screen, or ceremonial cloth backdrop, that came into his family with his great-grandmother. The central image in this artwork is a tall, stone pillar, topped by a fire and flanked by two wolves. Thunderbirds fly above, and a small, humanoid face peers into the scene from the right.

Although this artwork is intended for sale to nonnative people, its composition, like the older screen it emulates, recounts an important part of the Thompson family history. As the artist explains:

> *The curtain's origins come from Clallam Bay, Washington.*
> *My great-grandfather had to perform certain feats in order to win the hand of a woman, to be his wife. These feats were arranged by the family of the woman. They were called "Too-pah-tee." They were games arranged by the family of the woman. The husband himself or someone in his family had to complete these games without failure. Should they fail, there was a good possibility the marriage would not go through.*
> *When my great-grandfather was asking for this Clallam lady, her father had brought his "too-pah-tee" out to challenge my great-grandfather. He accepted the challenge. He soon found out that the too-pah-tee had involved him climbing up a greased rock and putting out a fire with his hands. He was successful with this feat. He had won the hand that he was asking for.*
> *As part of the bride "dowry" the father of the bride gave two thunderbirds and two wolves, which are included as part of the design field on the curtain. In the bottom right of the curtain is a human face representing a witness to the fact that my great-*

15

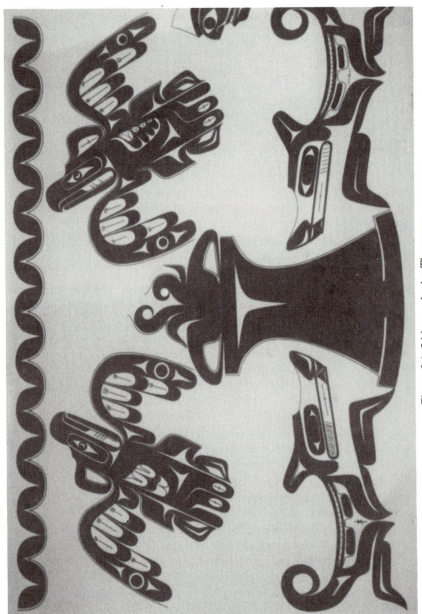

Figure 2.1 Lithograph, Art Thompson.

grandfather had indeed accomplished the feats presented to him.

With the too-pah-tee over with, the bride now at his side, my great-grandfather took it upon himself to document the event on a curtain for further use by our family. This particular curtain is still in use today by our family. (A. Thompson, personal communication, July 1989)

An artwork such as the *Thompson Family Dance Curtain* is an informative starting point for understanding Northwest Coast art, partly because of its strong reference to family history but also because it is supported by an intricate structure of social prerogatives, or marks of noble rank. Too-pah-tee, for example, were owned by certain Nuu-Chah-Nulth families of high status, as were rights to specific dance curtains, whereas the thunderbirds and wolves represent additional prerogatives that have continued to be transferred, by means of prescribed ceremonies, to three more generations. All of these privileges have names, and they are so carefully protected and respected that the artist himself could portray them only because they belong to his family. He could not have recounted their meaning in detail for this article without additional permission from his relatives (A. Thompson, personal communication, June 1989).

Many visual creations from the Northwest Coast make historical statements comparable to that shown on the *Thompson Family Dance Curtain*. The purpose of this chapter is to provide an overview of these artworks within the context of Coastal culture and its respect for lineage and noble heritage. For that reason, I will discuss social structure before examining the artworks.

History And Life Style

The region that we now think of as the Northwest Coast is a heavily forested territory extending along the Pacific Coast from the southern edge of Washington to the Lynn Canal in eastern Alaska. Its climate is characterized by heavy rains and relatively mild temperatures that have resulted in abundant resources for both food and arts. Its ocean once teamed with fish and aquatic mammals such as whales, otter, and seal; its streams flowed heavily with salmon and other delectable fish; and the land yielded copious supplies of roots and berries, as well as the cedar and other materials that craftspeople turned into their totem poles and other distinctive arts.

The indigenous people who occupy these forest lands may have arrived as

17

many as 10,000 years ago, and they developed canoes and other technology for taking advantage of coastal resources. The names of their main divisions, as recognized today, are the Tlingit, Tsimshian, Haida, Bella Coola, Kwakiult, Nuu-Chah-Nulth, and Salish, with the Tlingit being at the most northern tip of their territory and the Salish occupying the south. Each have distinctive characteristics but share a significant number of cultural traits, much in the manner that France, Spain, and Germany can be identified as separate peoples but share a number of religious, economic, and artistic principles. The groups that differ most markedly from the others are from the Salish region and will not be discussed here.

By the time the people of the Northwest Coast met European sea traders in the late 1700s, they had developed the complex social structure that would lead to such elaborate artistic renderings as the *Thompson Family Dance Curtain*. Out of this system emerged a highly formal sense of family heritage and a carefully ordered class structure that once was divided into nobility, commoners, and slaves and still acknowledges those of high birth.

The members of the society trace their ancestry through their mothers if they come from the northern groups and through both parents if they live in the south, and they pay careful attention to lineage. The northern tribes contain two, three, or four major segments, and everyone inherits lifelong and unalterable membership into one of them. These large groups, sometimes called *phratries,* are further divided into a number of smaller clans. The Tlingit, for example, consist of the Raven and Wolf phratries, which in turn contain a number of subgroups, of which 56 were being used early in this century (Emmons, 1982, p. 69). The Kwakiutl and Nuu-Chah-Nulth to the south, although no less concerned with lineage, emphasize many smaller groups instead of the larger phratries. The Kwakiutl, for instance, belong to numerous "numayma," which turn-of-the-century ethnographer Franz Boas believes refer back to old village sites (Boas, 1966, pp. 42-43).

Accompanying this structure is an equally precise ranking of the aristocracy. These are noble individuals who normally acquire status through inheritance or marriage, but sometimes achieve greater rank because of wealth and the giving of various kinds of formal feasts, commonly referred to as potlatches in the literature.

The emblems of one's group membership or noble status are often called crests or are referred to as privileges or rights. Often, these marks of social place represent composite ideas, as evidenced in a Nuu-Chah-Nulth too-pah-tee or dance curtain, whereas many take the forms of animals, human beings, and natural phenomena such as the moon or sun. Others represent mythical creatures and may combine human and animal features or join

18

characteristics from two animals. Whatever the creature, most crests are accompanied by songs and dances, as well as stories that may function as mythicized family histories.

These marks of group membership and noble rank are carefully guarded and can be used only by those who possess the privilege. Everyone within a specific phratry or clan has the right to use the motif of his or her group, which is why all Tlingit members of the Wolf phratry can wear the wolf image and all Haida of Raven ancestry use the specified killer-whale image. One's clan membership is clearly defined, however, especially in the north, where one always belongs to the group of one's mother, and the wearing of the crests of another group is almost unthinkable. This is the reason that a modern Tlingit woman has been criticized for wearing the regalia of her father instead of that which she properly inherited through her mother. Although, as explained by a Tsimshian member of the same region, her intent was simply to honor her deceased relative (K. Arriola, personal communication, 1988), her behavior disrupted the matrilinear system.

In a smaller fashion, noble crests can be displayed by their aristocratic owners or by those to whom the noble possessors have granted special permission, but they cannot be used by others and are as rigorously guarded as emblems of clan membership. Subsuming such a privilege would once have resulted in a bloody, physical war or a formal confrontation within the context of a public feast, and even today is likely to lead to ritualized challenges and other trouble. These boundaries are so carefully adhered to that an artist must limit him- or herself to family crests, as Art Thompson did, or seek permission to portray others.

The vehicles through which lineage and status are made clear are the spectacular winter feasts that require years of planning and extensive financing. In outward appearance, these several-day gatherings are impressive displays of beauty and drama: Skilled speeches are given; large numbers of artworks are displayed; dramatic dances are performed, complete with songs, loud drumming, and carved wooden masks; and, at the end, all who have attended are generously fed and sent home with gifts.

The motivation behind the complex ceremony is to validate the privileges discussed above, a process that Northwest Coast people sometimes refer to as the bringing out of crests. A family usually participates in such an event when inherited rights are to be transferred to new owners, particularly during namings or the marriages or deaths of high-ranking people. Because their primary intention is crest validation, much of what happens is designed with that purpose in mind. The speeches may proclaim noble histories, whereas songs and dances put prerogatives before the larger group and the

carved masks bring specific crests to life. The audience becomes witness to the bringing out of these marks of social status, and the gifts that they receive at the end function as payments for their witnessing. If the audience accepts their gifts, they signal the family's right to the crests that have been displayed, and the validation of the privilege is complete.

The artworks that appear during these feasts and in other aspects of Northwest Coast life are sometimes made for healing or other shamanistic purposes, but more often they function to make family lineage and noble status visible. Thus, the interior posts that once supported the roofs of high-ranking long houses were sometimes carved with special histories, whereas interior screens and exterior fronts were painted with huge images of the most important crests of the occupants. Canoes large enough to be seaworthy were painted and carved with additional images if they belonged to substantial chiefs, and tall totem poles stood in front of important homes and faced toward the sea to inform anyone who approached by water of the lineage of those living within. Additional crest motifs appeared on storage boxes, serving bowls, and carved spoons, as well as apparel such as garments, jewelry, and even face paint.

The artists responsible for these works were skilled craftspeople who had undergone rigorous apprenticeships and were regarded as specialists. Their products were made on commission and were often executed when an important family was planning a major feast. As preparations for the ceremony proceeded, these artisans were engaged to carve a pole, ready new masks for presentation, or produce the garments that participants would wear. Their works were often costly and time consuming; a man would require months to carve a pole, and a woman might need 2 years to weave a traditional blanket of goat's wool and shredded cedar bark. Much of this effort ultimately pronounced the status and wealth of the owners.

An Old Photograph

Given the importance of both genealogy and privilege in Northwest Coast culture, it is clear that visual arts are closely associated with financial prosperity, ceremony, family history, status, and power. As evidenced in the Thompson family dance screen, a fine object produced within this system represents much more than a skillful piece of craft. Once this is understood, photographic records take on new meaning because the wealth and status that they represent can be enormous.

The photograph illustrated in Figure 2.2, which was taken around the turn of the century, presents the interior of the venerated Whale House, which

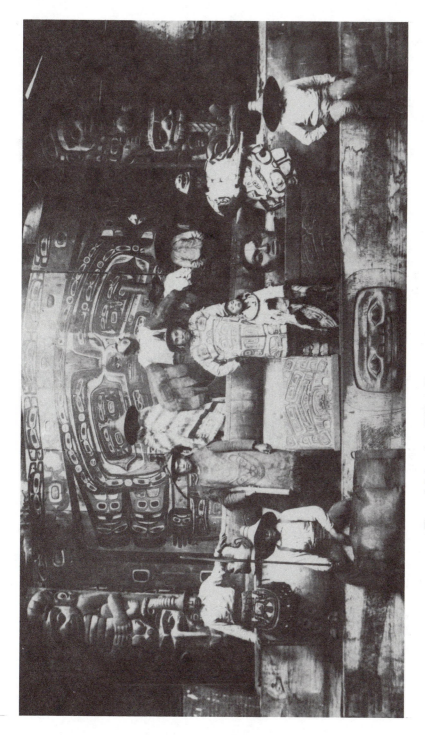

Figure 2.2 Interior of Whale House, Alaska State Library Collection.

21

stood in Klukwan, Alaska. This aged building, belonging to the hereditary chief and relatives of the Ganaxtedi clan, was built in the 1830s (Emmons, 1982, p. 77). It is shown here filled with fine carvings and occupied by a number of people posing in some of the insignia of their status.

The back of the scene is dominated by the Rain Wall, a carved and painted cedar screen 20 feet long. The crest portrayed in this screen has been variously interpreted as a large rain spirit with water drops splashing around it (Emmons, 1982, p. 81), Gonakadate, a wealth-bringing sea being, rising from the ocean with water dripping from his arms (Keithahn, 1963, pp. 132-133); or as Raven bringing fresh water to the world (Jonaitis, 1986, pp. 114-115). Whatever its meaning, it is clearly an important crest that asserts the high rank of its owners.

On either side of this famous screen stand two deeply carved house posts that support the main beams of the house and portray some of the stories that the family includes among their privileges. The one on the right, for example, is the Woodworm Post, which tells the story of a young and noble ancestor who found a woodworm that she secretly nurtured until it reached the size of a human. When her family discovered the child's pet, they reacted in fear, killing the creature and causing the girl such sorrow that she died of grief. As a result of this tragedy, the clan that owns the Whale House migrated to a new location and claimed the woodworm as crest (Emmons, 1982, pp. 88-89). Thus, the post simultaneously puts forth an inherited privilege and makes reference to a part of the clan's history.

The tall hat of the man on the far left is topped with a series of basketry rings that are called potlatch rings (after the term often associated with feasting) and signify status, while the rest of the people in the photograph wear other important hats, as well as masks and garments that are further indications of the strength of the household. Other objects that represent family prerogatives have also become crests in their own right, which is the case with the Mother Basket at the lower left and the aged and lengthy Wood-worm Feast Dish that stretches across the top step of the house. Even the house itself represents a privilege and is almost the last of a series that stood on the site and bore the same venerated name.

Once one grasps the implications behind such objects, it is possible to begin to understand the depth of information, as well as the immensity of wealth and high social position, communicated in this photograph. The intention of those who are wearing or using these objects is not simply to dress well or create a handsome home but to indicate ancestoral lineage and communicate the nature of their noble status.

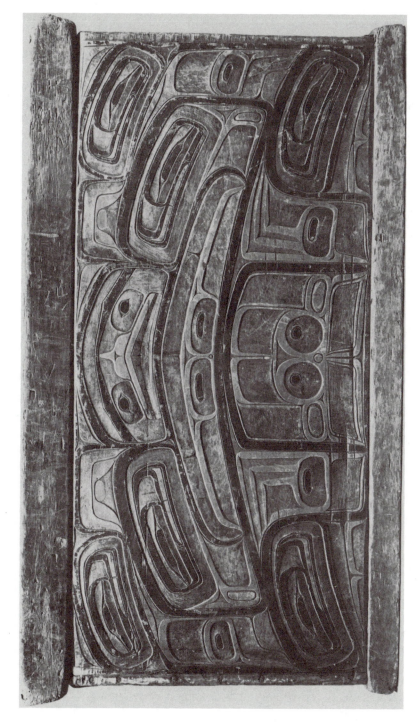

Figure 2.3 *Chest with Cover.* The Portland Art Museum, Rasmussen Collection of Northwest Coast Indian Art.

Formline Rules

The foundation of Northwest Coast art among northern groups such as the Tlingit, Haida, and Tsimshian is a unique system of aesthetic rules. These design elements affect almost all art from the region, because they are painted and carved on flat surfaces, wrapped around cylindrical forms such as totem poles, and woven into textiles. They are so carefully structured that they reiterate in visual terms the equally formal social structure.

The dominant element in this highly organized compositional system is a smooth, broad band that Northwest scholar Bill Holm (1965) has named the *formline*. Those bands fill highly specific roles. Some frame the main parts of the crest and are called primary formlines. Because these are often painted black, like those on the chest illustrated in Figure 2.3, they are easy to distinguish. Other bands, called secondary formlines, fill the insides of images and can be distinguished in the black and white photograph of the chest because they are medium grey and look smaller than the black parts. These broad bands are so predominant that they describe almost all of the important details in a Coastal design and are normally supplemented only by tertiary lines that are as thin as pencil marks and edge interior details.

Color rules are even more rigorously prescribed, especially in the northern part of the coast, where artists traditionally limit themselves to three colors — black, red, and blue. They normally make the primary lines black and the secondary lines red, but occasionally reverse the order or use only one of the two colors. This handling of color is so formal that the only other option is to carve a piece and leave it unpainted. Light or medium blue is sometimes used to cover tertiary spaces, but color rules are strict, so northern artists cannot make the primary lines blue and the tertiary spaces red or black. Only the Kwa-Gulth and Nuu-Chah-Nulth to the south indulge in a broader palette by including white, bright yellow, and green.

Almost every detail within a traditional design is made of one of two shapes, a U-form or a curved element called an ovoid, a convention that forces the artist to maintain tight control of surface organization and reinforces the sense that Northwest Coast composition is built on a tightly prescribed structure. Furthermore, each of these details is, in itself, bound by another series of rules. Properly shaped ovoids, such as the ones in each corner of the chest illustrated in Figure 2.3, or smaller ovals that form the eyes of the same creature, usually curve up at both the top and the bottom, like kidney beans, except that the lower curve is more subtle. The formlines defining the ovoid should be wider along the top and thinner at the sides and bottom, and their corners should curve abruptly, creating a boxy quality. U's should employ the same angular corners and remain wider at the base than at the

24

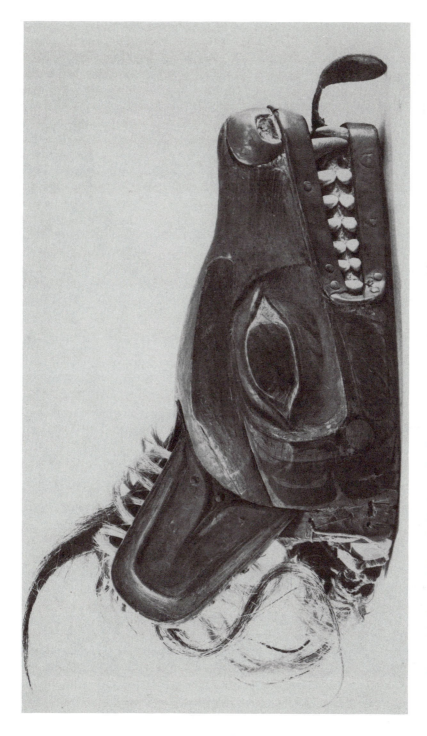

Figure 2.4 *Forehead Mask (Wolf's Head).* The Portland Art Museum, Rasmussen Collection of Northwest Coast Indian Art.

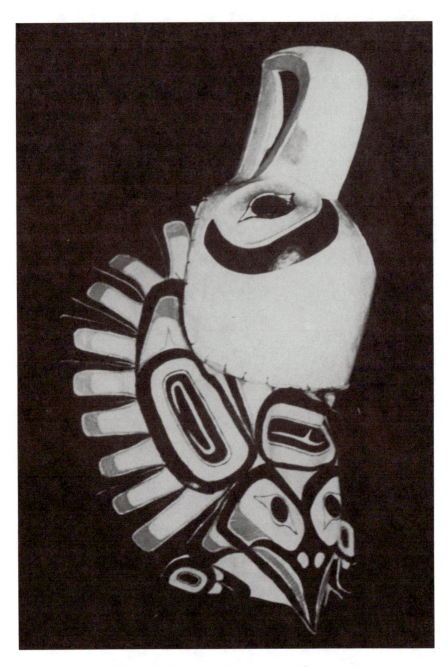

Figure 2.5 Thunderbird headdress, Freda Diesing.

legs.

Another principle that well-trained Northwest Coast artists follow carefully is the concept of continuity, which means that they connect every formline to another. All primary lines touch another primary, and all secondary lines adjoin at least one other main or secondary band. This tight interrelationship of parts once characterized almost all work of the northern groups and was in partial use in southern areas. In the 20th century, it was one of the features that artists lost sight of early, resulting in a softening of the tension that typifies well-made compositions, but this important rule has been revived by recent artists, so Northwest Coast design has recaptured the taut quality it had in the 18th and 19th centuries.

These are just a few of the formalized conventions that Northwest Coast artists took care to master, but they are so complex that the untrained viewer may initially be perplexed by what appear to be confusing masses of lines. Nonetheless, the images represent definable beings with heads, bodies, and limbs that relate to each other in realistic and systematic ways. The image on the storage chest is portrayed with a very large head that almost fills the upper half of the design and is further elaborated with a smaller face where the forehead would be. The smaller face rests between two U-shapes that represent ears, whereas the main head rests directly on a torso that is represented by another large, inverted U. Hips are defined by the two ovoids at the lower corners, and the dark bands that attach to the inner corners of those ovoids represent the creature's legs curving down to attach to claws. The latter can be easily identified because they are sandwiched between the torso and hips and are painted with a lighter, secondary red.

The carefully defined artistic conventions that predominate on the chest are so important that they also influence sculpted pieces. The mask illustrated in Figure 2.4 demonstrates this point well because it combines a relatively realistic visage of a wolf with a number of details clearly influenced by the formline system. The lips and eyebrows have a band-like quality distinctly similar to formlines and the eyes have been made with ovoids, which are echoed in the carved shapes of the eye sockets. The ears and copper-inlaid nostrils are constructed with U-shapes, and still more examples appear in the back part of the mask where painted U's mark the transition from eye socket to fur. A close examination reveals that almost every carved element or surface detail on this piece makes use of the highly refined formline system.

Once viewers become accustomed to the many compositional rules, images such as those on the box or mask become easier to read, and the dominance of the formline system becomes clear. It also grows apparent that Coastal

aesthetics can be as complex, but as orderly and cohesive, as the formally organized Northwest Coast society.

Northwest Coast Art Today

The highly structured systems of class distinction were unquestionably in place many centuries ago, affecting people from Tlingit all the way south to the Nuu-Chah-Nulth; however, the social system suffered greatly after the arrival of Europeans, and art work began to decline in response. As a result, the past hundred years have included a near loss of the old aesthetic rules in almost all regions but that of the Kwakiutl. However, this situation has reversed itself in the past 20 years as younger artists have made determined efforts to return their indigenous art forms to the technical and compositional excellence characteristic of their ancestors. They now produce numerous works for both internal use and external sale in fine art galleries. The works discussed below demonstrate a few of the varied responses these modern carvers and painters have made to the aesthetics of their forebearers.

Like many of her contemporaries, Haida carver Freda Diesing makes most of her art to sell to nonnative people but depends on indigenous traditions for subject, technique, and style. The piece illustrated in Figure 2.5 is a thunderbird headdress referring back to a personal crest figure that belonged to a great-grandfather on her mother's side. The face of the bird is carved of alder and is designed to fit over a dancer's head, just as it would have been if made to be worn in a formal ceremony. The heavily painted body of the creature is made of leather so it can hang over the wearer's shoulders.

Formlines cover the skin cape, adhering to old aesthetic rules that include a red and black color scheme, the predominance of U and ovoid details, and the consistent continuity from one element to the next, but they simultaneously recreate the physical characteristics of the thunderbird. A fan of U-forms along the base of the piece represents wing feathers, whereas ovoids across the back of this mythical bird define an additional face. This new visage ends in a large V-shape that portrays both the beak of the second creature and the tail of the sculpted thunderbird. Such a carefully considered use of a single element to represent two different body parts appears often in older Northwest Coast designs and demonstrates the degree to which the artist understands the complex structure of her artistic heritage.

The influential carver and printmaker Art Thompson also produces a significant percentage of his work for fine arts galleries and takes care to

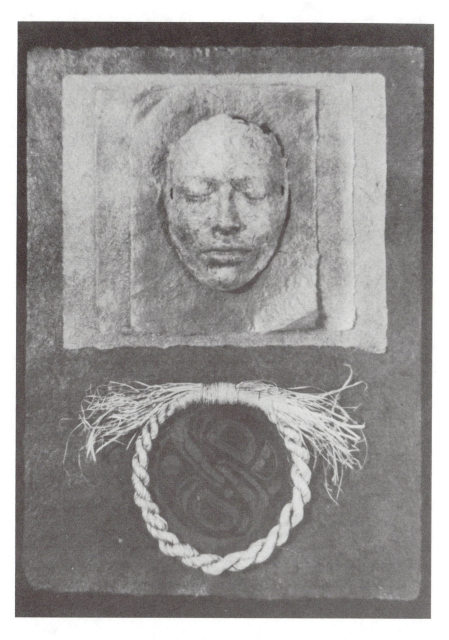

Figure 2.6 *Dawn's Mask*, Edna Davis Jackson, Tlingit, 1988, cast red cedar bark mask and shredded yellow cedar bark head ring on cedar bark paper. Owned by the Collection of Alaska Airlines, Seattle Corporate Headquarters.

adhere to traditional subjects and aesthetics; however, his artistic base is southern, so he handles the old rules in a looser manner than Freda Diesing. For the *Thompson Family Dance Curtain,* he constructed a number of elements such as eyes and wings with ovoids and U-shapes but skillfully incorporated less conventional details, especially for the stone pillar and the two wolves. In typical southern fashion, he expanded on the prescribed color scheme of the north by emphasizing black and brown and felt free to abandon continuity when it suited his compositional purposes. On this piece, he has connected all the formlines within the main images but has allowed each creature to float freely in its own space.

Diesing and Thompson acquired their knowledge by studying older pieces and working with relatives and other artists. Diesing also trained at 'Ksan, an art school established by the Tshimshian in the 1960s. Thus, these artists remained linked to internal systems of teaching. In contrast, Tlingit artist Edna David Jackson earned a bachelor of fine arts degree from Oregon State University in Corvallis and a master's degree in fine arts from the University of Washington in Seattle before moving back to the isolated village of Kake, Alaska. As a result, her work represents a complex interweaving of indigenous and imported aesthetic ideas.

For *Dawn's Mask* (Figure 2.6), she made a cast paper portrait of her daughter, using a plaster mold of the young girl's face, and placed the image over several layers of handmade, cedar paper. Below this visage she painted formline heads of an eagle and a raven and framed them in a circle of shredded cedar bark fashioned in the style of the traditional head and neck rings worn by certain Tlingit dancers.

At several levels, this work reflects the artist's university training. The concept of pressed cedar paper evolved from her early exposure to felt making at Oregon State University, and her use of plaster casts reflects back to both the molds used in 19th-century European studios and the live castings done by contemporary artists such as George Segal. Because of this technique, the face of her daughter is highly realistic and contains none of the stylized features of a traditional Tlingit carving. Furthermore, the two-part composition recalls the kinds of multimedia arrangements that have been popular in both the United States and Europe since the 1960s. The connection to nonindigenous ideas is completed with the structure of the work, because this paper piece can only function as a wall hanging in the Euro-American fashion.

In spite of this close study of Western artistry, however, Jackson's strongest roots remain Tlingit. Thus, her eagle and raven adhere to the formline rules, her materials have been consciously selected from the same woods that her

ancestors used, and the mask itself has a composed stillness almost identical to that of older, wooden pieces. More important, the eagle at the bottom of the work represents the moiety of the girl's mother and the raven portrays that of the father; thus, this work, like the *Rain Wall*, the *Thompson Family Dance Curtain*, or almost any other piece of Northwest Coast art, becomes a statement of lineage.

Closing Comments

The indigenous people of North America include several large culture areas so distinct from each other that combining their creative output under one heading would be comparable to interweaving the arts of Europe, Africa, and Asia. Thus, the precisely executed pieces that Northwest Coast artists made to acknowledge noble status and other inherited privileges differ markedly from the brightly colored, individualistic beadwork of the nomadic Plains people. The work is equally unlike the textiles and ceramics of the Southwest Pueblos, with their soft lines and conservative styles. Because the subject of Native American art is so large, I have focused on a single area. However, I hope that readers will remember that the masterful painting and sculpture of the Northwest Coast represent only a fraction of many forms of visual expression that originated in the diverse lands of the North American continent.

References

Boas, F. (1966). *Kwakiutl ethnography*. Chicago: University of Chicago Press.
Emmons, G. (1982). The Whale House of Chilkat. In A. Hope III (Ed.), *Raven's bones* (pp. 68-90). Sitka: Sitka Community Association. (Original work published in 1916)
Holm, B. (1965). *Northwest Coast Indian Art, An analysis of form*. Seattle: University of Washington Press.
Jonaitis, A. (1986). *Art of the Northern Tlingit*. Seattle: University of Washington Press.
Keithahn, E. (1963). *Monuments in cedar*. Seattle: Superior Publishing Company.

Additional Resources

Curtis, E. (1915a). *The Kwakiutl, The North American Indian* (Vol. 10). Norwood, CT: Plimpton Press.
Curtis, E. (1915b). *The Nootka and Halda, The North American Indian* (Vol. 11). Norwood, CT: Plimpton Press.
Gunther, E. (1956). *Art in the life of the Northwest Coast Indian*. Portland: Portland Art Museum.
Hall, E., Blackman, M., & Rickard, V. (1981). *Northwest Coast Indian Graphics. An introduction to silk screen prints*. Seattle: University of Washington Press.
Holm, B. (1987). *Spirit and ancestor, A century of Northwest Coast Indian Art at the Burke Museum*.

Seattle: University of Washington Press.

Holm, B., & Reid, B. (1975). *Indian Art of the Northwest Coast of America*. Seattle: University of Washington Press.

Samuel, C. (1982). *The Chilkat Dancing Blanket*. Seattle: Pacific Search Press.

Note

[1]Also referred to as Nootka or West Coast in the literature. Nuu-Chah-Nulth is the preferred tribal name and is used throughout this article.

3

The Minority Family as a Mediator for Their Children's Art and Academic Education

BERNARD YOUNG

Arizona State University

Multicultural education is becoming increasingly more important each day as our population changes, and this area of study includes the education of Black children. This chapter will primarily address the role the minority family can play as mediators for their children's art and academic education.

Multicultural education is increasing in its importance, partly because of larger enrollments of culturally different groups in our public schools. Statistics from the U. S. Department of Commerce (1987) have projected that people of Spanish origin will increase from 16 million to approximately 31 million by the year 2000, and that the Black population, which will be at 30 million in 1990, will increase to more than 37 million by the year 2000. With the present high numbers of multiculturally different groups and the expected increases in our population, it is clearly important for teachers to accommodate the needs of these students. To meet these changing needs, the content in our curricula and our teaching methodologies must be changed because they are not presently working. Psychologist Edward Zigler and his associates have presented a perspective developed over the past decade that I believe holds great merit: Differences among groups of people should be perceived as important empirical phenomena and as socially strengthening matter that should be investigated, appreciated, and valued. Instead of adopting a "deficit model" (that has been presented numerous times in the psychological literature), they argue that a commitment to their approach would lead us to deal with the question of how human variation can be employed for the enrichment of all. They believe that variation should be welcomed, rather than deplored, and that human diversity contributes to the richness of the social fabric.

A commitment to such a difference approach would encourage educators,

33

art educators and art historians, artists, behavioral scientists, and others who are interested to focus on the central question of how human variation can be exploited for the enrichment of all members of our society.

Not all culturally different or minority children are having problems in school today, but throughout the nation alarming numbers of minority children are having severe problems. In fact, a disproportionate number of these children are having problems that could be prevented.

The American educational system has not been effective in educating Black children. The emphasis of traditional education has been on molding and shaping Black children so that they fit into an educational process designed for middle-class White children. Such a middle-class approach has inherent problems, because many of these children live in conditions of extreme difficulty that directly affect their schooling. A careful reading of the literature on social class and ethnic group differences reveals that much research has been undertaken with the assumption that the behavior of White middle-class children represents the standard against which the behavior of all other children should be assessed. When a child's performance in academic or artistic work does not match this standard, the child is often considered "deficient." We have a great deal of evidence that the educational system is not working for many Black children because of the disproportionate number of Black children who are labeled hyperactive or mentally retarded, and are often placed in special classes. A disproportionate number of these children are being suspended, expelled, and finally "pushed out" of schools. We can see that the system is not working in the high Black teenage unemployment rate and the overrepresentation of Black people in the prison population (Hall-Benson, 1982) and in the small number of Black students majoring in programs of teacher education and the smaller number entering art education.

Why is the school and art achievement of American minority children, especially Black children, ranked below that of their White counterparts? Why are many of these children not fulfilling their artistic potentials? And why do the recent statistics from the U. S. Department of Education indicate such seemingly contradictory findings about minority children? For instance, the Department of Education (1987) reports that Black high school students from 1974 to 1985, between the ages of 18 and 19, have graduated at an increasing rate each year (55.8% in 1974, 62.8% in 1985). Blacks who went back to school after age 19 represent an even higher number of 20-24 year-olds who have graduated. In 1985, 80.8% of these Black students graduated from high school, compared with 86.0% of the White students who returned to high school. If the number of Black students graduating from high schools is at an all-time high, why is the number of Black students

entering colleges at an all-time low? These questions are not aesthetic, and they do not pertain to artistic or purely intellectual matters, but they are academic as well as political questions. In fact, according to cognitive psychologist Ulric Neisser (1986) and others, these questions are so political that few educators, art educators, social scientists, or educational researchers discuss them. The school performance of minority children remains a severe, persistent, troubling wide-scale national problem that continues to grow, while less attention seems to be given to these children. It is the contention of Boykin (1986) that poor performance relative to mainstream children and a high incidence of school dropouts are still the rule rather than the exception for minority children. We must ask why there has been so little progress toward solving many of these problems. Why is it important to develop curricula and art educational programs that will address the specific problems of these children? Why is socioeconomic status so often tied to a child's academic and artistic achievement? Why should we nurture art education?

The Importance of Nurturing Art

The acquisition of knowledge and success in school for Black children and all children is definitely linked to their future success and the success of the next generation. It is important to note that a one-sided education with an emphasis on only factual information, repetition, memorization, and recitation often neglects many very important attributes that our children need in order to properly adjust to this world. An unbalanced individual and an unbalanced education often lead to children becoming adults who have difficulty in their relationships with people and their environment. Art is part of a well-balanced education and part of a basic need.

Recently, I had the pleasure of visiting my son's first grade teacher for a parent-teacher conference at the beginning of the school year. She began to tell me how my son was doing academically. He was making normal progress in some areas and doing better in others. I asked her about possible homework assignments and expressed my concerns about different methods my wife and I could use to follow up on our son's schoolwork at home. Immediately, the teacher became concerned that we would give our child excessive amounts of homework. She was worried that if he worked hard in school each day and was required to repeat much of the same each evening, which would eliminate after-school activities, he might become burned out, a victim of the super-child syndrome. David Elkind (1987) expressed his view on this syndrome. He stated that a national trend toward pushing young children to achieve academically has led to the introduction of inappropriate teaching methods and expectations for kindergarten and

prekindergarten children. The result has been that many of these youngsters face possible stress and educational burnout in elementary school. Teaching six-year-olds as if they were eight-year-olds could create a great deal of stress that would, indeed, be counterproductive. Unnecessary pressure to learn through inappropriate methods could very well turn off a child to learning at a very young age.

The teacher went further to explain her position:

> *We have a special time in class when we ask each child to stand up and express their concerns about their families, hobbies, and extracurricular, after-school activities. And your son loves his extracurricular activities and his academic schoolwork. He quite spontaneously speaks with great detail, and I mean minute detail, about visiting a museum, playing soccer, climbing a tree, drawing pictures of daily events. It appears that life after school is just as important in his development as what he does in school. So, please, keep doing more of what you're doing. He thinks very independently and creatively, and part of this behavior can be attributed to the creative activities he is involved in.*

I was very pleased that the teacher was concerned about a balanced education, just as we were as parents. We all know that knowledge alone does not make people happy or well adjusted. The argument for a balanced education is a just one, and one to which parents need to pay particular attention.

Nurturing Talent

All artistic abilities are not learned, and all artistic abilities are not inherited. You can ask any parent who believes their child has a high level of artistic ability, and they will inform you that artistically talented children do exist, that is, children who are born with a natural gift. Unlike the researchers who have devoted extensive study to the problem of this complex quality known as talent, parents tend to believe and cultivate the notion of or belief in natural talent in their children. Figure 3.1 shows children from an inner city area enrolled in an after-school community based art program. The parents involved were attempting to cultivate their children's natural abilities. Researchers, on the other hand, claim that talent and its exact nature evade rigorous analysis. More commonly, some researchers think that artistic talent will develop in all persons in proportion to the potential with which they start. This notion raises a problem for low-income children and their parents. Parents from low-income areas who believe their children are

Figure 3.1 *Children in an after school art program at the Morton House in Lexington, Kentucky.*

Figure 3.2 *Young children watercolor painting.*

talented either artistically or academically cannot sit around waiting for their children to bloom and their abilities to flourish. They must take aggressive measures simply to survive. Poverty often causes despair, anger, and, sometimes, a lack of interest in anything except one's own worries. Studies show that large numbers of children born into low-income families remain poor all their lives. Many of these children may adopt the same feelings of helplessness and hopelessness that some of their parents have developed over the years. To compound the problem even more, practically all of these children will be enrolled in public schools that rely on local property taxes. Low-income communities generate less tax money, so they cannot afford the educational programs that wealthier communities have. Further, many low-income and poverty-stricken parents are inadequately educated themselves, and they cannot provide proper assistance or encouragement to their children. Their intentions may be great, but they may lack proper direction. The children in Figure 3.2 are in a daily after-school program that was developed with educators at their public school and local university.

Regardless of the odds that are very real, many low-income parents and grandparents believe very firmly in the self-worth and high educational goals that their children can achieve. They believe simply that their children are highly talented and gifted, and they vigorously support them against all odds. The dreams and aspirations that these parents have for their children are crucial ingredients in their children's success and development. These parents have no choice but to develop at least four starting goals for their children's education:
1. Set high aspirations.
2. Have persistence and determination.
3. Have a daily scheme (or game plan).
4. Obtain the highest quality information available.
Surely, these four goals will not be the only factors that will encourage a child's artistic growth, but they will help parents get started. Children need to work extensively with artistic materials. All children must make many drawings and paintings and handle clay a great deal to adapt their hands to the possibilities of the medium itself. I am not speaking about the child's need to learn specific techniques at this point; I am referring to experiences with the medium. Techniques will be developed over a longer period of time and will become aids in communication.

A study by McKenzie (1986) clearly showed that there are vast disparities in the resources available to different school districts for the education of children in New Jersey. It is doubtful that equality of educational opportunity can exist when the funding of educational programs relies so heavily on local resources and that inequalities between communities are translated

into inequalities in educational programs. This is certainly not a problem that is isolated in New Jersey school districts. Because of discriminatory evaluative practices that seem to have more to do with theory than practice, minorities and the disadvantaged have far less a chance of participating in gifted and talented programs than do advantaged members of the majority culture. Many of these programs have operationalized their definitions to selectively work to the advantage of the already advantaged. Even with the inequalities mentioned, it must be stressed that disadvantaged parents should give their children great support and encouragement at home.

This encouragement should be general, and specific in the area of the child's talent. The Development of Talent Research Project (1981), conducted under the direction of Benjamin S. Bloom at the University of Chicago, was a study of people who, before the age of 35, have demonstrated the highest levels of accomplishment in specific artistic, psychomotor, or cognitive fields. Bloom and Sosniak (1985) claimed, as a result of this project, that parental support and home support play a very important role in enhancing children's development, monitoring their practice, and encouraging and even correcting them, especially in the early years. In this particular study, in each talent field there were frequent events (recitals, contests, concerts) in which the child's special capabilities were displayed publicly, and there were significant rewards and approval for meritorious accomplishments. Frequently, in the early years, much of the early learning was exploratory and much like play; however, not until after age 12 did these talented individuals spend as much time on their talent field each week as their average peer spent watching television.

Piaget (1967) states that children develop their perception of good configurations (or simple euclidean forms) as a result of sensorimotor activity. The child is involved with continual eye movements, tactile exploration, imitative analysis, and active transpositions, which all play a fundamental part in this development. Young children learn best through active manipulation and exploration of materials with opportunities to initiate their own learning projects. So, without the appropriate art education that can be provided by the school and parents in a partnership (e.g., providing drawing, modeling, symbolic play, and other artistic activities), the cultivation of these means of expression and academic achievement can thwart rather than enrich children.

According to Lark-Horovitz, Lewis, and Luca (1973), the goal in teaching art to children is not to train artists but to offer experiences that contribute to personality growth. Experience with art heightens their sensitivity to the physical world and leads to a greater appreciation of their environment. It helps them to give order to their sense impressions and enlarges their

capacity for enjoyment. It opens a way of expressing imagination and feeling. If the child is to acquire knowledge and the facility to manipulate art materials, active participation is essential.

Under the supervision of Irving Lazer and Richard Darlington, two Cornell psychologists, a study by the Consortium for Longitudinal Studies examined the long-term effects of preschool educational programs. Their results indicated that preschool programs help low-income children and have long-term educational benefits. The Consortium was a collaborative effort of 12 research groups at major research universities conducting longitudinal studies on the outcomes of early education programs (Darlington, 1986). Their data bank contained information on approximately 3,000 low-income children. To arrive at their conclusions, the investigators collected a variety of cognitive and behavioral measures.

Cognition is the activity of knowing — the acquisition, organization, and use of knowledge (Neisser, 1976). It is something that organisms do and, in particular, something that children do. According to Neisser (1966), such terms as sensation, perception, imagery, retention, recall, problem solving, and thinking, among others, refer to hypothetical stages or aspects of cognition. Many of these cognitive processes surely exist in the art development and activities of preschool children. In a study on drawing development in preschool children, Goertz (1966) found that experience in working with art materials accelerates the developmental level of a child's drawing ability. As the Consortium, with Darlington and his investigators, pointed out, high-quality early education programs are likely to benefit both low-income children and the larger society in which we live. This represents merely a fraction of the child's academic development. However, it is an essential part of the total unit in the child's development that cannot be left to chance.

The Home Environment and Parents

All Black parents should ask themselves these questions: What role do I play as a parent in my child's general education? What role do I play in my child's education in specialized areas? Areas such as art, music, physical education, Black history, and art history are often not a regular part of school curricula. Art is an area that is often overlooked unless the child appears to display an unusual talent or the parent or teacher has a broad sense of what education includes for children. It is important that parents realize that often children have talents in art that they may not recognize, and that, if given the opportunity, most children enjoy art. Parents should visit and get to know their child's school and ask about the school art program. If there is not a

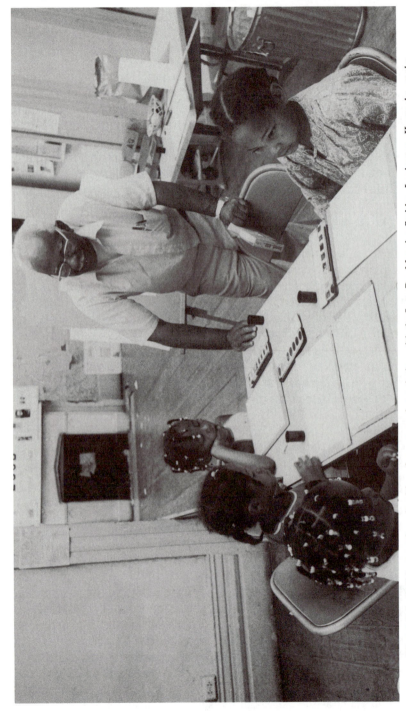

Figure 3.3 Children exchanging ideas for watercolor painting with the Late Dr. Maurice Strider, Lexington, Kentucky, at the Morton House.

school art program, questions should be raised about starting one.

Drawing, painting, and creating in the visual arts seem to be natural forms of learning for young children. No real external motivation seems to be necessary. According to Lowenfeld and Brittain (1987), the art activity may vary in length and intensity, depending on various factors such as the mood of the child, time of day, subject activities going on inside the home or environment, parental approval, and other circumstances. There seems to be a natural need for children to draw, to represent parts of their environment, to put down thoughts, and to reorganize and expand relationships among objects, places, and people. The need is generally one for graphic expression. Questions concerning the child's academic achievement are very important, especially for parents who are concerned with their child's artistic education. If these abilities are to be developed, they should be encouraged early in the child's education, which is also certainly true for the child's general education. In a review of literature on the academic achievement of Black youth, Slaughter and Epps (1987) provide three reasons why these abilities should be developed in early childhood education. First, the American family structure and organization are presently undergoing rapid social change. Second, the current and projected costs of higher education aggravate the ability to obtain a solid quality education. Third, there is increasing evidence that American schools, as they are now operated, are biased learning environments for many Black children.

Slaughter and Epps, in their literature review, identified four approaches to parental impact on the achievements of children and youth:
 1. Parents as decision makers
 2. Parents as supporters
 3. Parents as mediators
 4. Parents as teachers

Kenneth Clark's *Dark Ghetto,* published in 1965, placed the blame for low-income children's academic achievements on the shoulders of school teachers' expectations. Teachers, rather than parents, were to blame for the children's underachievement. The more influential view at the time was that parents were primarily responsible for their child's early learning and education (e.g., Bloom, 1965; Hess, 1964). Regardless of which side of the argument is taken, it seems clear that parents are important because they are consistent figures in the child's life. It is also a very legitimate claim that schools, in particular the quality of teaching in schools, do make a difference. However, parents are the child's first teachers, before nursery schools, babysitters, or even extended family members. At approximately 18 months and maybe before, the parents can encourage the child's creative and artistic desires. Clearly in the earliest stages of the child's life the parents serve as

supporters and decision makers.

Slaughter (1969) found that low-income Black preschool children who are successful school achievers through the first kindergarten year have mothers who set clear, firm, consistent standards for behavior. These parents also are warm, accepting, and flexible enough to consider the child's viewpoint and to communicate this understanding.

Families as Mediators for Their Children's Art Education

Often, a standardized score, school records, and the teacher's recommendation will serve as reasons to accept or reject a child for admission into a special program. It is especially important that minority children's parents act as mediators for special art and gifted programs and their admission procedures. First, find out whether these programs exist by contacting superintendents and principals. It is important that parents get as much information as possible from the school to determine that their child is properly placed once admitted to such a program. It is not uncommon for some principals and teachers to view students from low-socioeconomic-status groups as not being as competitive as middle-class students. Sometimes there are special needs to be addressed, and administrators and teachers will need to be made aware of these by parents. In a community where art is not offered in the elementary school to all children, art may be seen as a subject area that would benefit middle-class children. The assumption that low-income Black children are not interested in the arts is just as false as the belief that art is a remedial area in which all these children should be placed. Either extreme is false and harmful to the school achievement of these children. Social status in America, for purposes of educational research, is usually defined by measures of social class position — occupation of household heads, education, and income. When socioeconomic status (SES) is used by principals or even art education and educational researchers, it should be seen as an indirect measure of the home atmosphere. Many Black children and other minorities may be living in conditions of poverty for various reasons, but other factors that affect child-rearing practices and the education of these children must be carefully taken into consideration. For instance, a child's artistic interest and academic achievement may be influenced by family practices such as whether or not some relative in the family reads to the child about art, how frequently the child has been taken to museums, and how interested the child is in color, shapes, and design relationships. The child may have been encouraged to have a keen interest in developing manual skills or art history facts. How often the parents take the child to the library, how often the child draws, how parents encourage the child in school, how interested the parent is in art, and

so forth may all be better measures of the child's potential achievement than the occupation, income, or education of the parents. The family of the low-income child has no choice but to mediate in their children's education. White (1982) notes that SES may be an indirect measure of home atmosphere and that student achievement differences may be influenced more by child-rearing practices. Whatever unfair policy decisions are developed by the schools or society at large must be countered by parents of low-income children.

Bronfenbrenner pointed out, in *Two Worlds of Childhood* (1970), that the institution that stands at the core of the process in our own culture is the family. It is important that our educational institutions be committed to assisting low-income children and families.

Some low-income parents may perceive that their child's involvement in the arts is not productive. The family already lacks resources and has heard the stereotypical stories of starving artists, and parents conclude that art is not worth the child's or family's efforts. If the children and their families are educated to the potential benefits of having art, many of the negative perceptions will be eliminated. Once the parents' perception is properly focused, the material resources needed for a positive artistic and academic environment in the home can be achieved. Research has shown, especially in the area of general education, that positive learning environments do exist in many low-SES Black homes, and parental involvement is essential.

From elementary school through the university level, it appears that our school systems have failed children from these populations. Bronfenbrenner outlines five areas that need immediate changes: the classroom, the school, the family, the neighborhood, and the larger community. It should be pointed out, if it is not already obvious, that the status and power of the children's lower-income families are decidedly unequal to the recognizable influence held by the middle-class school system. Even when low-income families and middle-class families are in the same school, the balance of power is unequal. Mediation for the low-income parent becomes increasingly difficult while concerns such as the daily business of survival eat away at their ability and time to focus on their children's problems. In such cases, older siblings and the extended family can be very helpful to low-income parents.

It is commonly known that just as a chain breaks first in its weakest link, so the problems of a society become most pressing and visible in the social strata that are under greatest stress. This is often the case with low-income parents, who mediate their child's care without being familiar with school policy and without support from other low- and middle-income families

with similar problems. Schools should (a) be willing to help parents provide better educational environments at home for their children, (b) make parents clearly aware of special opportunities in the arts, and (c) not eliminate art classes from children because of high costs. These classes should be part of the curriculum and available to all children.

In a case study, Clark (1983) outlines his investigation of Black family influences on school achievement. The case studies of families of successful high school achievers included descriptions of literary-enhancing activities during childhood such as reading, writing, word games, and hobbies. This is very similar to the case study text recently published by Bloom (1985) on developing highly talented individuals, including visual artists. Visual artists' education in art began in childhood with artistically enhancing activities such as visiting museums, reading about art, making drawings, and building three-dimensional objects.

The families of successful achievers in Clark's study provided a home atmosphere that was strongly supportive of academic achievement. Bloom's study agreed with a home atmosphere strongly supportive of the child making art objects, and it also encouraged academic achievement. In both cases, family discipline was firm but not rigid or harsh. Parents were willing to explain decisions and to involve their children in the decision-making process. Clark also found that parents of high achievers were assertive in their efforts to keep themselves informed about their children's progress in school. Parents of low achievers in his study tended to avoid contact with school personnel as much as possible. It was further found that many of these parents only visited the school during times of crisis (e.g., when there was a problem to solve). Parents of successful students also appear to be more optimistic than parents of low achievers and tend to perceive themselves as persons who can successfully cope with life's problems. It appears, from the literature, that what parents tell or do not tell their children about art, their culture, and educational opportunities and achievement affects success and may influence the way children respond to the negative pressures they encounter in their school life. It is clearly accepted that parental involvement in children's educational experiences enhances their achievement.

Because low-income families must usually resign themselves to the neighborhood school, which is often poorly financed and under stressful conditions as mentioned earlier, parents should mobilize their extended families, their communities, and community organizations or neighborhood associations to support their schools. McAdoo (1982) and others have documented how extended family members can serve as a basis of support for both two- and single-parent Black families in caring for school-aged children. Young

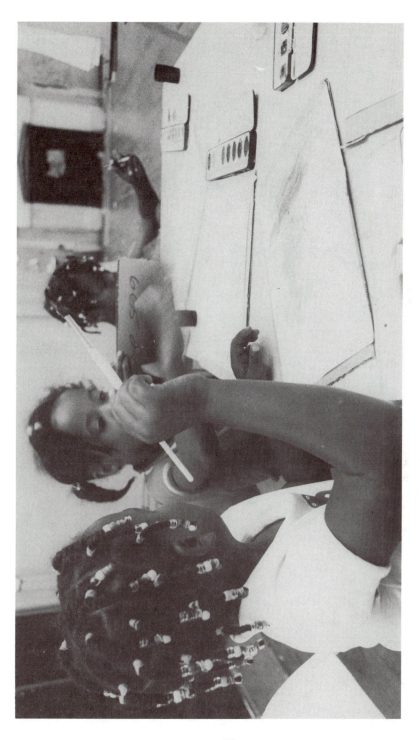

Figure 3.4 *Young children watercolor painting.*

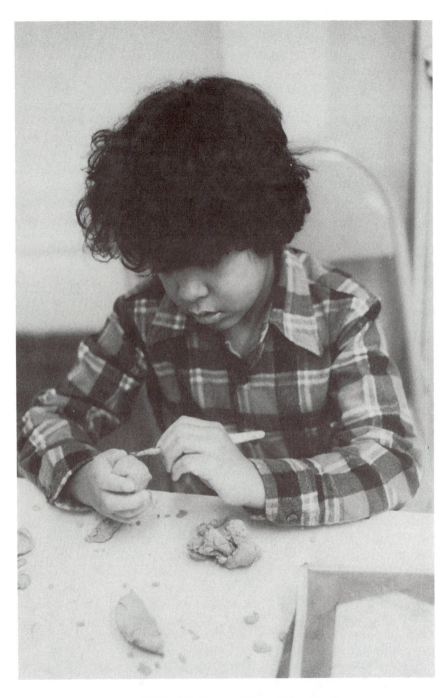

Figure 3.5 *Young child working with clay.*

(1983) has written about a low-income community art program that involved the immediate community. Slaughter notes that parents and educators cannot continue to perpetuate a "no-difference" ideology because it does not necessarily lead to equitable treatment; it may lead to an unbalanced focus on "negative" differences between children of different classes and races.

Programs similar to the one described by Young could influence and discourage potential dropouts in future years. If parents, teachers, and volunteers can serve as role models in the early years of children's lives, art experiences may stimulate creativity and possibly prevent a disinterest in school. Promising and problem low-income students alike can benefit from the mobilization of parents, educators, community organizations, churches, and neighborhood associations. In order for Black children to be successful in school, the parents and the schools need to work in close cooperation with each other.

Up until now, the view that I have expressed has concerned the home environment and what parents can do to enhance the child's academic and artistic development. But it bears a great deal of merit to momentarily focus on the school itself, essentially because several educators believe the school has the greatest influence on the child's development.

An Effective School Art Program

Ronald Edmonds (1986), an educational researcher, wrote about characteristics of effective schools. Much of his research involved large urban, low-income school systems in New York, Michigan, New Jersey, Pennsylvania, and other states. He claimed that the most powerful force in educating these children was the school itself, not families or teachers. In fact, he claimed that teacher effectiveness is much more a function of the nature of the schools in which teachers work than of any other set of characteristics that they possess as individuals. His report went on to argue that the school effect is more powerful than the neighborhood effect and more powerful than the cultural environment that describes the community. These effective schools are known primarily for their academic programs, but many of their characteristics seem reasonable and similar to ideals in effective school art programs of which parents should be aware. Parents should look at the following areas and be willing to act if these areas do not meet their satisfaction. The first area involves the principal's support of art and his or her behavior. According to Edmonds, principals of effective schools behave in ways that are observably and demonstrably different from the ways principals behave in ineffective schools. The primary difference is

that principals of effective schools are the instructional leaders in their buildings, whereas those in ineffective schools are not. As I have visited and talked with art teachers in schools over the past few years, I have come to realize that the success of their art programs in elementary and secondary schools is tied closely to the support they receive from their principals. If principals view art as a valuable subject, this perception is clearly reflected. The parent should be concerned with whether or not the principal views art instruction from a leadership perspective.

The second area I adopted from Edmonds involves the school focus, instructional emphasis, and institutional mission. The key variable examined was the proportion of teachers in the school who knew what the focus was. I selected a cross-section of teachers in both effective and ineffective schools and asked them, "What does this school care most about?" In the ineffective schools, the answer depended on the person asked. When the question was put to a cross-section of teachers in effective schools, the answers were uniform. Almost everyone answered the question the same way. There was a high correlation among instructional focus, the principal's leadership, and the teacher's agreement with this focus. Collegial interaction is always easier when there is widely understood articulation of the mission of the school. If this question were asked about the role of the art teacher in the school and art instruction, the instructional focus should be clear and respected by the teachers throughout the school. Here the art instructor's importance is established by the instructional leader and can be influenced by the demands of parents.

The third area has to do with the school climate. These factors are almost tangible measures; effective schools are relatively safer, cleaner, more orderly, and quieter than ineffective schools. The tangible measures of cleanliness in the art room would include safe areas to work in, orderliness, and windows that are not forever broken or dirty. The climate is usually pleasant and quiet enough for students to concentrate.

The fourth area was based on classroom observation. Usually effective art classes have teachers who do not mind being observed; parents are welcomed to visit, and often help out in the class. Parents can even be advocates with the parent-teacher organization to help obtain art materials and give support that a low-income district may not provide. In an ineffective school, this open classroom policy would be very limited or nonexistent.

Needed Research

Whether we agree with Edmond's notion that the most powerful force in the effective education of low-income children is the school itself, or whether we agree with Coleman's (1966) research indicating that family background and parental influences are the primary forces affecting student achievement over time, it is very clear that parents, family influences, schools, and, in particular, quality teaching do make a difference. The influence of quality instruction and parental support clearly affect children's development in academic achievement and art education. With the exception of a few notable developmental psychologists, and a far fewer number of art educators, research on poor children is no longer a popular topic of study. But it needs to be an immensely important part of our research. The educational problems of the 1960s and 1970s are still with us in the 1990s, possibly on a larger scale. Perhaps art educational research could concentrate in the direction of the issues of learning potential and less on what poor children and, very often, Black children cannot do. To make progress, we need to transform much of what we have been doing in relation to low-income Black students — we need to get to know them better, get to know their families better, and attempt to understand their distinctive cognitive and artistic styles (Boykin, 1986, and other Black psychologists) that may clash with the expectations of the middle-class school. We need to create research that has never before been conducted in the field of art education. We need to truly do what so many graduation speakers suggest: We need to commit or recommit ourselves. We need to truly commit ourselves by whatever means and with whatever allies are available.

References

Bloom, B. (1965). *Stability and change in human characteristics*. New York: Wiley.
Bloom, B. D. (1985) *Developing talent in young people*. New York: Ballantine Publishing.
Bloom, B. S. & Sosniak, L. A. (1981, November). Talent development vs. schooling. *Educational Leadership*, pp. 86-94.
Boykin, A. W. (1986). The triple quandary and the school of Afro-American children. In U. Neisser (Ed.), *The school achievement of minority children: New perspectives* (pp. 93-104). Hillsdale, NJ: Lawrence Erlbaum Associates.
Bronfenbrenner, U. (1970). *Two worlds of childhood, U. S. and U. S. S. R.* New York: Simon and Schuster.
Clark, K. (1965). *Dark ghetto*. New York: Harper.
Clark, P. (1983). *Family life and school achievement: Why poor black children succeed or fail*. Chicago: University of Chicago Press.
Coleman, J. S., Campbell, E., & Mood, A. (1966). *Equality of educational opportunity*. Washington, DC: U. S. Office of Education, National Center for Education Statistics.

Darlington, R. B. (1986). Long term effects of preschool programs. In U. Neisser (Ed.), *The school achievement of minority children: New perspectives* (pp. 159-167). Hillsdale, NJ: Lawrence Erlbaum Associates.

Edmonds, R. (1986). Characteristics of effective schools, In U. Neisser (Ed.), *The school achievement of minority children: New perspectives* (pp. 93-104). Hillsdale, NJ: Lawrence Erlbaum Associates.

Elkind, D. (1987, March). Superbaby syndrome can lead to elementary school burnout. *Young Children* p. 14.

Goetz, E. C. (1966). *Graphomotor development in preschool children.* Unpublished master's thesis, Cornell University.

Hess, R. (1964). Educability and rehabilitation: The future of the welfare class. *Journal of Marriage and Family, 26,* 422-429.

Lark-Horovitz, B., Lewis, H., & Luca, M. (1973). *Understanding children's art for better teaching* (2nd ed.). Columbus, OH: Merrill Publishing.

Lowenfeld, V., & Brittain, W. C. (1987). *Creative and mental growth.* New York: Macmillan Publishing.

McAdoo, H. (1982). Stress absorbing systems in Black families, family relations. In E. MacKlin & R. Rubin (Eds.), *Contemporary families and alternative life styles.* Beverly Hills: Sage.

McKenzie, J. A. (1986). The influence of identification practices, race and SES on the identification of gifted students. *Gifted Child Quarterly, 30*(2), 93-95.

Neisser, U. (1967). *Cognitive psychology.* Englewood Cliffs, NJ: Prentice-Hall.

Neisser, U. (1976). *Cognition and reality.* San Francisco: W. H. Freeman and Co.

Neisser, U. (Ed.). (1986). *The school achievement of minority children: New perspectives.* Hillsdale, NJ: Lawrence Erlbaum Associates.

Slaughter, D. (1969). Maternal antecedents of the academic achievement behaviors of Afro-American Head Start children. *Educational Horizons,* pp. 24-28. v. 47.

Slaughter, D. T., & Epps, E. G. (1987). The home environment and academic achievement of Black American children and youth: An overview. *Journal of Negro Education, 56*(1), 3-20.

U. S. Department of Commerce. (1987). *Statistical abstract of the United States* (Bureau of the Census, 197th ed.). Washington, DC: U. S. Government Printing Office.

U. S. Department of Education. (1987). *Digest of education statistics* (Center for Education Statistics). Washington, DC: U. S. Office of Educational Research and Improvement.

White, K. (1982). The relations between socioeconomic status and academic achievement. *Psychological Bulletin, 91,* 461-481.

Young, B. (1983, September/October). An art center for low-income children. *Design for Arts in Education,* pp. 38-41.

Additional Resources

Abrahams, R. D. (1970). *Can you dig it? Aspects of the African aesthetic in Afro-American.* Paper presented at the African Folklore Institute, Indiana University.

Bloom, B. (1980). Early learning in the home. In B. Bloom (Ed.), *All our children learning* (pp. 67-88.) New York: McGraw-Hill.

Borneman, E. (1956). The roots of jazz. In Nathentoff & A. J. McCarthy (Eds.) *Jazz.* New York: Rinehart and Co.

Hall-Benson, J. (1982). *Black children, their roots, culture, and learning styles* (rev. ed.). Baltimore: Johns Hopkins University Press.

Piaget, J., & Inhelder, B. (1967). *The child's conception of space.* New York: W. W. Norton & Co.

Yando, R., Seitz, V., & Zigler, E. (1979). *Intellectual and personality characteristics of children.* Hillsdale, NJ: Erlbaum.

4

Black Adults' Aesthetic Responses to Selected African American and African Art

PAMELA GILL FRANKLIN

Fairfax County Public Schools

PATRICIA STUHR

The Ohio State University

Black aesthetics has been the topic of much debate in the field of art education. Researchers have examined differences in aesthetic perceptions (Neperud & Jenkins, 1982; Neperud, Serlin, & Jenkins, 1986), and much has been written on the subject (DePillars, 1976; Fuller, 1971; Gaither, 1972; Karenga, 1971). Although there remains discussion about the existence of a distinct Black aesthetic, Neperud et al. (1986) suggest that most ethnic groups possess aesthetic values central to their culture. The purpose of this chapter is to describe the verbal aesthetic responses of Black adults to artworks by Jacob Lawrence and Faith Ringgold (African American artists) and by the Ashanti (African) people.

In order to determine Black adults' verbal responses to African American and African art, we conducted an ethnographic study. We sought answers to the following questions: What are Black adults' aesthetic responses to artworks by two contemporary Black artists and the Ashanti? What is the role of the Black artist?

Methodology

The design of this ethnographic study follows the methodologies and procedures for investigative field work employing the emerging paradigm termed *social anthropological*. The following literature provided the foundation for this approach: *The Study of Schooling — Field Based Method-*

ologies in Educational Research and Evaluation (Popkewitz & Tabachnik (1981), *Case Studies in Education and Culture* (Spindler & Spindler, 1973), and *The Ethnographic Interview* (Spradley, 1979). From this literature the process and rationale for conducting a qualitative ethnographic study was assimilated and applied to the research. The study's purpose was to collect valid descriptions for analyses. These descriptions were collected from site observations and the discussions of a Black study group at a small community center in Columbus, Ohio. The group's discussions were taped and literally transcribed. Pamela Gill Franklin had been requested by a member of the group to moderate four discussion sessions on Black artists and their art.

Population

On the first evening, members were asked to complete a questionnaire devised by the researchers. The purpose was to gain an understanding of the population and to aid in the planning of future discussion sessions. The questionnaire enabled us to develop a profile of the group, which was composed of 11 individuals (3 women and 8 men). They were all Black Americans, ranging in age from 24 to 62, with a median age of 43. Seven of the participants had never taken a formal course or class in art, and two had taken one or two such classes. One participant had taken three or four courses, and one had taken five or six. One person stated he had been apprenticed to an artist, and two said they had been apprenticed to craft persons.

Six participants were familiar with an African language. When asked how familiar they were with African cultural objects, four responded "very familiar," two were somewhat familiar, two were familiar, and three were not familiar at all. Those who said they were familiar with such objects said they learned of them from playing drums, studying about them, visiting Africa, and from artist friends. Eight in the group owned African objects (e.g., carvings, statues, paintings, and drums).

Five participants said they were very familiar with Black art, two somewhat familiar, one familiar, and three not familiar. Seven people owned Black art forms such as paintings, sculptures, and drawings. The group met four evenings for approximately 2 hours per session.

Procedures in the Discussion Group's Session

In the first session, the moderator, Pamela Gill Franklin, introduced herself

and explained that during the sessions the group would look at slides of paintings by two Black artists, Jacob Lawrence and Faith Ringgold, and slides of Ashanti wood carvings. The moderator passed out the questionnaires on which the population's art background and profile were to be determined. The remainder of the session was spent viewing and discussing three of Jacob Lawrence's works — *Live in Firetrap, Tombstone,* and *Migration of the Negro* — and an Ashanti wood carving of a slave.

In the second session, the moderator provided biographical information on Jacob Lawrence. The group had requested that this information be provided during the previous session. The Lawrence works previously viewed were viewed again upon the request of the group. Background information on Lawrence's *Migration* series and his work after a trip to Nigeria were shared. Then post-Nigerian paintings were viewed and discussed. The paintings discussed were *The Ordeal of Alice, Three Red Hats,* and *The Munich Olympic Games.* Ashanti wood carvings of fertility dolls and Madonna were shown, discussed, contrasted, and compared with the Lawrence works already viewed. Faith Ringgold's biographical background and paintings were introduced by the moderator in the third session. Two slides of her works, *The Flag is Bleeding* and *Slave Rape,* were presented and discussed. The group asked the moderator to bring in slides of paintings by both White and Black artists who used Blacks as subject matter to see whether they could determine the ethnicity of the artist by looking at his or her work.

In the final session, the moderator, as requested by the group, brought in 15 slides of paintings done by both Black and White artists who had used Blacks as subject matter. This activity was not structured as a scientific study and should not be viewed as such. The group was asked to indicate whether they believed a Black or a White artist had painted the work by circling "B" for Black artist or "W" for White artist on an answer sheet. This identification exercise resulted in a discussion about why group members thought a particular work was done by a Black or White artist and the role of the Black artist.

Reactions to *Live in Firetrap, Tombstone,* and *The Migration of the Negro* and the Ashanti Sculpture

The moderator asked the participants to describe the kinds of things they saw when looking at the work *Live in Firetrap.* Most spoke of what they saw in terms of the artist's use of color. One person remarked "that purple is powerful." Another person said that "the center of the picture is life itself because that is where the brightness is. The brightness is the green, white, and yellow — all symbolic colors of life." Neperud and Jenkins (1982)

have identified four distinctive features of Black aesthetics based on the speculative literature previously written on the subject. One of these features is formal structure, including the use of form, color intensity, and pattern of a composition. DePillars (1976) and Morrison (1979) have defined Black aesthetics by such characteristics as the use of bright color and the use of textiles as a direct means of expression.

Participants' responses to *Tombstone* and *The Migration of the Negro* relate to the aspect of Black aesthetics that reflects the special character of the Black experience. One person related the images in *Tombstone* to Harlem, New York. He said: "It looks definitely like one of those New York 146th Street tenements. Those are apartments and things. People down there do stuff like that." One participant said the *Migrations* painting was about "oppression in the South." Another person commented, "One might say that through the experience of migration, the brothers disappeared. That painting is probably as accurate now as it was then. One of the things that the painting is saying is where are the men?" When asked how the work of Lawrence relates to the Ashanti sculpture, an individual responded, "They both have a message." Another person remarked, "It's not important that you [the artist] have arms and legs that are the right size. It's important that the artist gets the message across."

Reactions to *Ordeals of Alice, Three Red Hats, The Munich Olympic Games,* and the Ashanti Madonna Sculpture

At the beginning of the second session, biographical information about Jacob Lawrence was presented to the group. This information had been requested at the conclusion of the first session. Three sources were used to compile this information: *Art: Afro-American* by Samella Lewis (1978), *The Afro American Artist* by Honig Fine (1973), and the April 1987 issue of *Arts and Activities,* which featured an article on Lawrence and his work.

After the discussion of this information, the group asked to view the slides shown during the first session. This time, they closely examined the works for what one person referred to as "the revolutionary theme." One person remarked, "It seems more and more like what we were doing in the 60s, screaming about the situation that the White man put us in." Another person observed that "the people look like they're hopeless, especially the women. You get this feeling of hopelessness. It's [the painting] very depressing."

Artworks produced before and after Lawrence's trip to Nigeria were compared. The moderator asked the group to describe what they felt were the differences in these works: "It [work after the trip to Nigeria] doesn't look depressing." "Before his pictures were all down." "These works [after

Nigeria] look cheerful. The people in the pictures have their own things going on and they're in control." When group members were asked why they thought Lawrence painted a woman in *The Ordeal of Alice,* one person said, "The woman represents the mother, and the mother concept, and also the perpetuator of the race. He's showing that he [the White] was not only destroying the [Black] male, but also the [Black] woman who has been the sustainer of the race." Another person added, "She is the backbone of the race." Another commented, "If the woman is not educated, then nothing is going to happen." When asked what they thought Lawrence was trying to say to the viewer in *The Munich Olympic Games,* they agreed that he was "telling us about the excellence of Black Olympians."

During the discussion about the Madonna sculpture, a heated debate occurred about the possibility of colonial influences on the work. One individual responded, "Is that Ashanti, 'cause you can see colonial influences?" Another person said that "the oldest theme of mother and child was African before Europe or anything." Comments about the Ashanti work centered around whether African cultures concerned themselves with efforts to produce naturalistic images before or after colonialism. The group decided that more information about the sculpture was needed. This discussion branched off into an unexpected area. Three persons who had been involved in the debate about the Madonna questioned whether a White artist could capture the essence of African art. One participant said, "You ask yourself, can a White artist paint Black? Can a White artist have Black consciousness?" Another person remarked, "Picasso tried to. He copied from us. I wouldn't say he had Black consciousness. He ... interpreted what was African." One individual asserted, "He copied [but] I don't think he got across a Black message." When the moderator asked whether they were saying that if slides of White artists' works and Black artists' works were brought in, they could determine which works were by Black artists, they responded, "Yes. We ought to try it." "We can as long as you don't bring in abstract stuff." The group decided that the artworks should be representational.

Reactions to the *The Flag is Bleeding* and *Slave Rape*

After presenting biographical information about Faith Ringgold, the moderator began the discussion of *The Flag is Bleeding* by asking the group to describe what they saw. The examination of the visual cues found in the work led them to make the following statements: "We can barely see the Black man because he is a nonexistent entity." "I believe they [the subjects] are all inside the flag, because it represents the White man and Black man in America, but the rule is that the Black man is the only one who has to shed

57

blood for the country." "It shows that the Black man in America is not very visible. The White man always puts the White woman between him and the Black man." When asked how the artist shows the power structure in America, one person responded, "By making the White man more visible." Another person answered, "He is larger." Still another said, "More definition of [the White man's] features."

Statements about *Slave Rape* initially were in reference to the title of the work. The male members of the group focused on the condition of the woman, and the women tried to draw meaning from the work. One man remarked, "I bet a White man raped her." Another man said, "He kept her working in the field." One woman asked, "Why are her eyes so large?" Another woman added, "I'm thinking there is a reason for those large eyes and dropped open mouth. You know, surprise. Someone is coming up on her. Maybe the overseer is on the way." One woman observed, "She looks like she is being shocked by something." When asked what the artist is trying to say in this work, one woman remarked, "She is making a statement about the rape of the continent [Africa]." A man stated, "I wouldn't have associated the rape of the continent to what the artist has [depicted] in this painting." One man declared, "I think [in] her other picture she made a profound statement. There was an obvious statement." This comment led to a discussion about the role of Black artists. One man argued, "I think they [artists] should make a more overt statement in their work. The statements the artist is making should be more obvious to let people know what [he is] saying. If they don't make strong statements, they aren't doing their job as Black artists." He went on to say, "If she is Black and an artist, she is obligated to paint stuff or do something to arouse her people." Another man asserted, "Black artists have to address the concerns of Black people." One man remarked, "Black artists should do things that inspire people and tell them what is happening, where we are, and where we can go." Another man argued, "Black artists must make strong direct statements in their works or people [would] interpret it differently." A woman argued that artists should be free to express themselves "any way they want to."

How the Group Members Defined Black Art

In the final session, the group looked at slides of artworks by Black and White artists to determine whether they could identify the ethnicity of the artist simply by looking at the work. As previously noted, this was not a scientific experience and should not be viewed as such. However, this activity suggests that some Black adults identify the ethnicity of the artist according to what they perceive as a positive portrayal of Black people or obvious assertive Black social and political "messages." For example, half

of the participants identified George Bellows as a Black artist because his painting, *Both Members of the Club,* shows "the brother winning."

When asked how they determined the ethnicity of other artists, the group members' answers varied: "Are they projecting the Black experience? That was the question in the back of my mind." "Because of the bold colors." "A feeling [is] in it." "Because of the subject." "The way Black people were painted." "It has a White experience." "It has a White feeling to it." "Its intenseness." "Features in the face."

Conclusion

The study of aesthetic responses to African American and African artworks is particularly important in art education given the nature of these responses. Many of the participants responded to the works of art to the degree that they reflect the Black experience. They seemed to place more value on artworks that convey social and political concerns. The male group members supported a revolutionary role of the Black artist.

As Black adults' interest in art continues to grow, we in the field must address their aesthetic values. If we are to effectively reach this population in community art programs, more attention to aesthetic responses is needed.

References

DePillars, M. (1976). African-American artist and art students: A morphological study in the urban Black aesthetic. *Dissertation Abstracts International, 37* 407-A. (University Microfilms No. 76-30, 335-351)
Fine, H. (1973). *The Afro-American artist.* New York: Holt, Rinehart, & Winston.
Fuller, H. (1971). On Black aesthetics. In G. Addison (Ed.), *The Black aesthetics.* New York: Doubleday.
Gaither, E. (1972). Visual art and Black aesthetics. *Journal of Affairs of Black Artists, 1.*
Karenga, R. (1971). Black cultural nationalism. In G. Addison (Ed.), *The Black aesthetics.* New York: Doubleday.
Lewis, S. (1978). *Art: African American.* New York: Harcourt Brace Jovanovich.
Morrison, K. (1979, Spring). A Pan-American point of view. *Emergence.*
Neperud, R., & Jenkins, H. (1982). Ethnic aesthetics: Blacks' and Nonblacks' aesthetic perception of paintings by Blacks. *Studies in Art Education, 23*(2), 14-21.
Neperud, R., Serling, R., & Jenkins, H. (1986). Ethnic aesthetics: The meaning of ethnic art for Blacks and Nonblacks. *Art Education, 28*(1), 16-29.
Popkewitz, T., & Tabachnick, R., (Eds.). (1981). *The study of schooling — Field based methodologies in educational research and evaluation.* New York: Praeger.
Spindler, G., & Spindler, L. (1973). *Case studies in education and culture.* New York: Holt, Rinehart, and Winston.
Spradley, J. (1979). *The ethnographic interview.* New York: Holt, Rinehart, and Winston.

5

Afro-American Culture and the White Ghetto

EUGENE GRIGSBY, JR.

Arizona State University

Most of us view the "ghetto" as that place on the other side where the "po-folks" live. And we know the "po-folks" as those who look alike, act alike, and are different from the rest of us. They are usually either Black, Hispanic (i.e., Mexican, Puerto Rican, or South or Central American), American Indian, Jewish, Appalachian White, or of some low-income European background. *Webster's Dictionary* defines *ghetto* as (a) a section, in certain European cities, to which Jews are, or were, restricted — the word is also applied, often in an unfriendly sense, to any section of a city in which many Jews live, hence, (b) any section of a city in which many members of some national or racial group live, or to which they are restricted. Here, the term ghetto is used as a "state of mind" rather than a "state of geography" or segregated or restricted section of a city. The "White Ghetto" can be defined or seen as placing the mind of the White person in a segregated boundary that is unaware of the rich African American culture by which it is surrounded, and for that matter, unaware of any others, culturally rich but ethnically different, that surround it. However, the concentration here is on African American culture.

By African American culture I mean that accumulated pattern of lifestyles developed by the descendants of African people who were forcefully brought to the Americas in chains. Most came from the west coast of Africa, but many came from the interior and some from the eastern shores. They came from different cultural and culture states and spoke different languages. They had inhabited city-states that had once known glory and power, such as the great kingdoms of Mali, Ghana, Melle, Songhai, Ife and Benin on the west coast, Kongo and Kuba in the central continent, and Masai, Ethiopia, Nubia, and Egypt in the east. They were people like Sundiata, the Mandingo proclaimed King of the Mali empire in 1230, and Mansa Musa, his grandson and successor, whose thousand-mile pilgrimage

61

(*hajj*) to Mecca in 1324 was one of the grandest tours ever recorded. His caravan of some 80-100 camels was loaded with gold dust. Some report that the caravan consisted of 60,000 people, including family, close friends, doctors, teachers, and important chiefs of the empire. It entered Cairo in July 1324 and became an immediate sensation. Mansa Musa's generosity was said to have had a financially depressing effect on the economy. A writer in the service of the Egyptian sultan reported that the Cairo gold market had still not fully recovered from Mansa Musa's visit 12 years after the "hajj" (Chu & Skinner, 1965, p. 64). At the height of Mansa Musa's power, the Mali empire covered an area approximately equal to that of western Europe.

The name of another Mali king was etched in the history of both Africa and America long before the coming of the slave traders. Abubakari II, another grandson of Sundiata, was fascinated with the sea rather than the sand. He assembled a fleet of 400 ships and sent them west across the Atlantic with the order, "Do not return until you have reached the end of the ocean, or when you have exhausted your food and water." Only one ship returned, and the captain reported he had turned back because the others had been lost beyond the horizon. Not satisfied, Abubakari assembled another fleet of ships with one made especially for himself with a *pempi* on the poop deck shaded by the bird-emblazoned parasol. In 1311 he turned over the regency to his brother, Kankan Musa, with the understanding that he would assume the throne if, after a reasonable lapse of time, Abubakari did not return. "Then one day, dressed in a flowing white robe and a jeweled turban, he took leave of Mali and set out with his fleet down the Senegal, heading west across the Atlantic, never to return. He took his griot and half his history with him" (Van Sertima, 1976, p. 48). Van Sertima advances the thesis, fully documented, that the ships of Abubakari landed on the west coast of Central America and fused with the Olmec and Aztec civilizations.

Three hundred years later, when Europeans invaded and divided the African continent into areas of domination, the mighty kingdoms of Ashanti, Ghana, Mali, and Songai were in decline. As a result of wars among these kingdoms and natural disasters, the slave trade flourished. Slavers captured, kidnapped, and bought Africans from a wide range of populations, many of whom had history as rich as that of Mali. In addition to the rich cultural background from which they came, the slaves brought a panorama of skills and professions to America.

They left behind the mighty heads and figures carved, cast, and shaped by artists of the African continent; the carvings and castings of Ife and Benin court artists; the masks, weavings, and magnificent beaded works of the Kuba, the Babembe, and the Bamun; the metalworks of the Baule and the

Benin; the huge stoneworks of the Nubians and the Egyptians; the paintings of the Zulu; and the rock paintings of the Kalahari and Sahara deserts. However, they brought the meanings found in these arts. More important, they did not leave behind the music and the dance, the story telling, and the theatre, which they brought with them as an integral part of their lives passed down from generation to generation.

Although they could not bring tools and materials to carve sculptural forms, it is conceivable that they brought the knowledge of how to carve and create the needed tools. Evidence of such knowledge is found in carved walking sticks and pottery heads created by slaves and found in South Carolina, and other locations in the South. In colonial Williamsburg decorative elements in carved furniture mirror patterns and designs of the Kuba of Zaire and the Yoruba of Nigeria can be found. In New Orleans slaves created filigree iron work balconies in the Latin Quarter. Slaves' skill with iron, however, was not limited to New Orleans. According to Porter (1943), "In 1796 all the iron furnaces and forgers in Maryland were worked by Blacks." A majority of pre-Civil War ornamental ironwork in Charleston and New Orleans was created by slaves and free Black artisans. In Georgetown, Guyana, there is more of the same lacy filigree ironwork adorning many older buildings.

Thompson (1969) cites folk art found in Georgia and South Carolina produced by Black artisans, and suggests that although opportunities for slaves to continue producing plastic arts were more limited than traditions in music and dance, there is evidence that a folk art was practiced.

The most vociferously practiced art was theatre, in the form of religion and pageantry. Dance, music, costumes, masks and figures, body painting, and ritual were involved. When dieties were included the dramatic effect of these pageants was heightened. These dramas were seen in the New Orleans Mardi Gras and the Carnival in Brazil, Trinidad, and other cities in South America and the Caribbean. In Brazil slave families and language groups were allowed to remain together rather than be separated as in the United States. Religious practices were kept intact and, because both the climate and the terrain were similar to the homeland, these practices flourished. Some may be more intact now in the New World than they are in the home of origin. An example would be Macumba in Rio de Janerio and Candomble in Bahia. The Orishas (gods) are Yoruba, and the ceremonies give homage to these gods through ritual dance, song, drums, cymbals, rattles, and so forth. Carybe, one of Brazil's most famous artists, has created a series of 24 panels of the "Candomble" depicting each of the Orishas for the Bank of Bahia. He is an Oba (chief) of the "Candomble." These carvings, from Brazilian hardwood, are approximately 5 feet high and 3 feet wide. They are carved in relief, and materials are identified with the Orisha attached.

63

Carybe has also created two murals in the American Airlines Building at Kennedy Airport in New York.

Rubem Vallentim of Brazil dedicates his works to the Orisha Shango. Each work includes something representing this god of iron and fire. African patterns of rhythm, color, dance, music, and costume have strongly influenced other local artists.

African American culture emanates primarily from Africa but, in the course of its travel, has picked up facets from the Caribbean, South America, the American Indians, and even from the Europeans who overran the African continent. The continent of Africa is rich in many cultures. Africa is often spoken of as a country when, in fact, it comprises some 44 different countries. Most are populated by those known as "Black Africans," and "Black" refers to more than color. In fact, the skin color of most Black Africans is anything but black. They vary in skin complexion, hair texture, and facial features as much as the African American. Once at a party in Nairobi, I remarked to my wife that "if I didn't know I was in Africa I would think that I was in New York's Harlem."

The cultures of these 44 countries are as varied as their populations. Even within one country there are many different languages. Nigeria, the country with the largest population, has a number of indigenous people who speak different languages, have different religions, and have strong rivalries that sometimes break out into civil war. Three major political groups of people are best known and have exerted the most influence: the Yoruba in the east, the Hausa in the north, and the Ibo in the south. Not only do they differ politically, but they follow different religions and do not look alike. The Hausas are predominantly Moslem, the Ibo Christian, and the Yoruba Christian and Animist. In addition to these major groups, there are numerous smaller ones. Nigeria, like many African countries, was conquered and ruled by one or another foreign power for nearly a century. Europeans divided Africa into a series of fiefdoms and with the British, imposed a veneer of European culture and values on those of the Africans. In spite of the many differences between the countries of Africa and the imposition of a variety of European cultures, there runs a thread of similarity between them. They are more similar to one another than to people of other continents. This thread of similarity is woven by their arts: music, dance, theatre, visual arts, the spoken word through oral traditions, and the culinary arts.

In their attempt to completely control the African countries, European conquerors tried to destroy the arts. They found ways to demean the people and declare them less than human. In the Americas they made them slaves.

In North America, the United States tried to extend the destruction of what remnants of their culture were left. In South America, particularly in Brazil, the cultural vestiges were allowed to remain somewhat intact. When African art was first brought to France it was declared the work of savages. There were some, however, who recognized early the value of these arts. Claude Roy (1957), in his book *Arts Sauvages*, writes:

Il n'ya pas d' art sauvages, parce qu'il n 'ya pas de sauvages. La notion de sauvagerie, lorsequ'il s'agit de l'espece humaine, en general, evoque des notions dont le prehistorien, l'ethnographe ni l'historien de trouvent acucune trace dans la realite. Nous connaissons tous des sauvages. Le sauvage est au coin de la rue: il viole les petits filles ou il est chef d' etat, Il arrive que le sauvage soit nous meme.[1]

Along with the rhythmic dance, melodious music, dramatic theatre, and beauty in the visual arts, the slaves brought conflict. They brought a variety of languages, religions, value systems, and animosities that were used by slave owners to control them. On the other hand, the system of slavery sometimes served to meld together Africans snatched from different parts of the continent. They took comfort in those who looked like themselves, even though they spoke different languages. They often discovered that there were similarities in dance and music that bridged much of the communication gap. Because they were more alike than different, many survived the rigors of slavery. In some instances there was a meld with those of similar conditions in the New World (e.g., American Indians), who resisted slavery. The slave population was also increased by those born to slave mothers. Some were fathered by slave fathers and struggled to live in as much a family as the situation permitted. Others were by "stud" fathers, controlled by the master, and ordered to increase the "herd" of slaves. Still others were fathered by the master, and a whole new genetic strain arose. A few of the latter were treated as members of the owner's family and educated in American or European schools. Most, however, were treated in the same manner as other slaves, and often worked like beasts and were sold like cattle.

From the inception of the first Black immigrant, there were those who came as indentured servants and those who were free. There were free Blacks living throughout the nation, but most were in the North. Some, however, were in the South. Thomas Day, a free man, was a cabinetmaker who designed the "daybed," and his skills as a cabinetmaker were in demand throughout the South. Although the number of "free" African Americans

was admittedly small, they played an important role in building what is now called an "African American culture."

It is even more remarkable that:

> ..., in some parts of the New England colonies the Negro artist may be counted among the pioneers of American portraiture. Peterson, in the History of Rhode Island, says Gilbert Stuart "derived his first impression of drawing from witnessing Neptune Thurston, a slave who was employed in his master's cooper shop, sketch likenesses on the head of casks." An early Boston paper advertised "A Negro Artist. At McLean's Watch-Maker, near Town-Hall, is a Negro man whose extraordinary Genius has been assisted by one of the best Masters in London; he takes faces at the lowest Rates. Specimens of his performance may be seen at said Place." James Porter tells of a printer who hired an unnamed Negro and his two sons, Caeser and Pompey, who had been instructed by Fleet in setting type engraving woodblocks. The father was an ingenious man who cut woodblocks for all the pictures that decorated the ballads and small books of the master. (Porter, 1943, p. 17)

The African American artist, of whatever medium, style, or concept, owes a debt of gratitude to that African heritage he or she inherited because of the strong magnetic draw this heritage has on the artist and the wealth of material it offers. No matter what direction the work takes, from abstract to magic realism or from nonobjective to surrealism, there is usually an acknowledgment of the debt to Africa and African art. One of the first to acknowledge this debt was Aaron Douglas, a leading artist of the Harlem Renaissance. A mural for the Harlem YMCA and illustrations for *The Emperor Jones* were among early works suggesting an African aesthetic. Charles Alston's Harlem Hospital mural depicting magic and science drew heavily on African themes. It was left to Hale Woodruff at Atlanta University to probe the essence of African art and deal with it aesthetically and intellectually. His interest in African art began while he was a student at John Herron Art Institute, where he first saw photographs of African art.

Soon after this experience Woodruff won a Harmon Foundation Award to study art in France, where he encountered the first actual pieces of African sculpture. At the invitation of John Hope, president of Atlanta University, he returned to the university to develop an art program and remained until after World War II. He then went to New York University, where he

continued to develop his skills as a muralist, a painter, and an art educator.

Two of his major murals are of African subject matter. The first was of *The Amistad Mutiny* for Talladega College, Talladega, Alabama, which depicted the successful overtaking of the slave ship *Amistad,* by slaves led by Joseph Cinque in 1839. His second mural was done for the Golden State Life Insurance Company and depicted contributions of Negroes to the State of California. Woodruff's Atlanta University mural, his most ambitious and most important, was titled *The Art of the Negro.* It has panels. In Panel 1, called "Native Forms," the art of the African manifests itself in a diversity of forms, styles, and materials. Panel 2 is called "Interchange." Here the artists of Africa are shown in contact with the Greeks, Romans, and Egyptians of antiquity. Panel 3 is called "Dissipation," and shows Europeans destroying the art and culture found when conquering African cities. Panel 4, "Parallels," shows different groups of people with similar cultural motivations and the art forms they developed. Panel 5, "Influences," shows the impact of African art on modern art. Finally, Panel 6 shows 15 Negro artists who have achieved eminence at various times and places throughout history. Woodruff's Atlanta mural excells in design quality, as well as in scholarship, and depicts the depth of skill of the artist. The murals and paintings of Alston and Woodruff, like those of other Black artists, rest on the walls of libraries, hospitals, insurance lobbies and in private collections, waiting to be discovered and published by the art historian for a public not likely to frequent locations where they are installed.

The "White Ghetto" becomes more poignant when one considers that little of the culture of the African continent has been made available in schools and colleges in America. Black as well as White children are deprived of this knowledge. Even more destructive is the fact that these children are taught little about African culture, and as a result they lack important role models. Art and artists from Africa and of African American heritage are important for Black, White, and other ethnic/cultural groups; they serve as role models and heroes to emulate and respect.

There is a continuum of ancient African cultures to the modern, from the shores of Africa to those of America, to form African American culture. This African is not limited to the shores of the United States — the culture emanates throughout the Americas. It pulsates in Brazil and in the Caribbean, in Central America, and from the Andes to Tierra del Fuego in South America. The rhythm of the dance and music provides clues to the extent of this culture. Calypso, samba, jazz, blues, and gospel are but a few of the well-known terms identifying the music and dance of African American culture. On the other hand, the visual arts are perhaps the least known and among the most vital. Heroes who might serve to inspire, motivate, and

revitalize art programs and art students have been ignored. I would like to serve an indictment in our school systems for these artists and their art being unknown; it is an even greater indictment of the school systems if they are known and ignored.

The African American artist "heroes" are becoming better known through the efforts of scholars like David Driskell, Samella Lewis, and Carol Green, as well as the pioneering work of Alaine Locke and James Porter, who first wrote about the Black American artist. The number of these artists in North America has grown dramatically since World War II. There are many throughout the continent who remain relatively unknown in the United States, including Wilfredo Lam of Cuba, Carybe, Rubem Vallentim, Alejendhino of Brazil, and others of the Latin part of the continent.

There is far more material about North American artists on which researchers should concentrate. The surface of knowledge has barely been scratched, even regarding such artists as Hale Woodruff, Charles Alston, Romare Bearden, Jacob Lawrence, Richmond Barthe, Selma Burke, Lois Mailou Jones, Edmonia Lewis, Elizabeth Catlett, and John Biggers — the list is long and getting longer. These are but a very few of the better known. Art teachers, on all levels, have the opportunity to open doors for understanding. When doors are opened, the walls of the "White Ghetto" will come tumbling down.

References

Chu, D., & Skinner, E. (1965). *A glorious age in Africa.* Garden City, NY: Doubleday.
Porter, J. (1943). *Modern Negro art.* New York: Dryden Press.
Roy, C. (1957). *Art sauvages.* Paris: Encyclopedie Essentielle.
Thompson, R. F. (1969). African influence on the art of the United States. In A. L. Robinson, C. G. Foster & D. H. Oglice (Eds.), *Black studies in the university.* New York: Bantam Books.
Van Sertima, I. (1976). *They came before Columbus, The African presence in ancient America.* New York: Random House.

Note

[1]There is no savage art, because there are no savages. The notion of savagery, when applied to human species, evokes the notion of a prehistoric being that neither the ethnographer nor the historian have found any traces of in reality. We know the savage. The savage is on the street corner; he is the butcher of children, the police who torture, the violator of young girls, he is chief of state. It remains that the savage is, unexpectedly, ourselves.

6

The Depiction of Black Imagery Among the World's Masterpieces in Art

LEE A. RANSAW

Morris Brown College

One of the priceless advantages to be derived by an American from a "trip abroad" is an education in the history and development of art. Art has always had a place and power among people as an expression of truth, an interpretation of the beautiful, or a symbol of religion. A work of art can play many roles. It can serve as a reminder of what had been experienced before, or while being created, or tell the story of those events that mark the victories of freedom and progressive movement of a people toward light and happiness. Art is also one of the most effective mediums of enlightenment, of refined taste, pure thought, and elegant manners. Art teaches the generations as they review the country's history and national heroes, and it defines the cultural roots of the people. It is important to stress the concept of "cultural roots" because one cannot understand the culture in which one lives without some notion of what went into its making. For Black people nothing in the entire range of art history should be more challenging and interesting than how the great artists of all time portray Blacks and define their culture. For this reason, if one examines the destiny of Blacks through the historical development of art, it is essential to turn to the European artists whose works have honored the great historical characters and events for the past 300 years.

It is widely known that from ancient Egypt through the present time, Black imagery has been depicted in art, and these portrayals have included slaves, entertainers, jugglers, acrobats, dancers, and even kings. Perhaps a smaller but equally important number of these images with Negroid features appeared in paintings produced by a few European master artists, and since the 17th century, have made their way into the permanent collections of the major museums throughout Europe and the United States. Each year, for the past century, millions of travelers, including scholars and educators, have visited these museums and have left with both tacit and vivid impressions

not only of the artists but of the imagery within these paintings. Most of these paintings are, by time and authority, the greatest works of these master painters and are now representative of Europe and America's national art. These European masters who portrayed Blacks in their paintings prior to the 20th century revealed certain attitudes toward the Black culture that I will explore in some detail.

Visitors to the collections of paintings in museums have been challenged by the prospect of viewing so many outstanding works of art and are often hard pressed to consciously remember enough about them to fully comprehend what they are seeing. However, two of the important characteristics of art are its capabilities to please and satisfy and to teach and illuminate. Often, this process brings about a concentration of deepened understanding of oneself, and a subconscious attitude toward other images in the painting. Art, to this extent, has an immense social import, and thus has taken its place in the development of culture and history for humankind. What, then, do the greatest treasures in the visual arts of all time reveal about the social significance of Black people and their history and importance to world events? It will not satisfy the thoughtful mind simply to recognize the influence of Blacks among Blacks. In the world of the inner personality there is a bridge between all races, and one must hope that with its enlargement into the sphere of intellectual understanding more people will begin to understand the unity in diversity that is the human race. One is often reminded that scientists and mathematicians find aesthetic pleasure in their own scientific and mathematical objects. It is clear why others miss these gratifying features. The same may apply to the portrayal of Black people and why appreciation of them is not a typical Anglo-Saxon illustration of aesthetic contemplation.

Because art is a form of truth, one must examine the collections at several major art museums to interpret the truth about the depiction of Black imagery. It is impossible to trace every personal representation worldwide, so I must be content to mention only a few of the most outstanding ones. If one educational purpose of any art museum is to provide the visitor with an aesthetic experience, it becomes important to determine how Blacks are depicted aesthetically by White artists, even though our knowledge of the artists' feelings for Blacks is inadequate. A secondary purpose of this review of art in special museums is to historically characterize the psychological and physical makeup of various cultures that are represented in their collections. The focus is on these masters for indicators that they depicted Blacks prior to the 20th century with the possession of reasonable intelligence. These artists will share the physical appearance of Black people, their psychological makeup, and their aesthetics. They are the Shakespearean scholars of art, they have had followers and disciples, and they have

founded schools. The vast majority of their paintings are noble works, the gems of the collection, and the paintings for which the various galleries are noted, and these works have been recognized by critics and the world as the masterpieces of the artists who produced them. Within these masterpieces of the visual arts lies a key to part of the history of Blacks and their culture from the 16th through the 19th centuries.

There are those who believe that something was learned about how Whites perceive Blacks through the writings of such authors as sociologist Margaret Mead or novelist William Faulkner, or even historian Albert Aphaker in his book *The American Negro Slave Revolt.* One can even go back in history to 1509 and the writings of Stephen Hawes on the "Palace of Pleasure" to see how perceptions of Blacks were used to create fear in literature. One reads, "Out of the Dragon's mouth there flew right black and tedious a foul Ethiop." On the other hand, one knows that Blacks portray other Blacks on the canvas, sing songs about Blacks, and write novels about Blacks, but little interpretation and analysis has occurred about how artists other than Blacks portray Blacks. There has been some loose exploration on this subject by J. A. Rogers (1952) in his book *Nature Knows No Color-Line.* Rogers spent many years in Europe and Africa tracing Negro ancestry in the Anglo-Saxon race and documenting important artifacts and paintings that included the Black image. Vercoutter and Snowden, Jr., were among four scholars who edited a comprehensive, three-volume study, *The Image of the Black Man in Western Art* (1976), that traces the development of Black people from Egypt through the 19th century. Research efforts by both Rogers and Vercoutter, although comprehensive and informative, fall short of a humanistic goal of understanding human behavior, and they describe only location, media, and some historical facts about the artists and events. They offer little insight into the perception of the image of Blacks as they are portrayed within the context of a specific painting, and the relationship of other images within the painting toward the Black image is also unclear.

Although the focus here is on the collections of the great museums, one has a rare opportunity to try to understand Black culture as seen in these unusual mirrors of the minds of master artists. Portraits of Blacks have been scarce. Did any of the great portrait painters like Holbein, Reynolds, Rembrandt, Van Dyck, or Valazquez, who gave the world vivid interpretations of the human face, dare to grace their canvases with portraits of Black people? What about such masters as Rubens, Delacroix, Ingres, and David, who were concerned with not only the perfect proportion of the human figure, but with the stresses, strains, and tension in human life! Surely, the Black image would play an important role in some of their compositions. By implication, most people have been trained to think that paintings like Botticelli's *Birth of Venus* or Da Vinci's *The Virgin of the Rocks* embraced

most of the ideals that were considered beautiful prior to the 19th century, and this concept has been a disservice to Black people as a whole. Art, with its appeal to the emotions, its sensuousness, its nationalistic and cultural roots, and its constant change and revolutions, enables people to learn basic things about themselves and the world. Many of the most essential features of the Black image have their origin in art forms that portray an exuberance of emotion, bliss, martyrdom, and self-dramatization. Part of the preconception of Blacks is that they play no meaningful role in the aesthetic development of world art.

The exploration of this preconception of Blacks and the treatment of the Black image begins at the great museums in France for two reasons. First, the French civilization has, for a long time, been the crossroads where all races — Mediterranean, Northern, and Eastern — have mingled and has always stood for openness and mutual understanding. The Moors invaded France in the 8th century and remained there until the 12th, when they were absorbed into the population. Five centuries later (1609) this stock was reinforced by the entry of about a million more who came in at the invitation of Henry IV on their final expulsion from Spain. Later, when modern Negro slavery began in Portugal, in approximately 1440, the number of Black slaves as well as free Blacks increased in France. Many Southern Italians and Greeks in the 18th century were so dark as the result of importation that when Napoleon ran short of Blacks for his Black brigades, he used them. Sicilians were then much darker than now. Hence, Black people were in Europe long before the 19th century, had master artists chosen to portray them. Second, France has The Louvre. If no other gallery were ever visited, the collections at The Louvre would furnish a very comprehensive and worthy idea of the development and triumphs of all cultures through art, from its earliest revival to the present time. To tour The Louvre — perhaps the most encyclopedic of museums — is to witness the unfolding of art history from prehistoric times to the 20th century. Here, among such renowned symbols as *The Winged Victory of Samotrace* and *The Mona Lisa*, the quest for Black imagery begins.

The Louvre

Its collections are divided among six departments: Oriental Antiquities, Greek and Roman Antiquities, Egyptain Antiquities, Paintings, Sculpture, and Art Objects. There are more than 20,000 artifacts on display and countless others in storage. The collection of oil paintings is doubtless the most complete collection in the world. Although the focus of this investigation is on the paintings, one finds no example of Black imagery in the Classical Antiquities departments. In fact, there are long periods in the

history of art at The Louvre where the Black image is not found. The initial inventory of the magnificent painting galleries led to a striking disclosure. Although there are in excess of 3,000 paintings on display, fewer than 50 contain images with Black features. The earliest dated portrayal of Black imagery is, indeed, a somewhat simplified and primitive image offering primitive data. In *La Sibylle de Tibur,* painted in 1579 by Antione Beauvalis, the artist portrays a pitch-black nude slave sitting on the steps to the right of the two central characters. The facial features of the slave are muddled and indistinct. Although he is fully grown and on the same plane as the two central figures, he is painted one third their physical size. All of the images in the composition are adorned in beautiful garments except the slave, whose back is turned toward the viewer. Other examples prior to the 17th century followed a similar pattern. In Paolo Veronese's exquisite portrayal of *The Marriage of Cana* (1528-1588), one is attracted to a large-scale composition of dazzling brilliance, magical colors, glittering lights, and decorative figures enjoying the gaiety of a feast. The banquet area is filled with people, life, and activities. Yet one recognizes that the young Black servants, although colorfully dressed, are unusually small, simplified, and seen only in profile. The Black image never truly interacts with other images in the composition, and again the facial features remain unclear. The public role of the Black person is being defined in the visual arts. Apparently, a special tradition was invented for portraying Black people.

It seems that throughout history Blacks have been content to adjust themselves to the world in their public roles. The history of the Black image in the visual arts, however, never stands still. There are times of accelerated impulse and times of slow imaginative activity. About a century and a half after *La Sibylle de Tibur* the French artist, Marie Guillemine Benoist, presented a view of Black womanhood that was radically different from other explorations of the Black image in her *Portrait of a Negress*. This rare Black 1800 portrait stressed simplicity in composition and clarity of line and texture in the artist's treatment of the figure and her clothing. Of greater significance, the image created is much more graceful, warm, and sensitive. The lines of the Black woman are clearly defined and organized in a harmony in which the separate tones create a pleasurable space. Along with presenting her sitter's sensitive face, long neck, full breasts, and graceful hands, the artist has emphasized the subject's tenderness. The Black image projects a feeling of dignity. This painting portrayed the simplicity and grandeur that some artists associated with the high point of classical Greek civilization.

Greek and Roman mythology was a very important source for subjects in art during the Renaissance period. Stories and themes by poets, painters,

and sculptors centered on the gods and the heroes. Perhaps for this reason Black imagery was somewhat rare. Several of the European museums display paintings with imagery that appears to connect Blacks with religion; the most popular theme, of course, is *The Adoration of the Maji.* Both the Prado, in Madrid, and the National Gallery of Art, in London, portray a Black man as a noble king and an important character in the theme of this composition.

The image of the Black woman at The Louvre remained unchanged from the 16th through 19th centuries, as she appears always portrayed in the role of a servant. Although three 19th-century paintings by Delacroix, Ingres, and Chasserlau portray Black women as servants just as important as other images in the composition, this is not the case with Manet's *Olympia.* This work was first shown at the 1865 Salon and caused an unprecedented scandal. Manet's provocative Olympia lies on a silk shawl, resting on her right elbow, with raised head gazing out toward the viewer. Her white flesh stands out in sharp contrast against the dark background, from which emerges the pale grey-rose of the dress of the Black servant who brings a bouquet of flowers. Although the public outrage was directed at Olympia, one can see the psychological primitiveness of the Black woman. The dress that she wears and the bouquet of flowers that she brings are characterized in greater detail than her facial features. Chances are that there was never a conscious effort on the part of these artists to portray Black imagery in a demeaning way. However, these tacit symbols of completely spontaneous and deeply expressive works provide one with a clear picture of the social role played by the Black woman during this period.

One need not accept a historical role of Black imagery at The Louvre as being one without crises and tension in the face of world events. Theodore Gericault was the pioneer of the Romantic movement in France, and his *Raft of the Medusa* of 1819 treated the Black image in the face of imminent danger, which had rarely been portrayed prior to this time and paved the way for other artists to make use of Black people in humanistic struggles. When the artist was barely 25 years old he went to Italy, where he became fascinated with the works of the Classical and Renaissance masters. Upon his return to Paris in 1817, it was clear how deeply his visit to Italy had affected him when he undertook his most famous single canvas. The "Medusa," a French frigate, was wrecked in 1816 on the coast of Africa, but not within sight of land. One hundred and forty-seven persons took to a raft, which sank three feet with the weight. Amid famine, bloodshed, madness, and despair, their diminishing numbers remained for 12 days. Sixty-five perished in one night. The "Medusa" had been carrying a number of government officials to Senegal, West Africa, to continue French administration of that colony, when it went down. The sinking of this frigate and the

problems with the African colony caused a major scandal, offering Gericault a perfect opportunity to attack the new government through his art. At the same time the incident was also a human drama. After 12 days on the raft only 19 passengers survived, including three Blacks. For the three who appeared in his final painting — one near death, one standing near the mast, and the other waving vigorously — it represented a major breakthrough in Black imagery in the early 19th century. Blacks appeared as key subjects in a monumental tragic painting. The Blacks aboard the raft were ordinary people of no heroic distinction, but projecting despair and vain hope. Significantly, it is a Black man who represents the dramatic climax of the composition. He is standing on a barrel, half supported by others as he waves desperately at the ship's horizon. Through his position and action he becomes a symbol of hope and heroic proof of the equality of men who endure disaster together. The artist captured the moment when the survivors catch sight of the gunboat Argus that rescued them. It is interesting to note that two White American masters prior to the 20th century presented the Black image in this new and challenging light. John Singleton Copley's *Watson and the Shark* (Figure 6.1) and Winslow Homer's *Gulf Stream* (Figure 6.2) add their interpretation of Blacks involved in human drama on the high seas. In Copley's painting, Watson had lost part of his right leg to a shark while swimming in the harbor at Havanna, Cuba. The artist depicts the moment when the shark, returning to the attack, is about to be driven off. In Homer's *Gulf Stream* the artist has depicted the loneliness of a Black man apparently adrift, alone on the powerful gulf stream among bloodthirsty sharks. Unlike works prior to the 19th century that used Black imagery, these three paintings demonstrate what existed in European culture but had rarely been seen — the Black man confronting the laws of nature. These paintings reveal a genuine effort on the part of the artists to show concern with the psychology of the Black man and the transport of his emotions. Whereas *Watson and the Shark* captures the moment that shows the solution to the struggle, *Gulf Stream* produces the strongest emotion the mind is capable of experiencing, a fascination with terror. The contest between the lonely Black man and the sea seems decidedly uneven — one man in a broken boat against the limitless, impulsive sea and a hoard of man-eating sharks. Yet the man seems curiously expressionless; he has, it seems, faced the probability that he will lose this battle as he awaits the end with dignity. In Copley's work the Black man shows concern for his fellow man. His clothes are equal to the rest of the crew, and he is an essential part of a rescue unit. In this sense, he is a savior, equal in status, if only for a moment, with others. A romantic temperament seems to underscore the Black imagery in these three dramatic portrayals. The Black man on the "Gulf" is the main event; the three Blacks on the "Medusa" have survived, whereas the Black man on the boat that rescues Watson represents hope. In these three 19th-century paintings, the artists explored the psychological makeup of the

Figure 6.1 *Watson and the Shark*, John Singleton Copley, National Gallery of Art, Washington, D.C., Ferdinand Lammot Belin Fund.

Figure 6.2 *The Gulf Stream*, Winslow Homer, The Metropolitan Museum of Art, New York, New York, Wolfe Fund, 1906. Catharine Lorillard Wolfe Collection.

Black subjects and expressed a frankness and openness about events and a people that was not popular to paint. Images were treated as noble characters conceived in terms of cultural ideals.

After reviewing close to 3,000 oil paintings in the great central hall of The Louvre that date from the 15th through the 19th centuries, I found fewer than 30 that portray any imagery with Negroid features. The only portrait of a Black is the *Portrait of D'Une Negress* by Benoist. Only in *The Raft of the Medusa* by Gericault, and perhaps one or two paintings by Eugene Delacroix, is the Black image presented with clarity and dignity.

The National Gallery

London is perhaps the second most important location for museums and collections of oil paintings in the Western world. The British Isles serve as one of the greatest storehouses of excellent art museums anywhere and include the National Gallery of Art, The National Portrait Gallery, The Wallace Collection, The Tate Gallery, and the Wellington Museum. These museums combine to exhibit a comprehensive collection of more than 20,000 paintings. Why look to England next for Black imagery? There is evidence that Blacks, or Negroids, lived in the British Isles in prehistoric times and in the Middle Ages. From the 15th century onward there also is abundant evidence of them. Black slavery was introduced in England around the 15th century and lasted until 1773, and probably even to 1834 when there was a general emancipation in the British Empire. How many Blacks came in during those centuries will probably never be known. However, there were enough, at least, to merit considerable mention in English literature, plays, and art. Shakespeare devoted two of his plays to the mixing of Blacks with Whites — *Titus Andronicus* and *Othello*. The drawings of Gainsborough, Kent, Horgarth, and others are some of the many sources that show their presence. Consequently, one would expect to find numerous examples of Black imagery and trace much of the past of Black people in these world-respected English museums. Sadly, this is not the case. In surveying this vast collection at the five museums, I found Black imagery in fewer than 30 paintings. For example, The National Portrait Gallery in London, which houses drawings, sculptures, and more than 2,000 oil paintings of Britian's famous men and women from every walk of life from the Tudor Period to the present, and makes a full sweep of British history through art, has only one Black image portrayed. This painting, *The Dutchess of Portsmouth* by the French artist Pierre Mignard, best illustrates how Black children were often pampered and dressed with great care as they posed with their aristocratic mistresses. The black skin and wooly hair of African boys fascinated English ladies perhaps more than the French and

other Europeans. Professor B. Sillman of Yale University, who visited England in 1805, wrote, "A Black footman is considered a great acquisition and consequently Negro servants are sought for and treated with affection."

In the Wellington Museum and The Tate Gallery there are several similar portraits portraying little Black boys dressed in oriental trousers and turbans posing with a mistress. They are generally carrying a cup of chocolate or bearing a prayer book in these paintings. The National Gallery of Art displays the widest range of activities by Black characters among the dozen paintings out of close to 4,000 works in which they appear. Other than two paintings that portray the Black image as a king, the majority of the paintings depict Blacks as being poor and generally of low and common life. It should be pointed out that there is a reason why early artists were not inspired by common life sources for subject matter for paintings. The so-called "genre" picture was thought of as opposite of mythological paintings, which were very popular and noble. Early genre paintings were considered vulgar and without virtue. On the other hand, there were several paintings at the National Gallery that exploited the Black man's triumph over tragedy, and in some cases, risking and even losing his life in battle. Two excellent examples are Giordano's *Phineas and his Companions Turned to Stone,* dated 1680, and John Singleton Copley's *The Death of Major Peirson,* dated 1783. In both examples, the Black image is part of a much larger cast of characters and has neither greater nor lesser responsibility than the others.

After reviewing close to 20,000 oil paintings at the five major museums in London, that date from the 15th through the 19th centuries, I found fewer than 35 works with Black imagery. Only in one museum, The Wallace Collection, is there a portrait of a Black man, and he appears to be no older than 16 or 17. G. Flinck (1615-1660) painted *A Young Negro Archer* who is dressed well for a sporting occasion.

The Metropolitan Museum of Art

The Metropolitan Museum of Art in New York is one of the three great museums of the world, rivaling the National Gallery of Art in London and The Louvre in Paris. Founded in 1880, the Metropolitan has steadily built up rich collections in all of its 18 separate departments. Outstanding among these collections are the Renaissance, French Impressionists, and Post-Impressionist paintings. Of greater significance, however, is the opportunity offered to compare how American White artists treated the Black image prior to the 20th century. Moreover, the perception was, of course, that American White artists were in some ways closer to the social struggles of Blacks and, therefore, there would be more examples of these paintings on

exhibit. Unfortunately, I must again admit disappointment in the extremely small quantity of Black images in paintings on exhibit. There were fewer than 20 portrayals by European artists and only 3 by American White artists prior to the 20th century that treated the Black image. In most cases, however, the expressive quality of paintings in this collection using Black imagery seems superior to the individual collections of the European museums. Again there are several *Adoration of the Maji* paintings with Black kings, one by a 15th-century German master and the other by H. Bosch that dates to the 15th century. The Bosch painting represented his earliest style, and he used an exotic cast of characters. Among the paintings by American White artists are two 19th-century works of Winslow Homer that depict the Black man in action. His *Gulf Stream* was analyzed earlier, and he is also represented with *Prisoners from the Front*, dated 1866. The prize of the museum's collection, however, is a work by the great Spanish painter, Diego Velazquez (1599-1660). The warmth and life of his masterly portrait of his assistant *Juan de Pareja*, a Sevillian of Moorish descent painted in Rome in 1650, astounded everyone. The museum paid an unprecedented sum for this painting because another of its quality was unlikely to be available.

In surveying the vast collection of oil paintings at the Metropolitan Museum of Art, I found fewer than 15 paintings by European masters and White American artists that portray Blacks prior to the 20th century. *Juan de Pareja* is the only portrait of a Black man that hangs in the museum.

Conclusions

We are deeply indebted to these master artists for much enjoyment and for leaving a record of the greatest explorations of their artistic powers through their paintings. No other kind of relic or text from the past can offer such a direct testimony about the world that surrounds us and other people at other times. In this respect images portrayed on canvas are often more precise and richer than literature. The more imaginative the work, the more profoundly it allows everyone to share the artist's experience of the visible. When people see the art of the past and images of Black people, they situate themselves in history. When they are prevented from seeing such art, they are being deprived of a part of history that belongs to everyone.

The focus of this inquiry has been on oil paintings from the time they were first used, at the beginning of the 15th century in Northern Europe, to the 19th century. What distinguishes oil paintings from any other form of painting is their special ability to render the tangibility, the texture, the lustre, and the solidity of what they depict. Although their painted images

are two-dimensional, their potential of illusionism is far greater than that of sculpture, for they can suggest objects possessing color, temperature, space, and time. The European artists who mastered this medium had an opportunity to share with the world what the Black experience was like long before the invention of the camera.

It may be too early for a balanced judgment on the historical role of the Black image in the visual arts based on the narrow range of museums covered in this survey. However, there are a number of conclusions that can be drawn concerning their treatment as an aesthetic image and as a historically important subject of a painting. Obviously, if the Black image appears in fewer than 100 works out of 20,000 at the world's great museums, one must conclude that, overall, Blacks were not an important image for European artists and played no significant role in their paintings. One reason may be that Blacks have always been perceived in European history as being low and dependent on Whites' generosity and charity for their livelihood. Apparently, the least artistic object in the world is a poor man, humbly clad, and without ornament. Although the survey revealed a number of 16th-century through 18th-century paintings portraying how Blacks looked, and thus by implication, how they had once been seen by other people, one still does not get a cross-section of Black culture and life in their community. Imagery prior to the 18th century depicted Blacks as rather simple, sketchy, and of menial character. In the works I viewed at these various museums, Blacks were never presented in a family setting or portrayed in their own home; in fact, there is the perception of a weakening of the tie between children and parents, as each is generally seen in isolation.

The role of the Black image in the visual arts prior to the 20th century has been unmistakable. Outside of the small group of 18th- and 19th-century paintings that recognized the Black man in his personal struggle against nature, and the Black kings that appeared in the "Adoration" series, Blacks are generally seen as kind and gentle servants. The broad themes have been the Black woman as a servant for White women, Black children as attendants or pages for large feasts, and the Black man as a faithful servant or soldier. With few exceptions, there is very little indication in these paintings that Blacks possessed a great deal of intelligence. Their mouths were never speaking, their eyes were rarely expressive, and they never were portrayed owning anything other than the clothing on their backs. Again, with the exception of several works by Delacroix, Gericault, Copley, and a few others, Blacks were never depicted in an influential role, were generally nameless, were often seen in profile, were shallow, and rarely looked reworked by the artists.

The shock of finding fewer than 100 oil paintings out of 20,000 that used

Black imagery is considerable, but even more stunning is that there are only three portraits of Blacks in this number. It is as if Blacks were never really here. In only a few paintings, *Juan de Pareja, Portrait of a Negress,* and *A Young Negro Archer,* are there powerful expressions of Blacks that grace an entire canvas by European artists. It is clear that Blacks retain an extremely low profile in European art, and it is sad to say that the preconception of Blacks, which implies that they played no meaningful role in the aesthetic development of Western art, may, in fact, be true.

This survey of Black imagery in European oil paintings has been very brief and, therefore, unfinished. It really amounts to no more than a project study — to be expanded perhaps by others. But the starting point for this project should be clear. Obviously, one would have to conclude that there is not a significant number of works of these museums to have an impact on the attitude of the audience. I make no attempt here to distinguish between exceptional works, or masterpieces, and average works on display at these museums. To establish such categories would be to eliminate more than half of the paintings needed for this study. If the painting contained a Black image and hung in one of the world's great museums, it was considered exceptional and probably the result of a prolonged and successful struggle by the artist. The clearest summary of this survey is that Blacks have been observed with friendly eyes by the European masters but with not too much respect. Masters, however, see themselves as doing something that nobody else could foresee. Even though these artists treated Blacks as strangers, they distinguished themselves from other artists of their time because they dealt with the Black person as a functioning human form. The two common traits revealed in all works portraying Black images is that Blacks were threatening and showed little success in the White world.

The narrative and visual styles remain of prime importance to the meaning of Black imagery. Everyone has been quite aware of the terse use of Black characters in masterpieces of Western literature; however, the sudden impact that there is also very little Black imagery in the visual arts is startling not only because of the coexistence of the two worlds shown, but because of the cynicism of the culture that shows one above the other.

References

Aptheker, H. (1915). *American negro slave revolts.* New York: International Publishers.
Rogers, J. A. (1952). *Nature knows no color-line.* New York: Helga M. Rogers.
Vercoutter, J. & Others. (1976). *The image of the Black in Western Art.* New York: William Morrow.

Additional Resources

Brown, C. (1987). *Flemish painters*. London: National Gallery Publications.

Craven, T. (1949). *Famous artists and their models*. New York: Pocket Books, Inc.

Gigetta, R. (1979). *Great museums of the world*. Paris: The Louvre.

Hibbard, H. (1986). *The Metropolitan Museum of Art*. New York: Harrison House.

Hobbs, J. (1982). *Art in context*. New York: Harcourt Brace Jovanovich.

Mathey, F. (1978). *American realism*. New York: Rizzoli International Press.

Potterton, H. (1976). *Guide to the National Gallery*. Order of the Trustees. London: The National Gallery.

Museums Surveyed

The Louvre: Paris, France
The National Gallery of Art: London, England
The National Portrait Gallery: London, England
The Wallace Collection: London, England
The Tate Collection: London, England
The Wellington Museum: London, England
Musee Jeu De Paume: Paris, France
The Metropolitan Museum of Art: New York, New York

7

Art and Culture in a Technological Society

VESTA A. H. DANIEL

The Ohio State University

Currently existing cultures can be described not only by their characteristics but by their interaction with and affect on the future. Similarly, multiculturalism and cross-culturalism, as educational and social tenets focusing on the value of ethnic/cultural diversity, are not static phenomena. They should be investigated, addressed, and applied in ways reflecting the changes in the perceived needs of small- and grand-scale cultures over time.

Many cultures are affected by the interactive domains to be explored here: art and technology and how their union can support cultural development and world making. Typically, the relationship between art and technology is viewed as a rift between the affective and intellectual or cognitive aspects of mental life. However, art and technology are viewed here as social-cultural phenomena that respond to or anticipate societal needs.

Are the function and importance of art so different from that of technology that it is impossible for the two disciplines to collectively support a movement toward transglobal communication, escalation of society into the next century, and future reduction of ethnic-cultural disenfranchisement? I will make an effort to present notions important to further ventilation of these issues and questions. For this purpose the relevant conceptual areas of technology, science, and art will be delineated briefly.

Technology is essentially a modern phenomenon that, by the second half of the 20th century, came to be known as "the means or activity by which man seeks to change or manipulate his environment." It should be noted that, when considering its relationship with art, technology has roots extending back to ancient Greece when the term *technelogos* meant a discourse on the arts, both fine and applied. The term now embraces a growing range of means, processes, and ideas in addition to tools and machines. Similar to man the artist, man the toolmaker has been a technologist from the

beginning, as exemplified by mastery of the ceramic techniques of ancient China, the technically astounding metallurgy of West Africa, and the much copied glass beadwork of India, among other historic accomplishments. The history of technology and our interaction with it encompasses the entire evolution of man.

Science, which is a knowledge of facts and laws arranged in an orderly fashion for the progressive improvement of people's understanding of nature, is often confused with technology because they frequently serve each other. What is considered science (e. g., herbalism) is a function of the needs identified by a culture and the resources available to it.

The third category, art, is characterized by unique perceptions and feelings about what should be included. Indeed, philosophers, artists, and aestheticians have been grappling with an inclusive definition for centuries. However, the art of concern here is a form of human activity that appeals to the imagination and can be looked at, like painting, drawing, or sculpture, and experienced, like the masquerade, as opposed to being watched, like theater or motion pictures.

As artists, art educators, and persons interested in supporting a promising future for art, we are charged with the responsibility of thinking clearly about the status of art in the context of a world society that is rapidly becoming a technological wonder. Our challenge is not confined to schools but extends into our daily environments, communities, homes, museums, galleries, and various media. We are confronted with the need to understand, and consequently harness and manage, the potential for technological developments to maintain and add clarity to existing cultures and societies while securing a place for art in the future.

It is posited here that not unlike science and its link with technology, art, and the culture it reflects, is a system of knowing and of defining and interacting with reality in a systematic way (e.g., by employing color theory in the analysis of nature and reality), but with the added virtue of creative input, imaginative interpretation, and mastery of expression.

Rosenberg (1983) suggests that art, with its affective components, can be approached "as a method of knowledge — commonly regarded as intellectual" (preface) by using the information sciences as a way of proceeding. Further, he maintains that the humanities can be approached as ways of knowing they are directed at the understanding of the same reality as that addressed by all knowledge, including scientific knowledge. Given this position, it follows that one method of securing a significant position for art among future, diverse cultures is to focus not only on its nondiscursive,

mystic nature, understood by a privileged number of savants, but to clarify also the content that can be shared and understood by more people through observation, language, and study. Attention to varying technologies and how they affect the art or material culture of a people can provide a broader understanding and acceptance of how important human events are recorded and how realities are reflected.

I am not suggesting that art be debilitated by reducing it to the scientific level of experimentation and conclusions, but that a strong case must be made for its inherent value to culture and society beyond its indisputable ability to provide pleasure and wonderment. By embracing a variety of technologies, some of which may be considered atypical by Western standards, the interaction of culturally diverse artistic values can be facilitated.

Functions of Art

The personal functions of art include a means of psychological, emotional, and aesthetic expression, as well as a vehicle for spiritual concerns. Political and ideological notions are transmitted by art, as are the human concerns characterizing architecture, community development, crafts, and industrial design. It seems, too, that the new technologies of the mass media of communication permit particular works of art to be disseminated throughout society, increasing the impact of art on people's personalities and modes of existence. This large scale experiencing of art may also be increasing the psychological impact of nonartistic events through their depiction (e.g., a photography show representing the plight of the homeless or cultures suffering slow starvation). Thus, the method of using photographed or videotaped images to illuminate details of the human condition are viable vehicles for presenting cultural phenomena in partnership with technological tools.

Over the ages the power of the visual image has given rise to political movements, social upheavals, and cultural transformations while affecting the perceived shape of history. The powerful world image, which is shaped by the electronic and printed media as well as museums and galleries, has also created a class of disenfranchised society members whose ethnicity, physical appearance, and cultural norms are inconsistent with this image. For example, the Eurocentric view of art typically encountered in America is based on the Greco-Roman standard of beauty and excellence. Such a limiting and narrowly focused perspective prohibits society members existing outside of the ethnic mainstream of European descendants, such as African Americans, Native Americans, Hispanic Americans, and Asian Americans, from acquiring a comfortable cultural fit. But the greater

inherent sin is committed against culturally and ethnically diverse younger generations who are not exposed consistently to images that identify and reinforce their cultural history while bringing them methodically into a comprehensible and manageable relationship with their current culture. In a world that is getting smaller because of innovations such as satellite teleconferencing, videotapes, and audiotapes, among others, the opportunities for making cross-cultural connections that expand on commonly held notions of beauty, value, and creativity are limitless.

Aesthetic Education

The discipline of aesthetic education supports such an investigation of cross-cultural standards by offering the "culture-critical" approach to education. As the name suggests, this approach offers a methodology for criticizing culture in the broad, anthropological sense. In the analysis of concrete works of art, their functions in the life histories of individuals and in the historical existence of societies (and particular groups within them) are also considered. This approach employs an empirical study of cultural history and of people's relationships to the symbolic expression of their experiences. The significance of this approach to fostering increased sensitivity to diverse cultures and their aesthetic systems is that it considers art in the context of all human experience rather than in the narrow social setting of an individual perceiver of art. It focuses on the recognition of patterns in which experiences are fitted together. These externally influenced, intuitively structured experiences, and their qualities and meanings, are interpreted to affect later experiences.

Aesthetic education as culture criticism seeks to develop the ability to make aesthetic judgments reflecting knowledge of the ways in which entire civilizations, and all things involved in them, have been working. As a method that can be employed most effectively at the college level, its purpose is not to produce art critics "but rather, persons more competent of judging civilizations, including their own, on the basis of an increasing understanding of what they have done, or failed to do, to human sensibilities" *(Encyclopedia Britannica, "Arts," p. 119)*.

Of course, this is an extensive undertaking requiring an interdisciplinary approach to the recognition and analysis of aesthetic systems. Computer science has made it possible to cross-reference data from art history and anthropology on a global scale if the information is made available to this system of artificial intelligence. Such access permits essential, rudimentary aspects of art and aesthetics in varied cultural contexts that may be considered intuitive, spiritual, mystical, and unspoken to be presented in

formats that can be shared by greater numbers of people from outside the culture. For example, a plethora of images, provided by a variety of media and techniques showing art in *context* as opposed to in sterile gallery settings, would do much for the movement away from the stereotypic standards against which all art is measured.

The challenge to cultures that would have their artistic practices and preferences known both at home and abroad is to determine the technological device that best solves the problems of communication and education in their own context while remaining mindful that all technology is not electronic. Ancient ceramic processes, metal smithing, and glass blowing, as well as printing presses, cameras, tools, and equipment for drawing, painting, sculpting and weaving, exemplify proven technological evolution and problem solving in the quest to manipulate one's environment and to interpret reality. However, it is also fundamental and progressive to contemplate the extremes of devices that may be possible in advancing the fight for cultural development and cross-cultural education in the future. To effectively manage the future, a culture, society, or nation must equip itself with educational formulas that are appropriate to its needs and that will allow it ever-increasing access to information throughout the world.

Official Knowledge

The use of information sharing and shaping to produce an "official knowledge" condoned by the existing power structure is a social-political reality regardless of its moral coloring. A culture that aspires to participate in the formation of official knowledge is faced with the following questions:
 1. What knowledge is appropriate for the culture?
 2. Who decides what knowledge is appropriate?
 3. What methods will be employed to acquire the desired knowledge? (P. Daniel, personal communication, December 10, 1988).

The answers to these questions are not immutable and must change along with transforming world affinities and techniques in order to avoid functional damage to the culture.

Successful participation in knowledge formation and transmission in art is a direct function of the extent to which one has control of the most advanced forms of technology affecting the visual world. However, if there is no strongly felt social need, such as for economic gain, an elevated standard of living or world acceptance and prestige, a society will not be prepared to devote resources to technological innovation. Moreover, all technological advances, including those that advance the arts, require the social resources of capital, materials, and skilled personnel. Many of the scientific-artistic

ideas contained in the notebooks of Leonardo da Vinci, for example, never reached fruition because of deficient resources of one sort or another.

The Computer

Perhaps the most impressive response to a societal demand for our age, garnering seemingly limitless social resources, is the computer. It will receive attention here because of its massive affect on the visual world and as a proven method of shaping future societies.

However, to make a reasonable assessment of the controversial area of computer art, to be addressed later, it is necessary to remember the long-standing dichotomy of art and science, reason and imagination, the mechanical and the spiritual, and opposition to the machine predating electronic technology. The crux of the argument against such highly analytical devices is that in spite of their efficiency of performance, they cannot originate anything; instead, they are created to do the bidding of human imagination and will. As was so eloquently stated by Geoffrey Jefferson in 1949:

> *Not until a machine can write a sonnet or compose a concerto because of thoughts or emotions felt, and not by the chance fall of symbols, could we agree that machine equals brain — that is, not only write it but know that it had written it. No mechanism could feel (and not merely artificially signal, an easy contrivance) pleasure at its success, grief when its valves fuse, be warmed by flattery, be made miserable by its mistakes, be charmed by sex, be angry or depressed when it cannot get what it wants.* (cited in Rosenberg, 1983, p. 7)

Art, in comparison to science and the machine, has been depicted as lacking virtue as well and has been historically taken seriously enough to be opposed as "deceptive." According to Plato it has "a dangerous capacity to subvert and seduce the mind from the contemplation of *Truth* that is its highest calling" (cited in Rosenberg, 1983, p. 20). Other suspicions surrounding art and contact with artists include the fear that they may "tap regions of darkness, ambiguity, and strange kinds of spontaneity in human beings" (Greene, 1987). To advance the conflict, art proponents posit that art and the humanities are concerned with a greater variety and range of interests than are the sciences. The related questions addressed by humanists concerned with reality and the problems of life are more subjective,

more difficult to answer, and more susceptible to error than are questions of science. Science, and the scientific experiment, seeks to "limit the number and degree of changes of its variables" (Rosenberg, 1983, p. 23), unlike the humanities.

In considering methods of using art to advance our cultures and societies into the future, it must be recalled that "technophobia" is part of the cycle of addressing art and technology as a unit. In 1859, for instance, Charles Baudelaire said of photography: "If photography is allowed to supplement art in some of its functions, it will soon have supplanted or corrupted art altogether" (cited in Hurwitz, 1987, p. 3). Prior to Baudelaire, Andrea Pozzo employed the scandalous technique of a mathematical perspective system to create an illusionistic masterpiece on the barrel vaulted ceiling of the Roman Jesuit church of St. Ignatius. The 17th-century Flemish painting genius Vermeer was also unfavorably scrutinized for his suspected use of the camera obscura to assist him in drawing. Probably the most accomplished artist and cultural clairvoyant known for the intelligent combination of art and technology as a scientist and inventor was Leonardo da Vinci in the 15th and 16th centuries. Since then numerous artists have struggled to remarry art to technology. However, the terms of the marriage contract and what is to be sought from the union are yet unclear.

Now, in the latter part of the 20th century, a distinction has been made between an artistic aversion to science and machine technology and the uncertainty and controversial nature of electronic (and cybernetic) technology. The latter is viewed more optimistically. It is predictable that because of the almost human-like responsiveness of the computer, it is likely to overcome the chasm between the "mechanical" and the "spiritual" that was deepened by the Industrial Revolution. It is hoped that the lessons taught by earlier technological cycles will eliminate the need for developing nations to repeat the more fundamental aspects of the trial and error process.

But Is It Art?

The term *computer art* is probably a misnomer because it refers to the machine or tool and not the art itself. One, for example, does not refer to "oil paint art." But, terminology aside, there is no doubt that computers are having a vast effect on the way art is conceived, created, and perceived and the way cultures are viewed as a consequence. Among its virtues are the speed, immediacy, and breadth of functions it makes available to the artist. Characteristics such as a palette of more than 16 million colors, unlimited shapes and sizes of marks, and three-dimensional modeling certainly have an undeniable appeal to those interested in high-tech artistic creativity. But

is it art?

Although the realist painter Philip Pearlstein maintains that the computer is just another wonderful tool for the artist, "like the tools we use to make paint" (Hurwitz, 1987, p. 2), his statement contributes to the debate over whether the computer is capable of personal, culturally significant expression because it is a machine and revives the assertion by some that computers can magically bring out the artistry in anyone.

Although this question of "what is art" has been pondered by artists and aestheticians for centuries, it seems especially suitable for artists working in borderline media that are difficult to classify, such as the three designated by Grant (1987): computer art, holography, and xerography. He wonders whether anyone really believes that computer art is art because:

> *computer art imagery is hardly ever seen in a museum or art gallery, but is almost exclusively contained on the pages of computer trade magazines. Holography has been used by some quite creative people to represent three-dimensional moving images of human figures or abstract shapes, but, outside of supermarket scanners or the reflecting area of one's credit card, few people have ever had any association with it. Xerography may be another example. It has been deemed a legitimate art process by the Print Council of America, but what is that? And what does that mean?* (Grant, 1987, p. 10)

Perhaps part of the meaning is that the line between fine art and commercial art is being shifted. If that is the case, then greater clarification of what technology is doing to fine art, traditional art, and culture-based art and what to do about it is an issue. Are artists able to use computers to produce works of fine art, and does computer art represent the art of a new culture? There is, as yet, no answer. But it should be noted that it has been the practice of such fine museums as the Bronx Museum, in New York City, and the Everson Museum, in Syracuse, New York, to exclude computer-generated *commercial* art from the category of computer *art*. Examples of items omitted typically include animated imagery on videotapes, created on a computer terminal and used in advertising and science-fiction movies (Grant, 1987, p. 10). However, in spite of the uncertain standards for computer art, more and more artists are using the computer to create images that would be impossible otherwise.

The further extent to which the challenges and demands of technology confront those of art is demonstrated in art schools, where sophisticated

equipment is becoming typical, as is the requirement that students become proficient in its use as a tool of art and commercial production. Unfortunately, it is unclear, at this point, whether students graduating with computer art skills will find jobs or galleries interested in selling work that is highly reproducible, given the proper software, and that is not unique. Moreover, students from developing nations who are trained as computer artists face the reality of not having the opportunity to immediately apply these new skills if they return to their homelands.

It is problematic that this nascent form of image making is accompanied by the shortcomings of not being exhibited often for review and enhanced understanding of the medium. It is also characterized by a lack of personal artistic style and consistent quality effected by artists unskilled in the nuances of computer programming. Consequently, Grant (1987, p. 17) maintains that the most successful use of the computer in the arts has been in the areas of computer-choreographed dance, fashion design, and art reproduction.

But what does all of this mean? Is the computer, and the images it generates, destined to be the thing in the saddle that determines the direction of our travel? Or, given the sophistication of computer art, and other art produced by new technology, is there the risk of their becoming obsolete and supplanted by newer technology? Will computer art pass the test of time and outlast the machine that produced it, and will there be an audience and buyers for the art in the near future? Whatever the answers to these questions, they must reflect a direction that fortifies national or cultural objectives and responds to evolving human needs that cross cultures.

Humanizing the Computer

Toward the goal of meeting human needs, recent efforts have been made to humanize the computer. The term *user friendly computer* has become fairly familiar and refers to hardware that is not too complex for the average person to master. But imagine a computer that permits one to communicate with it by talking to it or using gestures and eye movements similar to those employed when conversing with a friend. What about a video-cassette recorder that could automatically select and record appropriate television programs for someone on the basis of its knowledge of his or her interests and preferences? Further, holography-aided design has now joined computer-aided design for the advancement of video conferencing. People who cannot attend conferences can still participate in video conferencing enhanced by the creation of televised masks of actual participants employing life-like, moving facial expressions.

In 1986 the Media Laboratory of the Massachusetts Institute of Technology (MIT) in Cambridge, Massachusetts, put most of the aforementioned technology into place. However, full development of these innovations depends on a new synthesis of art, science, and technology, an interdisciplinary approach that promises "good news for commercial research, design and development" (Aldersey-Williams, 1987, p. 38).

The Media Lab has set an admirable standard for implementing objectives directed at fusing these disciplines. An attempt is being made to avoid enslavement to the computer, thus preventing electronic anarchy. Consequently, the director of the Media Lab, Nicholas Negroponte, aspires to couple "artistic thought with the most advanced scientific thinking in order to invent and use creatively new media" (cited in Aldersey-Williams, 1987, pp. 38-39).

According to Negroponte, the key to this interdisciplinary relationship is the personal computer, which permits the inventor and creative user to be in the same facility (e.g., a laboratory). It is hoped that in the future the functions of these two persons will be routinely conducted by one individual.

In the interdisciplinary MIT lab, the functions of a scientific laboratory, computer lab, and design studio are combined to create anthropomorphic units that are the new tools of people's interactions with machines (Aldersey-Williams, 1987, p. 40). For example, creative synthesis has endowed computer communications with body language through the use of a light-emitting, diode-covered suit functioning as a "graphical robot" (MIT Lab, 1987).

The diodes movements are picked up by four cameras that follow three-dimensional changes in the suit's position as its wearer moves. A computer records and then models these body movements. (Aldersey-Williams, 1987, p. 43)

Although the program was originated to expedite the creation of realistic cartoon animation from human figures, its overlap with the efforts of a learning research Media Lab group yielded a new idea. Persons with speech impairments who wish to communicate with a computer that responds to verbal cues can instead be taught to use a computer that has been programmed by a graphical robot to "understand" movement cues. The physically impaired can also practice motor skills with the assistance of the diode-covered suit. Now imagine diodes connected to a West African

masked dancer for the purpose of transmitting his or her movements through a computer screen. The possibilities for instantaneous viewing and increased understanding of dance-art forms never before experienced by geographically and culturally distant audiences are very exciting.

In a final example from the realm of learning research, Professor Seymour Papert of MIT intends to enhance the educational programs of third-world and educationally deprived inner-city areas with more effective and entertaining computer uses. In one study a mechanical building block set was connected to a computer to teach a child about programming (to control the movements of a motorized car of building blocks) and three-dimensional design while having fun.

The previously mentioned examples demonstrate that the art-tech conflict is reconcilable. Joan Truckenbrod, fiber artist and author of the book *Creative Computer Imaging,* agrees with other critics that there is no computer-generated art because computers act on instructions. She points out, however, that the seemingly antithetical modes of hard technology and the natural elements of traditional art media can be complementary. An interactive relationship can be developed that permits the expressive nature of the artist to transform the "character of the computing system. The computer is integrated into the creative process as both tool and catalyst thus expanding the artist's creative capabilities" (Truckenbrod, 1987).

Truckenbrod (1987) compares the computer to a lump of clay that must be molded into a workable form, noting that the artist has unlimited power to do so. Certainly, this philosophy represents an inroad for artists who wish to "sensitize" computer imagery with ethnic/cultural content.

World Making

Art and the role of technology in the creation or production of art are inseparable from the question of the maintenance and/or creation of culture. Perhaps, as Gablik (1987) suggests, visionary thinking about culture, which is not paradigm-bound like scientific thinking, may not be possible today because of our extensive acceptance of artificial intelligence as social reality. Moreover, technological advances may be stripping our cultures of aliveness, possibility, and magic. By demystifying reality and glorifying the factual world alone, our scope of human experience may be shrinking.

current social-cultural situation is the high road to an expanded world view and system of knowledge sharing.

In contrast to that position, another aspect of the scenario for cultural development includes a new quest by science for a more holistic, nonfragmentary world view. This new style of thinking consciously integrates logic and intelligence. It emphasizes "world-making" and the transmission of culture as "the principle function of mind, whether in science or in art" (Gablik, 1987, p. 31), and recognizes that social reality is a function of the strength of the bond between individual beliefs. Art and technology become significant in the process of cultural bonding and revitalization when they fulfill a cultural need by expanding our model of reality.

Regardless of the previous functions served by art, perhaps what is needed now is art that provides images helpful in the creation of a future that is an improvement over our present. Perhaps, too, the creative personality as futurist may be confronted with a love-hate relationship with technology in pursuit of a future culture.

Artists have somehow become responsible for evolution, moving backward and forward in time as guardians, determiners, and transmitters of their cultures. Like technologists, they too seek to change or manipulate their environment by employing techniques accumulated from one generation to the next. If social conditions permit, the path of technology, like that of art, inevitably highlights the stage-by-stage development of a culture. But development and transmission of culture must not be left to chance, because regression and loss of history can occur as well.

Rather, a society, nation, or culture must have an agenda for world making that includes recognition of the most advanced options for world development and participation in these options where possible. Without such an agenda for the future, empowerment, will, and self-definition are impossible. Fortunately, art has provided a ready and available body of resource materials for such agenda building. Throughout history, artists have shared their perceptions of the world and have directed others to a new knowledge. With the advancing reality of electronic technology as another tool for the creation of art, there is no reason for artists to yield the position of leadership in directing society to exercise its powers of observation, visual discrimination, cultural conceptualization, and translation of experiences into knowledge.

Advanced electronic technology is a reality that requires a response from the art world, either by adopting it wholly, maintaining a safe distance while it either progresses or self-destructs, or by rejecting it. It is suggested here that an aggressive, proactive, interactive, interdisciplinary approach focusing on harnessing the use of technological tools *that suit the need of the*

current social-cultural situation is the high road to an expanded world view and system of knowledge sharing.

Indeed, the union of art and technology promises to bring a humanistic dimension to what previously may have been a difficult interaction between people and machines. Moreover, training in, attention to, and respect for art equips us with the ability to state and defend our preferences for new combinations, techniques, and devices that change the environment and color our lives. These skills, which are readily translated to situations requiring decision making, problem solving, and critical evaluation, should be transmitted to the next generation.

It is probable that artists are still in control of their destinies because technology does not equal creativity and efficiency does not equal emotion and passion. However, what artists can garner from artificial intelligence, such as computer science, is how to share more effectively (and efficiently) the mysterious nature of art, the effect of experience on sensibilities, and the evidence that culturally, temporally, and geographically distant and ostensibly different societies may be advancing toward significantly similar conclusions.

References

Aldersey-Williams, H. (1987, January/February). Social science. *Industrial Design,* pp. 38-43.
Daniel, V. The artist as professional: An ethnic-cultural perspective. *The Journal of Career Education, 8*, 173-184.
Encyclopedia Britannica. "Arts," p. 119.
Gablik, S. (1987). The reenchantment of art. *The New Art Examiner, 15*(4), 30-32.
Grant, D. (1987). Art at the borderline. *Pix, A Supplement of American Artist, 51*, 10-17.
Greene, M. (1987). *Coming to our senses.* The Arts, Education and Americans Panel. New York: McGraw Hill.
Hurwitz, L. (1987). Artists and computers. *Pix, A Supplement of American Artist, 51*, 10-17.
Rosenberg, M. J. (1983). *The cybernetics of art, reason and the rainbow.* New York: Gordon and Breach Science Publishers.
Truckenbrod, J. (1987). Speakeasy. *New Art Examiner, 15*(3), 13-14.

Notes

This article was adapted from a keynote address presented to the 1988 Congress for Africa and the Middle East, International Society for Education Through Art (INSEA), Lagos, Nigeria, August 9, 1988.

8

Teaching Art in a Multicultural/ Multiethnic Society

CARMEN ARMSTRONG

Northern Illinois University

At one time, the idea of the United States of America being a melting pot of people seemed to work, but late in the 20th century an analogy to a patchwork quilt may be more appropriate. The melting pot depicted the assimilation of people from many countries into a working whole, but its principles failed for persons who were visibly different from descendants of the Europeans who first settled the country.

Today, much more cultural diversity exists in the United States, and our schools, where ethnic and cultural groups meet the mainstream culture, have an opportunity and challenge. The challenge is not to propagate the melting pot concept but to help all students understand and appreciate the diversity — commonalities and differences — of the present American patch quilt. The opportunity is to incorporate the richness and quality of each cultural and ethnic component and make a totality that is vibrant and harmonious. Art education can contribute to creating this harmonious patch quilt.

A Direction

To contribute to the harmony of a multicultural/multiethnic society, art educators can become more sensitive to the culturally diverse value systems operating in art and possible culturally based semantical barriers to student receptivity. They can also develop structured and sequential art curricula integrating art history, aesthetics, art criticism, and art production and use a wide variety of cultural and ethnic exemplars of fine arts and crafts. Finally, they can work on improving their instructional expertise. In particular, teachers can reflect on the semantics of their questions that (a) encourage perceptual awareness and the inductive formation of concepts,

principles, and generalizations based on art exemplars and other visual phenomena; and (b) focus students' attention on similar and different values operating in reference to common concerns seen in the art of cultures represented in our multicultural/multiethnic society.

Definition of Terms

Each of the directions recommended will be elaborated on following clarification of some basic sociological terms.

" 'Culture' consists of the behavior patterns, symbols, institutions, values and other human-made components of society" (Banks, 1984, p. 52) or "...the sum total of ways of doing things and the objects of human manufacture acquired by man as a member of society and transmitted from generation to generation...or a body of shared symbols to which conventionalized meanings are accorded" (Lee, 1963). The symbols of a culture may be concrete or abstract, and value is determined by criteria of truth and worthwhileness. Cultures may include subcultural or microcultural groups, such as college students, miners, or southerners; or ethnic groups, such as African Americans, Polish Americans, American Indians, or Jewish Americans. These groups may also be described as having a "less familiar cultural fit" (Daniel, 1988).

" 'Ethnic' groups within the United States are types of microcultural groups that have unique characteristics that set apart from other cultural groups" (Banks, 1984, p. 52). Banks goes on to clarify that (a) an ethnic group has a historic origin and shared heritage and tradition; (b) many U. S. ethnic subcultures are bicultural, acquiring mainstream American characteristics while retaining many characteristics of their ethnic group; and (c) some subcultural groups are voluntary, but ethnic microcultures are more likely involuntary.

"Multicultural/multiethnic curriculum" considers the mainstream (dominant value system) perspective on an issue or topic as one of the many perspectives representing the cultures and ethnic groups that constitute the population of the United States today. The curricular thrust is to broaden the exposure of any student to the diversity that is now "America" with acceptance, appreciation, and harmony as the goal. Common cross-cultural generalities can form the structure from which concepts that contribute to learning are identified.

For curriculum-structuring decisions, Banks (1984) defines "concepts" as words or phrases that enable us to categorize a large class of observations (attributes or visual qualities). Gagne and Briggs (1974) divide concepts

into "concrete" and "defined" types. Concrete concepts have observable properties that allow one to point to an instance of that concept (e.g., a pencil). A defined concept involves correctly and verbally demonstrating (as opposed to just repeating a definition) related use of all concepts that are critical to its description (sidewalk — a walkway beside a street).

Banks (1984) differentiates a "generalization" from a concept as a relationship or scientific statement between two or more concepts that can be tested and verified with data (sidewalks and streets are designed to accommodate pedestrian and motor vehicle traffic, respectively).

"Aesthetics" is a branch of philosophy dealing with questions about the nature and value of the arts. Aestheticians explore these questions and analyze the meaning of criteria used to describe "art."

As referred to here, aesthetics generalizations are high-level truths (big ideas) that pertain to the value of art forms, and, if not universal, they are applicable at least across time and in many cultures. The tentativeness of the aesthetics generalization suggests that these ideas are discussable, that is, issues about which there is not consensus in the world of art, but about which there are significant observable instances in the art of many cultures. Therefore, aesthetics generalizations may be more appropriately stated as questions that invite discussion and synthesis of instances (concrete and/or abstract) to support a general statement. For example, the statement that "Art is the portrayal of social relationships to arouse empathy in the viewer" is true in some instances. In others, the statement that "Art is the portrayal of humans in social situations where the arrangement was altered from the actual setting to compose a pleasing arrangement of visual symbols" may be more true. Both statements may be true about many works of art. Generalizations drawn from aesthetics can serve as life-oriented organizers for approaching appreciation of art representing the rich ethnic and culturally diverse population of the United States of America. This idea will be developed here.

Sensitivity to Multicultural/Multiethnic Value Systems

Teachers can prepare to teach in a multicultural/multiethnic society by seeking information about cultures different than their own. Studying to learn more about cultures and ethnic groups should help teachers avoid superficial assumptions about people having a less easily identified cultural fit and avoid making errors of interpretation and overspecification in regard to works of art.

Art teachers can study the significance of objects that have functional and aesthetic value. Objects testify to cultural values as objects worthy of aesthetic qualities in themselves, or as representations of cherished ideas. Objects that, over a period of time, are devalued for reasons associated with changed conceptions of the function of art or subject represented by that art form are replaced with new forms that communicate revised ideas and beliefs. These still have historic value as well as sustained value to individuals or groups (often age groups) clinging to the original conceptions of value "programmed" in their preadolescent years.

In researching culturally and ethnically diverse art forms, care should be taken that the art observed is not narrowly defined in terms of what has attained art museum status. Art teachers may need to reconsider the pervasive mainstream notions of formalism that differ from other systems of organization. The aesthetic quality of *The Great King of Mount T'ai* — a Chinese ink-on-silk "Hell" painting done in the Yuan period — is difficult to explain in terms of formalist principles of composition. According to Collingwood (1958), the work of art (from any cultural or ethnic group) may present a view of *some* truth about the subject (rather than *all* that is true about it). The artist's assumption is that some audience can also see the subject in the way portrayed or be brought to see that truth about it. Collingwood's philosophic position invites the teacher of art to help U. S. mainstream and nonmainstream students to value the art of many cultural and ethnic groups for *some* truths that the artists show in their works.

Teachers who respect their students as humans entitled to their unique cultural experiences and values will maintain a sensitive knowledge about those current trends, historical and cultural influences, and common experiences that contribute to the child's identity (Armstrong, 1970). A teacher who is aware of students' aspirations, activities, and values can select the most appropriate organizers of a lesson to promote a sense of familiarity with the topic posed, attract immediate interest, and build feelings of confidence in being successfully involved.

Maintaining sensitivity to the diversity of cultural and ethnic qualities to incorporate into the harmonious patch quilt of American society also means checking the information acquired from research against observations of the behavior of students representing those cultures. Graphic representations of human figures can reflect nontraditional, acquired values (now accelerated by the mass media) across cultures (Dennis, 1966) as well as traditional cultural values. Art education can help students to value their own heritage, understand the heritage of other persons, and appreciate the diversity of art forms and interpretations that communicate about common

concerns of life.

Curriculum Development in a Multicultural/Multiethnic Society

In a multicultural/multiethnic society an appropriate goal of art education is to contribute to students' comprehensive knowledge and valuing of the diversity and aesthetic qualities of visual arts. Therefore, attention to the aesthetic visual art contributions of cultures and ethnic groups constituting the United States is a logical way to help construct our "harmonious patch quilt."

Multicultural/Multiethnic Curriculum

In an "additive" (Banks, 1984) curriculum, special short courses focused on ethnic groups, special units of study devoted to ethnics, or a particular segment in a particular grade level of the social studies curriculum on world cultures are introduced into the traditional curriculum. In contrast, in the "multiethnic model students study historical and social events from several ethnic points of view" (Banks, 1984, p. 15). Topics in art could also be studied from several cultural and ethnic points of view.

Discipline-Based Art Education and Multicultural/Multiethnic Content

The development of multicultural and multiethnic sensitivity can occur within discipline-based art education. Teaching art as a discipline does not limit art exemplars to those that have achieved places in museums or imply that the study of art is for the elite or leisure class. Also, one need not be a professional in the world of art to understand and appreciate it. On the contrary, a common education for all persons should include the opportunity for continual, critical encounters with works of art that transcend cultures and time:

• to explore ideas about the place of art in the lives of people and the variety of criteria used for valuing works as art
• to recognize the place that art has held historically in the social, political, economic, fantasy, and religious lives of people
• to inspire and instruct one's own art production
• to grasp the relationship between geographic location and the choice of medium by which aesthetic ideas are given form
• to recognize relationships that contribute to the aesthetic qualities of "art" that form and communicate meaning through them

A Curriculum Theory Accommodates Multicultural/Multiethnic Content and Discipline-Based Art Education

Merging sociological and discipline-oriented curriculum content may be disconcerting to purist curriculum theorists, but there is an existing curriculum theory that can accommodate a multicultural/multiethnic application of discipline-based art education. The universal, fundamental, comprehensive institutions theory (Smith, Stanley, & Shores, 1957) is a sociological curriculum theory that, by deduction, offers a life-oriented structure for discipline-based art education. "Institutions" are organized means that humankind has developed and used to meet social, economic, political, and philosophical needs. These are functional customs and characteristics of evolving societies. These institutions, shown in Figure 8.1, are the contexts in which art is created, and they have influenced what has been valued as art.

Social, political, economic, and philosophic institutions could provide a comprehensive sociological structure to relate to philosophical and contextual ideas about visual art.

The Universal Aesthetics Themes Curriculum Structure

The universal aesthetics themes curriculum structure (Armstrong, 1987) is a deductive adaptation of the universal, fundamental, comprehensive institutions curriculum theory just described. It offers a way to responsibly use time-honored exemplars of art as well as sociologically relevant art forms, and it integrates universally relevant cultural institutions and the content areas of art (history, production, criticism, and aesthetics) through aesthetics generalizations.

Social, political, economic, and philosophical institutions and aesthetics theories provide content for the organizing categories of a universal aesthetics themes art curriculum. The visual arts have been influenced by and have played important roles in all of these institutions. Institutions influenced the values attached to art forms and even contributed to the record we have of cultures no longer in existence. Hence, value statements regarding the visual arts or aesthetics generalizations about art in the lives of people can be formulated in relation to any of the institutions. Those statements can be expressed in terms of the nature of art, what artists do, what they say in their work, the subjects that they feel important enough to recreate or comment on, and what has been valued as art by people at times throughout history or in different cultures. They invite examination of the bases for valuing art.

Figure 8.1. Universal institutions of an evolving culture and related curricular themes.

SOCIAL

FAMILY
SOCIAL CLASS
RECREATION
PHYSICAL COM-
PETITION
SYMBOL SYSTEMS
MOBILITY
UNDERSTANDING
DIVERSE PEOPLES

POLITICAL

GOVERNMENT
PROTOCOL
WAR MACHINE
INTERNATIONAL
RELATIONS
ACCESS TO
MEETING
BASIC NEEDS

ECONOMIC

ENERGY
SHELTERS
WORK PLACE
EMPLOYMENT
POPULATION
GROWTH
NATURAL RE-
SOURCES WATER

PHILOSOPHICAL

SUPERNATURAL
RITUALS AND
CELEBRATIONS
RELIGIONS
DEMOCRACY
SOCIALISM
COMMUNISM

THE EVOLVING CULTURE

103

Subsets of, or issues related to the institutions, such as employment, resources, mobility, population growth, and understanding between diverse people (Cortez, 1983), have long been subjects of artists' creations; however, those artists' works vary in styles and media and depict different cultural interpretations of common concerns. These subcategories suggest themes for art encounters, as seen in Figure 8.2.

Figure 8.2 shows how a subordinate generalization, derived from aesthetics and a cultural institution, serves as an advance organizer. The teacher can make general reference to it for initial focus and motivation for the students. The teacher's analysis of the big idea or one of its subordinate ideas will suggest some art concepts that students will need to grasp to comprehend the point of the generalization and lesson. The direction provided by the theme and subordinate generalization guides the teacher in the selection of art history topics to study, art exemplars to select for art criticism activities, concepts to develop that enable successful art production experiences, and the focus for group discussions dealing with aesthetics questions — an integrated encounter with art. Below are more specific recommendations for planning the integration of the four content areas of art education encounters.

Art history. Art curriculum planning also includes the selection of works of art that relate to the generalization or point of the lesson. Besides traditional art historical resources, the teacher can scan museum catalogs, travel resources, *National Geographic* magazine, or other sources dealing with art and cultural anthropology to make selections and obtain basic historical and contextual information about works of art. Charting the selections by grade level, culture or ethnic group, and universal aesthetics theme will help teachers become aware of any unintended gaps or undue redundancy in representing life-oriented values from a variety of cultures and ethnic groups. Through art historical experiences, teachers should be able to help their students determine why a certain work was important and how it fits into the lives of people at that time and place.

Art criticism. Teachers prepare for facilitating meaningful art criticism experiences by carefully selecting artworks and planning for students' involvement. The teacher plans to involve the students in examination of a work of art by describing, comparing and contrasting, analyzing formal qualities, interpreting through critical thinking, speculating, and evaluating. The work examined would most likely be one or more of the art historical exemplars because those would have been selected for their relevance to the theme. Works that are alike in ways related to the aesthetics generalization that organizes the encounter, but differ in cultural interpretations, may prove most enlightening.

Figure 8.2.

Art production. Meaningful art production applies concepts developed in the study of individual works of art or other visual analytical activities and provides a direct experience base for thinking about the meaning of that experience. The art production planned may or may not result in traditional child artworks. Several art educators (Anderson, 1963; Hurwitz & Madeja, 1977; Szekely, 1985) provide expanded ideas of art learning activities that involve sensory awareness, analysis, and focused discussion activities. These art learning situations may result in typical art products. However, it is feasible that a teacher would plan to display students' tempera-painted variations of color values, or intensity changes of a color, on a bulletin board rather than a painting about what was done on a vacation. One could display the traced analyses of the dominant gestures of bodies of working people and use of negative space depicted by artists from different cultures, which, by gesture and spatial relationships, communicate ideas about work. These activities provide concrete evidence of art learning and enable students to recognize and employ a variety of artists' methods to effectively communicate ideas graphically about universal institutions of life.

Aesthetics. The discipline-based art encounter can culminate with discussion of appropriate questions about art in our lives. Given time for thoughtful review, students should be able to formulate simple generalizations about the values of art that result from their art encounter experiences.The discussion time of the encounter contributes to student understanding of the relationship between art and the lives of people and reinforces the purpose of art activities.

In summary, the universal aesthetics themes curriculum model accommodates an integrated (art history, aesthetics, art criticism, and art production) visual arts discipline approach. It invites a life-themes curricular organization based on generalizations derived from aesthetics that also relates to universal institutions. It encompasses attention to the elements of art and the principles by which those elements are arranged in many art forms. It values worldwide visual art forms, both past and contemporary.

The sociological emphasis of a universal aesthetics themes curricular structure could help students put art into a personally meaningful context. It does not isolate art from the life that has inspired so much of it. It helps students relate to the art of the multicultural/multiethnic society of the United States, and to the society that has evolved outside of their immediate world. It encourages students to give form to their ideas through media and to discuss and evaluate the qualities of exemplars derived from productions in all cultures and across all times. In a word, students (a) can identify with such themes, (b) appreciate the expressions of cultures different from their own,

and, (c) with the help of the teacher, see a major idea of an art encounter translated into meaningful situations in their own lives.

Development of a sequential, districtwide universal aesthetics themes curriculum would benefit from the cooperative effort of art discipline specialists and from teachers from sociology and other social sciences. However, an individual art teacher could adapt several existing discipline-oriented curriculums (Chapman, 1985; Hubbard, 1987; Southwest Regional Education Lab, 1976) to a universal aesthetic themes structure.

Instruction in the Universal Aesthetics Themes Curriculum

Some basic recommendations about teaching can be reemphasized for their application to teaching for multicultural/multiethnic understanding and appreciation through art education. It is important to present the art lesson in terminology that is not distractingly different from what is understood by the student group, although that does not mean trying to be "one of the gang" by adopting students' latest language idiosyncrasies. Teachers may have to encourage curiosity and inquiry, minimize competitive situations, give concrete rewards, and plan to be more involved with some individuals or groups than others because of culturally influenced patterns of interacting (Barclay, 1966; Silverman, Hoepfner, & Hendricks, 1969). In discussing how to make the concept of constructive cultural pluralism work in schools, Havighurst and Levine (1979) write:

> *Constructive pluralism faces the major problem of working through education to help minority group members to retain their cultural group membership, and at the same time to increase the socioeconomic status of the economically disadvantaged minority groups. Helping minority children to retain a positive identity may be achieved to some degree through the schools by working to ensure that instruction reflects their racial or ethnic heritage and does not require them to reject their background in order to succeed.* (pp. 475-476)

Good art teaching that uses available help in instructional strategies and knowledge of and sensitivity toward students as other human beings, who may or may not have the same cultural fit as the teacher, makes sense in a multicultural/multiethnic society. The art teacher structures and introduces the art learning encounter — theme, experiences, introduction of concepts,

exemplars, techniques, problem possibilities, and questions — in such a way that students are motivated by recognition of the kinds of relevant experiences the teacher has had and are challenged by the meaningfulness of the encounter.

Teaching Art History Content

The study of art history can be exciting and appropriate even for elementary students. Art educators, such as Erickson and Katter (1987), Goldstein Saunders, Kowalchuk, and Katz (1986), Hubbard (1987), Mittler (1986), and Chapman (1985) have addressed ways of introducing students to art historical information through game formats, field trips, and storytelling. Formats vary from poster-size to postcard-size prints of works of art for group discussion or for each child's close examination and participation in discussion, diagramming, match and group, or writing activities.

Using the universal aesthetics themes approach, the teacher could plan to compare many cultural responses to the same institution subconcern (city dwelling) or art concept (color relationships that communicate) through conscious selection of examplars. Imagine comparing Utrillo's *St. Romaine Quarter,* El Greco's *View of Toledo*, and Crite's *Parade on Hammond Street.* All show places where people live, but different attitudes about city dwelling and about how to depict it.

Conducting Art Criticism Experiences

According to Feldman (1967), art criticism involves *description* of the indisputable content (subject, objects, media, form, technique, or character) present in a work of art; *analysis* of the sensory qualities and variations of the elements that the artist arranged (possibly following principles common in Western art); *interpretation* of the work (i.e., the total or specific effects created by the way the artist composed the content); and *evaluation* (i.e., how effectively the artist did what was intended, to the best that we can determine intent). In Hamblen's (1986) factual-analytical-speculative-evaluative art criticism taxonomy, she adds the *speculative* category ("Suppose how it would be different if...") to the Feldman structure.

Hamblen (1986), Armstrong and Armstrong (1977), and Armstrong (1986) have emphasized the semantics of teacher questions that effectively involve students in analysis of works of·art or visual stimuli in, respectively, art criticism and inquiry in art production experiences. These authors suggest key words in teacher questions that encourage students to engage in higher order, critical thinking — a major step to formulating generalizations.

Hamblen (1986, p. 6) suggests "who," "what," and "when" questions to help students observe the factual elements of a work of art (e.g., a cow, a red square, or a tree). She recommends "how," "decide," and "why" questions to encourage analytical observing (e.g., line qualities that contribute to the visual movement). "Imagine," "what if," and "change" questions involve students in speculative behaviors; "judge," "debate," and "assess" questions encourage the critical thinking involved in giving reasons for evaluative responses to works of art.

Facilitating Inquiry in Art Production

Inquiry in art (Armstrong, 1986) is a teacher questioning method that promotes higher order thinking as students develop, selectively relate, and evaluate concepts in producing art. The questions an art teacher asks in an inquiry-in-art lesson are based on behaviors typical of artists' inquiries as they produce visual art. Different types of questions are designed to facilitate each behavior in students. To help a student *set a direction,* the teacher asks interest-catching questions such as, "How many of you have seen those new flowered shirts?" The teacher asks questions to facilitate formation of concepts needed for the planned art production through questions aimed at involving students in the *discover, visually analyze,* and *classify stages.* The visual information needed to form the concepts is provided by visual stimuli (tree branches) or prints of works of art. Student attention is drawn to general observations or differences by questions such as, "What pictures or shapes made the dress of the girl in this painting interesting?" More specific questions encourage closer looking (visual analyzing) and differentiating of the attributes that make one general observation differ from another. Questions that suggest that the answer must be found in the work of art or visual stimuli provided ("How can you tell by looking...?") discourage wild guessing and preconceived notions and provide every child with the opportunity to correctly observe the attributes of the concept. Classifying things that are alike by their observed attributes (e.g., jagged edges) can be facilitated by teacher questions such as, "What are the kinds of edges that we saw?" With this stage the concept has been formed, and the verbal label by which we refer to it (edge variations of shapes) has been recognized or given by the teacher.

Concept development is temporarily put on "hold" as the teacher gives value to individuality and self-identity with questions that encourage students to *personalize* the experience (recall preferred observations and think about the student's own favorite activity, comfortable places to be, or his or her unique nature). Personalized questions might ask: "Do you like to do things energetically or quietly? Do you like bold colors and shapes or

the soft shapes and blended colors that we saw in the Monet?"

At this point the student has the knowledge and preferences from which to get an idea about the open-ended problem that the teacher has defined. To encourage the students to *hypothesize* possible solutions, the teacher might ask: "Considering what you know about ways to vary edges and the families of colors that Monet used (and the other painters' works that we saw), how would you make a tempera painting using analogous colors and related shapes that would fit with a place you'd like to be?"

The *hypothesize* stage is followed by giving form to that idea. The art product is begun, but the student should be encouraged to remain open (as artists do) to changes and review of the specific qualities observed that contribute to the concepts he or she is using. This stage of *reorder* is important. The teacher prolongs premature closure by questions such as, "As you paint the major shapes, are you thinking about background colors that will relate to them?" or "Looking again at the Monet, how do the edges of shapes fit with the colors used?"

Although prolonging premature closure is important, schedules mean that teachers will also need to encourage students to *synthesize* and come to closure with questions that remind them again of what can contribute to their success for last-minute decisions. The teacher asks, "In the five minutes left before we talk about our paintings, have you used related colors? Can you add small shapes of a color that will help your others be more related?"

As artists *evaluate* their own work, so, too, art students should be given the time to appreciate their own art products and those of other students. The critique is positive in approach, asking for evidence of specific concepts taught and recognition of unique selectivity. The teacher attempts to elicit students' positive strokes for their peers based on facts observed in the work displayed rather than personal friendship. The teacher could ask, "Which paintings varied the edges of the shapes painted? Which paintings used related colors?" The value of the evaluate stage lies in (a) reinforcement of the concepts learned, (b) positive self-identity for uniqueness, and (c) appreciation of ways that individuals can vary in a multicultural/multiethnic society.

Aesthetics

The art encounter in a universal aesthetics themes curriculum would be planned by the teacher with an organizing generalization derived from a subtheme of a social, political, economic, or philosophical institution.

Suppose that the political institution subtheme of "international relations" led the teacher to the idea that "Artists arouse feeling about conflict between groups by the way they graphically depict it in works of art." Exemplars selected, historical information learned, art criticism experienced, concepts developed, and the art production problem addressed would relate to the organizing aesthetics generalization.

A mix of declarative, informative talk preceding challenging Socratic teacher questioning can help students form generalizations about the value of art that acknowledge, tolerate, and appreciate the differing value systems that operate in producing cultural and ethnic diversity. As with the art criticism and inquiry in art production questioning approaches, this encouragement of inductive reasoning aids retention because the student has had to be intellectually involved in the structuring of the conclusion reached. On the basis of concrete exemplars in art and the personal experience of meaningfully integrated activities, those abstractions are more accessible to all ages to some degree of sophistication. The teacher's Socratic questioning strategy is less structured than the previous ones, but is designed to increase student reflection and critical thinking based on the art experiences that are the common experience of the group. For example, the teacher might ask: "Why is your reason for saying 'This is art' an adequate reason?" "What are some possible explanations for the fact that artists portray families in these different ways?" "Why might this Chinese 'hell' painting have been considered important even though it does not have a dominant focus or balance of colors?" "What big idea would speak to the different organizations evident in paintings from the East and West?" or "Why can they both be art?"

Enhancement of the group appreciation of differing interpretations can come from individual experience of cultural and ethnic representatives in the group. Certainly, the life experience of the viewer, which conditions expectations (a cultural or ethnic influence), will enter into the interpretation and instances of observable data cited to support a generalization. Teacher questioning can also prolong premature closure on an interpretation and encourage students to consider other interpretations to arrive at a broader synthesis. The respect developed for cultural and ethnic diversity through the entire art encounter is basic to the trust needed by students to make personal contributions and to develop into adults who are broadly informed about art.

Summary

The universal aesthetics themes curricular organization accommodates the criteria of discipline-based art education and focuses on specific considera-

tions for its appropriate application in a multicultural/multiethnic society. The art curriculum needs to be implemented by a teacher who is informed about the entire world of art, sensitive to cultural and ethnic uniquenesses, and knowledgeable about facilitating the intellectual and social growth of students through appropriately employed instructional strategies. These considerations would contribute to students' (a) understanding of our multicultural/multiethnic society, (b) developing a positive self-identity within or outside of the mainstream, and (c) integrating information about and understanding of the great diversity of art forms and symbols employed in giving visual form to ideas emanating from life experiences and value systems across time, cultures, and ethnic groups.

References

Anderson, W. (1963). *Art learning situations for elementary education*. Belmont, CA: Wadsworth.
Armstrong, C. (1970). Black inner city child art: A phantom concept? *Art Education, 23*(5), 16-21, 34-35.
Armstrong, C. (1986). Stages of inquiry in producing art: Model, rationale and application to a teacher questioning strategy. *Studies in Art Education, 28*(1), 37-48.
Armstrong, C. (1988). The visual arts in the self-contained classroom. *Educational Horizons, 66*(3), 126-128.
Armstrong, C., & Armstrong, N. (1977). Art teacher questioning strategy. *Studies in Art Education, 18* (3), 53-64.
Banks, J. (1984). *Teaching strategies for ethnic studies*. Boston: Allyn & Bacon.
Barclay, D. (1966). *A pilot study of art education for the economically and socially deprived child* (Final report EDO 10554.) Washington, DC: U. S. Department of Health, Education and Welfare, Office of Education.
Chapman, L. (1985). *Discover art*. Worcester, MA: Davis Publications.
Collingwood, R. (1958). *The principles of art*. New York: Oxford University Press.
Cortez, C. (1983). Multiethnic and global education: Partners for the eighties? *Phi Delta Kappan, 64*, 568-571.
Daniel, V. (1988). *Unpublished interview*. Northern Illinois University, DeKalb, Illinois.
Dennis, W. (1966). *Group values through children's drawings*. New York: Wiley.
Erickson, M., & Katter, E. (1987). *Teaching aesthetics K-12: Activities and resources*. Available from MELD, 464 E. Walnut St., Kutztown, PA 19530.
Feldman, E. (1967). *Art as image and idea*. Englewood Cliffs, NJ: Prentice-Hall.
Gagne, R., & Briggs, L. (1974). *Principles of instructional design*. New York: Holt, Rinehart and Winston.
Goldstein, E., Saunders, R., Kowalchuk, J., & Katz, T. (1986). *Understanding and creating art*. Dallas: Garrard Publishing Co.

Hamblen, K. (1986, February). *Constructing questions for art dialogues: Formal qualities and levels of thinking.* Paper presented at the Art Museum/Education Conference, Northern Illinois University Art Gallery, Chicago.

Havighurt, R., & Levine, D. (1979). *Society and education.* Boston: Allyn & Bacon.

Hubbard, G. (1987). *Art in action.* San Diego: Coronado.

Hurwitz, A., & Madeja, S. (1977). *The joyous vision.* Englewood Cliffs, NJ: Prentice-Hall.

Lee, A. (Ed.). (1963). *Principles of sociology.* New York: Barnes & Noble, Inc.

Mittler, G. (1986). *Art in focus.* Peoria, IL: Bennet & McKnight.

Silverman, R., Hoepfner, R., & Hendricks, M. (1969). Developing and evaluating art curricula for disadvantaged youth. *Studies in Art Education, 1*(1), 20-33.

Smith, B., Stanley, W., & Shores, J. (1957). *Fundamentals of curriculum development.* New York: Harcourt, Brace & World, Inc.

Southwest Regional Educational Laboratory. (1976). *Elementary art program.* Bloomington, IN: Phi Delta Kappa.

Szekely, G. (1985). Teaching students to understand their art work. *Art Education, 38,* 39-43.

9
Multiculturalism in Visual Arts Education: Are America's Educational Institutions Ready for Multiculturalism?

MURRY NORMAN DEPILLARS

Virginia Commonwealth University

Although there are varying theories related to the purposes and functions of art, few can question its role in the socialization process. As such, art is not passive. Even in its silence art speaks to the mind's eye, and as it speaks on a nonverbal level a context for the formation of an individual's image is being cast. It acts because art works, for example, the equestrian statues of Robert E. Lee and Stonewall Jackson tell where a people have been, and paintings of the "School of Athens," Lincoln, Washington, and Jefferson orient one and establish a frame of reference. By orienting an individual or a group, art establishes the "image-situation." Although Lerone Bennett, Jr., wrote most eloquently on the "image-situation" in the context of history, his words are most appropriate to underscore the point that art is not passive — it acts. He wrote:

> It acts because it is the basis of the image which is the ground of man's acts. This is a point of enormous importance, for men act out of their images. They respond not to the situation but to the situation transformed by the images they carry in their minds. In short, they respond to the image-situation, to the ideas they have of themselves in the situations.

> The image sees.

> The image feels.

> The image acts.

And if you want to change a situation, you have to change the images men have of themselves and of their situations. (Bennett, 1972, pp. 194-195)

Within the above context, art becomes a socialization vehicle. Here it is being suggested that art is not universal, it is not value free, it is not apolitical, and it is not fun and games. Art is serious. For example, through art American Indians have been depicted as lazy, drunken, and vicious violators of White frontier ladies' secret gardens. Of course, Geronimo is the epitome of viciousness and of the rapist. There are no paintings of Geronimo, the genius of guerrilla war tactics. Rather than being accompanied by thousands of Apaches, Geronimo had 35 adult braves, 8 half-grown boys, and 100 women and children (Debera, 1971). Deployed against Geronimo "were five thousand regular American soldiers, five-hundred Indian auxiliaries, hundreds of armed American civilians, plus a considerable Mexican force, both military and civil" (Debera, 1971, p. 31).

In 1885, during a 4-month period, Geronimo lost six men, one child, two half-grown boys, and two women. Of these, only three were killed in open battle (Debera, 1971). The losses of the forces deployed against Geronimo consisted of approximately 100 Mexicans, 10 soldiers, 12 Apaches who were friendly to the forces tracking him, and 75 civilians (Debera, 1971).

Once again, the silent image-situation projected through art is not passive. Art is a powerful socialization force that shapes behavior.

As a rule, when the history of art and the theory of art-making are discussed, their foundations and principles are linked to Europe. An objective appraisal of the art curriculum in America's public and private schools will affirm this observation. This curriculum focus and the increasing opportunities being made available for children enrolled in public and private schools provide a unique forum for the socialization process to take place (this will be discussed in detail later). As for the increasing opportunities for this to occur, Theodore Zernich (1987) comments only on the growth in art instruction. He notes that there are roughly 60,000 art teachers in America's public and private elementary and secondary schools. He also notes that approximately 90% of art instruction in elementary schools is provided by classroom teachers having either a modicum of or no education in the visual arts. It is little wonder why so many students' creative abilities become stifled before reaching the seventh grade.

In regard to art instruction at the secondary level, Zernich writes:

*Approximately 80% of our secondary schools offer art courses,
only about 20% of the students enroll in art classes. The schools
currently employ the largest number of art teachers ever em-
ployed (about 3% of all teachers), and the highest proportion of
student enrollments. The number of art courses offered in our
secondary schools has increased by 35% during the past ten
years, and the number of students taking art courses for more
than one year has increased by 20%.* (1987, p. 4)

The bedrock of curricula design and delivery is based on specific socializa-
tion assumptions. These assumptions can be grouped around three main
axes: "Anglo conformity," "the melting pot" theory, and "cultural plural-
ism" or "multiculturalism." In America, the Anglo conformity theory
demanded the complete renunciation of the immigrant's ancestral culture in
favor of the behavior and values of the Anglo-Saxon core group; the melting
pot thesis suggests a biological merger of the Anglo-Saxon peoples with
other groups. It was envisioned that through intermarriage, a blending of
the respective cultures would bring forth a new indigenous American
culture. The underpinnings of cultural pluralism or multiculturalism en-
courage the preservation of communal life and significant portions of the
culture of various ethnic groups within the context of American citizenship
(Gordon, 1964).

Mohandas K. Gandhi provides the most meaningful insights into the
concept of multiculturalism that I have read to date. He wrote: "I want the
winds of all cultures to blow freely about my house, but not be swept off my
feet by any" (Price, 1987, p. 6). Unfortunately, multiculturalism is probably
the most controversial and least practiced concept in the school system. It
was and continues to be controversial because the basic roots of America are
grounded in the soil of class, religious, and racial privileges. In considering
these roots, Lerone Bennett, Jr. (1975) wrote:

*A nation is a choice. It chooses itself at fateful forks in the road
by turning left or right, by giving up something or taking
something — and in giving up and taking, in the deciding and
not deciding, the nation becomes. And even afterwards, the
nation and the people who make up the nation are defined by the
fork and by the decision that was made there, as well as by the
decision that was not made there. For the decision, once made,
ingrains itself into institutions, nerves, muscles, tendons; and*

the first decision requires a second decision, and the second decision requires a third, and it goes on and on, spiralling in an inexorable process which distorts everything and alienates everybody. America became America that way. (pp. 61-62).

After making that historic turn at the fork in the road, America had to undergird its choice with a convincing philosophical base; America had to account for its decision to move from defacto to legislative slavery, from limited democracy to undeclared aristocracy. The justification for the historic turn was fashioned by many religious leaders, conscript fathers, social theorists, artists, and aestheticians. The religious leaders distorted the "holy scriptures"; the polygenesis and monogenesis schools of social science developed myths about the inferiority of people of color; the conscript fathers enacted restrictive laws based on race, class, and religion; the White artists visually distorted the image of the American Indian and Americans of African descent; and the aestheticians justified these distortions and deified[1] the image of the European American.[2]

Because of the high indices of illiteracy during the early periods of America, the visual artists were destined to become one of the prominent vehicles for America's deification rites. Through cartoons, drawings, engravings, paintings, advertisements, and later movies, the postures of approximately 250,000 White slaves were changed to "blue bloods" and they were deified; the thousands of children from the ghettos of England, Germany, Ireland, Scotland, and Switzerland who were kidnapped or enticed aboard ships with candy by the Spirits and the Newlanders for the voyage to the New World to serve as cheap labor were deified; the 1,000 young, poor Irish girls who were sent to Jamaica for breeding purposes were deified; the thousands of tobacco-purchased brides from Europe's underclass who set foot on these shores for the price of 120 pounds of tobacco were deified, and now their names and the names of their children and their children's children, appear in *Who's Who in Society;* and the tens of thousands of rogues, strumpets, orphans, convicts, and derelicts who were sentenced to Virginia's and Maryland's penal colonies, or duped with drink or tales of the promised land, were also deified.[3] This was done to justify the turn at the fork in the road of racial privilege.

While deifying the experience of White immigrants, who were, for the most part, involuntary travelers to the New World, some visual artists distorted the images of voluntary and involuntary travelers of African descent in the Americas and elsewhere. By creating a caricature to undergird the emerging practice of racial privilege, a climate was being prepared to relegate Black people to conscript servitude. As slaves, Black people would have to

give up their land, rights, and profits from their labors or professions. There was authority for these acts in Numbers, Chapter 33, Verse 52 of *The Holy Bible:* "Then ye shall drive out all the inhabitants of the land from before you, and destroy all their pictures, and destroy all their molten images, and quite pluck down all their high places." [4]

History is replete with examples of Black people being driven from their land, their "molten images" and pictures destroyed and "quite plucked down" from their high places: The Colonial Slave Codes of 1667, 1670, 1682, and 1699 became the legal basis for enslaving Blacks regardless of religion, and they were driven from the land. Through ignorance and White chicanery, nine million acres of land were lost by Blacks between 1910 and 1974 (Gribbs, 1974) — they were and still are being driven from the land, and "quite plucked down" from all their high places.

The expressed values that emerged from the deification rites established the parameters for societal goals, including education. The educational goals formed the basis on which the nation's children would be socialized. The distortion process was ingrained into institutions; the two prevailing theories of society and, ultimately, educational theory were preserved. If Anglo conformity were the preferred theory undergirding education, then, of course, Black people with no history were eliminated from consideration. Thus, to be successful, they had to subscribe to the preferred theory. If the melting pot thesis were the modus operandi, then the accompanying theories of cultural deprivation had to be considered in regard to Black people. Without a history of recognized cultural contributions, there was absolutely little for Black people to contribute to America's pot of cultural synthesis.

The theory and practices of studio art, art history, and certain sociological assumptions form the basis of art education. Because this chapter is concerned with multiculturalism, it is crucial that through art history and social thought a brief disquisition on certain notions related to Americans of African descent be presented.

Although Amy Goldin did not identify in specific terms the contributions of Africans, or the high regard in which Africans were held, she nonetheless concluded that art history is racist. She takes issue with the notion that world 'art is not the focus of introductory art history courses — and I would add, neither are the advanced level courses.This is a point of enormous importance because art history provides the historical and philosophical grounding for art students, including future art educators. In regard to her assertions, Goldin (1975) writes:

In fact, these are histories of Western European art. Usually purporting to be general and universal, these surveys are specialized and parochial, devoting little or no space to Islamic, African or pre-Columbian art. Historians account for this situation by granting the conservatism of their field — which is to say that their racism is implicit and habitual, not aggressive. Yet, the unavoidable suggestion of the literature is that artistic creativity must be measured against standards established by white Christians in Florence and Venice who based their work on the white marble sculpture of classical Greece. (p. 50)

If introductory art history courses are supposed to be a broad brush treatment of world art, Goldin's charge should be examined. The two most commonly used introductory texts in art history are Horst W. Janson's (1971) *History of Art* and Helen Gardner's (1959) *Art Through the Ages*. Both authors are victims of historical distortions. They tend to suggest that Egypt is not a part of Black Africa.

Janson and Gardner infer that the European powers and mapmakers were correct when they "decided that Africa ended on the western side of the Red Sea and on the west bank of the Suez Canel, in spite of the similarity of the geology of Northeastern Africa and Arabia on either side of the Red Sea, in spite of the similarity of language and culture, and the artificiality of a continental boundary based on a man-made canal" (Mazrui, 1986, p. 30).

This boundary is known as the Suez Canal. Conceptually, the canal came into being in 1869 to facilitate trading by Europe with other countries. For the Egyptians, the start of the Suez Peninsula intrusion of 1859 was welcomed; Egyptians as we know them today were oriented toward Europe in many aspects (Mazrui, 1986).

However, Egyptologists and historians, such as John Henry Breasted, Cheikh Anta Diop, Yosef ben-Jochannan, Frank Snowden, Jr., J. A. Rogers, Chancellor Williams, John Henrik Clarke, and Herodotus have argued that the Egyptians were Black Africans — Nubians — and they contributed greatly in civilizing the Mediterranean world. Many of these scholars present visual documentation of monuments, statues, painting, inscriptions, vases, and bas-reliefs to substantiate their claim that the Egyptians were Black Africans and that they had woolly hair, broad noses, thick lips, and black skin.

The most impressive visual documentation can be found in Snowden's

(1970) *Blacks in Antiquity*. He presents 120 illustrations to support his thesis that Egyptians were Black and that Black Africans were influential in civilizing the Mediterranean world. Chancellor Williams (1974) makes it clear in his book *The Destruction of Black Civilizations*, that Black Africans were at times referred to as Nubians, Ethiopians, Egyptians, or Colchians by Greek scholars who held Black Africa in high regard. Williams writes: "Ancient Greek scholars, through Herodotus, referred to the completion of their education in Ethiopia with pride and, it appears, as a matter of course" (p. 98). Commenting on the physical description of these educators, Herodotus wrote: "The Colchians, Ethiopians, and Egyptians have thick lips, broad noses, woolly hair and they are burnt of skin" (ben-Jochannan, 1972).

The prints in J. A. Rogers' (1963) *Sex and Race* leave little doubt that the ancient Egyptian pharaohs and queens were Black or products of intermarriages; nonetheless, they had kinky hair, broad noses, thick lips, and black skin, or the skin tone of the *mulattoe* (Rogers, 1963). The prints in Diop's (1974) *The African Origin of Civilization* support Herodotus's claim that Egyptians had dark skin, broad noses, and kinky hair.

In Janson's and Gardner's presentation on Egyptian art, there is no reference to the fact that Egyptians had thick lips, broad noses, kinky hair, and black skin. Nor is there an explanation of why the facial features of many of the monuments, statues, and bas-reliefs were disfigured. Janson and Gardner are not necessarily at fault for these oversights. They are products of their education. Their education prepared them to place importance on some things, not to question other things, and to simply ignore some things.

At another level, it could be argued that Janson, Gardner, and the other legions of misinformed art historians are nothing more than the scholarly carriers of their miseducation in regard to Black Africa and its descendants in the diaspora. This can be referred to as the dis-Africanization of history and culture. Dis-Africanization is the antithesis of multiculturalism.

In retrospect, dis-Africanization has resulted in many Black people being scattered throughout the world with little understanding of their history, culture, or value system. This intentional disorientation forms the bedrock of social theories, such as cultural deprivation, culturally disadvantaged, and the theory that Blacks lack self-concept. Dis-Africanization has resulted in Black boys and girls growing into man- and womanhood with the belief that their history represents the ghettos, slums, and cesspools of human-kind on earth.

On the other hand, it is known that Imhotep was the personal architect of the

Pharaoh Djoser (Zoser) of the Third Dynasty. Imhotep was also a respected builder, magician, philosopher, astronomer, and physician. He was referred to as the "Father of Medicine." The Greeks worshiped Imhotep, and roughly 2,500 years after his death changed his name to Asklepios (Roger, 1972). This could be referred to as Step 2 in the dis-Africanization of history. Step 1 was the claim that Herodotus was the "Father of History." Step 3 was the claim that Greeks were the "Fathers of Philosophy."

The pyramids were designed and built before the first Caucasians made an imprint on world history. Imhotep designed and supervised the building of the "Grand Step Pyramid of Sakhara," the tomb for the Pharaoh Djoser. The highest and largest pyramid was the tomb for the Pharaoh Knufu (Cheops). The Pharaoh Khafre not only had the third pyramid built, but also the Great Sphinx of Ghizeh (Giza). His facial features were used for the face of this monument (Simmonds, 1971). This meant the hair was woolly, the nose broad, the lips thick.

On separate occasions, when the Asians, Arabs, and Europeans conquered Egypt, they destroyed many monuments and married the facial features of others (witness the reproductions in Western-produced books on Egyptian art). The Sphinx of Ghizeh was so well constructed that it withstood the assaults of invaders over the years; however, in 1798, General Napoleon Bonaparte's cannons blew the nose asunder. Through drawings of Baron Viviat Denon, who accompanied Bonaparte in his attempt to colonize Northeast Africa, the facial characteristics were preserved. The drawings denote a broad nose, thick lips, and traces of woolly hair (ben-Jochannan, 1972).

The writings of Count Constantin de Volney clearly untangled the dis-Africanization process through the destruction and defacement of monuments. His visits to Africa between 1785 and 1793 (prior to Bonaparte's action on the Sphinx) led him to write:

> *All have a bloated face, puffed up eyes, flat noses, thick lips; in a word, the true face of the mulatto. I was tempted to attribute it to the climate, but when I visited the Sphinx, its appearance gave me the key to the riddle. On seeing the remarkable passage where Herodotus says: "As for me, I judge the Colchians to be a colony of the Egyptians because, like them, they are black with woolly hair..." In other words, the ancient Egyptians were true Negroes of the same stock as all native born Africans. That being so, we can see how their blood, mixed for centuries with that of the Romans and Greeks, must have lost the intensity of its*

original mold. We can even state as a general principle that the face is a kind of monument able, in many cases, to attest to or shed light on historical evidence on the origins of peoples. (Diop, 1974)

Once again, there is not a modicum of evidence presented in either Janson or Gardner that the Egyptians were Black Africans and that the monuments were defaced or destroyed as a part of the dis-Africanization process of Northeast Africa. To know that the history and culture of Black people can be traced to the kingdoms and nation-states of Africa would have a tremendous impact on the self-concept and racial and cultural identity of Black children. It is important that they know their history did not start with slavery but predates the Anglo-Saxon's fragile imprints on history.

Although Herodotus has been referred to by Western writers as the "Father of History," he attributes his education to Black Africans. The real question is, "How can someone father a subject area that has already been fathered?" Likewise, the Greeks openly worshiped Imhotep as the "Father of Medicine," but they changed his name to Asklepios and claimed the title for Greece.

Similarly, the "Father of Philosophy" can also now be challenged. For those of us who have managed to survive the year-long introductory art history course, Raphael's *The School of Athens* is etched deeply into our conscious and subconscious minds. The painting affirms that the Greeks were the "Fathers of Philosophy." The painting is not concerned with historical accuracy; its concern is to create a sense of purpose, a sense of destiny, and a sense of status for Greece.

Prior to 332 B. C. Aristotle had been credited with writing absolutely nothing. All that history records is that Plato studied in Egypt and departed at the age of 28 and that Aristotle studied in Egypt in 332 B. C. (ben-Jochannan, 1972).

In George G. M. James's (1976) work, *Stolen Legacy*, he writes:

In the drama of Greek Philosophy there are three actors, who have played distinct parts, namely Alexander the Great, who by an act of aggression invaded Egypt in 333 B. C., and ransacked and looted the Royal Library at Alexandria and together with his companion carried off a booty of scientific, philosophic and religious books. Egypt was then stolen and annexed as a portion

of Alexander's empire; but the invasion plan included far more than territorial expansion; for it prepared the way and made it possible for the capture of the culture of the African Continent. This brings us to the second actor, that is, the School of Aristotle whose students moved from Athens to Egypt and converted the Royal Library, first into a research center, and secondly into a University and thirdly compiled that vast body of scientific knowledge which they had gained from research, together with the oral instructions which Greek students had received from the Egyptian priests, into what they have called the history of Greek Philosophy. (pp. 153-154)

Visually, Raphael, in his painting, *The School of Athens,* depicted the third stage of the drama described by James. The painting is a form of visual communication, and it is relatively easy for the mind's eye to decode the visual message: Philosophy, like everything else worthy of documentation, was created by the people of Europe.

James explains these acts within the context of dis-Africanization. He writes:

The Greeks stole the Legacy of the African Continent and called it their own. And as has already been pointed out, the result of this dishonesty has been the creation of an erroneous world opinion; that the African Continent has made no contribution to civilization, because her people are backward and low in intelligence and culture. This erroneous opinion about the Black people has seriously injured them through the centuries up to modern times in which it appears to have reached a climax in the history of human relations. (pp. 154-155)

It could be argued that my implied assertion that Janson's and Gardner's histories of art are ethnocentric is not fair, that information such as that which has been presented was not readily available, and that art is universal and apolitical. Too often these responses are used to neutralize a serious verbal or written disquisition on the veracity of the documentation contained in such works as Janson and Gardner.

The documentation is available; however, there is great resistance to incorporating the documentation in art history, fine arts studios, and art education. Such documentation, if accepted and placed within the curricu-

lum, would be akin to indicting the educational system for miseducating generations and generations of students of all races. Goldin (1975) brings the miseducation of students into sharper focus in her study on the elitism, sexism, and racism that permeates the field of art history. She writes:

Art history was always and even perniciously political. How could we have supposed otherwise? After all, what better conditions can be found for brain washing than the darkened room, the glowing screen and an authoritative voice telling you what it is you are seeing? Unless it is specifically repudiated, the implicit message of most art history is that what you are shown has been carefully selected for you by the best taste of the ages, that great art looks like this, and you need to concern yourself with nothing more. (p. 49)

After extensive research in repositories that are readily available to scholars and students of the visual arts, *The Image of The Black in Western Art* was produced by Jean Vercoutter, Jean Leclant, Frank Snowden, Jr., and Jehan Desangers (1976). The topics of this three-volume work range from (a) the Pharaohs to the Fall of the Roman Empire, (b) the Early Christian Era to the Age of Discovery, and (c) 16th-century Europe to 19th-century America. The 385 illustrations in Volume 1 establish the incontestable fact that Egyptians were Black and that they had kinky hair, broad noses, and thick lips.

The illustrations also establish that the Greeks and Romans revered Black Africans. In addition, the illustrations show that the Egyptians' complexion, straight hair, and facial features of today are the result of centuries of intimate interracial contact among Black Africans, Asians, and Europeans. This is a point of enormous importance; too often, the retort to evidence that Egypt is a part of Africa, and that the monuments, bas-reliefs, and statues represented Black Africans, is that Egyptians have tanned-olive complexions and straight hair. Thus, the claim that the great civilizations of Northeast Africa were Black is too often successfully refuted by using contemporary Egyptians' features as the "smoking gun." For the scholarly guardians and unknowing practitioners of the European myths, superstitions, cultural bias, historical face saving, and exaggerated accounts of miraculous accomplishments, the evidence places them on unsound footing relative to the accomplishments of Africans.

For example, the Romans worshiped Imhotep as one with Christ. The early Christians acknowledge their indebtedness to the Egyptians, and that

Christian doctrine was interlaced with the religious writings and practices of North Africa, which caused historian Massey to write:

The child-Christ remained a starrily-bejeweled blackamoor as the typical healer in Rome. Jesus, the divine healer, does not retain the black complexion of Iu-em-hotep (Imhotep) in the canonical gospels but he does in the Church of Rome when represented as a little black bambino. A jewelled image of the child-Christ as a blackamoor is sacredly preserved at the head-quarters of the Franciscan order, and true to its typical charac-ter as a symbolical likeness of Lusa, the healer, the little black figure is taken out in state with its regalia on to visit the sick and demonstrate the supposed healing power of this Egyptian Escu-lapius, thus Christianized. The virgin mother, who was also black survived in Italy as in Egypt. At Oropa, near Bietta, the Madonna and child-Christ are not white but Black, as they so often were in Italy of old and as the child is yet conditioned in the little black Jesus of the Eternal City. (Rogers, 1972, pp. 40-41)

On high holy days, a Black madonna and child are displayed and worshiped in parts of Belgium, Italy, Poland, Switzerland, Spain, Mexico, Cuba, Brazil, the Philippines, and, not too frequently, in the United States. The Black madonna and child can be traced to Isis and her child Horus — the Egyptian and Nubian fertility symbol.

Considering the emotionalism attached to religion, and the fact that people have a tendency to create their gods in their own image, why have the statues and paintings of the Black Virgin Mary and child with African features been accepted on an international level? The overwhelming evidence, according to Yosef ben-Jochannan, is that the early Christian Church had its begin-nings in Egypt. Commenting on this, ben-Jochannan (1972) wrote: "More than 100 years before it [Christianity] reached Europe [Rome and Greece] in its organized institutional form, [the Christian Church] presented arti-facts, drawings, statues, documents and other artifacts which depicted the Madonna and Christ Child as a Black Woman and her Black child...and there was too much evidence to alter this particular event" (p. 375).

In Janson's and Gardner's treatment of religious art, there is no mention of or reproduction of a Black madonna and child in either of their introductory books. Neither considers the subject of religious art before the Middle Ages. Thus, one could conclude that Christianity had its beginnings in Europe. Through visual forms, Janson and Gardner have established Europe as the

seat of medicine, history, philosophy, and Christianity.

My point is not to discredit Janson or Gardner but to address much larger issues. These issues relate to the conscious attempts to dis-Africanize Black Africa and Africans in the diaspora. These issues have educational implications and are much broader than the past discussions on cultural pluralism and multiculturalism.

Cultural pluralism, or multiculturalism, is not the addition of an event associated with Black people here and the name of a Black individual there. These theories suggest an approach that requires a thorough examination of the total curriculum; they suggest that there are no sacred cows or turf in the curriculum; they suggest that information not considered in the past will indeed be considered; and they suggest that no matter how cherished a notion of the past, it must withstand a rigorous reexamination.

For example, each year Americans celebrate Columbus Day. It is alleged that Columbus discovered America in 1492. Despite evidence to the contrary, Americans continue to celebrate this mythical holiday.

History tells us that Africans came to the Americas before Columbus. On Columbus's second visit to the New World, the Indians of Espanola (Haiti and Dominican Republic) presented Columbus and the Spaniards with tangible evidence of their trading with Africans.The Indians presented the topping on the African spears. Columbus had the metal assayed in Spain, and it was 18 parts gold, six parts silver, and eight parts copper (Van Sertima, 1976).

The Atlantic drift routes from Africa to America are sometimes referred to as the "Black stream". Of the worldwide currents, it is the south equatorial currents off the coast of Africa that lead to the northern coast lines of South America, Cuba, the Caribbean Islands, Florida, and the Gulf of Mexico (Van Sertima, 1976). There were many who questioned whether Africans had the capacity to construct a boat that would survive the Atlantic crossing.

Heyerdahl wanted to test the "Black stream" theory. In 1969, he assembled African boatsmen to build a papyrus boat (the Ra I) similar to the one used by their forefathers to cross the Atlantic.The Heyerdahl expedition sailed to the offshore of Barbados on one of the drift routes used by ancient Africans. The Aymara (American Indians) built Ra II, corrected an error of Heyerdahl, and sailed successfully from Africa to the Americas. The drift currents, writes Van Sertima, are like "marine conveyor belts. Once you enter them you are transported (even against your will, even with no navigational skill) from one bank of the ocean to the other" (Van Sertima,

1976, p. 22).

On Columbus's third voyage, he landed on the coast of South America. The Indians presented him with handkerchiefs of cotton, headdresses, and loincloths that were of the design and type known to Guinea (Van Sertima, 1976).

Additional evidence came in the 16th century, when a Dominican priest, Gregoria Garcia, served a 9-year stint in Peru. He reported the presence of Africans on an island off Cartagena, Colombia. His book documenting this presence was banned during the Spanish Inquisition (Van Sertima, 1976).

Anthropologist Alponse de Quatrefages noted that "black populations have been found in America in very small numbers and as isolated tribes in the midst of very different nations." Such are the Charras of Brazil, the Black Caribees of Saint Vincent in the Gulf of Mexico, the Jamassi of Florida" (Van Sertima, 1976, p. 23).

In his book, *History of the Conquest of Mexico,* Orozco y Berra (cited in Van Sertima, 1976) stated that there was a close relationship between Africans and Mexicans in the pre-Columbian period. The huge stone heads of Africans discovered among the Olmec and in Mexico and Central America date scientifically from 800 to 700 B. C. The visual evidence is undeniable in that the archaeological finds and huge Olmec heads document the Africans' presence in Mexico, the Caribbean, and even in Europe.

In La Venta, the sacred center of Olmec culture, there are four colossal basalt heads. These heads stand between six and nine feet high and weigh up to 40 tons. There are five heads in San Lorenzo and two at Tres Zapotes in Veracruz (Van Sertima, 1976).

Through Jose Orozco's murals at Dartmouth College, we have become familiar with Quetzalcoatl — the messenger of the Sun king. According to Orozco, the Mexicans mistakenly thought the arrival of Cortez in 1519 was the return of Quetzalcoatl. Few American scholars are acquainted with the paintings in the valley of Mexico that depict Quetzalcoatl with black skin. Fewer scholars acknowledge the arrival of Abubakari II in Mexico in 1311, 208 years before Cortez. It had been six cycles (52 years per cycle) since Quetzalcoatl's disappearance. On his arrival, Abubakari II, the ruler of Mali, was accepted by the Mexicans as Quetzalcoatl (Van Sertima, 1976).

There are other examples of the Black presence: The Aztec god Tezcatlipoca is Black; Naualpilli, the Mayan god of traveling merchants and the Mexican god of jewelers, is Black (Van Sertima, 1976); Mariana Grajales

and Antonio Maceo are major political figures in Cuba dating back to the 19th century, and each is depicted as Black; and the Virgin de la Caridad del Cobre of the 16th century is also depicted as Black.

On September 25, 1513, when Balboa was on the Isthmus de Quarequa, the Indians informed him that gold was brought from the south by Black men. Close to Quarequa, Balboa came upon an Indian settlement. The Indians produced African captives of war. The Africans, it was explained, were from another settlement that waged war on their settlement (Van Sertima, 1976).

To some, the use of the color black or of the facial features of Africans can be said to be symbolic. The African presence can be dismissed as an anomaly. Thus, questions of Africans' presence have been dismissed and not considered in the settling of the Americas. Others —although few — will recognize that nowhere in the documented history of humans have a people erected monuments or shrines to glorify a people of another tribe or race that is inferior. The Olmecs, Aztecs, and Mayans are no exceptions. The presence of the African is indelible and can be observed in tangible forms throughout the world.

In the larger schema of history, Africans, like the Indians in America, have been depicted as natives; that is, they have been depicted as marginal humans lacking formal societal organization. Thus, their history, as natives, is irrelevant. Toynbee (1934) explains the native phenomenon:

> When we Westerners call people "Natives," we implicitly take the cultural colour out of our perceptions of them. We see them as trees walking, or as wild animals infesting the country in which we happen to come across them. In fact, we see them as part of the local flora and fauna, and not as men of like passions with ourselves, and seeing them thus as something infrahuman, we feel entitled to treat them as though they did not possess ordinary human rights. They are merely natives of the lands which they occupy; and no term of occupancy can be long enough to confer any prescriptive rights. Their tenure is as provisional and precarious as that of the forest trees which the Western pioneer fells or that of the big game which he shoots down. And how shall the "civilized" Lords of Creation treat the human game, when in their own good time they came to take possession of the land which by right of eminent domain, is indefensibly their own? Shall they treat these "Natives" as vermin to be exterminated, or as domesticable animals to be

*turned into hewers of wood and drawers of water? No other
alternative need be considered, if "niggers have no souls." All
this is implicit in the word "natives" as we have come to use it in
the English language in our time.* (pp. 152-153)

The Africans as "natives" were, in fact, empire builders, the best seamen
known to the world, and artists and artisans of the highest order. They
established settlements throughout the Mediterranean, conquered Spain,
and left an imprint observable even today.

It was Napoleon who observed "that the boundaries of Africa began at the
Pyrenees" and that "the oldest skulls discovered in the peninsula were
Negroid" (Scobie, 1975, p. 3). According to Edward Scobie (1975), "The
first colonizers of ancient Spain were the Carthaginians, descendants of the
Phoenicians, a Negroid people, who were great merchants" (p. 5). Barce-
lona, one of Spain's oldest cities and a center of culture, was founded by
Hamilcar Barca, the father of "Hannibal the African" who was born in
Carthage in 247 B. C. During the Romans' period of colonization of Spain,
Africans continued to arrive in large numbers. The Moors conquered Spain
in 711 A. D. and were expelled in 1492. The Moors, before expulsion, had
conquered the entire Iberian peninsula. "And it was the Moors who left their
indelible mark on Spanish and Portuguese physiognomy, art, language and
music." The architectural influence of the Moors remains, although misiden-
tified as Islamic by some "scholars."

The Moors, in 846 A. D., held the City of Rome; in 878 A. D., they captured
Sicily from the Normans; and in approximately 898 A. D., they defeated
Otto II of Germany and controlled Southern Italy. From these conquests, the
Moors' bloodline entered that of the royal families as well as the common
people. Allessandro De Medici was referred to as "The Moor." The
paintings of Bronzini and Vasari depict the first Duke of Florence's African
features (Scobie, 1975).

The Moorish or African presence can be observed especially in the seaport
towns of Belgium, the Netherlands, Holland, France, Britain, and Russia.
Although not often discussed and at times locked in the sacred archives, the
Africans' cultural imprints still remain in Europe.

The Africans' cultural imprints also remain in America. The capital city of
slavery in America was Charleston, South Carolina. Charleston's Sullivan
Island was America's major slave port. It could be referred to "as the Ellis
Island for Black Americans" (Rosen, 1982, p. 65). Although slavery is a
sensitive issue, it would be a gross oversight in curriculum development if

it were not noted that slavery was practiced in Africa; that Africans traded Black prisoners of war to White slave traders; and that later, as the demand for slaves increased, Europeans entered Africa's interior (accompanied and unaccompanied by Black guides) to meet this demand.

In addition, former African rulers and their families, along with Africans of various societal status, were sold or traded into slavery. The slave trade also included artisans of the highest quality — shipbuilders, brickmakers, builders of temples, lithographers, potters, woodcarvers, and gold, silver, copper, and ironsmiths.

African blacksmiths shaped the heavy bars of iron into gracious balconies, grilles, gates, and lunettes. They shaped the often revered and photographed ironworks from Baltimore, Richmond, Charleston, Savannah, and New Orleans. Initially, these artisans were not under the supervision of White craftsmen. The flaw in this notion is that White craftsmen were few in number and, qualitatively, their work was inferior to that of the Black artisans.

White artisans lobbied local and state officials to curb the Black monopoly in the skilled trades and crafts. To curb the Black apprenticeship system, in 1806 a Charleston ordinance forbade the teaching of craft trades to slaves; Savannah, Richmond, and New Orleans also imposed restrictions. Thus, the sons of Africa's longstanding "Iron Age" apprenticeship system would be scaled down or phased out; the sons of the brickmakers and builders who constructed the Temple of Queen-Pharaoh Hatshepsut at Deir el Bahari in 1503 B. C. would be limited in the practice of the ancient crafts of their forefathers in America; and the sons of the Nok and Soa cultures who apprenticed in terra cotta, copper, bronze, and iron were restricted or limited in the practicing of their skills in America (Myers, 1969).

Thus, racial motivations controlled the production of high-quality works by Black artisans for the multicopied fast-food approach to craftsmanship by some Europeans. The Germans introduced the latest mechanical labor-saving devices to America. Their foundries produced multicopied decorative items, such as jolly fat Teutonic angels and putties.

The information presented here, although sketchy, can be used as a basis to form serious and regularly scheduled teacher work sessions in school districts. The goal of these sessions would to be develop strategies to ensure that "the winds of all cultures blow freely" in art education. Additionally, strategies for curriculum development that transcend the isolation of multiculturalism in art education should be developed; this concept should become operative on a much broader level. Here, I would argue that

131

multiculturalism, if sound, can result in a model interdisciplinary approach to education. Because art courses are optional (elective course offerings), there should be an integrative multicultural effort that encompasses the total curriculum.

It is my view that the curriculum plays an enormous role in the identity formation of students. The curriculum, although presented as value free, is powerful. Also, as a powerful shaper of self-identity, it tells us where we have been and where we are, and it quietly directs our choices for the future. Despite the past, educators must accept a new challenge. This challenge, to paraphrase Gandhi, is to develop a curriculum that permits the true winds, not myths, of all cultures to blow freely about all schools without sweeping any students off their feet.

References

Bauba, K. L. (1929). *Uncle Sham.* New York: Kendall.
ben-Jochannan, Y. (1972). *Black man of the Nile.* New York: Alkebu-lan Books.
ben-Jochannan, Y. (1973). *African origins of the major western religions.* New York: Alkebu-lan Books.
ben-Jochannan, Y. (1974). *The Black man's religion and extracts and comments from the Holy Bible.* New York: Alkebu-lan Books.
Bennett, L., Jr. (1972). *The challenge of Blackness.* Chicago: Johnson Publishing Company.
Bennett, L., Jr. (1975). *The shaping of Black America.* Chicago: Johnson Publishing Company.
Breasted, J. H. (1916). *Ancient times: A history of the early world.* New York: Ginn and Co.
Breasted, J. H. (1954). *The conquest of civilization.* New York: Harper & Row.
Clarke, J. H. (1974). *Black-White alliances: A historical perspective.* Chicago: Institute of Positive Education.
Debera, D. (1971). Is Geronomo alive and well in the South Vietnamese Central Highlands? *Mankind, 3*(2), 31.
Diop, C. A. (1956, June-November). The cultural contributions and prospects of Africans. *Presence Africaine,* pp. 348-389.
Diop, C. A. (1974). *The African origin of civilization: Myth or reality?* New York: Hill.
Gardner, H. (1959). *Art through the ages.* New York: Harcourt, Brace and Company, Inc.
Goldin, A. (1975). American art history has been called elitist, racist, and sexist, the charges stick. *Artnews,* LXXIV (4), 50.
Gordon, M. (1964). *Assimilation in American life.* New York: Oxford University Press.
Gribbs, A. (1974, October). How Blacks lost 9,000,000 acres of land. *Ebony,* pp. 96-104.
James, G. G. M. (1976). *Stolen legacy.* San Francisco: Julian Richardson Associates, pp. 153-154.
Janson, H. (1971). *History of art.* New York: Prentice-Hall.
Jordan, W. D. (1968). *White over Black.* Chapel Hill: The University of North Carolina Press.
Kent, G. (1972). *Blackness and the adventure of western culture.* Chicago: Third World Press.
Mazrui, A. (1986). *The Africans: A triple heritage.* Boston: Little, Brown.
Myers, R. (1969). *Black craftsmen through history.* Brooklyn: The Institute of The Joint Apprentice-ship Program.
Parry, E. (1974). *The image of the Indian and the black man in African art, 1590-1900.* New York: Braziller.
Price, C. A. (1987). Cultural pluralism: An historical perspective. In *The Afro-American artist in the*

age of cultural pluralism. Montclair, NJ: Montclair Art Museum.

Rawlinson, G. (Trans.). (1982). *Herodotus, History, Book II.* New York: Tudor.

Rogers, J. A. (1963). *Sex and race.* New York: Rogers.

Rogers, J. A. (1972). *World's great men of color* (Vol. 1). New York: Collier-Macmillan.

Rosen, R. (1982). *A short history of Charleston.* San Francisco: Lexikos.

Scobie, E. (1975, April-May). Presence of Blacks in Western Europe and its impact on culture. *National Scene,* p. 3.

Simmonds, G. E. (1971). Things done by Africa before Europe. In Y. ben-Jochannan & G. E. Simmonds (Eds.), *The Black man's North and East Africa.* New York: Alkebs-lan Foundation, Inc.

Snowden, F., Jr. (1970). *Blacks in antiquity.* Cambridge, MA: Harvard University Press.

Toynbee, A. (1934). *A study in history* (Vol. 1). London: Oxford University Press.

Tucker, F. H. (1968). *The White conscience: An analysis of the White man's mind and conduct.* New York: Unger.

Van Sertima, I. (1976). *The African presence in ancient America: They came before Columbus.* New York: Random House.

Vercoutter, J., Leclant, J., Snowden, F., Jr., & Desanges, J. (1976). *The image of the Black in western art.* New York: Morrow.

Williams, C. (1974). *Destruction of Black civilizations.* Chicago: Third World Press.

Zernich, T. (1987). *Educational reform reports of the 1980's and their potential impact on art instruction.* Paper presented at the meeting of the National Association of Schools of Art and Design, Cincinnati.

Notes

[1]Deify, for the purpose of this article, means to idealize, to adore, and to look upon as a goddess. My reasoning for using "deify" in this context was shaped by the literature on the status of White women in colonial society: As early as 1619 many of the White women recruited or kidnapped for the voyage to the New World were strumpets, criminals, and from the lower classes of European society. In the New World, many of these women worked the fields with Black slaves. They were subject to the improper advances of their masters and were used for breeding purposes. When the colonists decided to restructure society on racial rather than social class, there was an attempt to rewrite the history of the relationship between White men and White women by deleting their experiences as field workers, prostitutes, and breeders from the history books. For a discussion on this topic see Bennett (1975) and Jordan (1968).

[2]For a more thorough discussion of the distortions mentioned, see Tucker (1968), Bauba (1929), Kent (1972), and Parry (1974).

[3]Spirits and Newlanders were paid so much for each person delivered to a given location for the voyage to the New World as servants. Their methods of delivering prospective servants varied from verbal to written contracts to kidnapping (see Bennett, 1975).

[4]For a thorough discussion on this subject, see Breasted (1916, 1954), Diop (1974), ben-Jochannan (1972, 1973, 1974), Snowden (1970), Rogers (1963), Williams (1974), Clarke (1974), and Rawlinson (1928).

10

Linking the Legacy: Approaches to the Teaching of African and American Art

PAULETTE SPRUILL-FLEMING

California State University, Fresno

The purpose of this chapter is to (a) identify some of the current problems in teaching African art and in introducing African-derived imagery; (b) examine the concept of transnational linkage as an important factor in the cultural development of African Americans; (c) explore some common curricular concerns that are relevant for both global multicultural education and art education; and (d) suggest some useful teaching strategies.

As Metcalfe (1983, p. 271) has noted, "Art represents and sanctifies what is valued in a society; the ability to create and appreciate art implies heightened human sensibility and confers social status and prestige." If African-derived imagery is not viewed within a context that reflects its contribution to humanity, America, and the Black experience, then a valuable link in the chain of culture is missing. The challenge of revealing the rich heritage of diversity that is so basic to America as a pluralistic society may go largely unmet without meaningful consideration of how various individuals and groups perceive and respond to art; the role of artists, critics, and historians in shaping the artistic heritage; and the role of art in society.

Africa: A Historical Perspective

In order to link the African legacy, the vestiges of institutional racism must be faced squarely. Historically, in the Western view, Africa has been characterized as the "Dark Continent." For years, European historians dismissed African societies as culturally insignificant, uncivilized, and lacking in terms of their contribution to the world, pointing out that they had few written records. Africa was not credited as a source of Western philosophy, religion, science, and mathematics. Nor has the importance of Africa

135

to world economy been widely examined.

Only recently have art historians begun to make statements such as "Our understanding of the history of African art and culture is in its infancy" (Townsend, Ross, & Ruttenberg, 1985, p. 1).

One of the most glaring errors in approaching the study of African art and culture is reflected in the lack of recognition that Africa is a vast continent of many individually different countries, climates, and terrains. It is not a single geographic entity — "the jungle" or tropical rain forest depicted in most films. Many art educators and art historians hold generalized, often stereotypical ideas about Africa and African art, usually limited to spirit masks and statues. As a result, the full range of African aesthetic values has not been revealed. African arts range from emotionalist masks used in connection with religious traditions to the highly naturalistic terra-cotta portraits from Nok.

An inadequate understanding of geography also plays an important role in another very serious historical error. Countless art historians and many uninformed art educators insist on denying what is perfectly obvious by looking at a map of the African continent. Egypt is an African country, and for the larger part of its historical development it was distinctly non-Mediterranean in culture. Egypt, and the high culture and civilization that it represents, is as African in origin as the sources of the Nile in Upper Egypt — south central Africa.

However, the attribution of the art and civilization of Egypt as anything except African follows a long tradition in European art history texts. Many Black scholars have suggested that misattributions about African origin of Egyptian civilization do not represent mere oversight, but rather deliberate attempts at the modern falsification of history (Diop, 1974; James, 1976; ben-Jochannan, 1973; Seifert, 1938; Williams, 1974). Citing Diodorus of Sicily and Herodutus, among other historical sources confirming the Black character of Egypt, Diop (1974) notes, "Contrary to generally accepted notions, it is clear that the ancient documents available on Egyptian and world history portray Blacks as free citizens, masters of the country and of nature" (p. 84). Diop states unequivocally:

That Black world is the very initiator of the "western" civiliza-
tion flaunted before our eyes today. Pythagorean mathematics,
the theory of the four elements of Thales of Miletus, Epicurean
materialism, Platonic idealism, Judaism, Islam, and modern
science are rooted in Egyptian cosmogony and science. One

136

needs only to meditate on Osiris, the redeemer-god, who sacri-
fices himself, dies, and is resurrected to save mankind, a figure
essentially identifiable with Christ. (p. xiv)

Diop (1974) asserts that "the history of Black Africa will remain suspended
in air and cannot be written correctly until African-Americans dare to
connect it with the history of Egypt" (p. xiv). Meta Vaux Warrick Fuller's
1914 sculpture, *Ethiopia Awakening,* is the earliest existing work of
African-American visual art that expresses this continuity of the African
legacy both through Ethiopia and Egypt, and the need for the rebirth of these
ideals. Her bronze sculpture reveals a beautiful Black woman wearing the
headdress of an Egyptian queen, whose head is turning slightly as the
wrapping of a mummy is loosening around her (Driskell, 1987). Remarka-
bly, the figure is African in both form and content. The proportions of the
standing figure are distinctive of many African statuettes, wherein the head
is about one quarter the height of the body, with torso, thighs, and legs in
subtly descending order.

Seifert (1938), writing on the relationship between art and religion, asserts
that if modern man could be reminded often enough that those essential
gifts, especially those that elevated him, are gifts of Black folk, this might
act as a check-rein against bigotry, arrogance, and race prejudice.

This was the belief of the artists and intellectuals of the Harlem Renaissance
period, who actively embraced African subject matter, themes, and design
motifs (Metcalfe, 1983). In the renaissance of Black aesthetic values that
occurred in the 1960s, Egypt once again assumed a dominant role in the
works of contemporary artists such as Al Smith.

Occasionally, because of such widespread misinformation about Egypt,
even well-intentioned efforts go astray. For example, Schuman (1981), in
a recent book aimed at helping to inject multicultural perspectives in art,
fails to identify Egypt with Africa. Instead, she discusses the Ancient
Egyptian artistic tradition in a chapter titled "The Arts of the Middle East."
Although it is true that approximately 70% of contemporary Egyptian
people are Muslim, and heavily influenced by the Islamic culture of the
Middle East, even the untutored eye can look upon the monuments, statues,
murals, and other art forms of Ancient Egypt and see that the physical
features of the people depicted are Black. They are as black in appearance
as the naturalistic court art from Nok, Ife, Benin, and Djanne.

To a large extent, many African-Americans have internalized negative
perceptions of African imagery. Many have believed the propaganda cam-

paigns that have extended the familiar "divide and conquer" tactic — separating Egypt from Africa, African "primitive tribal art" from African high-court art, and Black folk art from Black fine art. Even Black clergy were enlisted in the campaign to root out Africanisms from that strongest of unifying institutions, the Black Church, which was transforming Black Christianity into a unique spiritual expression at the beginning of the 19th century (Stuckey, 1987). African-Americans were being asked to turn their backs on the African past, and, even late in the second half of the 20th century, some Black people still believe the rhetoric that African-Americans are better off having been sold out of "barbarism" and "savagery" in Africa. Still others are rather resentful and unforgiving of their African brothers and sisters for permitting them to be sold into slavery in the first place.

Also, many African-Americans would rather not be bothered about the whole issue of identity, as they try to cope with this dual dilemma. Complex relationships may exist between ethnic minority identification and the degree of identification with the majority culture (Hutnik, 1986). Cortes (1979) notes that a person belongs simultaneously to various sex, age, economic, social, regional, national, cultural, and ethnic groups at any given time. For Cortes, one strength of global education is that it seeks to help students develop an awareness of this complexity of "belongings" (p. 86). Zora Neale Hurston (1979) expresses this sentiment in her essay, "How It Feels To Be Colored Me":

I am not tragically colored. There is no great sorrow dammed up in my soul, nor lurking behind my eyes... At certain times I have no race nor time...I am merely a fragment of the Great Soul that surges within the boundaries. (p. 153)

Transnational Linkage Within the Context of Global Multicultural Education

Until the success of Alex Haley's *Roots,* the question of the ethnic heritage was seldom raised outside a small circle of cultural reformers, political activists, and advocates of muliticultural education. The United States is a country full of hyphenated Americans. Not only are there African-Americans, but also Jewish-Americans, Italian-Americans, Chinese-Americans, Irish-Americans, Hispanic-Americans — the list goes on.[1] The difference in emphasis between the definition of "immigrant" and "emigrant" points out one of the historical challenges to American cultural diversity. Morris (1973), in his usage note to "migrate," states that "immigrate...refers to the

destination, emphasiz[ing] movement from there, and is followed by to"; on the other hand, "emigrate...has specific reference to the place of departure, emphasiz[ing] movement from that place, and is usually followed by from" (p. 831). Many immigrants came to America to seek a better life, often holding onto the idea of returning to their native land one day when conditions were better.

Transnational linkage is a term used by Cortes (1979) to describe the relationship between ethnic and cultural groups to their global antecedents. The level of transnational linkage varies with the affinity and identification with the heritage of the nation from whose shores one has descended. The level of linkage for many immigrant groups was often quite strong, as they consciously attempted to retain their own language and culture. But some Americans may be unaware of the details of their specific heritages, including most African-Americans, who are unaware of the specific African nations or cultural groups from which they are descended.

As Cortes (1979) has pointed out, "Ethnic and international image formation are necessarily interrelated" (p. 91). In addition to "severed roots," historical misperceptions about Africa and African-derived imagery have made transnational linkage much more problematic for the African-American emigrant group. Despite 20 years of the rhetoric of "Black is Beautiful," many African-Americans remain, at best, ambivalent about their African legacy, and they have passed this same mixed bag of aesthetic and cultural ambiguities on to the latest generation of school-aged children.

Many teachers, in attempting to interject a multicultural perspective, will include an art unit on mask making, with particular emphasis on the African sculptural tradition. Often, classroom teachers plan this unit so that it will coincide with Halloween, capitalizing on the expressive qualities of the works as motivation for the studio product. Some art specialists may choose to include such a unit to coincide with the observance of Black History Month, planning to view African masks as a visual art form that represents a historical antecedent for African-Americans.

Unfortunately, for many American children of African descent, both of these types of inclusions, if not carefully approached, may have less than the intended effect. In a worst-case scenario, Black children in a predominantly White classroom may imperceptibly shrink in their seats, perhaps somewhat traumatized by the sudden peals of laughter and derision displayed by their White classmates. Museum docents have also expressed dismay that even Black children from predominantly Black urban schools often exhibit the same verbal and nonverbal responses as their White counterparts when encountering the African art collection. Despite the best of good intentions

139

on the part of art educators, a peculiar problem has revealed itself.

To a large extent, the American educational system has been charged with the responsibility for acculturation and social integration of its diverse population. Multicultural education and global education have emerged as major mechanisms for addressing this diversity. Baker (1978, 1979) sees the multicultural education of the 1960s as the process through which individuals are exposed to the ethnic, racial, religious, language, and sexual diversity that exists within the country, as well as the relationship of this diversity to the world. As MacDonald (1977) notes, the "movement toward multi-cultural education arises from the practical failure of assimilation of subcultures into the historically dominant culture of American life" (p. 6). Proponents of multicultural education affirmed that the "Melting Pot" had not materialized in their 1972 statement, "No One Model American," which declared that major educational institutions should strive to preserve and enhance cultural pluralism.

Davis (1985) uses the metaphor of a "Great American Tossed Salad" to replace the old melting pot idea and to describe this new thrust toward pluralism. However, an equally important concern for advocates of pluralism should be the search for those attitudes, beliefs, values, and cultural forms that represent uniquely American cultural transformations. In order to adequately explore these transformations, an examination of antecedent cultures is necessary.

Global Education

Although positive cultural interactions have resulted in uniquely American creations, particularly in the visual and performing arts, racial discrimination and ethnic prejudice have also emerged as negative aspects of cultural interactions. Global education as a movement emerged in the late 1970s, and sought to address the international dimension of multicultural education. Cortes (1979), writing on the relationship between multicultural education and global education, had stated:

> To be truly valid, multicultural education should incorporate a global perspective to provide world context for its examination of American ethnic and cultural diversity. Likewise, to be truly valid, global education should include a consideration of the relationships of U. S. ethnic groups to the global system and the differential impact of global forces, events, and trends on American ethnic groups. (p. 84).

140

As Baker (1979) has pointedly remarked, global education does not become multicultural education until some aspects of what is being taught about a country can be linked to the behavior or lifestyles of ethnic groups who live in the United States, but whose ancestors originated from one of the countries being studied. Baker's point highlights the dilemma facing teachers who wish to teach about the African cultural heritage. Despite common historical, cultural, and aesthetic values that are shared by Africans and African-Americans, it has been difficult to establish the links that Baker refers to because of the historical treatment of Africa and African-derived imagery and the deliberate efforts to distance Black Americans from the African past. These factors have resulted in relatively low levels of transnational linkage among Black people.

Therefore, sincere efforts on the part of teachers who want to address multiple cultural perspectives are met with the triple threat of (a) a scarcity of accurate and accessible information resulting from years of disinterest by the general public, (b) negative stereotypes and visual imagery associated with Africa and African-Americans in the minds of students they are trying to reach, and (c) a meaningful method of approaching the problem of linkage.

Because the elimination of this prejudice has been one of the major, though unstated, goals of both multicultural and global education, an examination of the curriculum models and approaches from these fields would seem to be relevant. Banks's (1982) assertion that increased cognitive sophistication has been shown to be the most consistent method for reducing prejudice points toward a consistent method for reducing prejudice and toward a content-oriented or even a discipline-centered approach to curriculum.[1]

Structuring a Model for Global Multicultural Art Education

A comprehensive approach to global multicultural education can be developed if the work of researchers in global and multicultural education are viewed simultaneously. Combining the key variables suggested by the models of Baker (1979) and Banks (1982) would lead to a conceptualization of global multicultural education that has ethnicity as its core, multicultural education as its inner ring, and global muticultural education as its outer ring.

The multicultural inner ring would include such important factors as cultural continuity/cultural change; culture and ethnicity; intragroup similarities, differences, and interactions; communication; interdependence; and power and related concepts. These are extremely important concepts in

141

providing a framework that will assist students in the process of cultural mediation referred to by Nadaner (1985).

Unfortunately, the implementation of instruction in multiple cultural perspectives in American schools has not proceeded at a desirable pace. Progress had been dependent on the impetus of court orders and other bureaucratic pressures, and in the last 8 years these federal initiatives have slowed down dramatically. Nevertheless, because societal tensions and racial conflicts have escalated, such curricular reform is badly needed within each content area and at all levels.

The model for global multicultural art education shown in Figure 10.1 is proposed as a way to conceptualize important curricular considerations in art education, global education, and multicultural education.

EXPRESSION / RESPONSE
ART HISTORY
ART CRITICISM
STUDIO ART
AESTHETICS
CULTURAL CONTINUITY/CULTURAL CHANGE
COMMUNICATION
INTRAGROUP INTERACTIONS
SIMILARITIES AND DIFFERENCES
CULTURE AND ETHNICITY
INTERDEPENDENCE
POWER AND RELATED CONCEPTS
SUBJECT
THEME
MEDIA
PRODUCT
DESIGN
FUNCTION
STYLE

Global Multicultural Art Education
Figure 10.1

The model attempts to capture the emphasis on feelings, skills, and interdisciplinary studies that is essential to the long-range goals and objectives of global multicultural education. Three major streams of thought influence the model.

First, the *Ohio Guidelines for Art Education* (Efland, 1977) has emphasized seven content features for art and has spelled out 18 approaches to the study

of art based explicitly on studio art, art history/art in society, and art criticism. The addition of aesthetics is essential for understanding art criticism and in examining study approaches related to the cultural heritage in art. Implied in the study approaches for meeting art and society goals and personal development-response goals are a strong emphasis on understanding aesthetics through perceiving and describing works of art and the role of societal values and beliefs in expressing and responding to art.

Second, the importance of culture/ethnicity and cultural continuity and cultural change are but two very direct parallel concerns of both art education and global multicultural education. Third, the curriculum content, kinds of increasingly challenging questions, and art activities that are curricular concerns in DBAE are essential to a global multicultural approach to art education. However, the separation of the four disciplines of art into discrete categories is not meant to imply that they are not interrelated. "In quality art education, none of the components...stands alone; each combines with the others to reinforce, explain, clarify, or enrich the others" (National Art Education Association, 1986, p. 19).

Just as the efficacy of a triangulated model has been demonstrated in the field of empirical research, a triangulated curriculum model may help to structure relationships and suggest possible directions for activities that might not have been obvious before. Flexibility in scope and sequence is the intent behind the approach to curriculum planning undergirding the Ohio guidelines, because it is suggested that teachers vary study approaches and features of content to provide both breadth and depth as they see fit within their situations and with their particular students. In addition to structuring content and study approaches, the suggested model offers teachers one more dimension for addressing the question of "what to teach" in terms of providing issues related to multiple cultural perspectives.

Cortes's (1979) comment regarding the implementation of a global education model is appropriate here as well; he points out that "specific content will vary as the curriculum focuses on different topics, themes, concepts, ethnic groups, nations and culture areas" ... to achieve one common student goal of "helping students become 'multicultural global literates' " (pp. 85, 91). Similarly, the goal of global multicultural art education would be to help students achieve global multicultural aesthetic literacy, to become people with the knowledge, skills, and attitudes necessary to live enjoyably, effectively, sensitively, and constructively in our highly visual, increasingly small, interdependent world. Although Lanier's (1983) use of the term *aesthetic literacy* emphasizes the need for helping students become knowledgeable consumers of art in their world, acquaintance with studio processes is extremely important in developing an appreciation of the arts

and cultures of other peoples.

Interdisciplinary Approaches to the Role of Art in Society

Interdependence represents a major approach to global multicultural art education suggested by the curriculum model in Figure 10.1. With music as a theme, rhythm as a design principle, and study approaches that focus on the role of art in society, students can gain an understanding of the interrelationships between visual art, music, drama, and dance; the influence of African and African-derived arts on European and American art; and the relevance of these values and beliefs to contemporary American art forms.

The period surrounding the 1920s produced three important parallel artistic developments, reflecting the interdisciplinary nature of the African synthesis of the arts. One of these developments was the emergence of jazz from the Black "outlaw cathouses and speakeasies that spawned it" into a new and acceptable place on the American cultural scene (Lewis, 1987, p. 78). Just as European musicians were discovering the vibrance of Black musical forms, European visual artists had discovered African visual forms a few years earlier, giving birth to the Fauves and Cubists and, eventually, to modern art as a movement. Cubism continued to be an important development, as the concept of "simultaneity" inspired by African sculpture was explored in two dimensions by European artists like Picasso and Braque.

The other major cultural phenomenon of this period was the Harlem Renaissance, a movement by artists and intellectuals that embraced the African heritage in subjects, themes, motifs, and images of Black people and Black life.The strong relationship that had always been intertwined in Black music, drama, dance, and visual art was immortalized in the works of Aaron Douglas. The influence of three artistic disciplines on Douglas's work can be seen in his illustrations for James Weldon Johnson's song sermonettes, *God's Trombones,* where his use of theatre idioms becomes a major visual device. Of Douglas's mural *Jungle Dancers* from the series "Aspects of Negro Life," a reviewer writes, "The fetish, the drummer, the dancers in the formal language of space and color recreate the exhilaration, the ecstacy, the rhythmic pulsation of life in ancient Africa."

Black music has provided the subject, theme, and synaesthetic rhythm that have been pervasive throughout Black life and as a design quality in the visual arts. Larry Neal (1979) notes that a significant part of the artistic ideology AFRICOBRA art movement of the 1960s sought to make "visual griots" of Black artists, linking the aesthetic continuity in music and art

through sight, sound, and movement at once, particularly reflected in improvisation-like rhythmic variation and the spectral range of colors.

Different artists have reflected the significance of music to the Black experience in different ways. Some artists use music as subject matter, such as in Henry Ossawa Tanner's *Banjo Lesson,* Malvin Gray Johnson's *Orphan Band,* Jacob Lawrence's *Parade,* or Norman Lewis's *Street Music, Jenkins Band.* Musical improvisation serves as a recurring theme in the work of other artists such as Nelson Stevens and Romare Bearden.

Bearden, who initially wanted to pursue a career in music rather than visual art, feels that music epitomizes what he wants to express, particularly through rhythmic patterns and variations on a visual theme. Bearden has used music as subject, theme, and rhythm as a design motif in his compositional process, achieving rhythmic qualities through the placement of pieces in his collages. Contrary to popular opinion, he describes improvisation in both jazz music and his work as involving a high degree of structure, just as African art is highly structured (Jacobs, 1985). Although he does not make a drawing, the structure of the work is in his mind as it progresses. Bearden points out the significance of the interval, or the silent spaces between the musical notes, as a parallel to the visual rhythm reflected in his work.

The drum is an essential element in recreating African rhythmic forms. Focusing on drums as an important means of communication as well as an essential part of ceremonial occasions can help students understand how changes in African values and beliefs have occurred in the American context. African drums have taken many different forms, frequently being hollowed out of a single log with intricate designs carved on the outside. Drums made by African-American slaves reveal similar construction methods and carved motifs, ranging from geometric patterns to figural designs. Because drums played such an essential role in directing the lives of the people, slave owners banned their use, forcing slave craftsmen to disguise their creations as rice mortars or other household implements or to hide them, even by burying them (Moore, 1977).

Unfortunately, few slave carved drums are still in existence. However, in much of the Caribbean, where Africans were strictly forbidden to carve traditional drums, the steel drum emerged as a unique musical and visual form. Even today, steel drums have survived and are the dominant instrument in some Caribbean cultural festivals.

The drum is still an essential African continuity in a relatively new Black cultural transformation known as Kwanzaa. In 1966, Maulana Ron Karenga

145

proposed this December holiday to (a) provide Black people with a spiritually centered community celebration to bring families and communities together to share their mutual love, strength, and warmth regardless of religious faith; and (b) institute a Black holiday for African-Americans that reestablishes the traditional images and values of harvest celebrations that are found throughout Africa. The word *kwanza* means "first" and signifies the first fruits of a spiritual harvest (Lee & Plump, 1972, p. 1). In recognition of its African-American transformation, a second "a" was added to the end of the word to indicate that the American experience is unique to the struggle for harvest in the United States (Childcraft, 1982). Although the observances vary from household to household and city to city, there are specific visual symbols, in addition to the playing of the drum, that are always a part of the celebration and could be included in curriculum planning.

Handmade zawadi, or gifts for the children's good efforts throughout the year; decorations; karamu favors; greeting cards; and invitations are potential visual arts that can be created by family groups and students for Kwanzaa celebrations. Schools such as the Duxberry Park Arts Impact Alternative School in Columbus, Ohio, have already incorporated the study of Kwanzaa into their curriculum and traditional holiday observances.

Students can be introduced to the concept of cultural continuity/cultural change as a global concern through an emphasis on media. Study approaches might relate to how society works with its technologies to make art and express changes in values and beliefs. Aesthetic continuities between African and African-American art can be observed through a preference for particular processes, media, and products that students can become involved with through studio activities. In terms of processes, a survey of African and African-American art reflects a predominance of intricate carving in wood and stone; metalworking and delicate casting in bronzes; modeling in clay; assembling of materials for aesthetic effect; strip weaving and construction as a design motif; quilting, stitching, and appliqueing designs on fibers; basket making; and the crafting of instruments, jewelry, accessories, and works of art.

Many African artists brought to this country as slaves were highly skilled carvers. In Africa, ritual masks, headdresses, headrests, stools, statues, and figurines were often carved in wood, as well as drums, calabash dishes, bowls, utensils, and many functional objects. Early African-American slave artists also carved in wood using similar techniques, producing walking canes, statuettes, figurines, and everyday objects (Mason, 1986). Similar design motifs can be seen in the prominence of human figures, birds, reptiles and amphibians, and geometric patterns and the use of an-

thropomorphic forms. Carving from a single piece of wood, these early artists sometimes posed figures and objects in the same way they would have been placed in their African context.

The list of African-American artists who continued to reflect Black values in stone includes 19th-century sculptor Edmonia Lewis in her work, *Forever Free.* Emerging from the Harlem Renaissance were sculptors like Selma Burke, Sargeant Johnson, and Marlon Perkins. Elizabeth Catlett brought this tradition in carving into the second dawning of Black consciousness in the 1960s, revealed in such wood carvings as *Homage to My Young Black Sisters, Mother and Child, Pregnancy, Black Unity, The Black Woman Speaks,* and *Magic Mask.*

Metalsmithing, whether by forging or casting, has a long tradition throughout Africa. The culture of Igbu-Ukwu produced intricate openwork silver castings by a sophisticated cire-perdue (lost wax) process. The life-sized portrait heads of Ife, the bronze heads and wall plaques of Benin, and the Ashanti gold masks and weights are but a few examples of this tradition. African processes of working with metals were revealed by slave artisans and blacksmiths in such forms as the ornamental wrought-iron balconies, gates, and fences of New Orleans, Charleston, Savannah, and Mobile (Moore, 1977). Students need to know about African American sculptors like Meta Vaux Warrick Fuller, Richmond Barthe, Augusta Savage, Valerie Maynard, Melvin Edwards, and Elizabeth Catlett, who have continued the tradition of creating with metals.

Donaldson (1972) sees Elizabeth Catlett's work as a visual bridge connecting our common ancestry, through which light can be shed on the art and social systems of ancient Egypt, Nigeria, and Pre-Columbian cultures in the West. Modeling in clay has been a traditional African process, as revealed by the open-fired portrait heads of Nok and the utilitarian pottery forms found on both continents. Effigy jars found among the Akan people in West Africa, Zaire, and Angola were transformed into water jars, often called "face jars" or "monkey pots" by potters like Henry Gudgell or Dave the Potter in the Carolinas (Brookhouser, 1986; Coleman, 1976; Mason, 1986; Moore, 1977). Because most elementary art curricula include an introduction to clay, some of these images can be introduced to students as examples for discussion.

Strong African continuities can be found in fiber arts processes in textile design. According to Wahlman (1986), textile techniques, aesthetic preferences, and religious symbols that were adapted by Black quilt makers in the New World are traceable to their African origins, even though these were often combined with Euro-American and Native American idioms to create

unique "creolized arts" (p. 68).

Visual complexity through multiple patterning is another aesthetic continuity revealed through quilt designs, with increased complexity often indicating prestige, power, wealth, or the desire to ward off evil (Wahlman, 1986). In addition to visual complexity, Wahlman notes the improvisational use of asymmetry, unpredictable rhythms, and tensions as design features that are also characteristic of African-derived music and dance.

Several contemporary African-American artists have chosen to incorporate aspects of traditional idioms in their work. Faith Ringgold (1985) embraced fabric and soft sculpture to move away from the European tradition that so heavily influences painting and as a way of expressing "what it meant to be a black person and identifying African art as the classical art form" (p. 37). Her unique story quilt book, *Who's Afraid of Aunt Jemima*, depicts the Black "heroine (or anti-heroine)" in 56 squares combining narrative text, images, and squares of traditional quilting (Gouma-Peterson, 1985, p. 6). Ringgold's story quilt book reflects the African merging of literary and visual art forms, carrying a politically significant message through the story and richly patterned, appliqued block-quilt designs. Even elementary children, who are constantly asked to illustrate stories, can appreciate and make story quilts.

Perhaps the most enduring example of continuity in African fiber arts can be found in the contemporary African-American hair styles of many Black girls. Thomas and Bullock (1973) see hair weaving as a living art form for millions of women of African ancestry, noting that it was a symbol of status, a sign of age, and was at one time closely associated with spirituality and ritual. The meaning of beads and other small decorative items woven into the hair varied from one culture to another. Most African-Americans are not aware of the historical significance of many designs that have been highlighted by Thomas and Bullock (1973) and Yarbrough (1979).

Operationalizing the Curriculum Model

In addition to the formal curriculum, the guidelines for the Iowa State Board of Education suggest that instructional materials and teaching practices be assessed if the goals of achieving multiple perspectives are to be met. Students should feel that the art of their cultural heritage is valued by being represented throughout the curriculum and in the instructional materials. Research on the effects of instructional materials of children's racial attitudes has resulted in the inclusion of more ethnic minority group members in the visual teaching materials and textbooks available.

Unfortunately, very few texts are available that include African or African-American art for elementary and secondary students. When such art is included, the artist is often unidentified and the art used as an illustration of various media processes. Computerized retrieval systems are making the task of locating reference materials in this area much easier.

Once art educators become knowledgeable about African and African-American art, they will need to become skillful at developing instructional materials that reflect a global multicultural perspective. Several good audio-visual presentations are available on African art, although they may have to be scheduled well in advance through listings available at colleges and universities, through media catalogues, or through state departments of education.

Lanier (1983, p. 191) uses the term *canalization* to describe the process wherein learning is presented to the student in ways that are most familiar, progressively widening the areas of art a child sees as viable sources of aesthetic experience and promoting increased insight into how to obtain such experiences. Creative art educators can look to many popular art sources as background and inspiration for operationalizing the suggested curriculum model. "Heroes" might be a popular theme, including posters, album covers, calendars, dolls, and toys by African-American craftspersons as a point of departure. Children's literature is an excellent resource because it introduces content through an art form that students are already familiar with and can create for themselves.

Teaching Practices

Whereas the formal or manifest curriculum consists of discernible environmental factors such as curriculum guides, textbooks, bulletin boards, and lesson plans, a latent curriculum communicates the school's attitudes toward a range of issues and problems regarding diverse racial and ethnic groups (Banks, 1982). One of the most common approaches to injecting multiple perspectives is to add ethnic content to the existing curriculum on special days, such as during Black History Month, that are set aside. However, Banks feels that schools' relegating multicultural education to the teaching of specialized units on particular ethnic groups at specific times of the school year may have the unfortunate effect of continuing to perpetuate the idea that certain cultural groups are not an integral part of the society.

One method of avoiding this problem would be to incorporate content from the four art disciplines throughout the curriculum, as noted earlier in this chapter. As long as this content is not isolated during one specific period in

the school year, there is nothing wrong with celebrating Black History Month. However, Black history could very effectively become a prism through which other ethnic heritages are viewed in a thematic approach that focuses on important junctures of human life — the rites of passage from birth, childhood, coming of age, marriage, working, waging war, making peace, growing old, and death. As Banks (1987) has stated, "Whites must deal with their own ethnic diversity before they can deal with other people's cultures." A great number of art educators may need to become knowledgeable about their own ethnic heritages.

Cortes (1979, p. 86) points out that no person belongs exclusively to one single group, but simultaneously to various sex, age, economic, social, regional, cultural, and ethnic groups in a complexity of "belongingness." Sorting out common cultural values is an extremely worthwhile pursuit, offering students an opportunity to explore transnational linkage and their own place on the identity continuum. Students need to know of the struggle for recognition of African-American artists who function within both an Afrocentric and Eurocentric world or who produce art that they consider to be "mainstream" but that is dismissed as Black art by critics and historians (Jacobs, 1985, p. 5).

Success in getting students to meaningfully discuss issues requires an analysis of long-term learning outcomes and consideration of learning styles and teaching models. Through interactive learning environments, and the use of peer learning, active learning, cooperative task structures, competition, and individualization, appropriate strategies for accomplishing goals can be devised (Johnson & Johnson, 1979; Slavin & Devries, 1979). Varying the amount of structure to accommodate the needs of different students for independent art exploration would also extend to the creation of an aesthetic, pluralistic physical environment for independent (but not necessarily individual) learning. Because most education takes place outside of schooling, the traditional classroom would need to be extended into the home and community through frequent field trips, guest speakers, and coordinated art activities at local festivals and events.

Conclusion

For many Americans of African descent, an unresolved internal struggle for identity results in "no true self-consciousness," which manifests itself as two separate and "unreconciled strivings" — one African and one American (Hale, 1982, p. 21). Yet, it is imperative that this schism be dealt with and the roots of the African heritage be allowed to nourish the cultural deprivation in which much of African-American art finds itself.

150

The effectiveness of a more content-centered approach to curriculum planning has been discussed in relation to its potential for providing greater cognitive sophistication through art activities. Curriculum planning that emphasizes interdisciplinary approaches and specific long-range goals has been shown to be one of the most effective ways of opening the door to real communication and understanding.

In reviewing the work of theorists in the field of global education and the classroom experiences of art educators, it becomes apparent that the African cultural legacy must be effectively linked to the African-American cultural experience to be successfully communicated to contemporary Americans, who have been significantly influenced by several centuries of negative image formation. The task of operationalizing global multicultural art education will not be easy. As Coleman (1976) has stated, African-American art can serve as an integrating factor, providing visual metaphors for shared ideas and cultural values.

In 1938 Charles Seifert wrote, "To advance forward...you must press backward" (p. 5). This statement is no less true today than it was over 50 years ago. In a real sense, art educators who would link the African legacy for American youngsters must press backward to make advancements by becoming fully grounded in African and American art and cultural traditions. They must be willing to take on the role of cultural catalyst, recognizing that in the case of African-Americans the job of cultural mediation may be as complex and beautiful as a Kente cloth.

References

Baker, G. C. (1978, February). *Multicultural teacher education: The state of the art*. Paper presented at the annual meeting of the American Association of Colleges for Teacher Education, Chicago. (ERIC Document Reproduction Service No. ED151 357)
Baker, G. C. (1979). Policy issues in multicultural education in the United States. *Journal of Negro Education, 3*, 253-266.
Banks, J. A. (1982, February). *Reducing prejudice in students: Theory, research and strategies*. Paper presented in the Kamloops Spring Institute for Teacher Education Lecture Series, Burnaby, British Columbia. (ERIC Document Reproduction Service No. ED215 930)
Banks, J. A. (1987, November). *Cultural literacy, the liberal arts curriculum, and the human condition*. Conference presentation, "Ethnic Studies: Crossroads to the 21st Century — Dominance or Pluralism," Bowling Green State University, Bowling Green, Ohio.
ben-Jochannan, Y. (1973). *Black man of the Nile and his family*. New York: Alkebu-an Books Associates.
Bearden, R. (1986). *Artist's statement. Romare Bearden: Origins and progressions. Exhibition catalogue*. Detroit: Detroit Institute of Art.
Brookhouser, K. K. (1986, February). Country potter Burlon Craig: The last of a generation. *Country*

Home, pp. 59-63.

Childcraft: The how and why library. Kwanzaa — A new holiday. In *Holidays and birthdays*, Vol. 9. Chicago, IL: World Book-Childcraft International, Inc. 1982.

Coleman, F. (1976). African influences on Black American art. In *Black Art: An International Quarterly, 1,* 4-15.

Cortes, C. E. (1979). Multicultural education and global education: Natural partners in the quest for a better world. *In Curriculum dimensions of global education.* Harrisburg, PA: Pennsylvania Department of Education. (ERIC Document Reproduction Service No. ED187629)

Cortes, C. E. (1981). The societal curriculum: Implications for multiethnic education. In J. A. Banks (Ed.), *Education in the 80's: Multiethnic education.* Washington, DC: National Education Association.

Davis, W. B. (1985). *Keynote address: Symposium on Multicultural Education and Art Education.* Bowling Green, OH: Bowling Green State University.

Diop, C. A. (1974). *The African origin of civilization: Myth or reality.* New York: Lawrence Hill & Company.

Donaldson, J. (1972). *Commentary. Elizabeth Catlett: Prints and sculptures. Exhibition catalogue.* New York: Studio Museum in Harlem.

Driskell, D. (1987). The flowering of the Harlem Renaissance: The art of Aaron Douglas, Meta Warrick Fuller, Palmer Hayden, and William Johnson. In *The Studio Museum in Harlem. Harlem Renaissance: The Art of Black America.* New York: Harry Abrams.

Efland, A. (1977). *Planning art education in the middle/secondary schools of Ohio.* Columbus, OH: State Department of Education.

Gouma-Peterson, T. (1985). Faith Ringgold's Journey: From Greek Busts to Jemima Blakey. In Faith Ringgold, *Painting, sculpture, performance. Exhibition catalogue.* Wooster, OH: The College of Wooster Art Museum.

Hale, J. (1982). *Black children: Their roots, culture and learning styles.* Provo, UT: Brigham Young Press.

Hurston, Z. N. (1979). How it feels to be colored me. In Alice Walker (Ed.), *I love myself when I am laughing...and then again when I am looking mean and impressive: A Zora Neal Hurston Reader.* Old Westbury, NY: Feminist Press.

Hutnik, N. (1986). Patterns of ethnic minority identification and modes of social adaptation. *Ethnic and Racial Studies, 12,* 150-167.

Jacobs, J. (1985). *Since the Harlem Renaissance: 50 Years of Afro-American Art. Exhibition catalogue.* Lewisburg, PA: The Center Gallery of Bucknell University.

James, G. J. (1976) *Stolen legacy.* San Francisco: Julian Richardson Associates.

Johnson, D., & Johnson, R. (1979). Cooperation, competition, and individualization. In H. J. Walberg (Ed.), *Educational environments and effects.* Berkeley, CA: McCutchan Publishing Corporation.

Lanier, V. (1983). *The visual arts and the elementary child.* New York: Teachers College Press.

Lee, D. L., & Plump, S. D. (1972). *Kwanza.* Chicago: Institute of Positive Education.

Lewis, D. (1987). Harlem my home. In M.S. Campbell, *Harlem renaissance: Art of Black America.* New York: Abrams.

Macdonald, J. B. (1977). Living democratically in schools: Cultural pluralism. In C. A. Grant (Ed.), *Multicultural education: Commitments, issues, and applications.* Washington, DC: Association for Supervision and Curriculum Development.

Mason, P. L. (1986, July). *The retention of African culture in the arts and crafts of Black American artisans 1865-1969.* Paper presented at Expose '86, The University of British Columbia, Vancouver.

Metcalfe, E. (1983). Black art, folk art, and social control. *Winterhur Portfolio: A Journal of American Material Culture, 48,* 271-290.

Moore, J. L. (1977). *The Afro-American tradition in decorative arts: Notes on the exhibition.* Cleveland: The Cleveland Museum of Art.

Morris, W. (Ed.). (1973). *The American heritage dictionary of the English language.* New York: American Heritage Publishing Company.

Nadaner, D. (1985). The art teacher as cultural mediator. *Journal of Multi-Cultural and Cross-Cultural Research in Art Education, 3*(1), 51-55.

National Art Education Association. (1986). *Goals for schools.* Reston, VA: Author.

Neal, L. (1979). Africobra/farafindugu: Celebrations and survivals. In *African and African-American*

152

Traditions in American culture. Africobra. Exhibition catalogue from the colloguium. Oxford, OH: Miami University.

Ringgold, F. (1985). *Interview. Since the Harlem Renaissance: 50 years of Afro-American Art. Exhibition catalogue.* Lewisburg, PA: The Center Gallery of Bucknell University.

Seifert, C. C. (1938). *The Negro's or Ethiopian's contribution to art.* Baltimore: Black Classic Press.

Schuman, J. (1981). *Art from many hands: Multicultural art projects.* Worcester, MA: Davis Publications, Inc.

Slavin, R., & Devries, J. (1979). Learning in teams. In H. Walberg (Eds.), *Educational environments and effects.* Berkeley, CA: McCutchan Publishing Company.

Stuckey, S. (1987). *Slave culture: Nationalist theory and the foundations of Black America.* New York: Oxford University Press.

Thomas, V., & Bullock, S. (1973). *Accent African; Traditional and contemporary hair styles for the Black woman.* New York: COL:BOB Associates.

Townsend, R., Ross, H., & Ruttenberg, J. (1985). *African sculpture.* Chicago: The Art Institute of Chicago.

Wahlman, M. S. (1986). African symbolism in Afro-American quilts. *African Arts, 20,* 68-76, 99.

Williams, C. (1974). *Destruction of Black civilization.* Chicago: Third World Press.

Yarbrough, C. (1979). *Cornrows.* New York: Coward-McCann, Inc.

Notes

[1]A fuller discussion of the relationship between DBAE, content-centered teaching models, and cultural pluralism can be found in my article, "Pluralism and DBAE: Toward a Model for Global Multicultural Art Education," *Journal of Multi-Cultural and Cross-Cultural Research in Art Education,* 1988, 6(1), 64-74.

11

The Black Aesthetic: An Empirical Feeling

ADRIENNE WALKER HOARD

University of Missouri — Columbia

The environment in which the African American concept of the Black aesthetic has developed in the 20th century has largely expressed the Western tradition found on the American continent. The form and content of the information received from this environment have bottled and distributed data predominantly about an apparent social order as perceived by the mainstream of Western (i.e., American) thinkers. Technology has supported transmission of this mainstream imagery to every household; however the system for receiving information known as the Black experience has contributed its own sets of visual images that are expressions of an ethnic consciousness, or a "felt" reality, an expression of Black self-identity. This study suggests that the presence of this consciousness promotes certain aesthetic response patterns among selections of artwork by Black viewers, which can be quantified using empirical structure. Certain works of art by Black painters were found to evoke recognition responses in other persons with a similar "cultural racialism" (Locke, 1945, p. vi).

Black American ethnic culture has its roots in the African aesthetic, which presents the felt reality or expressive quality from any work of art with such intensity that it seeks to evoke movement or utterance (activity, visual and verbal) in the context of aesthetic response. Works of African art present a certain rhythmical, flowing quality evident among the visual elements that can be considered a "Gestalt" (Arnheim, 1954, Eysenck, 1942), a cultural, visually significant, characteristic form representative within Black aesthetic expression.

Fry (1920) contends that Negro sculptors appear to compose not only their solid forms in the artwork, but also the voids, the intervals between the forms; much like the syncopated musical beat in jazz fills in the tones in and

155

around the main beats. Goldwater (1968) agrees, suggesting that this expression is in the "rhythm of the solid and void" in sculptural African art. The felt aesthetic of the African cultural art form adds life, vitality, and character to a work of art, because of the resulting visual harmony of positive-negative interlocking rhythms. This study seeks to characterize an element of Black aesthetic response by identifying and exposing patterns of response to rhythmical, significant forms in African American abstract painting.

Toldson and Pasteur (1976) set out to categorize elements of this Black or African-derived aesthetic. They suggested that this "attitude," which is designated the "Black aesthetic," appears to be more cultural than racial in origin but specifically manifests itself in the expressive behaviors and cultural lives of Black people, whether on the continent of Africa or within the African diaspora.

As psychologists, Toldson and Pasteur were uniquely concerned with the behaviors and attitudes representative of the Black aesthetic and their impact for optimal mental health. They reviewed the expressive outlets in the Black lifestyle and concluded that "the Black art forms are rich in correct Black imagery and aesthetics, and express value sentiments that Black people need to start using to bring dysfunctional behavior under close scrutiny" (p. 116).

In the analysis of their data, Toldson and Pasteur (1976) reported five dimensions constituting the Black aesthetic and characterized this felt reality as an attitudinal orientation and a response to style. Two of these dimensions relate to visual images and the task in this study. The first is "depth of feeling," meaning the essence of empathic understanding that "suggests an attempt to squeeze every ounce of substance from an experience through total absorption in it. This defies the principle of possession by spiritually flowing into things, rather than owning or conquering them" (p. 106). The second is "physical responsiveness to affective stimuli," which is demonstrated as group selections among rhythmic fluid movements in music or dance, or by group propensity for selection of a certain interchange of visual elements present among the elements and principles in two- and three-dimensional Black art.

O'Neal (1972) cleverly defines the "Black aesthetic" as "the principles of Black art," which are systems that must be "discovered." He says "they come after the fact as a result of reflection and observation" (p. 53). After more than 28 years of expression, reflection, and observation, heroically contemporary Black American aesthetic thought is still looking "for the scientist to find the means to take us there...[and] for the artist to see and

show the way by being what he [she] sees" (O'Neal, 1972, p. 50).

Fouda (1988) speaks about the unique structure of aesthetics in Negro-African tradition, which involves a cultural aesthetic with its origins of "awareness and response" in an elite problem-solving body existing as the consciousness of the group ancestors. This governing body exhibits accepted manners of human actions and expressions as a code of attitudes and beliefs, on the basis of which the group decides the laws of life, truth, and beauty. Fouda suggests that the "deep felt cooperative consciousness" is an African ancestral group experience (p. 274).

The responses reported among the ethnic or cultural population in this study show evidence of group patterning reflecting certain perceptual selections, which may indicate a group tendency for preference among certain visual complexities (Berlyne, Ogilvie, & Parham, 1968). Analysis of these data suggests that this felt response quality, as an element of the Black aesthetic, was a shared experience among Black viewers. This rich, emotional attitude within the cultural life of an African-derived people manifests as the "affecting presence" (Armstrong, 1971), an expressed and felt response quality of Black people through their art. Through the centuries this attitude and its responding behavior have been described as spirituality, soul, animism, and "Negritude" (Cesair, 1939; Dumas, 1938; Senghor, 1939).

Thus, the expressive quality of Negritude has been shown to be statistically evident through a unique patterning of responses from Black viewers to abstract paintings created by Black American visual artists. Guptill (1962) refers to the guiding force behind one's artistic choices as "aesthetic instinct." Could at the base of the Black aesthetic lie an instinctual response to form? This could create scientific answers to the aesthetic visual questions posed by the Senegambian basketry of 13th-century West Africa and the corresponding Afro-American decorative sea grass baskets of 17th-through 20th-century South Carolina and the Sea Islands (Vlach, 1978).

Langston Hughes (1972) declared that the common people among American Negroes would "still hold their own individuality in the face of American standardizations. And perhaps these common people will give the world its truly great Negro artist, the one who is not afraid to be himself" (p. 168). It appears that long-term exposure within Western thought has not yet eroded Black American artists' capacity for "expression of their own soul-world" (Hughes, 1972, p. 171), when perceived by other Black persons.

Although perceptual sensitivity to art forms involving responses from African Americans has been investigated by Gaither (1972), Gayle (1969,

1971, 1972), Spellman (1973), DePillars (1976), Daniel (1982), and Neperud and Jenkins (1982), particularly regarding realistic and naturalistic sources, only Neperud, Serlin, and Jenkins (1986) have presented geometric or expressionistic abstractions. The current attempt is to monitor and identify discriminant patterns of similarity among recognition responses to a unique set of visual stimuli, which include abstract and nonobjective paintings by Black American artists.

This investigation concerns not only the dimensional responses to visual structure (Hoard, 1987) that art-naive and art-sophisticated African American viewers might issue as a result of seeing certain works of nonobjective painting, but also their perceptual responses to aesthetic images that might embody sensitivities to cultural or ethnic stylistic cues. Researchers in visual perception, cross-cultural psychology, and visual arts education (Bornstein, 1975; Deregowski, 1972; Eisner, 1979; Frances & Halasz, 1980; Miller, 1973; Morrison, 1979; Neperud, 1970) have presented studies concerning perceptual sensitivities and intercultural differences that tend to support the current hypotheses.

Hypothesis 1. African American art-sophisticated and art-naive viewers will be able to perceive visual structure and categorize abstract and nonobjective paintings on the basis of this stylistic attribute.
Hypothesis 2. Abstract and nonobjective paintings created by African American artists will exhibit ethnic or cultural cues that African American art-sophisticated and art-naive viewers are able to perceive as visual attributes.

Design

The design for this study was composed of three variables, each with multiple levels. The predictor variables were training in art and the visual structure categorized in the nonobjective paintings from the nine classifications of Hoard's Test of Visual Structure in Nonobjective Painting (1987). The criterion variables were the classifications of sorting of the stimuli by viewers. Similarity judgments of 90 color art prints were solicited using two exclusive sorting conditions: one in which exemplar prints were presented as sorting targets and one without exemplars, titled the "free sort." The second sorting of the same stimuli requires art-naive and art-sophisticated viewers to identify an additional category embedded among the original nine, in which only paintings by African American artists appear.

Procedures

Subjects in this study were 20 students at a predominantly Black university. Ten undergraduate students who were majoring in fine arts, art education, and art history constituted the population of art-trained viewers, which will be called art sophisticated. The 10 undergraduates who constituted the lay group, or art-naive viewers, were majoring in business administration, medical technology, math and elementary education, physical therapy, and child development. As a result of research funding from the Committee on Minority Concerns (COMC), an affiliate of the National Art Education Association, all participating subjects were financially compensated for their involvement. Upon their initial selection, each viewer was asked to complete a two-page questionnaire regarding any previous exposure or education in the visual arts.

The average art sophisticate had participated in 11 formal courses in the visual arts since secondary school, including studio and art history courses. Most of the participants did not record courses in aesthetics on their questionnaire. The art-naive viewer's average art exposure included three or fewer formal courses of study in the visual arts, no tendency to select books on art for academic or personal reading, and limited formal or informal exposure to actual artworks. For both groups, the greatest exposure to works of art appears to have taken place in junior high and college.

The average age of students was 22. Each training group was represented by rural-divided-by-urban home dwellers in a ratio of 6:4. Although art professors within the university were considerably active as studio artists, the lack of available galleries and museums in and near the students' homes probably accounts for the lack of viewer-recorded exposure with actual artworks.

The training groups divided equally on the question of personal consideration of the visual arts, with art-naive viewers considering the discipline as solely a recreational pastime. The art-sophisticated viewer considered the field to be a lifestyle, vocation, or favorite hobby. Both training groups had previously had almost no exposure to nonobjective works of art, and 90% of all participants expressed a desire to learn more about these abstract color prints.

Stimulus materials consisted of a characteristic set of 90 nonobjective or abstract paintings collated to isolate the stylistic attribute of visual structure and to simulate a test for the perception of visual structure among adults both formally trained and untrained in the visual arts. These abstract paintings were selected to correspond to and express three of Wolfflin's

(1915) conceptions of structure — amorphous, organic, and geometric. For this study, embedded in the nine original visual structure categories, already valid and identified, is a tenth category of abstract art by Black American painters. The artists include Vivan Browne, Edward Clark, Emilio Cruz, Willaim C. Hutson, Al Loving, Sam Middleton, Larry Erskin Thomas, Alma Thomas (represented by two paintings), William T. Williams, and Adrienne W. Hoard. A complete description of the stimuli and selection process is included in the dissertation by Hoard (1987).

The unique contributions of this stimulus set include (a) the absence of representational subject matter as a relevant cue in the classification task regarding scanning for stylistic cues in painting (Hardiman & Zernich, 1985), (b) the presence of properties of the stylistic attribute visual structure (Hoard, 1986; Schultz & Klein, 1966), and (c) presence of the embedded category of African American paintings, which exhibit their own characteristic style of cultural Gestalt.

Data collection for this study began using random assignment of Black American viewers to either the free or exemplar condition for sorting the 90 stimuli set of color prints, presented on a 7-foot-long wooden table equipped with individual sorting instruments and pencils.

The criterion tasks were performed solely by the individual, with each viewer making unaided judgments of similarities about the entire stimulus set. The sorting task presented an advantage in this study over pairwise or triad judgments, in that viewers can make evaluations about any one item compared to the entire set in a relatively short span of time (Rosenberg & Kim, 1975).

The two tasks differed in the level of affective processing necessary for viewer success on the task. The initial sorting, as a classification task, involves recognition (on the part of the viewer) of the attributes of visual structure within nonobjective painting. The second task offers a distinction between recognition and perception (Dewey, 1934) in that the viewer is called on to perceive more subtle and complex cultural cues, in which his or her own cultural experience lends a sense of "connoisseurship" (Eisner, 1985), or "knowing," necessary for success in this task.

Results and Discussion

The documentation and evaluation of this cultural phenomenon, known as the Black aesthetic, uses visual cue searching, involves connoisseurship, and supports aspects of the analytic process called for in a multiple

perception/convergence model (Ecker & Baker, 1984), in which "quantitative data collected as reports of perceptions are analyzed using standard descriptive statistics and parametric and non-parametric inferential statistics" (p. 250).

The sorting scores from the visual structure and African American categorization tasks were submitted to two- and three-way statistical comparison (analyses of variance) to identify any effect of art training or either sorting condition. The results revealed significant main effects for both sorting condition and category, meaning that the type of sorting to which viewers were assigned has an impact on their scores and that the elements of visual structure expressed in certain categories make some easier to find than others.

There was no significant main effect of training level, which suggests that viewers who differed in levels of art training do not significantly differ in their categorization judgments of similarity among the structural attributes of the stimuli or in their ability to "discover" the attributes characterizing the works of the African American artists. Both groups were able to perceive the various dimensional and expressive cues of visual structure and ethnicity.

Exemplar sorting participants had the greater number of correct paintings selected within each category (see Table 11.1). Presenting the target paintings for the nine categories seemed to enhance the perceptual scanning strategies of these viewers. When scanning for cues of visual structure, the prototype or exemplar image appears to contain the visual information necessary to generate the total category (Berlyne, 1974).

Even though the mean number of correct choices made by viewers showed no impact from art training, there were significant differences in the order of categories well sorted by each level of training. Art-sophisticated viewers better sorted the amorphous category, followed by the organic and geometric categories. Art-naive viewers, on the other hand, best perceived the cues of geometric visual structure categories, followed by the amorphous category, and finally, the organic categories.

"Action Painting" (Category 7), which exhibits amorphous visual structure, was the best selected category over all sorts and levels of training, which replicated one aspect of Hoard (1987). The second, third, and fourth category means in selection (Central Circular, Central Square, and Stripes, respectively) all exhibit geometric visual structure (see Table 11.2).

For the second task, the "best" condition for success completely reversed.

161

Table 11.1

Mean Number of Correct Paintings Within Each Category By Type of Sort and Overall, African American Viewers

Category	Sort		All (n=20)
	Exemlar (n=10)	Free (n=10)	
Central square	5.8	5.7	5.75
Central circular	6.5	5.8	6.15
Hardedge graphic cartoon	4.7	1.9	3.30
Cubist	4.6	2.5	3.50
Stripes	5.5	5.4	5.45
Organic	5.3	5.1	5.20
Action painting	7.6	7.0	7.30
Geometric soft	5.4	4.6	5.00
Squares multiple	5.4	3.9	4.65
All	5.6	4.7	5.15

Table 11.2

Mean Number of Correct Paintings Within Each Category By Level of Training and Overall, African American Viewers

Category	Level of training		All (n=20)
	Naive (n=10)	Sophisticated (n=10)	
Central square	6.6	4.9	5.75
Central circular	7.3	5.0	6.15
Hardedge graphic cartoon	3.4	3.2	3.30
Cubist	3.2	3.9	3.50
Stripes	5.7	5.2	5.45
Organic	4.7	5.7	5.20
Action painting	7.0	7.6	7.30
Geometric soft	5.0	5.0	5.00
Squares multiple	5.7	4.6	4.65
All	5.3	5.0	5.15

Use of the "free" condition for sorting without exemplars greatly enhanced the ability of African American viewers to be sensitive to perceptions of ethnic or cultural attributes in the abstract paintings by these African American artists. Free sort viewers were more than twice as successful in their selection of these painters than their exemplar counterparts. By random selection, a mean of 1.1 would be expected, and the free sort participants' results are more than double chance (see Table 11.3). Viewers who were given target exemplars in the initial sorting task appeared to exhibit a lack of facility for determining a personal novel exemplar on which to prototype category members for the second or African American sort (Berlyne & Ogilvie, 1974; Posner & Keele, 1968).

African American students with formal training appeared to leave ethnicity out of their evaluations of the stimuli and to classify the paintings according to formal elements and qualities of visual images learned through instruction. As with many young specialists, perhaps they had abandoned an intuitive perception of what presumably was "African American" for a newly learned, more academic formula of evaluation and description. African American novices, on the other hand, apparently perceived another set of attributes pertaining to mood and interpretation and actually seemed more receptive to the cultural and personal tone within this abstract artistic form.

When using an arscine transformation to check the effect of small numbers of participants, for the number correctly chosen by each viewer, the observed significance level was almost statistically significant, $.05 < p < .10$, which means that as the sample size increases the significance of the scores will remain valid.

Works by Alma Thomas, Larry Erskin Thomas, and Sam Middleton exhibited the most perceivable cues of ethnicity or cultural attribution among these viewers (see Table 11.4). The Alma Thomas works can be found in two geometric structure categories, Central Circular and Stripes, predominantly because of the colorful linear brush patterns that became one of her more characteristic stylistic attributes. The Larry Erskin Thomas painting, found in the geometrical category, Central Square, is a highly designed canvas with structured central checkerboard patterning reminiscent of the Dogon. To augment the black and white shapes there are high- and low-intensity red colors. Sam Middleton's watercolor/collage exhibits organic structure and is found in a category called Cubist. The work is a visual collage of undulating dark and light shapes, patterned, textural, and accented with low red color.

Four paintings by Euro-American artists were selected, though incorrectly,

Table 11.3

Mean Number of African American Artists Correctly Chosen by Type of Sort and Level of Training, African American Viewers

| Type of Sort | Level of training | | All (n=20) |
	Naive (n=10)	Sophisticated (n=10)	
Exemplar	1.6	1.4	1.5
Free	4.0	2.2	3.1
❑All	2.8	1.8	2.3

Note. Because 11 of the 90 paintings were painted by African American artists, a mean of 1.2 pictures would be expected by chance alone.

Table 11.4

Paintings Chosen by 20 African American Viewers as Painted by African American Artists

| Painting | Exemplar | | Free | | All | |
	n	%	n	%	n	%
African American artists						
41 — Alma Thomas	5	50	5	50	10	50
214 — Sam Middleton	4	40	4	40	8	40
288 — Larry Erskin Thomas	3	30	5	50	8	40
90 — Alma Thomas	1	10	6	60	7	35
122 — William C. Huston	1	10	4	40	5	25
815 — Vivian Browne	1	10	4	40	5	25
44 — Alvin Loving	0	0	3	30	3	15
Non-African American artists						
305 — Stuart Davis	6	60	4	40	10	50
283 — Stuart Davis	4	40	5	50	9	45
114 — R. Pousette-Dart	4	40	4	40	8	40
26 — Theodoros Stamos	4	40	3	30	7	35
294 — Arthur B. Carles	3	30	4	40	7	35

with high frequency. These works presented predominantly an organic visual structure and were created between 1938 and 1948, the dates bordering the Great Depression and the immediate aftermath of World War II in America. In looking historically into the background and expressed motivations of the Euro-American artists selected, their works exhibited a thematic preoccupation with the American lifestyle of the period (1936-1948), which was at the time infused with "New World" philosophies and concepts, such as Negritude, jazz ("Negro music"), and African art ("Negro carving").

The attributes of the elements constituting cultural cues of similarity appear evident amid stylistic variations in the paintings, and may reside in color field selections, the handling of light, intensity of tonal patterns, or spatial design choices. Similar features were suggested by previously mentioned studies, and continued research concerning works of art and cultural response phenomena from certain viewing groups is in order to further isolate and expose some of the visual cues resplendent of a cultural Gestalt.

Conclusions and Implications

This study hypothesizes that cues of a particular visual aesthetic involving ethnic or cultural attributes are evident in abstract works by African American artists. Black American participants who questioned selectively the authorship of paintings that were (though unknown to them) created by African Americans during the pilot study of Hoard (1987) exhibited a trend in responses that promoted the necessity for this subsequent investigation. Both hypotheses were accepted, the results of which will contribute to the theoretical knowledge concerning prioritized responses to works of art and provide statistical information suggesting contemporary evidence of ethnic or cultural sensitivities among patterned responses from African American adult viewers of this particular style of Black American art.

The results of this investigation will certainly have an impact among studies that seek to quantify stylistic cue searching or scanning (Bruner, Goodnow, & Austin, 1956; Gardner, 1970) and among studies regarding any influence of ethnic sensitivities when scanning and evaluating works of art (Neperud et al., 1986). Current conclusions support and expand (a) the findings of Triandis (1964), Wober (1966), and McFee (1970), whose investigations of cultural variables affecting the process of human perception suggest that perception may develop along culturally determined understandings and biases; and (b) the research of Erickson (1977), who formulated a theory of perceptual features of culture in which populations share the tendency to favor one fusion of senses over another, resulting in the development of

165

intuitive traditional forms and understandings.

What are the implications for the current movement to a multicultural restructuring of curricula offerings? Indeed, what are implications for the educational reform movement in progress among institutional procedures in the preparation of teachers? Could this model provide strategies to enhance the perceptual responses of all students by expanding the conceptual framework of educational strategies to include positive instruction in the perception of stylistic visual similarities within nonobjective painting? Knowledge of evident categories (based on visual similarities) within such abstract image sources may enhance appreciation and desire for further exposure.

This study, which uses significant African American cultural art objects, reviews and evaluates perceptions of elements that express a cultural aesthetic, observing for any trend of convergence or pattern of agreement among viewers. This mode of inquiry may be creatively considered by other subject disciplines that seek to enhance perceptions among their learners in the multicultural classrooms of the continental 21st century.

Results such as these impel educators to review contemporary art training, recognize the impact of a cultural view, and teach to, and not away from, models that express differences from the Greco-Roman aesthetic norm. It is imperative that teachers, who are in the position to shape children's self-concepts and augment their strategies for learning, be able to distinguish and value equally the most significant acuities among multicultural populations of students in American public schools. It is precisely such cultural sensivitity that will eventually empower the necessary transfer of knowledge and skills connected with conceptual learning across disciplines, and in particular, with instruction and valuing in the visual arts.

References

Armstrong, R. (1971). *The affecting presence: An essay in humanistic anthropology.* Urbana: The University of Illinois Press.
Arnheim, R. (1954). *Art and visual perception.* Berkeley and Los Angeles: University of California Press.
Berlyne, D. E. (1974). New experimental aesthetics. In D. E. Berlyn (Ed.), *Studies in the new experimental aesthetics.* New York: John Wiley and Sons.
Berlyne, D. E., & Ogilvie, J. C. (1974). Dimensions of perception of paintings. In D. E. Berlyn (Ed.), *Studies in the new experimental aesthetics.* New York: John Wiley and Sons.
Berlyne, D. E., Ogilvie, J. C., & Parham, L. C. C. (1968). The dimensionality of visual complexity, interestingness and pleasingness. *Canadian Journal of Psychology, 22*(5), 376-387.

Bomstein, M. H. (1975). The influence of visual perception of culture. *American Anthropologist, 77*(4), 774-798.

Bruner, J. S., Goodnow, J. J., & Austin, G. A. (1956). *A study of thinking.* New York: Wiley.

Cesair, A. (1939). Cahier d'un retour au pays natal (excerpts). *Volontes,* Paris, (August), *20* (p. 42).

Daniel, V. A. H. (1982), March). The artist as professional: An ethnic-cultural perspective. *Journal of Career Education,* pp. 173-184.

DePillars, M. N. (1976). *African-American artists and art students: A morphological study in the urban Black aesthetic* (Unpublished doctoral dissertation, Pennsylvania State University, 1976). *Dissertation Abstracts International, 37,* 407-A.

Deregowski, J. B. (1972). Pictorial perception and culture. *Scientific American, 227*(5), 82-88.

Dewey, J. (1934). *Art as experience.* New York: Minton, Balch and Co.

Dumas, L. (1938). *Retour de Guyane.* Paris: J. Corti.

Ecker, D., & Baker, T. (1984). Multiple perception analysis: A convergence model for evaluating arts education. *Studies in Art Education, 25*(4), 245-250.

Eisner, E. (1979). Cross-cultural research in arts education: Problems, issues and prospects. *Studies in Art Education, 21*(1), 27-34.

Eisner, E. (1985). *The educational imagination: On the design and evaluation of school programs.* New York: Macmillan.

Erickson. E. (1977). Factors and patterns: The nature of sociocultural variation. *Behavior Science Research, 12*(12), 227-250.

Eysenck, H. J. (1942). The experimental study of the "Good Gestalt," new approach. *Psychological Review, 49,* 344-364.

Fouda, B. J. (1968). Negro-African oral literature. In *Colloquium: Function and significance of African Negro art in the life of the people and for the people.* Senegal: Editions Presence Africaine.

Frances, R., & Halasz, L. (1980). Comparative study of collative variables between French and Hungarian workers and university students. *Magyar Pszichologiai Szemle, 37*(1), 10-20.

Fry, R. (1920). *Vision and design.* Harmondsworth, England: Pelican.

Gaither, E. B. (1972). Visual arts and Black aesthetics. *ABA: A Journal of Affairs of Black Artists, 1*(1), 10.

Gardner, H. (1970). Children's sensitivity to painting styles. *Child Development, 41,* 813-821.

Gayle, A. (Ed.). (1969). *Black expression: Essays by and about Black Americans in the creative arts.* New York: Weybright and Talley.

Gayle, A. (1971). *The Black aesthetic.* Garden City, NJ: Doubleday.

Gayle, A. (1972). *The Black aesthetic.* New York: Doubleday.

Goldwater, R. (1968). The western experience of Negro art. In *Colloquium: Function and significance of African Negro art in the life of the people and for the people.* Senegal: Editions Presence Africaine.

Guptill, A. (1962). *Color manual for artists.* New York: Van Nostrand Reinhold.

Hardiman, G. W., & Zemich, T. (1985). Discrimination of style in painting: A developmental study. *Studies in Art Education, 26*(3), 157-162.

Hoard, A. (1987). Art trained and non-art trained subjects' classifications and evaluations of visual structure in nonobjective art (Unpublished doctoral dissertation, University of Illinois, 1986). *Dissertation Abstracts International, 47,* 2426-A.

Hughes, L. (1972). The Negro artist and the racial mountain, 1926. In A. Gayle, Jr. (Ed.), *The Black aesthetic* (pp. 167-172). New York: Doubleday (Anchor Books).

Locke, A. (1945). Up till now. In Albany Institute of History and Art, *The Negro artist comes of age: A national survey of contemporary American artists* (pp. iii-vii). Albany: Albany Institute of History and Art.

McFee, J. (1970). *Preparation for art.* Belmont, CA: Wadsworth Publishing Co.

Miller, R. (1973). Cross-cultural research in the perception of pictorial materials. *Psychological Bulletin, 80*(2), 135-150.

Morrison, K. (1979, Spring). A pan-American point of view. *Emergence,* pp. 11-12.

Neperud, R. (1970). Towards a structure of meaning in the visual arts: A three-mode factor analysis of non-art college student responses to selected art forms. *Studies in Art Education, 12*(2), 40-49.

Neperud, R., & Jenkins, H. (1982). Ethnic aesthetics: Blacks' and nonblacks' aesthetic perception of paintings by Blacks. *Studies in Art Education, 23*(2), 14-21.

Neperud, R., Serlin, R., & Jenkins, H. (1986). Ethnic aesthetics: The meaning of ethnic art for Blacks and nonblacks. *Studies in Art Education, 28*(1), 16-29.

167

O'Neal, J. (1972). Black arts: Notebook. In A. Gayle, Jr. (Ed.), *The Black aesthetic* (pp. 46-56). New York: Doubleday (Anchor Books).

Posner, M., & Keele, S. (1968). On the genesis of abstract ideas. *Journal of Experimental Psychology, 77,* 353-363.

Rosenberg, S., & Kim, M. J. (1975). The method of sorting as a data-gathering procedure in multivariate research. *Multivariate Behavioral Research, 10,* 489-502.

Senghor, L. (1939). Ce que l'homme noir apporte. In C. Verider (Ed.), *L'Homme du couleur.* Paris: Plon.

Skager, R. W., Schultz, C. B. & Klein, S. P. (1966). The multidimensional scaling of a set of artistic drawings: Perceived structure and scale correlates. *Multivariate Behavioral Research, 2,* 425-436.

Spellman, R. C. (1973). A comparative analysis of the characteristics of works and philosophies of selected contemporary mainstream Afro-American artists (Unpublished doctoral dissertation, New York University, 1973). *Dissertation Abstracts International, 34,* 3266-A.

Toldson, I., & Pasteur, A. (1976). Therapeutic dimensions of the Black aesthetic. *Journal of Non-White Concerns in Personnel and Guidance, 4*(3), 105-117.

Triandis, H. C. (1964). Cultural influences upon cognitive processes. In L. Berkowitz (Ed.), *Advances in experimental social psychology* (pp. 1-48). New York: Academic Press.

Vlach, J. (1978). *The Afro-American tradition in decorative arts.* Catalogue of an exhibition at The Cleveland Museum.

Wober, M. (1966). Sensotype. *Journal of Social Psychology, 70*(3), 181-189.

Wolfflin, H. (1915). *Kunstgeschichtliche grundbegriffe.* Munich: Bruckmann. *(Principles of art history.* New York: Dover, 1950.)

12

An Eskimo Village School: Implications for Other Settings and Art Education

JOANNE KURZ GUILFOIL

Eastern Kentucky University

This chapter presents a study of one Eskimo village school (Kurz, 1983) designed to examine several aspects of formal schooling. Following a brief history, the school is described in terms of its architectural design, student and teacher behaviors, and student attitudes toward school. Physical, behavioral, and social attributes of the school are identified and used to suggest implications for the study of other cross-cultural school settings. The data-gathering techniques are discussed throughout, with suggestions for additional experimental art education activities and projects.

The School

Selection of this school as the research setting was based on a pilot study and advice from other researchers to study formal schooling of a homogeneous group of people in a spatially restricted environment (Kurz, 1983). The selected site was a one-room school in a rural Eskimo village of Akiak in southwest Alaska in which I was hired as a co-teacher for the 1981-82 school year. During the first two years of operation (1980-1982) school was conducted in four different settings with native and nonnative teachers and a variety of accommodations for heat, running water, toilets, hot lunches, materials, and equipment (Madsen, 1983).

A total of 12 to 16 elementary students (ages 4-13) in preschool through the eighth grade and three teachers served as sources of information to develop a description of day-to-day classroom affairs. Observations were conducted in the one-room school during three months of a school year (January-March 1982). During participant observation architectural design ideas,

Design Ideas and Classroom Spaces

Design Ideas (Kleinsasser, 1981)...applied to each area below
Place
Purpose
Longevity
Space
Time
Technical Systems

Figure 12.1. Design ideas and classroom spaces.

Classroom Spaces (Kurz, 1983)

Active Teaching Spaces	Focused Public Spaces	Non-Focused Public Spaces	Administrative Spaces
Three active teaching spaces	Bathroom Library Lunchroom Heater/fountain Computer/typing	Outside Entrances Middle floor	Machines/cabinet Teacher desks Kitchen Shower/laundry

Figure 12.2. Classroom spaces (Kurz, 1983).

behavior mapping, and cognitive mapping were adapted and used as descriptive techniques to gather data about students' behavior and experiences of school.

The School Setting

The physical setting of the school was described with data from architectural design ideas (architectural analyses), behavior maps (coded notations on a series of floor plans) done at regular intervals, and behavior sketches (a series of drawings done at regular intervals).

Data from the design ideas (Kleinsasser, 1981) were used to illuminate two recurring critical issues: appropriate spaces for current users and original intentions of the designer about purposes of the building. For example, during one school year (1981-1982) the teachers established "house rules" to maintain the water fountain, sinks, and toilet and to prevent the pump, drains, and pipes from freezing (Kurz, 1983). One problem was that many types of people used this facility. A single definition of "appropriate" was difficult in such a multipurpose, cross-cultural setting without specifying "appropriate" to whom or for what purpose (see Figure 12.1). Findings from the design ideas were summarized according to the classroom spaces. Related design attributes may have influenced student and teacher behaviors and, possibly, attitudes toward school but did not appear to cause them (see Figure 12.2).

Data from behavior maps and behavior sketches were used to describe and identify small social distances between students and staff as the most important variable and characteristic of the school (Kurz, 1983). In addition, choice of language (both English and Yup'ik) and student body position (usually informal) also became key characteristics and attributes of this school setting (see Figures 12.3 and 12.4). Behavior maps were used to record student and teacher locations and movements. Behavior sketches were used to observe and record various student and teacher body positions and small social distances. All observed variables may have been influenced by house rules (school policy). Comparison of data from another public school classroom in the village was used to support characteristics specific to this one-room school and to identify attributes (see Figure 12.5).

Data from cognitive maps were used to identify five variables as attributes and to focus on the category of people (teachers and friends) as the most influential variable from the students' perspective. The other four variables mentioned in varying degrees were places, things, activities, and rules.

Behavior Map (Kurz, 1983)

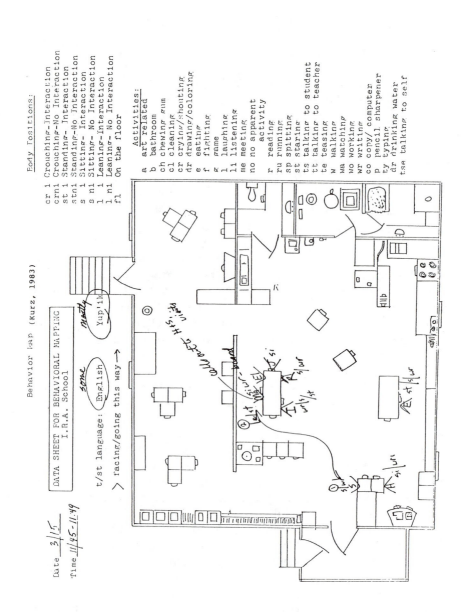

Body Positions:

cr 1 Crouching-Interaction
crn1 Crouching-No Interaction
st 1 Standing- Interaction
stn1 Standing-No Interaction
s 1 Sitting- Interaction
s n1 Sitting- No Interaction
l 1 Leaning-Interaction
l n1 Leaning- No Interaction
fl On the floor

Activities:

a art related
b bathroom
ch chewing gum
cl cleaning
cr crying/shouting
dr drawing/coloring
e eating
f fighting
g game
l laughing
ll listening
me meeting
no no apparent
 activity
r reading
ru running
sp spitting
st starting
ts talking to student
tt talking to teacher
te teasing
w walking
wa watching
wo working
wr writing
co copy/computer
p pencil sharpener
ty typing
dr drinking water
tse talking to self

DATA SHEET FOR BEHAVIORAL MAPPING
I.R.A. School

Date 3/5

Time 11/45- 11/49

t/st language: English some Yup'ik mostly

⟩ facing/going this way →

Behavior Sketch (Kurz, 1983)

$11:40 — 11:47$

all around the
shouting words

Meaning Attributes (Kurz, 1983)

Behavior Maps					Behavior Sketches		
K/1st	P	K/1st/P	Big Kids		P	K/1st	Big Kids
languages	languages	languages	languages		student	student	student
student	student	student	student		body	body	body
body	body	body	body		position	position	position
positions	positions	positions	positions		student	student	student
student	student	student	student		location	location	activity
activity	distance	distance	activity		teacher	teacher	student
student	from	from	student		body	body	location
distance	teacher	teacher	location		position	position	teacher
from			teacher		teacher	teacher	body
teacher			activity		location	location	position
			teacher		student	student	teacher
			location		distance	distance	activity
			student		from	from	teacher
			distance		teacher	teacher	location
			from				student
			teacher				distance
							from
							teacher

Figure 12.5. Meaning attributes (Kurz, 1983).

However, people appeared most frequently in students' writings and drawings (see Figure 12.6). Classroom experiences included essays, interviews, picture taking, photo interpretation, and an adapted cognitive mapping technique. These modified mapping techniques were familiar tasks and perceived by students as fun. Most activities were group tasks that may have been more appropriate here than in past one-on-one procedures (Kurz, 1983).

Implications for the Study of Other Cross-Cultural Settings

Several of the observed characteristics of this one-room village school can be used to suggest implications for other cross-cultural school settings. For example, problems with the technical systems (plumbing and heating) were due in part to cultural differences among the designers, builders, and users of the building. If the teachers, Eskimo students, and villagers had had more of a role in the initial design process or information concerning maintenance, perhaps portions of the building and its appliances would not have been in a constant state of disuse, misuse, or disrepair. For instance, one student suggested that the new electric heater be replaced by the original oil stove, which was quieter. Then at least the room would stay warm when the electricity went out, which happened regularly, and the noise level would remain constant. Other design-related problems might have been prevented (and could be prevented in other similar settings) if the intended user group had provided input during the building design process.

Specific cultural groups could also influence school policy to ensure the most effective learning environment for their children. For example, this Eskimo village school was established by a group of concerned parents (Madsen, 1983). To me, the most notable characteristic of the school was the small social distance between students and teachers. This seemed to provide a familiar and effective learning situation for these students, and it was also an important part of this school. Similarly, students' language choice (English or Yup'ik) and body position (formal or informal) were also effective characteristics and could easily be adopted in other cross-cultural settings.

Finally, as in all school settings, but particularly cross-cultural settings, teachers and researchers could benefit greatly by soliciting student opinions. For example, in this study some of the observed data were used to identify the relative importance of people (e.g., social distance). Although I placed much weight on the importance of building design (e.g., noise, cold, and lack of space), the students' writings, drawings, and photos demonstrated that four walls, equipment, and materials do not necessarily make

175

Places Attributes (Kurz, 1983)

Student	Place Attributes	Details
Ri	people	(students, Ma)
	activities	(Math, drawing, games, mousenuts)
R	activities	(play)
	places	(outside, inside, gym)
	people	(students, J, no people)
	things	(computer, monkeybar, heater, dogs)
I	people	(students, Ma)
	things	(inside and outside)
	activities	(art, SRA, food, singing, playing)
	places	(BIA, IRA, river, spring camp)
El	things	(much detail for objects in school)
	places	* (outside, inside — much detail)
	activities	(some school, most outside, playing)
	people	(various representative, sometimes just people)
J	people	* (various representative detail; students and teachers)
	activities	(variety, school subjects)
	things	* (computer, graphic representative)
	places	(only context for people and activities)
S	people	* (drawing styles, friends, teachers)
	places	(bathroom, lunchroom)
	things	* (furnace, water fountain)
	activities	(special events, subjects)
	rules	(starting school day)
H	people	(students, teachers)
	places	* (detail! compare school rooms)
	things	* (furnace)
	activities	(identified, described, compared)
	rules	(snuff, fighting, rules are good)

*Research questions identified

Figure 12.6. Place attributes (Kurz, 1983).

Cognitive Map (Kurz, 1983)

4a. IRA, This Year (Floor Plan)

a school. Memories of their friends and teachers, past and present, seemed to be more important than all other items and categories. This finding, although characteristic of these schoolchildren, might also be valid in many other school settings.

Implications for Art Education

The data gathering techniques used to support these findings can also be employed in experimental art activities and projects. For example, the design ideas could be used with any group of students for description, evaluation, and perhaps redesign of classroom spaces and other settings. These visual critical processes are similar to those already practiced in art criticism. Only the subject matter is expanded to include critical analyses of architectural spaces, including acknowledgment of cultural differences in use of space and architectural design. Educators, researchers, and designers could work together, using these design ideas, to identify appropriate physical settings for specific cultural groups.

Next, behavior mapping, behavior sketching, and cognitive mapping could be modified for student use as visual tools to inquire about people in places. Students could then (a) describe limitations and opportunities of school spaces and other settings, (b) use drawing and writing as instruments for learning about specific places and groups of people, (c) discover meanings of human behavior in various places, and (d) practice visual description, analyses, and judgment of places (Guilfoil, 1986). In addition, educators, researchers, and designers could use these techniques in a predesign program for a classroom, a school, or other spaces designed for children. Knowledge of children's use of space is needed and could be applied to specific design projects for specific cultural groups if it were available in a useable format. These mapping techniques provide comprehensive information in comprehensible formats for designers as well as researchers and educators.

These projects would help us move beyond vague appeals for aesthetically attractive classrooms toward specifying physical contexts for various cultural groups and educational activities. As art educators, we need to help students evaluate classroom design and other settings they use. Students of any age or cultural group could participate at appropriate levels of analyses in the design and evaluation processes.

178

References

Guilfoil, J. K. (1986). Techniques for art educators in architectural design research and evaluation. *Art Education, 39*(2), 10-12.

Kleinsasser, W. (1981). *Synthesis.* Eugene, OR: School of Architecture and Allied Arts, University of Oregon.

Kurz, J. (1983). *Classroom spaces: A descriptive case study of a one room school in Alaska.* Unpublished doctoral dissertation, University of Oregon.

Madsen, E. C. (1983). *The Akiak "Contract School": A case study of revitalization in an Alaskan village.* Unpublished doctoral dissertation, University of Oregon.

13

Children's Drawings:
A Comparison of Two Cultures

W. LAMBERT BRITTAIN

It is well established that children's art goes through predictable stages of development (Lowenfeld & Brittain, 1982). The stages are most clearly defined at the younger ages, with most children scribbling before the age of four; this is followed by a stage of head-feet representation with objects floating on a page, which is followed at about the age of six by a definite baseline at the bottom of the page with objects resting firmly on this. This latter stage is primarily two-dimensional; objects are drawn separately and oriented toward the viewer. The stages of development in drawing seem to be consistent in Western societies (Luquet, 1927; Lansing, 1969; Leeds et al., 1983). The same developmental stages are so clearly marked that it appears that there may be biological factors involved and that growth in art is somewhat predetermined in the same way that physical growth goes through predictable patterns.

There has been some debate as to the effect of culture and environment on children's drawings. A fair amount of literature compares the drawings by children from various cultures on the Goodenough-Harris Draw-a-Man-Test. For the most part, this tends to show that youngsters from other than Western cultures score somewhat lower in mental maturity on this scale (Scott, 1981). However, the Draw-a-Man-Test deals only with the human figure and does not take into consideration other factors in the drawing act.

Differences in societies can be seen through their art products (Dennis, 1966), not merely through the reproduction or representation of objects but also through the techniques or method of reproduction. It is not surprising that children adapt to these cultural patterns, and drawings by eight- or nine-

Printed with permission from *Journal of Multi-cultural and Cross-cultural Research in Art Education,* Fall, 1985.

year-olds from various countries show different environmental influences. It is not as clear whether early representations by children who have just progressed beyond the scribbling stage will show cultural differences. In a study of drawings by children from six cultures, Alland (1983) claims that cultural influences appear early and strongly affect children's drawings, and although he presents no statistical analysis of his data other than his own observations, Alland feels that the generally accepted stages of development beyond scribbling may be false. Deregowski (1978) argues that exposure to representational art through books and schooling affects children's drawings by suppressing the emergence of ideographic or stick-figure representation. Morley (1975) gathered drawings by Australian children: White, urban Aboriginal, and traditional Aboriginal. He states that the pattern of development for all three groups follows an identical growth structure.

There does seem to be some difference of opinion. On the one hand, it appears that the cultural setting may play an important role in limiting or directing a young child's drawing; on the other is the view that cultural influences are minimal and that the drawings of young children exhibit a universal pattern reflecting a commonality of cognitive growth.

Two separate and distinct locations were chosen for this study. One was in upper New York state, the other was on the Aboriginal reserves in Queensland, Australia. The former is primarily urban and suburban, filled with houses and apartments, where streets are crowded with cars and buses, stores and supermarkets are plentiful, and television and coloring books are readily accessible. In sharp contrast, the Queensland locations are devoid of the trappings of the New York culture. Instead, the Aboriginal family is apt to be seminomadic or to live in a row of government-built houses up on stumps or stilts. The occasional car might belong to a local health officer, and possessions are minimal. These family groupings live on isolated reserves in the "Outback" or in the rainforest areas on the Cape York Peninsula. There is no implication that one of these settings has more "culture" than the other, merely that these are diverse locations. However, it has been over 20 years since Mountford (1961) called the Australian Aboriginals probably the most primitive of any living people. The efforts of the Australian government notwithstanding, the traditions of a proud people are rapidly disappearing, and it is doubtful that in another 20 years many of the distinctive features that set these people apart will continue to survive.

It is hypothesized that children of four or five years of age from diverse backgrounds will show similarity in their early representations.

Method

Subjects

Drawings were collected from children of four to eight years of age in both the New York and Queensland areas. The New York children were enrolled in various public schools located in towns and small cities. Many of the children were brought to school by bus from the surrounding rural areas. The population could be said to be typical, with single family dwellings, apartments, one car, one or more television sets, newspapers and magazines delivered regularly. Out-of-school activities were often adult supervised and age segregated, with a fair amount of time spent in television watching. The Queensland children were in what were formerly mission schools and presently operated by the Department of Aboriginal and Islanders' Advancement. The schools were located on reserves that were inaccessible, because of location and strictly enforced regulations, to the White Australian population. Although some locations had government-constructed, one-room shelters, there were no cars, no televisions, no buses, and no native-language newspapers or magazines. Some of the families stayed at one location for a limited length of time, and the school population tended to decrease rapidly beyond the first few grades. The children were required to wear a garment to cover the torso while in school, but feet were bare. Activities outside school were unsupervised and included practicing physical skills, catching wildlife, finding edible grubs, and playing cooperative games. It should be noted that not all Aboriginal children are on reserves. Many families have left the isolated areas and are living in or close to the populated areas. These children generally attend nonsegregated schools and their drawings are not included in this study.

Some 1,000 children were involved in the New York sample and about 300 Aboriginal children in the Queensland sample. The drawings by four- and five-year-olds were of particular interest. In New York State these children were from local nursery schools or daycare centers; in Queensland they were being oriented as part of a preschool or "kindy" program and were contacted during the first few weeks of attendance.

Materials

All of the drawings from the children in the New York sample were done on 8-1/2 by 11 inch paper. The drawing tool was a black fiber-tipped pen. The drawings from the Queensland sample were done on white paper 20 by

30 centimeters with a similar pen. A few of the Australian drawings were done on somewhat larger paper with pencil when the standard materials were not available.

Procedure

In both samples the drawings were collected under comparable conditions. A short discussion was started with the children about "Eating." Eating was selected because it was a topic believed to be universally interesting and because it would provide the opportunity for drawing both a human figure and some environment.The children were asked what their favorite food was and where they ate. Other questions such as "When do you eat?" or "Whom do you eat with?" were often asked to stimulate a discussion. Once it was obvious that children were aware of the topic, paper was handed out with the drawing tools, and the children were asked to draw a picture of "Eating."

The author in many instances led the discussion; in other cases it was an assistant or the teacher in charge, as in some of the isolated Aboriginal settlements where children were more conversant in their own regional dialect. All the drawings were saved, dated, and marked according to the sex and age of the child and the location where collected.

Analysis

For the purpose of analysis, the study was divided into two sections. The first section dealt primarily with an objective evaluation of the developmental levels of the two samples. The primary concern was whether differences could be seen in how the drawings were executed, in the way in which the objects were portrayed, and in the amount of detail shown. The second section dealt with a more subjective analysis. This included a study of the subject matter, the portrayal and use of space, and the relationships between the objects within the picture.

Section 1. Drawings by four- and five-year-olds were selected from the two groups, matched according to sex, age, and subject matter. The drawings were examined, and ranged from scribbles to detailed portrayals of eating. Although more children from the New York sample attempted interior scenes and the Aboriginal drawings showed more outdoor fires, these were not considered as features that would bias judging procedures. A few drawings had to be set aside because of particular characteristics that quickly revealed their source. Some of the New York drawings included an automobile, a picnic table, a television set, or a stove, and some of the

drawings from the Aboriginal sample included a palm tree, a kangaroo, or a house on stilts. These drawings were saved for the second analysis. Forty drawings were thus selected, 20 from each group.

Figure 13.1. Examples of eight steps of development used as basis for judging the drawing by four- and five-year-old children.

A scale was devised on the basis of the normal Western developmental sequence that is exhibited in most children's drawings. The scale consisted of eight steps illustrated by visual and verbal descriptions (see Figure 13.1). These steps were (a) a scribble composed of random marks, (b) a scribble with concentrated marks or filled-in areas, (c) an attempt at making closed forms, (d) closed forms with representation attempted, (e) the beginning of recognizable shapes but no relation between these, (f) clearly recognizable shapes but objects floating and unorganized, (g) objects defined and related to one another, and (h) pictorial representation showing some attempt at proportion.

All of the 40 drawings were photocopied so that the slight differences in paper size would not be a clue as to the origin of the drawings. Three judges sorted these copies basing their judgments on the eight-point scale. Each drawing was given a rank order using a composite score from each of the three judges.

Section 2. The second analysis was primarily a comparison of content

between the two samples of drawings. For this aspect of the study approximately 300 drawings were used, including some of the drawings by four- and five-year-olds previously set aside and drawings by children up to age 8. These drawings were spread out on large tables, and listings were made of the apparent differences between the drawings from the two populations.

Three areas were examined in detail. The first was the subject matter. Notation was made of the occurrence of objects in the drawings by each of the populations, and a record was made of the differences that existed. The second area examined was space. Of particular interest was the amount of space used and the space left between objects. The third area examined was the relationship between objects; did the objects have any size relationship or functional relationship, and did they have any common baseline?

Results

Section 1

The first section of this study attempted to determine the developmental level of the drawings from the two populations. Three judges had distributed the drawings on an eight-point scale. A Spearman Rank Order Correlation between each pair of judges was .91, .89., and .89. The three scores were added, giving a possible range from 3 to 24 for the drawing. The mean score for the Aboriginal group was 13.85, with a range from 3 to 22. The mean score for the New York group was 15.5, with a range from 7 to 24. A t test for the difference between sample means indicated that the groups were not significantly different at the .05 level of confidence.

Although the New York State group scored higher on the eight-point scale, the differences were small and could have occurred by chance. In some instances an individual child from the Aboriginal group scored higher than the matched child from the New York State sample, and vice versa.

Section 2

In an analysis of the content of the drawings from the two populations, certain subject matter differences were apparent.These differences became obvious in some drawings by children as young as five years of age. The presence of palm trees, alligators, and houses on stilts in the Aboriginal drawings set them aside as being from a culture different from New York State. However, in those drawings in which only the food and the child appeared, there were no stylistic indications as to the source of the drawings, particularly in the drawings by four- and five-year-olds. It was also noted

that many of the children in the New York sample portrayed themselves eating inside a house. Most of the Aboriginal population drew themselves either outside of the house or gave no indication that they were showing themselves inside a structure. Space was a second factor looked at. There seemed to be no differences in the amount of space used on the page, but the Aboriginal population tended to elaborate more, putting a greater amount of detail on certain items. The novelty of the drawing tool, which was not a common instrument in their schools, may have prolonged the drawing time and thus affected the amount of detail.

Figure 13.2. Typical drawings by seven-year-old Aboriginal children (top row) and New York State children (bottom row).

The populations showed some differences in the way they portrayed relationships between objects. The New York children had a baseline at the bottom of the page much more frequently than did the Queensland children. By the age of seven, nearly all of the New York sample used a baseline, either a definite line or the bottom of the page to which everything was anchored. Few of the Australian sample used this device; instead, objects tended to float on the page, seemingly unattached to a ground or baseline. Although objects were portrayed so that their bases or feet were spatially oriented in a consistent way, they were drawn on different planes with

objects often shown above one another.

Table 13.1 shows the percentage of drawings that use a baseline, at each grade level from nursery school to fourth grade. Ages were not readily available for children beyond the nursery school in the Aboriginal schools, so the grade level is used for comparisons. The third grade appears as the peak of the baseline use. The decrease in use of the baseline in the fourth grade indicates other means of space representation, notably attempts at perspective or three-dimensionality for the New York State sample.

Table 13.1
Percentage of Children Using a Baseline

| | | | Grade Level in School | | | |
	N	K	1	2	3	4
Aboriginal	0%	0%	50%	10%	37%	26%
New York State	2%	8%	58%	95%	98%	87%

Discussion

It seems clear from the results that the four- and five-year-old children drew surprisingly similarly regardless of whether they were New Yorkers or Australian Aboriginals. Cultural differences seemed to become more apparent as children became more proficient at drawing their environment. Aboriginal children on reserves are isolated from many of the pictorial images of today's modern society. They are not exposed to multiple images, see little in the way of posters, are not bombarded with television advertisements, rarely have seen picture books or cute stereotypes on nursery furniture, and in fact have lived for their four or five years in isolation except for other Aboriginal children and their own extended family. Except possibly for a drawing in the sand by older children, these youngsters would not have been exposed to art in the Western mode before attending school.

On the other hand, the New York urban and suburban population is constantly bombarded with printed images. A young child cannot escape from a continual exhibition of pictures, screens, photos, and displays. It is therefore interesting to note that these two populations follow an identical pattern of development during the first few years of representational attempts, with cultural differences not becoming obvious until about six or seven years of age.

One of the differences between the New York State sample and the drawings from the Aboriginal group was the limited use of the baseline in the Aboriginal sample. The pictures that appear in story books readily

available in New York present the world as being viewed from a single viewpoint outside the picture plane. The same is true of television, where the screen is perpendicular to the floor and the images are seen as viewed through a vertical frame. On the other hand, Aboriginal children were not exposed to such images and may therefore have no reason to portray their environment on paper as if it were a screen or vertically placed page. Instead, the drawings might be viewed more as a map with symbols placed one above the other as if seen progressing through space. Hess-Behrens (1973) found that isolated Brazilian children made many small baseline drawings arranged in a repeat pattern somewhat resembling a textile design.

It is interesting that the present findings regarding a baseline do not agree with those by Morley (1975), who found no differences between traditional Aboriginal, urban Aboriginal, and White children's drawings. He had hoped to obtain drawings that were "free," that were executed from the children's own thinking. But owing to the inaccessibility of many of the remote locations from which he secured drawings, he was unable to see all of them being produced. He mentions that certain factors bear considera-tion. In the Aboriginal schools some drawings were apparently similar, and in one instance almost identical, as if the drawings resulted from dictated lessons, and others seemed as if the child was repeating a skill to master it. However, Morley seemed to feel that copying was not more prevalent among the traditional Aboriginals, and occurred less so with younger children.

The drawings in the present study were, for the most part, gathered by the author with near identical discussion. Part of the activities observed in both populations included copying pictures: American Indians in full ceremo-nial dress in one Aboriginal school room and Pilgrims in a New York State school, yet the "eating" drawings did not seem to be influenced by these activities.

Other than the portrayal of indigenous subject matter, the difference in baseline usage was the most striking contrast between the two groups of drawings by children over six years of age. To what extent the use of the baseline is a result of viewing pictures or cartoon strips can be questioned, but the proliferation of visual symbols seems to be part of upper New York State's socioeconomic standards. The Aboriginal population in Australia has a different set of standards, and the rock carvings and cave paintings indicate that the usual Western spatial organization was never used even by artistic adults. Their art provides a very tangible link with the past because there is no record of a written language, and images were painted and repainted to keep alive the myths and customs of a people. Most of these paintings have been kept sacred and were shown neither to women nor

189

children. It is doubtful that any children in the present investigation were exposed to these art forms, at least not to the extent that New York children are shown pictures and read to as part of their usual daily activities. It would seem therefore that the traditional art forms of the Australian Aboriginal grow from a different set of drawing conventions, discernable as early as seven years of age.

Gardner (1980) has pointed out that different cultures have evolved different graphic solutions, and that in preliterate societies the drawings system arrived at in early childhood may be adequate for adult art expression. Evidence in this study gives some indication that drawings may evolve along divergent routes. The concepts of a baseline and the organizations of drawings as if projected on a vertical surface are natural outgrowth of a society that depends on words and symbols displayed on a similar surface. However, other solutions to graphic expression are possible, and the Australian Aboriginal youngsters seem to have relied more on a system of depicting their environment as if on a horizontal surface and show direction and distances as if on a map. It would seem that either solution is adequate and that no inferences can be made about the superiority of one drawing system over another.

In examining the data, it appears that the early stages of artistic development are predetermined and invariant. The scribbles and early attempts at representation look surprisingly similar in both populations. This gives added support to Kellogg's (1979) thesis that "the child's mind works similarly in art the world over." It is only after 6 years of age that these drawings by children can be differentiated. Beyond this point the stages of development as seen in the drawings by New York State children may no longer be applicable for children in a non-Western society.

Drawing is a reflection of what and how children think. With little or no difference between the graphic expression of these two diverse populations of children under the age of six it can be argued that cultural differences play a minor role in the development of early drawing expression.

References

Alland, A., Jr. (1983). *Playing with form: Children draw in six cultures.* New York: Columbia University.
Dennis, W. (1966). *Group values through children's drawings.* New York: Wiley.
Deregowski, J. (1978). On examining Fortes data: Some implications of drawings made by children who have never drawn before. *Perception, 7,* 479-484.

Gardner, H. (1980). *Artful scribbles: The significance of children's drawings*. New York: Basic Books.

Hess-Behrens, B. M. (1973). *The development of the concept of space as observed in children's drawings: A cross-national cross-cultural study*. Berkeley: University of California Press. (ERIC Document Reproduction Service No. ED 101 849)

Kellogg, R. (1979). *Children's drawings/children's minds*. New York: Avon.

Lansing, K. (1969). Art, artists, and art education. New York: McGraw-Hill.

Leeds, A., Dirlam, D., & Brannigan, G. (1983). The development of spatial representation in children from five to thirteen years of age. *Genetic Psychology Monographs, 108,* 137-165.

Lowenfeld, V., & Brittain, W. L. (1982). *Creative and mental growth*. New York: Macmillan.

Luquet, G. H. (1927). *Le dessin enfantin*. Paris: Alcan.

Mountford, C. P. (1961). The artist and his art in an Australian aboriginal society. In M. W. Smith (Ed.), *The artist in tribal society*. New York: Free Press of Glencoe.

Morley, M. (1975). *Findings one: A survey into the nature of children's drawings*. Keswick, S. Australia: Torrens College.

Scott, L. H. (1981). Measuring intelligence with the Goodenough-Harris drawing test. *Psychological Bulletin, 85*(3), 463-505.

Note

I wish to thank the director and staff of the Queensland Department of Aboriginal and Islanders Advancement for their permission for and assistance in gathering the children's drawings from the various Aboriginal communities.

14

Multiculturalism and Art Education

JUDITH MARIAHAZY

Arizona State University

If a man does not keep pace with his companions, perhaps it is because he hears a different drummer. Let him step to the music which he hears, however measured or far away. (Henry David Thoreau 1817-1862)

The United States of America is populated with peoples of many different backgrounds, cultures, and ethnic and racial origins. These different groups of people and individuals within these groups all march to culturally "different drummers," especially in relation to the White majority. As a result of this diversity, we have a richness of cultural creativity unseen in many other countries. Unfortunately, American education has primarily consisted of the use of the "melting pot" concept in educating our youth (Craft, 1984; Grigsby, 1977; Litsinger, 1973; Mason, 1988; Sadker & Sadker, 1988; Saville-Trioke, 1984; Stuhr, 1986).

Such educational practices have not only caused alienation and low self-esteem among these minority groups but have also cost our nation countless varied artistic creations. This chapter will explore the topic of multicultural education as it relates to the teaching of the visual arts in public schools.

Multiculturalist art educators have been divided into four categories by Ralph Smith. Exegetal multiculturalists interpret foreign cultures on the basis of their own personal viewpoints, primarily to criticize the society of which they are members.

Individuals who maintain that their own culture is superior to those of others, and thus profess the conformity of other cultures to their own, are considered to be dogmatic multiculturalists.

Agnostic multiculturalists are more interested in the collecting of "exotic artifacts" than they are in the historical and cultural contexts of these objects

193

and are dismissed by Smith as having rather shallow interests.

The fourth type of multiculturalist has a dialectical approach. This individual has few preconceived notions about a particular culture and avoids any judgments based on his or her cultural values. "They are willing to engage with and learn from alien cultural traditions with a view to improving their knowledge of self and of the right relations of self to culture" (Mason, 1988, p. 2).

The dialectical multiculturalistic approach is the one considered most suited to art education by Rachel Mason and was used for her research conducted at two racially integrated inner-city schools in Leicester, England. Mason suggested that "subjective knowledge" rather than facts and information should be exchanged to help foster the understanding and respect of other cultures. However, it is difficult for an individual without a sense of his or her own cultural identity to participate in such an exchange (Mason, 1988, p. 35).

Robert Jeffcoate has criticized this approach because it does not directly address racism, and as a result is ineffective in eliminating racist beliefs (Madiano, 1982, pp. 490-495). Mason's research in Great Britain found that teachers encouraged face-to-face interaction and multicultural conversation among students. However, there were no discussions of physical characteristics and racial origins. In fact, questions raised by the students were often ignored.

Mason's study concluded that there should be three orientations of multicultural art education. The global orientation would offer the student a greater variety of cultures than simply the Anglo-European. The ethnic orientation would encourage appreciation and a higher esteem for the arts of local minority people. An antiracist approach would include materials and class discussion that would directly fight racism (Mason, 1988, pp. 36, 87).

These orientations did not specifically propose that the enhancements of self-esteem among minority students should be a part of the art education curriculum. However, it was pointed out that rarely are the artistic endeavors of minority cultures included in the typical study of art in public schools. Therefore, the implication is that these cultures have contributed little to the knowledge and art of mankind (Mason, 1988, pp. 22, 24).

This implication of minor contributions by ethnic people is very evident in the "melting pot" theory of education by assimilation. Such assimilation was attempted with Native Americans, with little regard for their own

culture or beliefs, leaving them with the impression that their own culture was of little value. As a result, the Native American's self-image depends primarily on the image "held by the dominant white society" (Noffz, 1984, pp. 22, 58).

Class discussions of Native American art should include contemporary artists and not only the historic and prehistoric art produced. If their self-esteem is to be maximized, Native American students must be able to relate to successful adults of their own ethnic group (Grigsby, 1977).

Mexican Americans would also benefit from increased self-esteem resulting from the inclusion of the study and production of their art in schools. A letter to the editor published in *The Arizona Republic* on July 21, 1974, states:

> *Mexico abandoned us. We have no ties or claims there. How, then are we Mexican? The U. S. denied us full citizenship and its people, the unhyphenated Americans, treated us for the most part, a goodly amount lower than human. Where are we then Americans? (cited in Grigsby, 1977, p. 14)*

"It gradually became clear that the identity crisis [for Mexican Americans] might be a crucial factor in the production of creative expression," said Grigsby, after experiencing difficulty in locating successful artists of Mexican heritage who were previously poor (Grigsby, 1977, p. 15).

One goal of Mexican Americans is to be recognized as an ethnic entity in a cultural setting. "Chicanos feel educators do not recognize and understand their unique qualities" (Litsinger, 1973, p. 77). There is a constant search for self-identification and recognition that should not be ignored by art teachers. Examples of art from Mexican artists, as well as local Hispanic artists, need to be included in class discussions because it is difficult to locate written material (Grigsby, 1977, pp. 15, 17).

There is little doubt that Blacks in America have been struggling with low self-esteem for centuries. "Separate but equal" schools clearly communicated to Black children that they were not equal.

> *It was never the hardship that hurt so much as the contrast between what we had and what the white children had ... our*

seedy run down school told us that if we had any place at all in the scheme of things it was a Separate place, marked off, proscribed and unwanted by the white people ... whatever we had was always inferior. (Sadker & Sadker, 1988, p. 465)

The visual arts can be a very effective way to help instill pride and self-esteem in Black children who desire some way to express themselves. Viktor Lowenfeld, one of the premier art educators in the United States, realized the need for self-actualization and self-development. He immigrated from Austria, where he was an artist and art educator, to teach psychology at Hampton Institute (Hampton, Virginia), a college for Black youth. Lowenfeld successfully initiated the visual arts program at Hampton Institute by convincing the school president to allow him to offer a zero-credit evening drawing class. Of the 750 students enrolled at Hampton Institute, 700 showed up for this class. As a result, a visual arts major was made available.

This beginning drawing class was attended by John Biggers (presently a renowned artist and teacher). He had previously been enrolled in a course of study to become a plumber. Although he was interested in art, he had never before been exposed to Black artists and thus had never even considered art as a possible profession (Grigsby, 1977, pp. 132-133). How many fine Black artists have been lost simply because of a lack of role models and the motivation for self-expression?

My work is drawn from personal experience. Things that are important to me. More often than not my subject matter is Black people, but this is what is closest to me, and it does not make me a Black artist, but rather only an artist trying to relate experiences. (Van Lewis & Waddy, 1971, p. 18)

Global and ethnic appreciation in art education would be a major benefit of multicultural education. An appreciation for the richness of many other cultures would be fostered among our youth. Art and creativity would be enhanced through the exposure of budding artists to varied stimulation. Although research has shown that parents often do not favor the inclusion of school lessons (Craft, 1984) pertaining to cultures other than their own, the benefits to their children of receiving such lessons may convince them otherwise. The study of and appreciation for the art of ethnic minorities should not consist of schoolchildren copying these art forms but permit the

interpretation by students through their own creativity (Noffz, 1984, p. 37).

One of the most significant benefits of multicutural art education may be the elimination of racist attitudes. Mary Dillard, of Stanford's Black Student Union, says that "there is an appalling ignorance among many students about other cultures and that leads to trouble." Recent racist incidents at the University of California at Berkeley have resulted in the administration proposing a new course requirement. The American cultures requirement would provide students with knowledge about contributions made by the four largest groups of ethnic minorities in the United States.

> *We've created in such short order such a substantial diversity of people here that some self-conscious attempt to address the variety of backgrounds seems to be a good idea.* (Chancellor Ira Michael Heyman, *Arizona Republic*, Nov. 26, 1988, p. A5)

There should be a willingness among art educators to "exploit" the learning of art to help foster the understanding and respect among all peoples because, in the process, the self-esteem of individuals will also be enhanced.

> *Of all the activities of non-western people, historically, the arts have commanded the greatest respect. Perhaps through these expressions, respect for the people creating the arts may be generated.* (Grigsby, 1977, p. 24)

An additional aspect of multicultural art education, not yet considered here, is the need for art teachers to understand the pupils that they are teaching. Research has shown that the average art teacher has very little knowledge about cultures other than his or her own (which is usually Anglo-European) (Congdon, 1986; Lanier, Madiano, 1982; Saville-Trioke, 1984; Stuhr, 1986). Many researchers have stated that minority students would benefit most from having minority teachers to relate to and to serve as role models. However, most also agree that this is not likely to occur in the near future. On the other hand, additional research has found that there is a definite correlation between teacher quality and high achievement among disadvantaged students. Quality art teachers who bring understanding and skills to the classroom have a substantial effect on students in higher grades, and are more important to achievement among disadvantaged children than to achievement among advantaged children (Silverman, Hoepfner, & Hendricks, 1969).

Understanding of one's students should take many forms. The discussion of art in the classroom should not discourage students from expressing their thoughts in their own cultural terms. Art criticism is considered by many art educators to be an important aspect of art learning. However, many of the abstract terms used by artists and art critics to describe works of art are thought by some to be elitist. The use of folk speech may help "promote cultural pluralism in art criticism and appreciation" (Congdon, 1986, p. 140).

Additional understanding involves the comprehension of, and respect for, the cultural beliefs of one's students. Some examples of the lack of such understanding among White art teachers in four Wisconsin schools in and near an American Indian reservation were observed by Patricia Stuhr (1986). Native American social beliefs reflect the importance of sharing and of close peer groups. There is a rejection of the acknowledgment of individual achievement. Therefore, when one of the White teachers observed held up the artwork of three talented Native American students as exemplars to the class, these students withdrew from the class because they were embarrassed.

Native Americans place a primary importance on spirituality and unity with nature. Harmony with nature permeates their lives, and the art teacher can provide much artistic motivation by understanding this (Anderson, 1973, pp. 22, 24).

"Love versus authority" is a teaching method effective with Native American children. Favorable parent and student comments regarding a White teacher reflected his ability to joke with the students and communicate well with them. "Gentle banter" is effective (Stuhir, 1986, p 25). Navajos also love teasing and puns, although puns do not translate well into English, (Anderson, 1973, p. 29).

Rachel Mason's research in British schools with Muslim minority children also reflects the lack of understanding by White art teachers. A teacher's request of students to draw pictures of their families was ignored because of Muslim religious restrictions on the painting and drawing of the human figure (Mason, 1989, p. 28).

Conclusion

The various texts and journal articles researched for this article all seem to agree that multicultural education is of primary importance to American society. I wholeheartedly agree, but I am disappointed in the lack of

commitment among our institutes of higher education. The teachers that will be entering the classrooms are not being properly trained. The current controversy surrounding the initiation of a required multicultural class at Berkeley is one example. At the very least, prospective teachers should be required to take such a class. Most public and private universities do not have such requirements either in their colleges of education, for elementary and secondary education students, or in their colleges of fine arts, for art education students. Because it appears that new teachers have a tendency to teach the most recent material they have learned (Craft, 1984, p. 453), it would make sense to include multicultural studies in a curriculum for education students.

Art education students, especially, need to be exposed to art of varied cultures. Currently, there are few examples of historical or contemporary minority artists in the art history textbooks used at major universities. Often the historical references, when included, are of "primitive art." Although some disclaimers regarding this term are beginning to be included, it is still being used, and negative connotations are difficult to avoid.

Much of the research examined for this article revealed insights into the needs and beliefs of various minority cultures. This has been very important to my understanding of people with ethnic backgrounds different from my own. No doubt, I will find the information I learned useful for me, as a teacher, and beneficial to my students. Unfortunately, had I not embarked on this inquiry, I would have known little about the cultural beliefs of students that I hope will someday be in my classroom. It disturbs me that the great majority of my colleagues will have little or none of this background because it is not a requirement for teacher accreditation. I propose that colleges of fine arts around the nation offer courses on multiculturalism in art education using the three approaches mentioned by Rachel Mason (global, ethnic, and antiracist). The focus of these orientations should be on the enhancement of the self-esteem of all of our nation's youth.

References

Anderson, S. (1973). *Songs of the Earth spirit.* New York: Friends of the Earth.
Congdon, K. (1986). Meaning and use of folk speech. *Studies in Art Education.* 27(3), 140-148.
Craft, M. (Ed.). (1984). *Education and cultural pluralism.* East Sussex, England: The Falmer Press.
Grigsby, J. E., Jr. (1977). *Art and ethnics.* Dubuque, IA: Wm. C. Brown Co.
Lanier, V. Art and the disadvantaged. In G. Battcock (Ed.), *New ideas in art education* (pp. 181-202). New York: E. P. Dutton.
Lewis, S., & Waddy, R. (1971). *Black artists on art.* Los Angeles: Contemporary Crafts, Inc.

Litsinger, D. (1973). *The challenge of teaching Mexican-American students*. New York: American Book Co., Litton Educational Publishing Co.

Madiano, N. (1982). Accurate perception of colored illustration, rates of comprehension in Mexican American children. *The Journal of Cross-Cultural Psychology, 13*(4), 490-495.

Mason, R. (1988). *Art education and multiculturalism*. London: Croom Helm.

Noffz, R. C. (1984). *Art education in a Native American environment: Phenomenological approaches*. Unpublished thesis, Arizona State University.

Sadker, M. P., & Sadker, D. M. (1988). *Teachers, schools, and society*. New York: Random House.

Saville-Troike, M. (1984). Navaho art and education. *Journal of Aesthetic Education, 18*(2), 41-50.

Silverman, R., Hoepfner, R., & Hendricks, M. (1969). Developing and evaluating art curricula for disadvantaged youth. *Studies in Art Education, 11*(1), 20-33.

Stuhr, P. L. (1986, April). *A field research study which analyzes ethnic values and aesthetic/art education: As observed in Wisconsin Indian community schools*. Paper presented at the meeting of the American Educational Research Association.

Additional Resources

Bowker, J., & Sawyers, Jr. (1985). *Influences on exposure to preschoolers' art preferences*. Blacksburg: Virginia Polytechnic Institute and State University.

Denscombe, M., & Toye, C. (1987). Receptiveness to multi-culturalism in art and design education: A survey of parental attitudes. *Journal of Curriculum Studies, 19*(3), 237-258.

Gage, N. L. (1963). *Handbook of research on teaching*. Chicago: Rand McNally.

Ianni, F. A. (1968). The arts as agents for social change: An anthropologist's view. *Art Education, 1*(7), 15-20.

Jenkins, H., Neperud, R., & Serling, R. (1986). Ethnic aesthetics: The meaning of ethnic art for Blacks and non-Blacks. *Studies in Art Education, 28*(1), 16-29.

Lashley, H. (1980). Art education: The curriculum and the multi-cultural society. In M. Ross (Ed.), *The arts and personal growth* (pp. 27-35). New York: Pergamon Press.

Lokken, C. (1983). Student responses to the art of a past culture. *School Arts, 82*(7), 39-42.

National Coalition of Advocates for Students. (Eds.). (1985). *Barriers to excellence: Our children at risk*. Boston: Author.

Pear Cohen, E., & Strauss Gainer, R. S. (1986). *Art, another language for learning*. New York: Schoken Books.

Peconer, J. (1984). The education of the imagination: Understanding human equality through art. *The Journal of Educational Thought, 18*, 3-11.

Westly-Gibson, D. (1968). New perspectives for art education: Teaching the disadvantaged. *Art Education, 21*(8), 22-24.

Young, B. (1983, September/October). An art center for low-income children. *Design for Arts in Education, 85*(1), 38-41.

Young, B. (1984). Afro-American Artists and the Brandywine Workshop. *Art Education, 37*, 6-8.

15

A Portrait of a Black Art Teacher of Preadolescents in the Inner City: A Qualitative Description

MARY STOKROCKI

Cleveland State University

Most of the research on minority education focuses on the characteristics of disadvantaged students and experimental programs that are designed to help them achieve. Examples include the studies of Silverman, Hoepfner, and Henricks (1969) in Los Angeles and Corwin (1975-76) in New York City. Churchill (1971) and Silverman (1984) reported teaching experiences with inner-city preadolescents. Many of these studies, however, do not consider the teacher's views on preadolescent education. The National Art Education Association has done little to acknowledge and to determine the unique abilities and aspirations of Afro-American art educators (Smith, 1985). A review of the literature revealed only two personal descriptive accounts from Black art educators — Grigsby (1954) and Young (1984). Grigsby (1954) described his experiences teaching art to adolescents at Carver High School in Phoenix, Arizona. He discovered that in spite of his students' deficiencies, he was able to help students adjust their personalities while mastering techniques. Young (1984) described his community-based art program for low-income elementary Black children.

The purpose of this study is to describe, examine, and interpret, through participant observation, the characteristics of an effective minority art teacher of preadolescents in the inner city. The focus is on the framework of beliefs, conceptions, and practices of one Black art instructor. One of her 40-minute, eighth grade art classes was observed once a week for half a year. Although a few participant observation studies have dealt with teachers of preadolescents (Degge, 1976; Johnson, 1985), only one has described a minority teacher (Stokrocki, 1987).

201

Methodology

Participant observation was used as a method for describing, analyzing, and interpreting the everyday data. The study began with data collected through daily notes, documents, photographs, questionnaires, and informal interviews. Time sampling, a method of timed note taking, was also used to record the teacher's instructional behaviors and their frequency (Barker, 1968). Managerial, substantive, and appraisal behaviors were mainly measured and explained (Schmid, 1980; Stokrocki, 1986). Table 15.2 describes instructional behaviors observed on the third Wednesday of every month.

The next phase consisted of content and comparative analysis (Glaser & Strauss, 1967). Content analysis is the search for conceptual themes that arise from a teacher's understanding, such as teaching the basics (art elements), or from everyday data (e.g., "boardwork"). Comparative analysis is the interrelation of conceptual themes to form insights on understanding effective instruction, which may be compared with other similar situations in generating theory, not generalizing about it. At various phases of the study, the instructor clarified her behaviors and beliefs.

Description of School, Art Room, and Instructor

The junior high school was part of a large, low-income, predominantly Black, inner-city, midwestern school system. The school was managed well, and the principal supported the teacher's (Mrs. B) art program through such favors as giving her the use of a basement room for teaching ceramics.

Mrs. B considered her art room spacious (52 feet x 30 feet), organized, and well lighted, but overheated. Storage was ample, consisting of five large, locked cabinets and an adjacent storeroom; however, a tiny sink created problems during cleanup. Pictures of famous artworks were displayed on the cabinets, and student work was exhibited on four (4 feet x 8 feet) vertically mounted homosote bulletin boards. Lack of funding for art materials forced Mrs. B to use inferior materials, such as newsprint and manila paper. Students provided their own pencils, crayons, and glue.

Mrs. B has a master's degree in art education and counseling and has been teaching art for 19 years in this school. Her art supervisor, principal, students, and student teachers testified to her effectiveness and dedication.

On a questionnaire, students indicated that she was patient, understanding, and helpful. She taught six classes a day with two 40-minute breaks, and she arranged her schedule to meet with the eighth graders every day for half a year.

Students' Characteristics and Their Expectations

The observed class of 231 eighth graders consisted of 15 Black and six White students, of which 14 were girls and seven were boys. The students had had only 2 years of art because the system does not provide art teachers at the elementary level. From an open-ended questionnaire (Table 15.1), I discovered that her students mainly conceived of art as drawing (43%) and making designs (38%). In addition, drawing such things as cars, unicorns, faces, and sunsets was their favorite art project (33%), but also their least favorite one (29%). Four students disliked messy projects like painting, and five students had no opinions.

Results

Several findings about Mrs. B's framework of beliefs, conceptions, and practices emerged as characteristics of effective art teaching of preadolescents in the inner city. Because of space limitations, each characteristic will be presented separately with its descriptive evidence.

Mrs. B was an effective manager who established her expectations and rules on the first day and reinforced them often. Well organized, she usually began her lesson at the front chalkboard, on which she had written the current art concepts, vocabulary words, and lesson directions. She arranged desks so that students faced each other in small groups, which allowed for supportive and responsible peer interaction as well as teacher control. Discipline was usually brief (3 minutes). She commented, "I was very stern with them in the beginning and demanded that they respect me and each other." The longest managerial session (March 25) that I noticed lasted 15 minutes (Table 15.2), in which she changed students' seats (3 minutes), auctioned off Black portrait photographs for them to copy (10 minutes), and directed cleanup duties, which consisted of collecting papers and rulers (2 minutes).

Mrs. B's philosophy of art was harmonious with her school system's goals to promote "looking at art and making it." She stated in her questionnaire:

Table 15.1
Eighth Graders' Reactions to Instructor, Art, and Content

		Number	Total	Percentage
	Reactions to instructor			
1.	Is Mrs. B a good teacher?			
	patient	20	21	95
	understanding	18	21	86
	helpful	18	21	86
	Conceptions of art			
2.	What is art?			
	drawing	9	21	43
	making designs	8	21	38
	painting	3	21	14
	Reactions to content			
3.	What is your favorite art project?			
	drawing	7	21	33
	photography	3	21	14
	miscellaneous	11	21	52
4.	What is your least favorite art project?			
	drawing	6	21	29
	messy projects (painting)	4	21	19
	no answer	5	21	24

I aim to develop my students' appreciation of their present and past art heritage, their recognition of art careers and recreational uses, and their own artistic possibilities. I find that my students generally view [create] art representationally, and my task is to build their confidence in art-making and understanding.

Her course of study emphasized the elements and principles of design from simple to complex. Beginning with a 6-week unit on lines in nature and in manmade things, she expanded the program to include drawing Black portraits, emphasizing shape/proportion/value, forming three-dimensional sculptural animal shapes in clay, and adding texture. Art appreciation was primarily fostered through discussions about art in *Art and Man* and the Reinhold visuals. Through directed questioning, students became aware of the basic art elements and principles of design in artworks. Mrs. B explained to them that "the elements of art are like the ingredients in a cake, and the principles of art are like the cake directions." Then she added that her job was to help them to see and to understand them.

In the first lesson (January 28, 1987), students explored the expressiveness of lines through word association. "What kind of line does the word 'pain' bring to mind?" Mrs. B asked. "Prickly, jagged," responded one girl. Mrs. B directed the class to "Draw a painful line, then." Later, she asked them what the word *overlapping* meant. "Criss-crossing," responded another student. Mrs. B continued, "Good. Draw some overlapping lines. We will be using overlapping lines in our next project. Here, we start in a simple way."

Mrs. B constantly directed students' perception by drawing on the blackboard. Perception is the process of awareness and discrimination, in this case, of lines and their relationships. On one occasion (February 11), she guided their perception while demonstrating how to draw a feather on the board:

Draw the center section first, which is a double line, and notice that it gets thinner. Learn to focus your eyes. Notice that some feathers are clustered together closely; some lines are spread out [she outlines them individually]; and other lines overlap. Where is the largest cluster? At the top. As the feathers go up,

205

Figure 15.1 Mrs. B. demonstrates how to draw by starting with the simple, overlapping lines of a plant.

Figure 15.2 She demonstrates how to use guidelines to draw a face from the 3/4 view.

Figure 15.3 Then she shows how to determine the direction of guidelines for the eyes and nose by using a ruler.

Figure 15.4 Later, she explains shading to emphasize the nose.

they sweep away. It can be difficult. Draw one section at a time (5 minutes).

After Mrs. B passed out small feathers, her students then drew them larger on their paper (18 inches x 24 inches).

In order to help develop her students' comprehension, she felt that she must present her lessons slowly with much explanation and individual attention and use a step-by-step approach, with both two- and three-dimensional models, to build up forms in one final drawing. Mrs. B spent 15 minutes at the blackboard during one session on measurement directions for drawing portraits of famous Blacks (Adams, 1969) during Black History Week (February 25, 1987). After instructing students on how to divide the paper to leave room for biographic information, she then instructed them on how to use guidelines to draw the face, depending on the view. She directed, "Draw an oval and put an 'X' at the top of the oval in the middle. If you have a view with more face to the left side (3/4 view), then draw a curve from the 'X' to the nose line." She also demonstrated how to determine the direction of guidelines for the eyes by using a ruler or pencil. Later she explained shading to emphasize the nose. Substantive behaviors (41%), that is, the teaching of the subject matter, predominated her instruction and were predominantly academic (Table 15.2). Two-dimensional models were again used as drawing references. However, she also gave copious individual instruction (30 minutes, April 15). For example, she showed a student where to place the nose in her portrait using the three-quarter view.

Mrs. B used extensive boardwork for instructional purposes and review. Besides the blackboard instruction indicated above, Mrs. B also used her bulletin boards as learning resources. Such instruction is evident in photographs of her ceramic directions: Examples of the coil and slab method are drawn on the blackboard, written procedures are posted, and models of animal or cartoon subject matter are illustrated on paper and taped to the bulletin board.

Mrs. B usually related art appreciation to studio activity. For instance, when students were drawing feathers, she questioned them about Audubon's hand-colored engraving *(Art & Man,* 1987), *Snowy Heron or White Egret* (February 5). She began the 30-minute discussion by asking students why the class was discussing this particular work, and they answered that it had many different lines in it. She then told students that as a child in Haiti, Audubon loved to watch and to draw birds and that he later authored a book about the birds of America. The following is an excerpt of their conversation:

208

Table 15.2
A Time Sampling of Mrs. B's Instruction

Class session	Managerial Minutes	(%)	Substantive Minutes	(%)	Appraisal Minutes	(%)	Nonfunctional Minutes	(%)	Total Minutes	(%)
Feb. 25	7	18	25	63	5	13	3	8	60	100
Mar. 25	15	38	20	50	0	0	5	13	60	100
April 15	5	13	5	13	30	75	0	0	60	100
May 27	10	25	15	38	15	38	0	0	60	100
Average	9	24%	16	41%	13	32%	2	2%	60	100%

Figure 15. 5 Students use two-dimensional models as drawing references (Famous Black portraits from calendars).

Figure 15.6 Mrs. B shows a student where to place the nose in his 3/4 portrait.

Figure 15.7 Examples of the ceramic coil and slab method of building are drawn on the blackboard.

Figure 15.8 Written procedures are also posted.

211

Figure 15.9 Simple animal or cartoon models (favorite preadolescent subjects) are illustrated and taped to the bulletin board.

Figure 15.10 Examples of students' ceramic sculptures include cartoon and animal faces with such exaggerated forms as ears, noses, and eyes. This was the students' first experience with clay.

Mrs. B:	"How do you like this drawing?"
Student 1:	"The colors are mysterious."
Student 2:	"His bill is too long. It reminds me of a dagger."
Mrs. B:	"Do you remember our lesson on drawing sharp lines, like pain, just like these? Would this bird frighten you?"
Student 3:	"His eyes are scary!"
Mrs. B:	"Now you are beginning to see what he [Audubon] is trying to convey. The more you look, the more you find out. Does this bird look like he belongs here?"
Student 4:	"Looks funny, out-of-place, destructive."
Mrs. B:	"Good, tell me about the colors."
Student 5:	"Dark sky, white bird."
Mrs. B:	"Good, This work has contrast, and it expresses fear."

She then told her students how Audubon would deliberately make the birds large and use complementary colors to make the drawing more exciting. She directed their attention to the variety of lines in the bird's feathers and emphasized this when they were drawing feathers.

Mrs. B also catered to students' interests in clay animals and cartooning as she influenced their results. She motivated her students' interest in ceramics by presenting former student examples of clay animals. Exaggeration was a key concept that she continually emphasized. All of the students listed this project as their favorite at the end of the year (Table 15.3). Examples of the students' ceramic sculptures include cartoon and animal faces with such exaggerated forms as ears, noses, and "bug eyes."

She further allowed students to decorate their folders with popular subcultural cartoons, which she approved in advance (March 27). Students chose to imitate such stereotypic cartoons from the Sunday comics as Ziggy, Garfield, B. C., and Snoopy. She influenced their outcomes by insisting that their drawings "fill-the-space" and by encouraging them to exaggerate a part. Some of their more original images resembled a break dancer, the Taurus car, and the rock group "Bad Boys." However, students (50%) found reading *Art & Man* boring.

She arranged for guest artists to visit and explain how they used art as a career and a hobby. On one occasion, Mrs. B invited a local artist, who was a Black cowboy, to speak and demonstrate his technique to the class. He

Table 15.3
Eighth Graders' Responses to Preferred Art Projects This Year

1. What was your favorite art project this year?			
clay	21	21	100%
2. What was your least favorite art project?			
reading *Art & Man*	10	21	50%

developed a positive/negative drawing in relief on cowhide. He related well with students because of his "down-to-earth" talk and asked them, "What do you think a cowboy is?" They were surprised that Black cowboys existed and that artists could also be considered cowfolks. This artist was invited every year as a guest.

Mrs. B constantly used group and individual in-process appraisal. She announced to the class one day, "As I walk around the room, I still see small, skinny lines in your drawing. Use some variety. Use thick lines too!" Then she commented to a student, "Don't use yellow to make your lines, there is no contrast. Use a darker color." Then she again reminded her students, "Look to see if you have used the entire space" (April 15).

She gave students criteria for their grades. At the end of their unit on Black portraits, Mrs. B spent the entire class discussing grades with her students (March 15, 30 minutes). She began:

> *Some of you judge work by how accurate your work is to the original. More important is facial proportion, size, shading, contrast, and texture. Everyone who puts forth effort gets a "C."*

She proceeded to announce her grades and rationale for each child: "[Your grade is] 'C'; your letters need to be darker; the face is realistic; lines are nice." Then she asked a student in the back of the room, "Tell me about how he [one student] drew his clothing." The student responded, "Looks flat." "That's right," she praised, "It's not shaded right, and you need to show overlap. [Your grade is] 'B'."

Mrs. B rewarded students for good behavior and participation. At the end of each week, she gave an extra activity, such as a movie, to those students who performed adequately, especially in reading *Art & Man*. She also obtained grant money for clay materials and kiln expenses. For the first time in years, she was able to offer ceramics to her students.

In order to build her students' confidence, *Mrs. B addressed students with respect, endearment, and honesty, offered positive reinforcement, and counseled individuals and the group.* Mrs. B always spoke to her students with consideration and affection: "Is that yours, sir?" "Very good, madame"; "Lay it aside and try another, doll"; "Listen up, now"; and "That's OK. Some artists 'change-up' in midstream."

She counseled her students inside and outside of class. For example, Mrs.

B encouraged one particularly stubborn student: "You're not taking your time. Slow down and follow the steps." The student answered, "It's not that I don't like you, Mrs. B. I don't like art, and I can't draw." At the end of the project, this student had changed her mind and was helping classmates with their work. The student commented, "Yeah, I learned to look better."

Pep talks were periodic in Mrs. B's class. At the end of the Black portrait unit (March 12), she asked her students, "How many of you felt that you had no [art] talent when you first came here?" All the students raised their hands. "Now, how many of you feel that you have developed somewhat?" One half of the students raised their hands. She summarized, "Don't compare yourself with another. You were surprised to see that you could do it by using your eyes better. I'm proud of you." The next day she said to the class:

Why are you studying art? So that you can develop your own talent and appreciate different types by looking at past [art] masters. Some [styles] are realistic and others are more abstract. Everyone has some ability ... lettering, drawing, coloring, or cartooning. You will be using the same information that you are learning here every day in your choice of clothing, household furnishing, and car selection.

Conclusion

This portrait has described the effective talents, skills, and aspirations of one minority art teacher of preadolescents in the inner-city. Findings from her framework of beliefs, conceptions, and practices suggest that the primary goals of art teaching are to relate art to students' everyday life and heritage and to improve their confidence and comprehension. Art teachers need to be aware of inner-city students' personal, social, and cultural needs and art interests, such as cartooning and ceramics. Experience in counseling, human qualities such as respect and endearment, positive reinforcement and rewards, feedback, in-process appraisal, and pep talks are necessary when relating to these students.

Inner-city art teachers must be well-educated, well-cultured, and well-organized. The following instructional methods are suggested: setting rules early and reinforcing them; developing a step-by-step instructional approach; giving perceptual guidance in basic art elements, principles, and expressive properties; and using extensive learning resources, including lists of art elements, vocabulary words, procedures, and possible ideas to incorporate.

Given ample physical, temporal, administrative, emotional, and instructional arrangements and motivation, reasonable student success can be afforded. Even with a lack of supplies and quality materials, students can be taught basic art skills and concepts. Quality art education for minority children must be based on a solid foundation program and an understanding of how art relates to their lives, their current needs, and their future aspirations. While students develop their own art skills and attitudes, they can be introduced to a few historical and contemporary artists, techniques, and careers as models, especially from their own backgrounds. This evidence suggests that minority art teachers should expect more from their students. Furthermore, implications from this study suggest that students in minority contexts should be taught differently and that instructional content in various art education settings should be diverse, as opposed to the discipline-based art education model.

More studies are needed to determine the characteristics of effective minority teachers. Comparative studies are needed to determine how minority art teachers instruct in other racial and socioeconomic settings and at different levels. Comparisons of the instruction and background of art educators of various racial backgrounds can be made. Finally, the contributions of minority art teachers to the larger social system need to be determined.

References

Adams, R. (1969). *Great Negroes: Past and present.* Chicago: Afro-American.
Art & Man. (1987). Mini-issue: John James Audubon: Working with nature. *Art & Man, 17*(4), 2-9.
Barker, R. (1968). *Ecological psychology: Conceptual methods for studying the environment.* Stanford, CA: Stanford University Press.
Corwin, S. (1975-1976). *Reading improvement through the arts: Curriculum guide.* Albany, NY: Department of Education.
Churchill, A. (1971). *Art for preadolescents.* New York: McGraw-Hill.
Degge, R. (1976). A case study and theoretical analysis of the teaching practices in one junior high school art class (Doctoral dissertation, University of Oregon, 1975). *Dissertation Abstracts International, 36,* 5750-A.
Glaser, B., & Strauss, A. (1967). *The discovery of grounded theory.* Chicago: Aldine.
Grigsby, E. (1954). Art education at Carver High School. *Art Education, 7,* 6-8, 16-18.
Johnson, N. (1985). Teaching and learning in art: The acquisition of art knowledge in an eighth grade class. *Arts and Learning SIG/Proceedings, 3,* 14-25.
Schmid, H. (1980). Perceptual organization and its relationship to instructional arrangements in contributing to the effective instruction of a distinguished university teacher (Doctoral dissertation, Ohio State University, 1979). *Dissertation Abstracts International, 32*(8), 4390-A. (University Microfilms No. DEM80-01824)
Sevigny, M. (1978). A descriptive study of instructional interaction and performance appraisal in a university studio art setting: A multiple perspective (Doctoral dissertation, Ohio State Univer-

sity, 1977). *Dissertation Abstracts International, 38,* 6477-A. (University Microfilms No. 7806099)

Silverman, R. (1984). *Learning about art: A practical approach.* Newport Beach, CA: Roman Arts.

Silverman, R., Hoepfner, R., & Henricks, M. (1969). Developing and evaluating art curricula for disadvantaged youth. *Studies in Art Education, 11*(1), 20-33.

Smith, J. (1985). Affirmative action consciousness: A proxy for shared governance in the NAEA. *Art Education, 37*(1), 46-47.

Stokrocki, M. (1986). A portrait of an effective art teacher. *Studies in Art Education, 27*(2), 82-93.

Stokrocki, M. (1987). *Teaching preadolescents in an urban setting from the perspectives of a Black elementary art teacher and her students.* Manuscript under review.

Young, B. (1984). *A community-based art program for low income Black children. The Ohio Art Education Association Journal, 23*(1), 16-21.

Note

Mrs. Margaret Board, Mrs. B, teaches at Patrick Henry Junior High School in Cleveland, Ohio.

16

Shattered Fantasy: Minority Access to Careers in Art Education

ESTHER PAGE HILL

University of North Carolina at Charlotte

What are minorities? A problem? An Achilles heel of the American conscience? Wagley and Marin (1964) defined a minority as a social group whose members experience various disabilities at the hand of the dominant group. The terms *racial, ethnic,* and *cultural* identify these groups as minorities. "Ethnic" minorities are identified by cultural criteria; "racial" minorities are identified by physical criteria. The minorities considered here include Black Americans, Mexican Americans, Puerto Ricans, and American Indians. In all cases visible features demark members of the respective groups (Vander, 1966); such demarcation implies some form of social isolation. The visual arts can mitigate some of the effects of social isolation on these groups. Social isolation is the converse of, and in fact a barrier to, interaction, which is essential to the development of a self-concept. As a social product, the self is shaped by others' reactions, and one's self-concept directly influences the benefits gained from a situation as well as performance in the situation. Interactionism as a process plays a dominant role in providing minority access to careers in art education.

The 25.5 million Blacks in the country now constitute approximately 12% of the nation's population — nearly one of every eight Americans ("Social and Economic Status," 1979). They are the nation's largest minority. No longer concentrated as heavily in the South as they once were, Blacks, because of great migrations, are now distributed more evenly across the country. Eleven states — California, Florida, Georgia, Illinois, Louisiana, Michigan, New York, North Carolina, Ohio, Pennsylvania, and Texas — have Black populations of 31 million or more. A total of 76% of Blacks live in metropolitan areas, and of those, 55% live in the inner city. Hispanics are predicted to outnumber Blacks by the year 2000. Twenty million Hispanics live in the United States today; 41 million are projected by the year 2000. National, state, and local perspectives must be viewed within these frameworks. The key actions in providing minorities access to careers in art

education must be based on recognition and acceptance by the dominant culture of the right of entry and passage, and commitment to these concepts at *all* levels of education — elementary, secondary, and higher education. As early as 1848, Horace Mann, in a report to the Massachusetts State Board of Education, assessed education as a key instrument for ensuring equality: "Education then, beyond all other devices of human origin, is the greatest equalizer of the conditions of men — the balance wheel of the social machinery" (Wright, 1982, pp. 11-14).

National Perspectives and the Fantasy

The right of passage was affirmed at the national level in 1965 by Executive Order 11246 and subsequent Executive Order 11375, signed into law in 1967. These legislations embody two important concepts — nondiscrimination and affirmative action to eliminate discrimination based on race, color, religion, sex, or national origin. The facade of affirmative action for many Blacks raised the level of expectations of access to careers.

Stephen Wright (1982) asserts that the Civil Rights Act of 1964 has had increasing effects, especially on the admission policies and practices of southern colleges and universities. First, in the wake of the assassination of Martin Luther King, Jr., many colleges and universities made special efforts to recruit Black students and provide special programs for them. Second, community colleges — with their low tuition, commuting distance locations, and open admission policies — have provided access to higher education for thousands of minority students who otherwise would never have had the opportunity to pass through the doors of 4-year institutions of higher learning, where requirements for admission are based on SAT scores. Historically, minority students, and Black students in particular, do not score well on the SAT. The SAT and other tests have been under intermittent fire for alleged and proven bias. But a student who enrolls in a community college and successfully completes the requirements for an AA degree can seek admission to a 4-year institution on the basis of academic record.

Third, Black enrollment has been affected by the Adams case, which sought to require the Secretary of Health, Education, and Welfare to enforce the provisions of Title VI of the Civil Rights Act of 1964 prohibiting the granting of federal funds to institutions that discriminate on the basis of race, color, and so forth (*Educational Record,* 1981). Finally, and probably the most important factor, the Educational Amendments of 1972 included, among other programs, the Basic Education Opportunity Grants, which provided major financial assistance to students.

All these factors combined to increase Black enrollment during the 1970s to nearly 10% of the total higher education enrollment. National support of programs for disadvantaged youth who are minorities is strongly and positively correlated with minority access to higher education. Traditional passage to the "good life," or the American dream, is through a college education, coupled with the remnants of the 19th- and early-20th-century work ethic. But for minorities this is not enough. As Karenga (1982) asserts: If hard work were passage to the good life and an economically profitable career, every slave would be rich.

This increase in Black enrollment in higher education is a statistic that requires analysis. According to Wright (1982), matters that should be examined include:

1. *Enrollment at various levels: The higher education enroll-ment patterns of black students differ substantially from those of most American students. Eighty-six per cent of black students are enrolled in two-year and four-year colleges, compared with only 75 per cent of all students.*

2. *The types of institutions in which blacks are enrolled reflect the problems of access and choice — The National Commit-tee on Higher Education and Black Colleges and Universi-ties pointed out in 1979 that twenty-five per cent of all students but only 15 per cent of the black students were enrolled in universities. The difference in enrollment pat-terns is probably due to higher admission standards and higher rates in the universities.*

3. *The graduation rate reflects the problem of persistence. En-rollment is merely one step in the education process. The number of blacks entering higher education is small and their attrition rate is disproportionately higher. Although by 1976 the enrollment of blacks in higher education exceeded one million, or 9.3 per cent of the total enrollment in higher education, blacks received only 6.38 per cent of the bache-lor's degrees. The reasons for these low graduation rates are complex, but they include (1) the disproportionately high dropout rate of blacks at the high school level — 27 per cent for blacks as compared with 15 per cent for whites, (2) the small number of blacks who are counseled into academic prepatory curricula — 27 per cent for blacks and 49 per cent*

*for whites, according to the National Longitudinal Study, (3)
the comparatively poor college preparation provided by
inner-city high schools, and (4) the inadequacy or absence of
supportive and developmental programs in many predomi-
nately white colleges and universities.*

*4. The black colleges and universities still play a significant role
in the higher education of blacks: these institutions awarded
39 per cent of the bachelor's degrees that blacks receive. This
statistic is astonishing when the fact that these institutions
enroll only 18 per cent of the black students is taken into
account. Among the explanations offered for this phenomenal
performance is that most of these are four-year, residential
institutions.*

Passage and entry into higher education is a prerequisite for access to
careers in art education and is affected by legislation and activity at the
federal level. Federal legislation concerning nondiscrimination and af-
firmative action have functioned to the advantage of all minorities as well
as women. However, analyzing the results of affirmative action in higher
education as it pertains to women, especially Black women, presents a bleak
picture. "There has been a lot of affirmative action but few affirmative
results for blacks in general and for black females in particular in the higher
education arena" (Mosley, 1982, p. 23). All of the institutions studied by
Mosley in 1974 had official policies of nondiscrimination in hiring and
promotion; yet a whopping 74% of the respondents felt discriminatory
practices existed against the hiring of Blacks, and one third stated that
discrimination was extremely prevalent at their institutions. One woman
remarked, "The reason I'm here is because this institution practices dis-
crimination." In fact, many Black faculty members, administrators, and
students are on predominantly White campuses because of past and present
discriminatory practices and because of legal requirements that previously
closed doors at least must appear to be open. This same study of the results
of affirmative action in a large public university showed that the number of
Black faculty members had *decreased* since the advent of so-called affirma-
tive efforts in 1970. "The reports of others, including Weidlin (1973) and
Bayer (1973), indicated that this finding can be generalized among major
institutions of higher education" (Mosley, 1982, p. 23).

Black PhDs are a scarce commodity. If the Black applicant pool is to
increase, graduate schools must make a major thrust toward increasing
Black enrollment with the goal of preparing Blacks for faculty and admin-
istrative positions in the future. If the doctorate degree is to remain the

credential for access into faculty and administrative positions, the importance of looking at future prospects cannot be underestimated.

Mosley asserts that Black female administrators are an endangered species. They are few in number, and the number is shrinking. They occupy positions that are outside the main structure of the university. They have little if any power. Many receive little or no support from peers, Black or White. Disillusionment with higher education has led many to indicate their intentions to leave their positions. Affirmative action policies, once thought of as a panacea for equal opportunity, have failed them miserably. The Black woman's status in higher education can be summed up by a passage from Ralph Ellison's *Invisible Man:* "She is an invisible woman. It is never advantageous to be unseen, and it is wearing on the nerves. She is constantly being bumped up against by those of poor vision. She often doubts that she really exists" (Mosley, 1982, p. 25).

Once access to careers in higher education has been gained, the dilemma of maintaining faculty and administrative positions becomes salient to most minorities and women. Data on the numbers of minorities in art education would certainly reflect the admission practices of colleges and universities and the hiring practices of school systems as well as colleges and universities throughout the nation.

State Perspectives in Federal Context

Minority access to careers in art education emerged through direct links with federal legislation and the practices of the early 1960s and 1970s. The history of federal support of the arts shows encouragement of coordination between the local agencies and an extended interpretation of the arts to include artists, community resources, and formal schooling.

Legislation in 1965 supported the arts. The National Foundation on Arts and Humanities Act created the National Endowment for the Arts (NEA) and the National Endowment for the Humanities (NEH), both of which have given highest priorities, as well as substantial funding, to educational projects. The same law opened the way for state legislation that created state arts councils and commissions. The Artists-in-the-Schools programs of the NEA are administered through the various state arts councils (Bloom, 1971).

The year 1965 marked the beginning of significant federal support for arts education that encouraged coordination among and between state and local agencies. The Elementary and Secondary Education Act (ESEA) initiated,

for the first time in the history of federal legislation, a partnership between the arts and education (Rockefeller, 1977). The passage of this legislation provided a means for accomplishing major changes in the direction of the arts in the nation. The primary purpose of this act was to assist state and local education agencies in providing compensatory programs for disadvantaged youth. Minorities at all schooling levels have benefited tremendously from this thrust.

In 1973 the Alliance for Arts in Education (AAE) was established jointly by the U. S. Office of Education and the John F. Kennedy Center in Washington. State AAE committees throughout the United States have attempted to establish grass-roots movements in arts education at state and local levels. By 1977, every state had established at least a planning committee for a state AAE, organizing AAE committees to develop master plans and to coordinate activities that embrace a broader view of the arts (Holden, 1978).

In 1973, North Carolina became the first state to establish a Department of Cultural Resources, and the North Carolina Arts Council was a component of its Division of Arts. The Artists-in-the-Schools program is administered by the Council but is operated by the Department of Public Instruction. The Division of Arts Education, formerly the Cultural Arts Division, operates within the Department of Public Instruction with a director and a staff of six consultants in art, dance, music, theatre, and creative writing, as well as in research and teacher training. This is an example of one mode of response to government guidelines (Rockefeller, 1977).

The Division of Arts Education makes no specific reference to minorities in program planning for the nearly 1.25 million children and youth in North Carolina's 148 school districts. Minorities here include Koreans, Cubans, Iranians, Puerto Ricans, Indians, and Blacks, who constitute the largest group. The comprehensive state plan for arts education is designed for *all* students regardless of race, color, or creed. Information concerning careers in the arts is a part of the K-12 curriculum and is emphasized throughout the elementary and secondary grades. The scarcity of role models is a negative factor in educating minority children for careers in art education.

In 1976, the North Carolina State Board of Education adopted N. C. Administrative Code 2E.0103, which mandated a standard course of study consisting of a K-12 continuum in six broad areas. The third area, Cultural Arts Education, includes the fine and performing arts, recreation, and avocations, and is addressed to both performance and consumer objectives. This action was significant because for the first time in North Carolina (or any but a few other states) school districts were mandated to include the arts in their curricula. This mandate paved the way for administrators to hire art

teachers.

The state comprehensive program provides philosophy and content for arts programs in the schools and for colleges and universities involved in the preparation of arts teachers. The curriculum is the responsibility of the school district and each college or university. The State Department of Public Instruction (SDPI) publishes documents and guides to assist school districts and universities in implementing arts programs. Some of these are the *North Carolina State Course of Study, Competency Goals and Indicators, State Accreditation Program Descriptions, State Standards and Guidelines for Teacher Training,* and *Curriculum Models.* The *Art Education Directory, State Adopted Textbooks for N.C. Schools* lists art textbooks adopted in March 1982, including *Art: Meaning, Method, and Media,* authored by Guy Hubbard and Mary J. Rouse, levels 1-6. These textbooks are part of a comprehensive art program teaming the art professional and the classroom teacher. The North Carolina Competency Based Curriculum sets forth the philosophy:

> *The purpose of art in the public school curriculum is to reinforce the individual student's innate creative abilities and to offer opportunities for creative self-expression in a visual capacity ...*
>
> *The essential nature of the arts, then, is to build confidence within individuals and increase sensitivity between and among people. These two outcomes are paramount in the school setting and compatible with the general aims of education.* (p. 545)

A Program Assessment Instrument is designed and used to assist teachers and others in local school systems in addressing programs in art, dance, drama, and music to the needs and aspirations of their students. The instrument is composed of seven catagories and a summary. The purpose of the summary section is to provide, in a graphic manner, a means for looking at results and for planning program improvement.

The Cultural Arts Coalition (NCCAC), founded in 1977, is a Black organization in North Carolina that emerged as a result of concern on the part of a Black administrator in the North Carolina Division of Cultural Arts. Patricia Funderburk, grant coordinator for the Theatre Section, found widespread inequities in the distribution of funds to the Black community. When she raised questions as to the reason Black artists were not receiving funding through the Division of Cultural Arts of the NEA and why there were not more Black administrators, she was told that "there were no

qualified Black artists in the state of North Carolina." The identification of Black artists in the state was a challenge Funderburk could not resist. She "knocked on doors all over the state and made telephone calls urging Black artists to come together and meet each other." As a result, on May 14, 1977, nearly 400 Black artists and patrons of the arts from various regions of the state met on the campus of St. Augustine College in Raleigh.

The major objectives of the North Carolina Cultural Arts Coalition (NCCAC) are (a) to educate artists about techniques for marketing their artistic skills; (b) to promote and encourage public interest and support of art in general and of Black art in particular, with special emphasis on the Black community as consumers, investors, and entrepreneurs; and (c) to assist in the development of relevant arts-related programs, facilitating educational and cultural relations among members of the NCCAC and other institutions and agencies.

Job vacancies and positions available throughout North Carolina are listed in the monthly publication of the NCCAC. Positions and programs include museum operations assistant, visiting artists program residencies, chairperson — Department of Art, executive director — Arts Council, ceramics instructor, paste-up artist, graphic arts technician, and fellowship programs for arts managers.

In 1978, the Board of Governors of the University of North Carolina established a continuing Doctoral Study Assignment Program to encourage selected qualified faculty members of the comprehensive and general baccalaureate institutions of the university to pursue one year of full-time study toward the doctorate degree. Faculty members selected to participate in the program are reassigned to pursue doctoral studies in an accredited university on a full-time basis with full salary and other benefits for the year of study. Priority is given to qualified faculty members in traditionally Black institutions because of the lower proportion of faculty members with doctorate degrees at those institutions and because of the national shortage of Black people having this degree.

Local Perspectives

At the local level, teachers' attitudes toward minority students significantly affect their cultural experiences and shape their attitudes toward future careers in the arts and art education. Minorities are bicultural, and their members, for the most part, function very effectively. Malcolm McFee, an anthropologist working with the Blackfoot Indians of Montana, found that many retained their old culture and learned the new one — they were

bicultural, and he called them "150% man" (McFee, 1968). June King McFee asserted that it is necessary to ask students to give up the old to learn the new. Minority students can be helped to respect and understand their own culture while coping with and making their way in the dominant culture. If some learn to operate this way, then more will. Much of the hostility toward teachers of the dominant group comes from minorities' deep-seated fear that they will have to give up what they value to succeed in school. Value formation is always done *for* them. Teachers need to be aware of differences among students and the degree to which students' values differ from the school's values. What motivates minority students? Their motivations and what they express through the arts will be relative to where they see themselves. A young sociologist, Eugene Grigsby III, writing in the *Journal of Black Studies,* shows the meagerness of input by Blacks and other minority groups into the value making of American society. Just because people can learn to live in more than one culture doesn't mean that the dominant culture doesn't have to live up to its standards that "all are created equal." Minority groups have developed their own frameworks for identity through subcultures. The Black Muslims exemplify such a subculture. The Jim Jones cult and others also have resulted from the need to identify with elements of one's background culture.

Teachers must understand the impact of social isolation on the self-image of minority students. Isolation severely constrains the emergence of the self. According to Margaret Mead, the self is a process rather than an organization or structure awaiting activation from without. Meaningful experiences in the visual arts act as an integrative force in overcoming the effects of isolation and reestablishing positive interaction among and between groups in the schools and in society. The self is validated by the reactions and expectations of others, especially "important and significant" others such as teachers. Conceptions of a student are communicated through the teacher's expectations and result in a self-fulfilling prophecy — the student becomes what the teacher thinks he or she is.

Teachers using the arts as an integrative force to mitigate some of the social and educational problems of minority students need to:

1. Create school environments in which students may share cultural diversity by helping them to use and enjoy their own cultural forms and understand how these have contributed to our multicultural society.

2. Use representative role models to whom students can relate and emulate. Eugene Grigsby (1977, p. 36) states that, "Most art classes, whether studio or art history, will touch upon European art and artists; English, French,

German, Spanish, and so forth, where backgrounds will be similar to many members of the class. References to African or American Indian art are usually made in the context of primitive, 'exotic, or strange', in the sense that these are interesting but not works to be used as models to emulate." In October 1977, a 10-year retrospective exhibition of the work of Romare Bearden was organized by Jerald Melberg, curator of exhibitions at the Mint Museum of Art in Charlotte, North Carolina, through a grant from Philip Morris and the National Endowment for the Arts. Several weeks after a prestigious elaborate opening, extensive local, state, and national media coverage, invitations to schools and community organizations and agencies, groups of junior and senior high school students were asked whether they had heard of Romare Bearden or had seen the exhibition. Many had not heard of Bearden, and others had heard of him but did not know that he was Black. The implications are clear: Minority students must be helped to preserve cultural meaning by maintaining respect for their own culture. The work of contemporary Black American visual artists should be emphasized.

3. Help minority students deal confidently with media images by sorting out and discriminating between television advertisements and films that distort values and others that are culturally realistic (e.g., Mr. "T").

Problems and Prospects of the Fantasy

Special problems affect the access, choice, survival, and optimal development of Blacks and other minorities. There is an urgent need for problems to be placed much more conspiciously on the national agenda for in-depth study, to be followed by prompt, appropriate action equal to the dimensions of the problems involved. Twenty of the most thoughtful individuals involved in the education of Blacks in America were asked to respond to what they considered the most critical problems surrounding the education of Blacks and other minorities. As presented by Wright (1982), the most salient responses were:

> 1. *The inadequate* basic *educational and personal development of young people — including motivation — in the elementary and high schools. It is essential to get a grip on this problem of basic preparation, self-esteem and positive response to the opportunities and problems.*

> 2. *The worst problem, not only for the black community but for the whole American community, is the plight of black youth in the big ghettos — the failure of our society to give thou-*

sands of these young people a decent start in life. Our schools and other social institutions are simply failing to deal with this tremendous human disaster building up in our cities.

3. *First and foremost is a continued drive for parity in degree production. All black progress in the white collar and professional sector depends on this. Something like 100,000 baccalaureates must be produced year after year in this respect, 10 to 12 per cent of the total produced nationally. We are presently at about 60 per cent of parity, producing about 60,000 annually. Parity figures for Ph.D.'s and medicine and law are more dismal, about 33 per cent of parity, with about a thousand degree recipients in each area instead of the 3,000 and more required for parity.* (p. 26)

The most critical barrier to access and careers in art education is financial. In 1987 the median Black family income in the United States was $18,098 — 56% of the median White family income ($32,274). The financial barrier alone may determine whether a young Black man or woman goes to college, even when financial aid programs are operating. Under the Reagan Administration, these programs suffered drastic cuts in funding (Wright, 1982).

Perspectives from the national, state, and local levels are discouraging. Especially at the national level, many see events as an erosion of gains for disadvantaged minority youth in the area of educational opportunities. It is a well-known fact that the quality of public school education one receives determines, to a large degree, the kind of higher education one receives — if any. Also, in turn, the kind of higher education one receives determines, in large part, one's life career or careers. The small number of minority youth seeking access to careers in art education reflects the overall picture and climate in the nation.

The *Higher Education Advocate* (Power, 1987), as well, cites the biggest barrier to increased minority participation as financial. Since 1980, the average cost of a year at a public college has climbed by 76.4%. Another barrier is the recent series of ugly incidents of racism at some of the major universities (e.g., the University of Massachusetts at Amherst, the University of Michigan, Columbia University, and The Citadel in South Carolina). These have dramatized the racism that persists a generation after the defeat of segregation. Although minorities constitute more than 21% of the population in this country, minority enrollment in the nation's 2- and 4-year colleges remains at 17%. Encouragement may be found by remembering the quantity and quality of support at all levels during the past decade, when

affirmative action was alive and well.

References

Bayer, A. (1973). *Teaching faculty in Academe, 1972-73*. Report. Washington, DC: American Council on Education.
Bloom, K. (1971). Development of arts and humanities programs. In *Toward an aesthetic education*. Washington, DC: Music Educators National Conference and Central Midwestern Regional Education Laboratory, 91-92.
Education Record. (1981, Summer). Washington, DC: American Council on Education. (Used with permission).
Grigsby, J. E. III. (1971, December). Stratification in American society. *Journal of Black Studies, 2*(2), 163.
Grigsby, J. E., Jr. (1977). *Arts and ethnics*. Dubuque, IA: Wm. C. Brown Company.
Holden, C. (1978). Aesthetic education, aesthetic literacy and the arts in general education. *Art Education, 83*(3), 23.
Howard, J. (1970). *Awakening minorities*. Chicago: Aldin Publishing Co.
Hubbard, G., & Rouse, M. J. (1977). *Art: Meaning, method, and media*. Westchester, IL: Benefic Press.
Karenga, M. (1982). *Introduction to black studies*. Inglewood, CA: Kawaida Publications.
McFee, M. (1968). The 150% man, a product of Blackfoot acculturation. *American Anthropologist, 70*(6), 1096-1103.
Mosley, M. (1982). Black women administrators in higher education: An endangered species . *Ivy Leaf, 59*(1), 21-25.
North Carolina competency based curriculum. (1985). Division of Arts Education, Instructional Services, North Carolina Department of Public Instruction, Raleigh, NC. 545.
Power, J. (Ed.). (1987). Attitudes, economy stall minorities; drive for equal share in college. *NEA Higher Education Advocate, 4*(10), 1.
Rockefeller, D. (1977). *Coming to our senses: The arts, education and Americans panel*. New York: McGraw-Hill.
Social and economic status of the Black population in the United States, 1790-1978. (1979). *Current Population Reports, 80*, 23.
Vander, Z. J. W. (1966). *American minority relations* (2nd ed.). New York: The Ronald Press Co.
Wagley, C., & Marin, H. (1964). *Minorities in the new world*. New York: Columbia University Press.
Wright, S. (1982). Black higher education in the eighties. *Ivy Leaf, 59*(1), 11-14.
Wright, S. (1982). The tragic waste of the Black mind and talent. *Ivy Leaf, 59*(1), 26-27.

Note

Statement by Karenga taken from personal notes at a lecture at the University of North Carolina at Charlotte, September 22, 1982, sponsored by the Department of Black Studies.

17

Alain Locke Revisited:
The Reconsideration of an Aesthetic

ROBERT L. ADAMS

Alabama A & M University

*The American Negro brought over as an emotional inheritance
a deep-seated aesthetic endowment. And with a versatility of a
very high order, this offshoot of the African spirit blended itself
in with entirely different culture elements and blossomed in
strange new forms.* (Locke, 1925, p. 254)

Afro-American artists have distinguished themselves by making signifi-
cant contributions to the art world. The styles of their artwork are varied.
Sometimes Afro-Americans' artwork represents "Black art" themes, sub-
ject matter, and ideology by means of a new aesthetic. At other times, Afro-
American artists' "Blackstream" artworks represent Black consciousness
making use of established Western aesthetic conventions. At still other
times, Afro-American artists' "mainstream" artworks range from mostly
abstract to nonobjective formal designs without any explicit reference to
Blackness. Thus, the established contemporary Afro-American artists'
works are diverse in their plural modes of expression.

Despite the diversity of Afro-American artists' modes of expression, I want
to pose some singular aesthetic concerns relative to this multiform body of
artwork: "Is there a singular purpose or *raison d'etre* for Afro-American
artists?" That is, "Can Afro-American artists distinguish themselves from
other artists by having a different or unique reason for being?" "Is there a
different aesthetic for Afro-American artists?"

In order to gain insight into these and other questions, I will refer to and
make inferences from the writings of Alain Locke (1886-1954). Locke —
writer, philosophy professor, cultural historian, the principal philosopher

for the Harlem Renaissance, and the leading spokesman for Afro-American humanist values during the second quarter of the 20th century — synthesized from a diversity of sources in traditional and contemporary philosophy, literature, art, religion, and social thought a "New Negro formulation" of racial values that charted for the Afro-American a strategy for achieving freedom through the arts. This complex formulation was rooted in philosophy and applied to the problems of race. Moreover, Locke was led to study purposes for which the arts exist, especially when they influence group thinking. He makes clear time and time again that Afro-American artists first and foremost should create art in its various forms for the Afro-American audience. According to Locke, artworks that may have started as highly personalized expressions go on to operate as tools for advancing the social causes of Afro-Americans.

Under the rubric of the visual aesthetic, Locke's ideas can be found in *Negro Art: Past and Present* (1936), *The Negro in Art* (1940), and many articles on African and Afro-American art. Despite the variety of his writings, Locke did not write a treatise on aesthetics. However, from his voluminous writings, I am able to infer his aesthetic position. Thus, my purpose here is to examine Locke's many publications and to infer from them his aesthetic stance.

A perusal of Locke's publications clearly indicates that he had a profound understanding of formal aesthetics. He redirects this formal aesthetic theory and gives it a new focus within the context of the Afro-American experience. Although these ideas on aesthetics are of a time somewhat removed from the last quarter of this century, the Afro-American artist may want to reconsider this aesthetic, for the cogency of Locke's ideas is relevant to today's art world. Hence, Locke's timeless message is that the visual arts have an impact on the societal attitudes of Afro-Americans, for art can be a most potent form of propaganda.

It appears to me, from reading all of Locke's writings on the visual arts, that his socially defined approach to art is theoretically eclectic but relies heavily on an aesthetic position called *instrumentalism*. Beardsley (1958) and Feldman (1987) refer to this as instrumental aesthetics. Briefly, instrumental theories conceive art as a device for promoting social, cultural, moral, religious, political, or psychological purpose. According to this theory, the rationale for art is not based primarily on solving design problems, that is, problems that are intrinsic to artistic excellence. The extrinsic functions of the art object are of major concern to instrumentalists. The real purpose of the art object, they contend, is to transcend solving formal problems. Art serves as an instrument for facilitating social change, as art is a tool for

advancing social causes.

From the many writings of Locke, I am able to identify various aesthetic tenets; however, space precludes discussing all of them. Noteworthy are the five aesthetic strands that I subsume by the theory of instrumentalism, which is central to Locke's aesthetic:

1. *Afro-American artists should employ propaganda in their art.*
2. *The Afro-American artist should know that African art is the "fountainhead" source of modern art.*
3. *The Afro-American artist should not be restricted to racial subject matter.*
4. *The Afro-American artist's work should embody the particular and the universal.*
5. *The Afro-American artist's work should have rootage in a cultural soil.*

Afro-American Artists Should Employ Propaganda in Their Art

When Locke says that art can serve as propaganda, his writing is consistent with an instrumental aesthetic; hence, he recommends that Afro-American artists employ propaganda in their art to foster social change. Beardsley (1958), in concurrence with Locke, emphasizes the "instrumental" value of art; art has an "extrinsic" value that lies outside of the art object. Feldman (1987) extends this point and says that "the history of art is the history of its service to society's principal institutions and dominant classes" (p. 467). Only in the modern era, Feldman claims, has art functioned to some extent as a "free-floating" activity exclusive of any specific institution, group, or class. Locke, along with other instrumentalists, argues that aesthetic values do not exist in and of themselves, as the full meaning of an art object goes beyond itself; the value of the object transcends the object. For instance, Locke and other instrumentalists would perhaps argue that Hale Woodruff's "Amistad Murals" are objects (seen in Locke's, 1940, *The Negro in Art*) of value not only because of their *form*, which is tangential to their real meaning, but more for their influence on the percipients' conception of social issues, psychological states, and personalities. Therefore, these instrumental reasons are the rationales for which these art objects exist.

Instrumentalists cite various social reasons for which art objects exist. The one that appears to have the greatest concern for Locke, a seminal figure in African and Afro-American art, having written one of the initial books on

the subject, is that art operates as propaganda and performs a social function of influencing group thinking. Locke is keenly interested in social reform, for he makes clear, as I will later show, that art is created in response to the social needs of an audience. The Afro-American artist, according to Locke, should attempt to make social ideologies explicit and identify with the ethnic needs and interests of Afro-Americans. Essential to his thinking is the idea that the visual arts should most substantially affect the societal attitudes of Afro-Americans, altering the way in which they think, feel, and perceive life. Consequently, art, Locke argues, is a form of propaganda.

When I read Locke's early writing, however, I clearly saw that he was not always an instrumentalist. During the Harlem Renaissance, he strongly objected to the propagandistic functions of art. At that time, his chief objection to art as propaganda was based on the idea that propaganda perpetrates the position of group inferiority even in crying out against it. Moreover, Locke's misgivings were based on the idea that art, in the best sense, is rooted in self-expression. The social aims and functions of propaganda inhibit self-expression, according to Locke. A detailed examination and review of Locke's writings in the 1920s revealed that he staunchly maintained that Afro-Americans must choose art (creativity and expression) and put aside propaganda. I infer that Locke's aesthetic stance, at that point, was that self-expression is an *a priori* consideration in art and that propaganda must not hamper it. I can clearly see the polarity of self-expression and propaganda that was to be at variance with his later instrumentalist position. A shift in Locke's position is evidenced in "Advances on the Art Front" (1939). The "Negro" must capitalize on art, "for it is after all the most persuasive and incontrovertible type of group propaganda, our best line of defense" (1939, p. 132).

In the same article, Locke emphasizes the importance of artistic freedom and the artists' right to express themselves freely. Self-expression is a recurring concern in most of Locke's writing, whether he is admonishing "Negro" artists to seek inspiration from African art, to explore the propagandistic potentialities of art, or to establish a "Negro" school of art; however, he remains adverse to doing so at the expense of self-expression and artistic freedom. Consequently, I infer from Locke's writing indications of a polar aesthetic embrace — *instrumentalism* and *expressivism*.

Unlike Locke, I must point out, many aestheticians argue that instrumentalism and expressivism are not compatible schools of thought, as they are mutually exclusive. In explaining the relative position of instrumentalism to other aesthetic schools, it has been observed that there is a strong distinction between the rationales of formalism, expressivism, and instrumentalism. The instrumentalist diverges most widely from that of the

formalist (Bell or Fry), who ponders whether an art object has realized or met its ideal possibilities resulting in "significant form," the orderly arrangement of the visual design elements in artworks. The formalist, therefore, bases artistic excellence on how well an artist succeeds in organizing the elements and principles of visual design. Also, somewhat different from the instrumentalist is the expressivist's (Langer, Croce, Santayana) rationale of artistic excellence based on the notion that art communicates inner feelings and emotions. These expressions, the expressivist claims, are "nondiscursive" (Langer) in nature. They argue that art is a nonlanguage mode of expression, as this anologic mode differs from the logical strictures of language. Artistic excellence, to the expressivist, is based on how well the art object conveys emotions and feelings. Differing from these two views of formalism and expressivism, the instrumentalist sees and emphasizes the extrinsic purposes for which the art object exists. Unlike the formalist and expressivist, the instrumentalist sees that the art object serves a social purpose greater than expression or formal design. Art is a tool for influencing group thinking.

Unlike many aestheticians, Locke came to realize that an instrumental aesthetic was compatible with a formal and expressivist aesthetic. Therefore, Locke could argue that the Afro-American artist should create art within the framework of the Afro-American experience; this art should function as a stimulus to the social needs of Afro-Americans. At the same time, he argues in favor of expressive and formal considerations. The propagandistic-instrumental tenet, coupled with formalism and expressivism, is one of the main strands in Locke's aesthetic.

The Afro-American Artist Should Know That African Art Is the "Fountainhead" Source of Modern Art

Afro-American artists should be aware of the contribution of African art to modern art. They should know that the art of Africa is the "fountainhead" source of modern art, for it "has influenced modern art most considerably. It has been the most influential exotic art of our era" (Locke, 1940, p. 207). Speaking of this influence, Locke says that African art has taught European artists the valuable lessons of simplicity and originality of expression at a time in Western art history (documented by Feldman, 1972, and others) when art had become sterile and bankrupt for ideas, because of generations of inbreeding of style and idiom. Greek Classicism had become exhausted, as had the possibilities of the Impressionists' and Post-Impressionists' color. African art profoundly influenced many modern artists, including Matisse, Picasso, Derain, and Modigliani, as well as Max Perchstein, and such sculptors as Modigliani, Archipenko, Lipchitz, Lembruck, Zadkine, and

Faggi.

When Locke writes of the importance of African sculpture and says that it has given modern European art a mine of fresh and novel motifs, it appears that he shifts away from his instrumental stance. The main concern, seemingly, is the acknowledgment of the importance of African art. However, a more detailed examination reveals that this concern for the importance of African art in no way contradicts his instrumental position. It follows that in African cultures there are no epithets "fine" and "applied" art; "things can be superlatively beautiful and at the same time objects of ordinary use" (Locke, 1940, p. 207). Further, "African art embodies and vindicates one of the soundest of all aesthetic principles — beauty in vital application to life and use" (Locke, 1940, p. 207). In concurrence with Locke, Feldman (1982) says that the African artist "realizes that practical and religious purposes must be served first" (p. 39). African art is truly instrumental in nature.

"What lessons can Afro-American artists learn from African art?" Locke cautions the Afro-American artist not to copy African art because this art, more or less, has already been copied by modern artists. The lessons to be learned from African art are the sound aesthetics of "beauty in vital application to life and use." Again, the Afro-American should use art to advance the social causes of Afro-Americans.

The Afro-American Artist Should Not Be Restricted to Racial Subject Matter

In Locke's aesthetic thought there seems to be a kind of vacillation between instrumentalism specifically and matter such as artistic freedom and the idea that the Afro-American artist is not restricted to racial subject matter.

According to Locke, Afro-American artists should know in their art that they are not restricted to racial subject matter. This is clearly illustrated in the following quote: "No one is so foolish as to want to restrict the Negro to racial subject-matter or being an exponent of Negro art" (Locke, 1936, p. 501). Afro-American artists, therefore, are not restricted in terms of subject matter. They may, if they so desire, create "mainstream" artworks, "Black art" works, or "Black stream" artworks.

Locke concurs with the vast number of aesthetic theorists in that artistic freedom, which is not a tenet of instrumentalism, is always a requirement in art. It is an a priori certainty or self-evident consideration in art. Otherwise, there would be no creativity or individuality of expression. Locke, somewhat in contradiction, acknowledges the instrumental aes-

thetic concern for the importance of Afro-American artists having regard for the "social causes" of Afro-Americans, while still arguing in favor of creativity and individuality of expression. According to Locke's thinking (and somewhat of a contradiction to mine), originality, creativity of expression, and instrumentalism are mutually compatible.

The Afro-American Artist's Work Should Embody the Particular and the Universal

Again Locke admonishes Afro-American artists, this time to be "creatively rooted in a particular cultural soil"; that is, he recommends that they produce art within the context of the American culture. At the same time, he also encourages the creative "Negro" artist to achieve "international order of mutual exchange and appreciation." Hence, there appears to be the dichotomy of the particular (art should have rootage in a cultural soil) and the universal (creative art transcends the particular and achieves universal aesthetic appreciation) evident in Locke's aesthetic.

This concern for the particular and the universal is a traditional philosophical dichotomy that dates back to the time of Plato and is not essentially instrumental. "How can a work of art embody both the particular and the universal?" is the rhetorical question philosophers have posed for thousands of years.

Locke too addresses this traditional question when he writes that "art has maintained, in spite of hectic nationalism and passionate particularisms an instinctive feeling for universality" (1924, p. 134). This succinct statement clearly underlines the concepts of the particular and the universal. Another evidence of this same concern is seen as early as May 1924 in his *Opportunity Magazine* article, " A Note on African Art." Here Locke writes that "It [African art] has an aesthetic meaning and a cultural significance" (p. 134). He takes, in this case, the "aesthetic" to be universal and the "cultural" to be particular.

Locke advances the idea that the more deeply representative that art is racially, the broader and more universal it is in appeal and scope, there being for truly great art no essential conflict; these two elements are compatible. However, I think Locke's taking the "cultural" to be the "particular" and the "aesthetic" to be the "universal" makes for some circularity in his reasoning. To my thinking this is only an assumption, which may be denied by instrumentalism, that the aesthetic is universal. I agree with many others who argue that aesthetic principles are culturally based, as they differ from culture to culture; aesthetic principles are not universal. This point is clearly

underlined in the history of world art. For instance, the art of India may be instrumental (not truly universal) in that it is often used in the service of Hinduism; however, this Eastern aesthetic that is found in Indian art differs drastically from Western aesthetic conventions of beauty. No aesthetic is truly universal. I contend that aesthetic principles — though they may to some extent transcend a particular culture, class, or period in time — are largely culturally based and fall short of universal appreciation by peoples of all cultures.

Often, when Locke writes on African art (1924, p. 134), he nonetheless characterizes it as being twofold: having both aesthetic meaning and cultural significance, the *particular* and the *universal*. Therefore, a visual image rates as a work of art when it has fulfilled the requirement of the universal aesthetic — having transcended "the particular" culture in which it was made and achieving standards of artistic excellence. However, I think here again that Locke's stance may deny culture-bound instrumentalism. Locke, however, rightly seems to advance the notion, just as do R. G. Collingwood and others, that *craft* and *technique* precede "art" as universal standards of excellence; truly great art is based on the expression of human feelings and not on technical mastery over media. I must, however, point out that this position is inconsistent with the basic premise of instrumentalism — art in service to society; it is expressivist in nature and runs counter to the instrumental aesthetic position.

Locke writes (1924):

> *African art has two aspects ... it has an aesthetic meaning and a cultural significance. What it is as a thing of beauty ranges with the absolute standards of art makes it a pure art form capable of universal appreciation and comparison, what it is as an expression of African life and thought makes it an equally precious cultural document.* (p. 134)

Locke's words about Richmond Barthe's sculpture *Mother and Son* explains his instrumental point of view. "Here is a subject racial to the core — a Negro peasant woman kneeling and mournfully cradling in her arms the limp, broken-necked body of her lynched son" (1939, p. 133). This work, Locke goes on to write, is very potent antilynching propaganda; it, he reasons, is universal as it elicits responses of pity from those who know nothing of lynching; thus, it produces instrumental value (instrumental value in this context implies universality). Thus, the Afro-American artist's work should embody the particular and the universal.

238

The Afro-American Artist's Work Should Have Rootage in a Cultural Soil

This aesthetic tenet is somewhat related to the previous one in that the "cultural soil," as I interpret it, means "the particular."

The task of Afro-American artists is that of expressing themselves within a cultural context by means of a contemporary idiom — those of an adopted culture, America. Art is a culturally laden product. It seems very clear to me that Locke here is recommending that Afro-American artists employ contemporary Western aesthetic conventions in their art. Apparently, Locke does not acknowledge the validity of Afro-American artists using non-Western aesthetic conventions and styles in their art — they should make use of a contemporary idiom that is peculiar to their culture. Locke strongly cautions, however, that in "terms of group and cultural significance, it should never be forgotten that in America the Negro is having his second career in the fine arts" (Locke, 1940, p. 8). The first was in Africa. Afro-American artists should be proud of their heritage.

The Western modern artist has already been strongly influenced by African art. Locke warns the American "Negro" against copying and imitating the style of African art. Therefore, he aptly concludes that the American "Negro" artist's goal should be to recapture the spirit of African art and to resume a long-standing career in the visual arts. African art should only be studied for its basic aesthetic principles (and not its style): (a) rootage in its cultural soil, (b) usefulness and utility, and (c) wide popular appreciation. According to Locke, these are the lessons that Afro-American artists can learn from African art.

In sum, Alain Locke brought a new focus to Afro-American art several decades ago. He rightly argued that the Afro-American artist's work reflects, transmits, and extends the culture of the Afro-American, and that the arts personify and ultimately define the values of a culture. Precisely, Locke's conscious stressing of social values provided Afro-American artists with the charge of creating culturally significant works of art.

Locke's instrumental aesthetic remains a timely message for the Afro-American artists of today. His ideas, considered valuable then, may be in some respects more valuable in today's world of integration and acculturation. Thus, Locke's aesthetic warrants revisiting, a reprise. Just as any great work of art transcends the age in which it was created, Locke's ideas (on art as propaganda, the African roots of modern art, freedom of artistic expression, the particular and universal in art, and art in a cultural soil) likewise demand a type of systematic analysis and further consideration.

Finally, Locke attempted to turn the art and culture of Africa to Afro-Americans' aesthetic and political advantage. He emphasized art's potential as a "usable past," for he saw that the art of Africa is an instrument for advancing social change for Afro-Americans.

References

Beardsley, M. (1958). *Problems in the philosophy of criticism*. New York: Harcourt, Brace and World.
Feldman, E. B. (1971). *Varieties of visual experience*. Englewood Cliffs, NJ: Prentice-Hall.
Feldman, E. B. (1982). *The artist*. Englewood Cliffs, NJ: Prentice-Hall.
Locke, A. (1924). *Opportunity Magazine, 2*, 134.
Locke, A. (1927). Art lesson from the Congo: Blondian theatre arts collection. *Survey, 57*, 587-589.
Locke, A. (1931). American Negro as artist. *American Magazine of Art, 23*, 210-220.
Locke, A. (1936). *Negro art: Past and present*. Washington, DC: Associates in Negro Folk Education.
Locke, A (1938). Freedom through art: Review of Negro art, 1870-1938. *Crisis Magazine, 45*, 227-228, 229.
Locke, A. (1939). Advances on the art front. *Opportunity Magazine, 17*, 132-136.
Locke, A. (1940). *Introduction to the Negro in art: A pictorial record of the Negro theme in art*. Washington, DC: Associates in Negro Folk Education.
Locke, A. (1977). The legacy of the ancestral arts. In A. Locke (Ed.), *The new Negro*. New York: Atheneum.

Additional Resources

Bell, C. (1935). Significant form. In M. Rader (Ed.), *A modern book of esthetics*. New York: Henry Holt and Company.
Collingwood, R. (1964). *Principles of art*. New York: Oxford University Press.
Croce, B. (1922). *Aesthetics*. New York: Macmillan.
Fry, R. (1935). An essay in esthetics. In M. Rader (Ed.), *A modern book of esthetics*. New York: Henry Holt and Company.
Langer, S. (1957). *Problems of art*. New York: Scribner.

18

Assimilationism: Learning How to Learn the Beauty of It All

BRADLEY SMITH

Tyler School of Art, Temple University

Nearly a decade ago, I attended a Buckminster Fuller lecture, and I remember his explanation of what you observe when you focus on a star. He said that what you see is the result of something that has happened a hundred or more years ago. Now, when I see a star, I feel a special linkage with the past. Also, I now understand that I am, like everyone, as uniquely important as anything that has ever happened in the universe, and at the same time, as insignificant as any grain of sand from any desert of this same universe. I now understand that I am, as you are, "Change" searching for a perfect balance, fully cognizant of the fact that this degree of balance is without change. I further understand that together we are on this planet, which is in trinity with a life-giving sun and a romantic moon, and we are intrinsically linked to its first past beginnings and its last future endings. We are the chosen of God, striving to learn the beauty of it all.

We are the benefactors of the "Star-Teachers" of the world, past and present, who have guided us in our search of this illusive beauty. In a time when the fabric of the world is still more burlap than silk, I shudder to think what it would be like without having benefited from the ability of these "teachers" to give direction to the mindset of humankind. They have been more than just certified leak fixers of education in the more habitable parts of the world. They have been the molders of new departures, continuously cultivating the creative efforts of that raw recruit we call learner. Yes, they have been the thermostat of human knowledge and understanding, preventing a mismanaged world from uncontrolled sadness. They have redirected the concept "survival of the fittest" to include the survival of all. Star-teachers of the world, past and present, I salute you.

In the future, we must not forsake proven methodology to accommodate the onslaught of technological change. No, we must not abandon the *tools of*

learning — awareness, focus, transformation, and evaluation. In fact, we must not only broaden their usage, but we must develop a longer running continuity of teaching people from the "cradle to the grave." Yes, teaching that raw recruit the tools of learning is still in vogue. The question is, How do these tools work together for good or for evil?

Let's say a colt wanders off from the safe protection of other horses. Looking into the distance, the colt, for the first time, becomes aware of a berry bush. Slowly it approaches the bush and focuses its senses by seeing, smelling, feeling, hearing, and tasting the berries on the bush. The colt then transforms the bush by eating some of its berries, and feels better for the experience. The colt's evaluation of other encounters with similar berry bushes will be favorable.

Let's say a beautiful little six-year-old who is walking down a street in some part of the world becomes aware of and picks up what appears to be a toy. In reality, this toy is an XK-5 grenade, government issued. Like the colt, the six-year-old uses the tools of learning, but the results will be evaluated by others as his or her last actions. Here we have transformation that went out of control.

In both examples, the tools of learning were exercised, but the actions, reactions, and results were completely different. Change can be controlled until the point of collision, and then the result will be uncontrollable. In other words, the latter experience lacked a star-teacher's concern for the aesthetic interrelatedness and balance of intellectual action, emotional reactions, and socially environmental world concepts. It lacked the proper environment for learning and, without the proper atmosphere, we will see changes colliding out of control.

Like the home thermostat that controls heat and cold, future teachers of real-life experiences should help regulate the learners' ability to see, hear, feel, and taste *what is*. Learners, on the other hand, must learn to ask *what would happen if*. Also, they must learn to think and not just love or hate to feel. But, above all, they must learn to control the different results of change.

Teachers of the world — What should we be cognizant of as we toss the pebble of awareness into the pond of focus and cause ripples of transformation and change? While we search for the first tool of learning and look at the world today, we must, in truth, recognize the unintellectuality and unperceptiveness of too many human beings from the four corners of the globe. Do you see what I see?

I sense prehominid abnormalities forcing the human immunity toward

ultra-human moralities, but I see a world mismanaged by unprincipled leaders of tribal gangs called nations. Each boisterously claims impregnable air space, indigenous territorial waters, and indissoluble land boundaries that provide a feast for some and famine for others. I smell the exhaust of the industrial revolution breathing its acid rain, killing rivers, lakes, and forests and endangering the biological species of the world. I feel the results of that old unrelenting adversary, War, with its new defensive and offensive weaponry that threatens large-scale annihilation. I hear of religious persecution, racial genocide, nuclear meltdowns, and genetic engineering from abortions to cloning. Although the taste of acculturation seems putrid, there is light at the end of the tunnel, which brings us to the second tool of learning.

When we try to bring the above issues to a point of concentration, we must do so with the microscopic visionary of the greatest dreamers of all time. Oh, to awaken to not only no countries at war, but no countries — only one well-organized world of interdependent parts under one name, one governmental system, and one ordinary-language philosophy with the following realizable aspirations: a free educational system from day nursery to geriatric care; free health care for all species of the planet; individual liberty and freedom of religion, communication, travel, and privacy; guaranteed minimum income to all citizens of the world; and free research for new discoveries.

It is time to reach deeply into our own understanding of truth and stamp out greed, envy, hate, and war. It is time to live a life of love, sharing and caring for all of God's creation, in a world where individuals are encouraged to direct full attention to a self-balancing of the intellectual, emotional, physical, spiritual, social, and aesthetic realms of life. How can we not be successful as a species if we encourage the learner to do better than each previous best?

The third tool of learning how to learn is the most exciting and most difficult to achieve. It is a search for a new tomorrow, after researching the best and worse of an unacceptable today. Transformation can be slow or fast, but remember, *friction creates change*. Most people of the more developed countries want to improve their environment and desire world change that is fueled with little friction, whereas those people who live in the less developed countries want to survive any change they feel helpless to control. Both groups are on automatic pilot ready to be exploited by friction-created change. The world is chained together, and its survival is determined by its weakest reaction. However, friction does not have to come in the form of war; it can come in the form of love, just as fission may result in new life. It only takes one seed to sow a flower or a tree. We need one love

revolution or the signing of one world constitution based on the best each and every nation can provide — in other words, the genetic modification of thinking, with normality as a transfusable departure from the abnormal to the creative.

I realize the last thing a teacher of spelling wants is a creative speller, but we must provide room for new thinking and new words. Creativity does not have to be the enemy of normality, nor do abnormalities deserve any lack of respect. If you watch what might appear to be a weed long enough, you may see it flower.

An excellent example of *change* based on focus was seen in 1962 when biologist Rachel Carson mobilized environmentalists with her book *Silent Spring*. She brought to world attention the dangers of synthetic pesticides and opened the way for others to someday alleviate the damage done to agriculture by herbicide residues. We must learn to see the beauty of the leaf, but not at the expense of the tree, and to see the strength and beauty of the tree, but not at the expense of the forest. Still greater than this is to replenish and/or recycle the changes done to nature by humankind. Change in time is the final antagonist to uncontrolled accelerations of a chain reaction.

When things don't work in education, we come together and change the curriculum. Well, we need to change the world curriculum, because the world has been held hostage by this latest reign of ballistic madness for more than 40 years at a cost of millions of lives and trillions of dollars. It is time to come together.

In summation, the beauty of it all is to know that every human born has the potential to learn, therefore making it possible to modify world conditions for the betterment of humankind. Learning affords us time to redirect our energies and turn our ballistic waste into plowshares for discovery. Learning sparks the search that may ignite the extension of old boundaries or even break new dawns.

The beauty of it all is, when dropping the pebble of awareness into the pond of focus, the ripples of transformation must be evaluated in the context of change searching for perfect balance and knowing that it only comes before and after life.

Yes, the beauty of it all is to see a tree stand barren in the winter and know it will have leaves to house birds in the summer. The more we learn about nature, the more we need to know to anticipate its wonders.

It is Time

Stop the killing and learn to live.
Stop the hating and learn to love.
Stop the stealing and learn to share.
Stop the starving and learn to feed.
Stop the scarring and learn to heal.

It is time

Learn truth and start the praying.
Learn justice and start the caring.
Learn knowledge and start the thinking.
Learn understanding and start the searching.
Learn wisdom and start creating.

It is time.

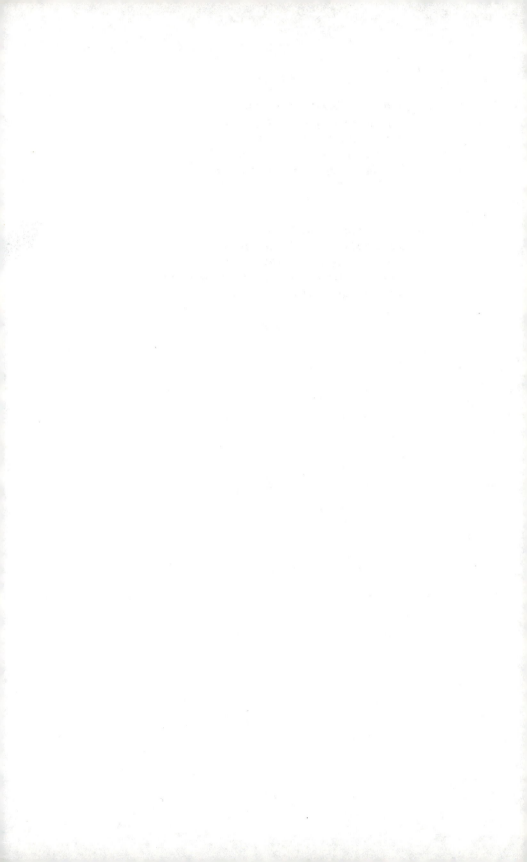

19

Concepts and Values of Black and White Art Instructors Affecting the Transmission of the Black Visual Aesthetic in Historically Black Colleges and Universities

OSCAR L. LOGAN

Alabama A & M University

The continuity of a Black culture is very important, because it is from this context that Black aesthetic preferences emerge and are appraised. The survival and continuity of aesthetic preferences, like other cultural forms, depend largely on the fidelity with which such information is passed from one generation to the next. The transference of information (aesthetic or cultural knowledge and values) may occur by means of oral interpretation, written documentation, and/or visual imagery. Furthermore, it may be operationalized through informal (home and community) or formal (school) channels.

This investigation is primarily concerned with the formal aspects of transmission: To what extent do art instructors in historic Black institutions of higher education conceptualize and evaluate tenets of the Black *visual* aesthetic/art experience?

Given the origin of the historic Black college, its inherent mission, and the composition of its major student population, one would assume that its art program would be especially responsive to the transmittal of concepts and values pertaining to Black art and Black aesthetics.

The Black Aesthetic

African-Americans, like members of other ethnic groups in this country, demonstrate endemic sociocultural and sociopolitical as well as aesthetic

preferences. The existence of an African-American aesthetic for many writers, researchers, and educators, however, remains a dubious notion. Interestingly, most will agree that there is a Black experience stemming from the forced migration of Blacks to America and the peculiar conditions surrounding their lives thereafter. Yet, they do not recognize characteristically divergent aesthetic choices that deviate from those of the major (Euro-American) groups.

The Black aesthetic is an essential component within an interdependent triad consisting of Black culture, Black aesthetics, and Black art. Black American artists who choose to work from the context of a Black visual aesthetic necessarily abandon those standards imposed on them by the operatives of the major Western aesthetic. They refer to their African past as well as their American existence for purpose and inspiration. As Ron Karenga stated: "The Black artist must take from the people and give back to the people images more beautiful and colorful than real life" (cited in Gayle, 1971, p. 33).

Gayle (1971) edited a comprehensive group of articles dealing with various influences of the Black aesthetic in theory, visual arts, music, poetry, drama, and fiction. In another effort to lend credence to the Black visual aesthetic, historian Rosalind Jefferies (1980) identified several major variants stemming from a Trans-African art perspective, including syncretism, creolization, improvisation, double-consciousness, and cultural pluralism (Donaldson, 1980, pp. 97-98).

The exploration of a Black aesthetic demands examination of or involvement with every aspect of Black life, whether in music, athletics, theater, the church, the streets, the visual arts (principles of Black art), or traditional African cultures. The Black aesthetic relies on these contributors for its subsistence. If it is anything, it is the search for a new program, because all the old programs spawned out of the Judaeo-Christian spirit have failed us. It is the search for new spiritual quality or the recapture of an old one, lost and buried deep in Africa's past (Mayfield, 1971, p. 27). According to Carolyn Fowler (1981), "The Black aesthetic, like all aesthetic traditions, is above all an affirmation of life." She perceives balance as the core concept of the Black aesthetic. Balance, writes Fowler, is knowing how far to go and still get back, how long to bend over in the dance without falling, how long to draw out a note without losing musicality, how far to take an improvisation without losing the theme (p. 6).

In structuring a workable definition of the Black aesthetic, referents are drawn from Black culture. Although not elaborated here, the phenomenon of Black culture has been developed in the writings of several prominent

investigators (e.g., Herskovits, 1958; Senghor, 1956; Whitten, 1970; Staples, 1976; Blassingame, 1972). These writers have variously attributed the origin and continuity of Black culturisms to socialization and African heritage.

The Black College as Transmitter

Most studies in Black aesthetics are similar in that they acquire research data from urban or established Black artists. To date, there have been only two empirical studies that have dealt with the Black visual aesthetic in predominantly Black colleges (Neperud & Jenkins, 1982; Logan, 1983). However, White (1982), Bontemps (1976), Cordoza (1970), Jordan (1964), and Rouse (1967) have conducted studies that have addressed the issue of art departments in Black institutions of higher education. These studies do not deal with a Black aesthetic but rather demographic concerns (e.g., number of teachers, number and type of degrees held by teachers, years of teaching experience, student enrollment, program directions, and budgets).

Black colleges and universities touch the lives of many Black people (students and community). Of 600,000 Black students enrolled in bona fide senior college programs in 1972, more than one third were enrolled in Black colleges (Wilie & Edmonds, 1978, p. 184). By 1978, these colleges enrolled a third of the 1 million Black college students around the country. Enrollment grew steadily until 1976, but since then has been on a decline. The college-going rate of Black students in the United States averages nearly 25%. Approximately 17% attend historically Black colleges (Klein, 1982).

The fundamental purpose of higher education — its obligation and responsibility — is to transmit purposeful knowledge, facilitate awareness and self-discovery, and develop value priorities (Grigsby, 1977). In spite of declining enrollment trends, writes Rouse (1967), "it is generally believed that Black colleges will remain the most immediate and efficient avenue for training upward-bound Blacks and consequently, those individuals who will enter the visual art field." Over the years, the mission of Black colleges has been amended or subjected to varying definitions. The main focus, nonetheless, remains relatively unchanged. Fundamental functions of Black colleges, therefore, include the recruitment, maintenence, and transmittal of Black culture. The Black visual aesthetic is a viable component in this process.

Studies on Black Aesthetics

Although there is lasting concern relative to the interpretation of a Black visual aesthetic, available literature on the subject remains sparse. The literature that does exist, for the most part, results from historical or philosophical, and occasionally, descriptive research.

In his study of the urban Black aesthetic, Depillars (1976) listed five categories that shape the Black aesthetic: (a) historical perspective, (b) call and response, (c) improvisation, (d) representational balance, and (e) balanced intensity in color. Spellman (1973) and Staats (1978) similarly observed mainstream or simply contemporary styles in art on the one hand and "Blackstream" or obvious sentiments of Black subject matter, protest, or nationalistic images on the other. The framework for Staats is found in Fine's (1973) *The Afro-American Artist*. Fine assigned contemporary Afro-American artists to one of three style categories — mainstream, Blackstream, or the Black art movement.

Coleman (1975) examined some of the perceptual questions surrounding African cultural retentions among Blacks in America. He also endeavored to offer a theoretical framework for examining works by Afro-American artists. This study (a) defined the problem and discussed concepts that are important in making contextural descriptive analyses of works that exhibit traditional African art similarities, (b) examined the West African background and characteristic world views, and (c) discussed selected works by Afro-American artists from slave craftsmen to the late 1960s and early 1970s.

Research dealing with empirical inquiry into the existence and practice of a Black aesthetic is represented in the studies by Depillars (1976) and Neperud and Jenkins (1982). Using the semantic differential technique, Neperud and Jenkins conducted a study involving Black and White southern, non-art college students. The semantic differential technique (Osgood, 1957) takes one concept and asks the respondent to rate that concept in terms of several criteria. Each criterion is stated as a pair of bipolar adjectives (good-bad), and the respondent is asked to indicate his or her perception of the concept to be rated somewhere on a continuum from *good* to *bad*. The researchers sought to determine whether there were ethnic specific choice differences between the ethnic groups. Students reacted to Black artists' works that had been categorized into three distinct styles: mainstream, Blackstream, and activist. Factor analysis of the responses indicated that Blacks more highly favored artworks containing recognizable Black imagery, evaluating Blackstream and activist images more positively.

This study is structured around a fundamental question of Black cultural

transmission: Do instructors of art in colleges and universities with predominantly Black student populations possess concepts and values representative of Blacks' visual art contributions and Black aesthetics?

A major model of concept learning and development consists of four successive levels of attainment (concrete, identity, classificatory, and formal). This investigation is limited to the identity level. Concepts acquired at only the identity level can be used to solve simple problems that require nothing other than the relating of obvious sensory perceptions (Klausmeier, 1974, p. 13).

The purposes of this inquiry were (a) to assess Black college art instructors' ability to identify comparable works by African-American and non-Black (European or Euro-American) artists, (b) to evaluate instructors' value priorities relative to issues in Black art/aesthetics, (c) to examine differences between instructors' concept and value choices by ethnic affiliation, and (d) to draw inferences from instructors' group responses regarding their commitment to transmit Black visual aesthetic information. Its purpose was not to validate prevailing Black aesthetic theories or resolve any outstanding arguments relative to the existence of this phenomenon. Rather, this inquiry attempted to evaluate art instructors' awareness and opinions in regard to prevailing Black visual aesthetic subject matter.

Materials and Methods

Subjects

Data for this inquiry were gathered from 52 art instructors (31 Black, 21 White) from 11 predominantly Black colleges and universities in seven southeastern states (Alabama, Mississippi, Tennessee, Kentucky, Georgia, South Carolina, and North Carolina). According to the *Education Directory,* the *Negro Almanac,* and other published materials on historic Black colleges, over two thirds of the 101 such schools are located in this area. A major criterion for including a particular school in this study was that it offered at least a bachelor's degree in art or art education.

Value and Concept Measures

The value assessment section of this study was designed to evaluate the degree that art instructors agree or disagree with statements representing divergent viewpoints on Black aesthetic issues. This section was composed of 26 opposing viewpoints (13 "pro" statements — views concurring with Black art/aesthetic doctrine, and 13 "con" statements representing noncon-

curring views). These statements were taken from writings on Black aesthetics (e.g., Fine, 1973; Lewis & Waddy, 1969; Gayle, 1971; Driskel, 1976; Lewis, 1978).

Four experts in the area of African-American art/studies unanimously agreed upon the placement of each value statement into one of five established categories: (a) aesthetic/art creation context, (b) social context, (c) political context, (d) historical context, and (e) economic context. Statements were written on separate index cards that were numbered on the reverse side.

After reading the accompanying background information, the respondent was given the stack of index cards and corresponding answer sheets. Answer sheets contained a seven-category rating scale for each statement. The respondent was asked to print his or her code number at the top of the answer sheet (partial anonymity), select the top index card, record his or her response on the answer sheet, and then move on to the next card until each statement had been reacted to. Cards were shuffled between subjects to avoid methodological bias. Also, participants received alternately arranged rating scales (i.e., one half of them received scales arranged from *strongly agree* to *strongly disagree*, and the other half from *strongly disagree* to *strongly agree*). The reliability coefficient for all 26 value statements taken together was 0.740; for pro-con subgroups the coefficients were 0.754 and 0.588, respectively. The confidence level for con value statements seems low. These results are possibly due to some respondents' inconsistency in rating. They were not in agreement with the pro views, yet showed little or no conviction for the opposing (con) viewpoints.

The concept assessment section was designed to evaluate instructors' ability to identify outstanding visual art forms — matching pictures of the art forms with the name of the producing artists. Respondents were shown 32 illustrations of outstanding artworks, 20 of which were produced by famous Black artists (e.g., Bannister, Douglas, White, Gilliam, and Chase-Riboud). Twelve were produced by famous non-Black artists (e.g., Constable, Benton, Dekooning, Stella, and Nevelson). Illustrations were selected according to their historical placement — period or year of their creation; imagery — representational or nonrepresentational; technique — handling of the medium; and ideology — political or nonpolitical.

Artists and illustrations of their works were selected from popularly used art history and art survey textbooks, for example, *Gardner's Art Through the Ages* (6th ed.) by de la Croix and Tansey (1975); *American Art of the Twentieth Century* by Hunter (1973); *Art: An Introduction* by Cleaver (1977); *Art in Context* by Hobbs (1975); and the previously mentioned

publications on Afro-American (Black) art. The illustrations used represent the most well-known or, rather, most commonly publicized works by each artist (typified by the recurrence of pictures in the various textbooks).

Artists and artworks were first grouped by period, for example, post-colonial, mid-19th century to World War I, modernist, mid-20th century, and 1960s to early 1970s. They were later subcategorized into three groups listed by Fine (1973). These subgroups emphasize the variety of attitudes and styles expressed by contemporary Black artists:

1. *Black Art Movement (Activists):* Art incorporates obvious subject matter — especially the figure — to accentuate the social and political plight of Black people in America. Artists are more interested in creating new standards than accepting the traditions or aesthetics of Western art.

2. *Mainstream:* This subgroup includes those artists whose style conforms to accepted international art trends. Their reactions to the complexities of society become an aesthetic statement and their work is, for the most part, nonobjective.

3. *Blackstream (Trans-African):* Artists often work figuratively to syncretize symbols, colors, and techniques of African art with those of the Black art experience in an attempt to universalize the Black condition in America, but with generally accepted aesthetic standards.

Procedure

The basic components of this research instrument were developed and initially used in a pilot investigation to assess instructors' concepts and values relative to Black artists' works and Black aesthetics. Eighteen department chairpersons were later sent letters of inquiry and requests to participate. Of these 18 requests, there were 12 consenting responses, 11 of which could be used in this study.

The art departments of the selected schools were visited, appointments were set up with individual art instructors (30 to 60 minutes), and survey questionnaires and concept-value assessments were administered and followed up with an in-depth taped interview (interviews were conducted with 10 chairpersons and 17 randomly selected instructors).

After completing the questionnaire, instructors were asked to read a brief historical writing about the Black American artist. Background information was included to enhance or supplement respondents' basic understanding of contributions made by these artists.

253

Table 19.1

Analysis of Variance for All Value Statements

Source	df	MS	F
Between groups	1	813.89	2.77
Error	50	293.37	

Table 19.2

Analysis of Variance for Various Contexts

Context	Source	df	MS	F
Art	Between groups	1	121.37	1.14
	Error	50	106.50	
Social	Between groups	1	84.47	4.25 *
	Error	50	19.88	
Political	Between groups	1	52.56	2.67
	Error	50	19.67	
Historical	Between groups	1	5.90	< 1.00
	Error	50	11.14	
Economic	Between groups	1	1.84	< 1.00
	Error	50	3.68	

* $p < .05$.

One-half of the participants surveyed responded to the value section first, the other half to the concept section first. Immediately following concept-value assessments, 27 respondents (15 Black and 12 non-Black) were asked to openly respond to seven questions about Black art/aesthetics and related art departmental issues.

The resultant data were analyzed using techniques from the Statistical Package for the Social Sciences (SPSS) and Bio-Medical Data Processing (BMDP) in an analysis of variance (ANOVA) including repeated measures. Additional analyses using two sample t tests were employed. The 0.05 level of confidence indicated statistically significant differences between instructors' mean responses. The frequency and breakdown procedure, along with interview data, was used to ascertain descriptive information about groups of interests.

Results

An ANOVA for Black and non-Black (White) respondents on all 26 value statements together showed no significant difference between means, $F(1, 50) = 2.77$, $p < .10$ (Table 19.1).

Value Analysis

Each value statement was then placed into one of five contexts to determine whether instructors more or less agreed with particular statements relative to these derivatives: (a) art context, (b) social context, (c) political context, (d) historical context, and (e) economic context.

An ANOVA for the context variables indicated a statistically significant difference between racial groups' responses only on the social context items, $F(1, 50) = 4.25$, $p < .04$ (Table 19.2). There were no significant differences on pro-con subcategories within the various contexts. However, Blacks' mean scores exceeded Whites' for all pro and con statements except those within the historical and economic con contexts. Black and White instructors had practically identical scores on the con or anti-Black aesthetic variables within the historical context, $M = 9.45$ and $M = 9.52$, in that order.

When value statements were analyzed separately, via t tests, Black and White instructors' responses differed significantly on only three statements: statement 9 at $p < .002$ where Blacks were in stronger disagreement; statement 10 at $p < .011$; and statement 23 at $p < .007$ where Blacks more strongly agreed (all significant at .05 or less).

Table 19.3

Analysis of Variance for Identification Items

Source	df	MS	F
Between groups	1	114.53	1.46
Error	50	78.41	

Figure 19.1. Pro-con group mean scores by race.

Groups	Mean	SD
PRO		
Blacks	56.48	12.97
Whites	50.28	5.67
CON		
Blacks	49.67	11.64
Whites	47.42	6.75

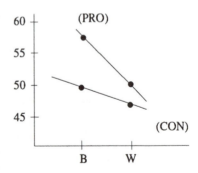

A *t* test of mean differences for pro-con statements, on the other hand, indicated a significant difference between Black and White instructors' responses on the pro items at *p* < .429.

The mean scores in Figure 19.1 show that Blacks consistently rated both pro (*M* = 56.48) and con (*M* = 49.67) value statements higher than did Whites (*M* = 50.28 and *M* = 47.42, respectively). That is, Blacks were in greater agreement with pro (Black aesthetic) viewpoints and greater disagreement with con (anti-Black aesthetic) viewponts.

The statements referred to above read as follows:

Statement 9: First and foremost, the Black artist must be concerned with his/her own individual aesthetic principles and creative development, not the evaluative criteria of a social or cultural affiliation.

Statement 10: First and foremost, the work of the Black artist must reflect the sociocultural preferences of the Black community.

Statement 23: The contributions of Black artists have not received their rightful recognition. This is not due to any lack of generic talent by Blacks, rather to their purposeful omission in history books, museums, and galleries by the powers that be.

Value responses for both groups fell generally about the neutral position (between 3 and 5) on the rating scale. Obvious positive reactions (at or above the 6th position — agree) were seen in response to Statement 23 exclusively. Whites registered a mean score of 5.95 as compared to 6.68 for Blacks. Obvious negative response (at or below position 2 — disagree) was observed for six (23%) of the statements.

Concept Analysis

An ANOVA for identification (concept) items (Table 19.3) showed no significant differences between Black and White instructors' responses. Further, when items were broken down into Black and European subgroups (Black = artworks by Black artists; European = artworks by European or Euro-American artists) and analyzed via *t* tests, there still was no statistically significant difference between instructors' performance means: Black, $t(50) = 1.13, p < .27$; and European, $t(50) = 1.28, p < .21$. Mean scores for instructors are plotted in Figure 19.2.

Closer analysis of concept measures is accomplished by breaking down identification items by (a) style — mainstream, Blackstream, and Black

art; and (b) historical time period — Time 1 = mid-19th century, Time 2 = modernists (early 20th century), Time 3 = mid-20th century, Time 4 = 1960s and early 1970s.

In an ANOVA including repeated measures where art styles constitute the dependent variables and race the independent variable (Table 19.4), significant differences were observed between groups on mainstream measures, $F(1, 50) = 7.17$, $p < .01$, and Black art, $F(1, 50) = 5.79$, $p < .02$, but not on Blackstream, $F(1, 50) = 2.50$, $p < .12$.

The mean scores in Figure 19.3 clearly show that Black instructors were better able to identify the artworks from the mainstream and Black art subcategories. Whites' scores on the Blackstream artworks appeared slightly higher than Blacks'. This difference, however, was not statistically significant.

An ANOVA for the clustered art styles showed, as indicated in Figure 20.3, a significant interaction between the style subcategories and race, $F(2, 100) = 16.37$, $p < .000$. In other words, respondents' race meaningfully influenced their ability to identify concept variables according to style groupings.

An ANOVA including repeated measures with historical time periods (Time 1 - Time 4 together) as the dependent variable (Table 19.5) revealed no significant differences between group responses.

Separate t test analysis, however, showed a statistically significant difference between Black and White instructors' performance on Time 3 at $p = .000$, but not on any of the other time measures: Time 1, $p < .486$; Time 2, $p < .197$; and Time 4, $p < .074$. White instructors outperformed Blacks at Times 1 and 2: Time 1, Black $M = .596$, White $M = .650$; Time 2, Black $M = .544$, White $M = .642$. Blacks outscored Whites on the identification of art concepts from Time 3: Black $M = .672$, White $M = .301$. The difference at Time 4, .633 and .480, respectively, was not significant. (See Figure 19.4 for plotting of concept means by race and time periods.)

A repeated measures ANOVA indicated a significant interaction between respondents' race and their reactions to the concept items as assigned to the various time periods, $F(3, 150) = 35.64$, $p < .000$ (Table 19.5).

Descriptive data about the populations of concern were ascertained by breaking down respondents' *identification (concept) responses by race and value performance*. This procedure involved participants' concept scores by all value responses by race, whereby instructors were assessed in terms of how well those who scored above (high) or below (low) the population's

Table 19.4

Repeated Measures Analysis of Variance for Art Styles

Source	df	MS	F
Race	1	4.51	1.93
Style	2	2.57	7.37*
Race by style	2	5.84	16.73*
Error	100	.35	

*$p < .05$.

Table 19.5

Repeated Measures Analysis of Variance for Time Periods

Source	df	MS	F
Race	1	.491	1.40
Time	3	.170	10.30*
Race by time	3	.588	35.64*
Error	150	0.16	

*$p < .05$.

Figure 19.2. Black/European subgroups' mean scores by race.

Sub-group	Mean
BLACK	
Blacks	12.45
Whites	10.76
EUROPEAN	
Blacks	7.09
Whites	5.76

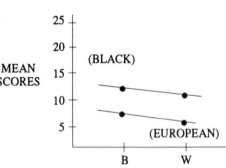

Figure 19.3. Mean scores by art styles and by race.

Groups	Mean
MAINSTREAM	
Blacks	1.935
Whites	1.095
BLACK ART	
Blacks	1.870
Whites	1.238
BLACKSTREAM	
Blacks	1.709
Whites	2.142

Figure 19.4. Concept mean broken down by time periods and race.

	Time 1	Mean Score Time 2	Time 3	Time 4
Blacks	.5964	.5444	.6720	.6334
Whites	..6508	.6429	.3016	.4805

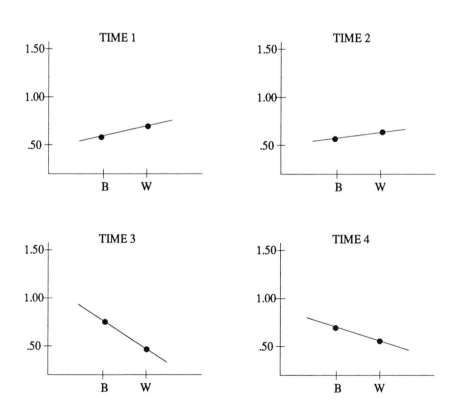

value median score (107.5) performed on the concept items.

Blacks who responded most positively (high) had a mean of 22.58 on the value statements and seemed better able to identify pictures of artists' works than did the corresponding non-Black group ($M = 14.00$). Non-Blacks who scored low ($M = 18.08$) appear to have been better able to recognize the artworks than were the Blacks in this group ($M = 14.75$).

High/low value responses by concept scores and race revealed no significant differences across groups. There was, however, a significant interaction between these variables, $F(1, 48) = 5.94$, $p < .019$. In other words, instructors' performance on the concept measures was very much influenced by race as well as by their rating of the value statements.

Further analysis of *pro/con value responses broken down by concept scores by race* indicated that Black instructors ($M = 21.15$) and non-Blacks ($M = 21.25$) who scored above (high) the pro median (53.5) recognized approximately the same number of artists' works. Of the instructors scoring low (below the pro median), Blacks ($M = 17.00$) appear to have identified more works than did non-Blacks ($M = 13.61$).

Con value responses, when broken down by concept mean scores by race, indicated that Blacks ($M = 21.72$) above the con median (47.8) scored higher than non-Blacks ($M = 14.5$) on the concept items. However, of the instructors who performed below the con median, non-Blacks ($M = 18.18$) seemed better able to identify the artworks than did Blacks ($M = 16.53$). Blacks who rated the con statements most negatively (strong disagreement), on the average, identified more of the artworks. These results were consistent with Blacks' pro high value responses.

Further descriptive assessment of concept scores by pro/con value responses by race indicated how those who scored above or below the concept median (18.5) performed on the separate pro/con value subgroups.

Respondents who were most familiar with the concept items tended to rate the pro value statements more positively. Whether Blacks scored high or low on concept variables made very little difference as to how they rated the pro value statements. Both Black groups (high, $M = 56.83$; low, $M = 56.00$) rated the pro statements more positively than either non-Black group (high = 53.00, low = 48.92).

Blacks scoring above the concept median rated con values most negatively ($M = 52.88$). Non-Blacks who identified fewer of the artworks (low, $M = 48.35$) seemed slightly less negative. Con values were rated equally by

Blacks below the median and Whites above it ($M = 45.23$ and $M = 45.57$, respectively). The participating population in this inquiry was a small group. Correspondingly, the number of historic Black colleges and universities is small. The number of these institutions offering formal training in art is likewise very small. This study, although not representative of all Black college art departments, closely depicts their programs. It offers practical and theoretical assessments of teachers' art concepts and value orientations.

Discussion and Conclusions

The results indicated that race had a lot to do with how instructors rated most of the value statements and, to a smaller degree, their ability to identify artists' works. It appears that Black instructors were more likely to embrace Black aesthetic ideology than were non-Black (White) instructors. Whether the producing artists were Black or not apparently made little difference in the Black instructors' ability to identify them.

The value statements were assigned to various context descriptions (e.g., art, social, political, historical, and economic contexts). Instructors' value responses were analyzed in reference to these subcategories, with race as the independent measure. A statistically significant difference between racial groups appeared only on the social context variables, which may be attributed to the somewhat inclusive nature of these arguments. The statements constituting the social value category probably evoked more potent reaction from the respondents because (a) the viewpoints dealt with issues that personally confronted many of them, such as individual aesthetic ideology, creative freedom, and racial or cultural accountability; and (b) the foci cut across some of the other context variables, in effect interfusing direct and indirect social reactions.

Black instructors' performance on the non-Black artists' works can probably be attributed to the fact that they, like their White counterparts, had to study them as part of their undergraduate and graduate training. Blacks' familiarity with Black artists' productions, on the other hand, cannot be credited to formal training — only about 3% of the Black instructors in this study had taken courses in Black or Afro-American art. Those who had averaged approximately 6 credit hours of course work. This compared with about 2% for Whites who had Black art course credits, with an average of 4 credit hours.

Whether Black instructors' knowledge of Black artwork is the result of personal commitment to internalize the information for purposes related to

the formal transmission process is not clear from the evidence provided in this inquiry. However, an examination of requirements associated with these instructors' educational backgrounds and current teaching responsibilities strongly suggests that personal motivation and immediate environmental influences are major contributors.

In the examination of artworks according to style, Blacks were significantly better at recognizing artworks that fell under the mainstream and Black art headings. Their performance on the Black art variable was not surprising. The predominance of Black imagery, coupled with strong sociopolitical symbolisms, would undoubtedly make such works more personal and thus more familiar to the Black instructor.

Non-Black instructors were able to identify more of the Blackstream artworks. These results were unexpected given the contrary results of earlier pilot study data. Blackstream works are not as emotionally charged with Black imagery and symbolism as Black art. Whites possibly are more accepting of Blackstream imagery because it does not appear as negative, offensive, or threatening as Black art. It is also possible that the more allowable inclusion of Blackstream artworks in commonly used art publications may have made these images more familiar to students of art.

When artworks were arranged according to historical time periods, Black and White instructors' ability to identify them differed significantly on only one period — mid-20th century. Blacks were much better at identifying these works. It was not until the mid-20th century that any art publication attempted to deal with the works of Black artists. The first comprehensive effort to deal with Black American art contributions appeared in 1940, with Alain Locke's *The Negro in Art,* followed by James Porter's *Modern Negro Art* in 1943. An interesting point is that many of the artists from this period worked at Black colleges, where a number of their works were completed and where some remain. It should not be surprising, then, that the Black intructors, most of whom were products of historic Black colleges, were more familiar with these artworks. Furthermore, some of the more experienced instructors had the advantage of knowing some of the Black artists personally — they were their contemporaries. Similar justifications can be made for Time 4, where Blacks, again, were able to identify more of these artworks. This period witnessed a resurgence of Black racial pride and self-reliance that inspired a zenith of Black art production.

Non-Black instructors were slightly more able to identify artworks from the two earlier periods. It was from these time periods that 100% of the responding White instructors correctly identified three artists' works: Edmonia Lewis, Mary Cassatt, and Hale Woodruff — two of whom are

Black artists. Whites' level of performance on these variables was probably related to the frequency of their inclusion in popularly used history/survey tests.

The resultant data suggest a strong interrelationship between instructors' knowledge and art/aesthetic-related value choices. Both Black and White instructors are clearly in stronger agreement with Black art/aesthetic comments when they are more aware of Black artists' contributions. The reversal of this order (identification by value) seems less true for Black instructors because they appear equally positive about Black aesthetic concerns regardless of their art concept awareness. If instructors of art in Black colleges are not convinced that there is a Black art/aesthetic or that it is an efficacious body of information, they will probably not include its salient aspects in regular art classes. The transmission of a Black visual aesthetic and, consequently, Black culture will be adversely affected.

This study suggests that neither Black nor White instructors, as a group, demonstrate a very high degree of commitment to formally transmit Black art/aesthetic information. There was no preset reference criteria to indicate instructors' success or commital proficiency on concept or value measures. It was established, however, from an earlier pilot study, that respondents should be able to identify well over half of the Black artists' works. Therefore, it is reasonable to conclude from this assessment that the participating Black instructors are more likely to include and disseminate knowledge and aesthetic choices related to Black art and aesthetics.

The Black visual aesthetic is a viable component of Black culture. The importance of its programmatic transmission cannot be overstated. The historic Black college or university has considerable potential to make the aims of transmission and, subsequently, the continuity of the culture realizable. Teachers of art in Black institutions should, either through individual or formal initiative, become familiar with salient artistic contributions and related cultural preferences of African-Americans. Their ensuing awareness and sensibility should plausibly encourage the formal communication of Black aesthetic information.

If the results of this study were generalized beyond the population studied, it would be reasonable to expect that teachers who do not share in the Black cultural experience and who have not made a conscientious effort to become aware of such matters will likely be poor transmitters of cultural knowledge in any educational program.

References

Blassingame, J. (1972). *The slave community*. New York: Oxford University Press.

Bontemps, J. M. F. (1976). Art departments in selected predominantly Black institutions of higher education in the United States (Doctoral dissertation, Illinois State University, 1976). *Dissertation Abstracts International, 38,* 76-A.

Cleaver, D. G. (1977). *Art: An introduction* (3rd ed.). New York: Harcourt Brace Jovanovich.

Coleman, F. W. (1975). *Persistence and discontinuity of traditional African perception in Afro-American art*. Unpublished doctoral dissertation, University of Georgia.

Cordoza, J. (1970). *The development of art programs in Negro land grant colleges*. Unpublished doctoral dissertation, Indiana University, 1970.

de la Croix, H., & Tansey, R. G. (1975). *Gardner's art through the ages* (6th edition). New York: Harcourt Brace Jovanovich.

Depillars, M. N. (1976). African-American artists and art students: A morphological study in the urban Black aesthetic (Doctoral dissertation, Pennsylvania State University, 1976). *Dissertation Abstracts International, 37,* 4074-A. (University Microfilms No. 76-30)

Donaldson, J. (1980). Trans-African art. *The Black Collegian, 11*(2), 91-98.

Driskell, D. C. (1976). *Two centuries of Black American art*. New York: Los Angeles County Museum of Art and Alfred A. Knopf, Inc.

Fine, E. H. (1973). *The Afro-American artist*. New York: Holt, Rinehart, and Winston.

Fowler, C. (1981). *Black arts and Black aesthetics: A bibliography*. Atlanta: Atlanta First World.

Gayle, A. (Ed.). (1971). *The Black aesthetic*. New York: Doubleday and Co.

Grigsby, J. E., Jr. (1977). *Art and ethnics*. Dubuque, IA: Wm. C. Brown Co.

Herskovits, M. (1958). *The myth of the Negro past*. Boston: Beacon Press.

Hobbs, J. A. (1975). *Art in context*. New York: Harcourt Brace Jovanovich.

Hunter, S. (1973). *American art of the twentieth century*. New York: Harry Abrams, Inc.

Jeffries, R. R. (1980). Transafrican art. *The Black Collegian, 11*(2), 91-98.

Jordan, J. (1964). *Report to the committee for the development of art in Negro colleges*. Unpublished doctoral dissertation, Indiana University.

Klein, F. C. (1982). Black colleges undergo their stiffest test ever as student aid is cut. *The Wall Street Journal, 62*(100), 1-16.

Klausmeier, H. J., Ghatala, E. S., & Frayer, D. A. (1974). *Conceptual learning and development*. New York: Academic Press.

Lewis, S. (1978). *Art: African American*. New York: Harcourt Brace Jovanovich.

Lewis, S. S., & Waddy, R. C. (1969). *Black artists on art* (Vols. 1 & 2). Los Angeles: Contemporary Crafts.

Locke, A. (1940). *The Negro art*. Washington, DC: Associates in Negro Folk Education (reprinted in 1968 by Hocker Art Books, New York).

Logan, O. L. (1983). Concepts and values affecting the transmission of a Black visual aesthetic: A study of art instructors in historically Black colleges and universities (Doctoral dissertation, University of Wisconsin, 1982). *Dissertation Abstracts International, 43*(7). (University Microfilms No. 82-14, 749)

Mayfield, J. (1971). You touch my aesthetic and I'll touch yours. In A Gayle (Ed.), *The Black aesthetic*. New York: Doubleday and Co.

Neperud, R. W., & Jenkins, H. C. (1982). Ethnic aesthetics: Either/or? The meaning of paintings by Blacks for southern college students. *Studies in Art Education, 23*(2), 14-21.

Osgood, C. E., Suci, G. J., & Tannenbaum, P. H. (1957). *The measurement of meaning*. Urbana: University of Illinois Press.

Porter, J. A. (1943). *Modern Negro art*. New York: The Dryden Press.

Rouse, M. (1967). *Art programs in Negro colleges* (United States Department of Health, Education and Welfare, Project No. 3199, OE-610-113). Washington, DC: U.S. Government Printing Office.

Senghor, L. S. (1956, Winter). African Negro aesthetics. *Diogenes*, pp. 23-24.

Spellman, R. C. (1973). A comparative analysis of the characteristics of works and philosophies of selected contemporary mainstream Afro-American artists (Doctoral dissertation, New York University, 1973). *Dissertation Abstracts International, 34,* 3266-A. (University Microfilms No. 73-31, 234)

Staats, R. (1978). *Toward a Black aesthetic in the visual arts*. Unpublished doctoral dissertation, Columbia University.

Staples, R. (1976). *Introduction to Black sociology*. New York: McGraw-Hill.

White, A. (1983). Art departments in predominantly Black and White public colleges and universities: A comparison (Doctoral dissertation, University of Maryland, 1982). *Dissertation Abstracts International, 44,* 6. (University Microfilms No. 83-23, 602)

Whitten, N. E. (1970). *Afro-American anthropology: Contemporary perspective*. New York: The Free Press.

Wilie, C. V., & Edmonds, R. R. (Eds.) (1978). *Black colleges in America: Challenge, development, survival*. New York: Teachers College Press.

20

A Chronological Minority Bibliography

ELIZABETH ANN SHUMAKER

The Ohio State University

Introduction

This chronological listing of articles on minority art education found in the NAEA journal, *Art Education,* is presented with neither apologies nor congratulations. Rather, the bibliographic arrangement chronicles a historical evolution of cultural changes. Camouflaged by other terms, early literature concerning minorities did exist from the time of first publication of the journal (Dix, 1951; Howell, 1952; Barkan, 1953; Grigsby, 1954). The oblique titles such as the difficult school, the disadvantaged, social change, and competency education were used in the 1960s to indicate minority education (Barclay series, 1968, 1969). In the 1970s, articles specific to ethnic minorities appeared (Hudson, 1970; Toyoshima, 1973; Monteverde, 1972), as did articles about women in art education (*Art Education,* Vol. 28, No. 7). After that, both direct and indirect references to minorities can be found, indicating multicultural pluralism.

To say that the journal did not face squarely or consistently minority needs in art teaching is not to say that writers of art education literature completely ignored minority concerns. Articles about art teaching and minorities can be found in *Art Education.* On the other hand, the production of those writers in consistency and in quantity may not be reason for self-congratulation, but a base on which further to build.

Dix, M., & Groves, G. (1951). Problems of art education in cities under 200,000. *Art Education, 4*(5), 5-9.

Howell, A. (1952). Problems of art education in cities over 200,000. *Art Education, 5*(1), 15-16.

Barkan, M. (1953). Art and human values. *Art Education, 6*(3), 1-2.

Grigsby, J. E. (1954). Art education at Carver High School. *Art Education, 7*(4), 6-8, 16-18.

Attebury, F. (1960). Creativity and family background. *Art Education, 13*(2), 6-7.

Eisner, E. (1960). Initiating art experiences for delinquent students. *Art Education, 13*(2), 8-9.

Caldwell, O. (1960). Art and communication. *Art Education, 13*(8), 4-6, 21-22.

Snow, R. (1960). The execution and the dream. *Art Education, 13*(8), 11-13.

Wilson, D. (1963). Art in the difficult school/a study. *Art Education, 16*(6).

Fass, N. (1963). Art in the difficult school/a study. *Art Education, 16*(6), 9-14.

Michedzinski, R. (1963). Art in the difficult school/a study. *Art Education, 16*(6), 15-16.

Schreiber, D. (1963). Art in the difficult school. *Art Education, 16*(6), 17-18.

Gordon, S. (1963). Art in the difficult school. *Art Education, 16*(6), 18-19.

Horn, G. (1964). Art and the underachiever — a study. *Art Education, 17*(5), 10-14.

McFee, J. (1965). Means and meaning in art education. *Art Education, 18*(3), 9-12.

Dauterich, E. (1965). Guest editorial on federal funding. *Art Education, 18*(7), 2.

Ozurles, S. (1965). Federal legislation and the school art program. *Art Education, 18*(7), 3-6.

Hurwitz, A. (1966). A creative solution to close the cultural gap. *Art Education, 19*(3), 21.

Silverman, R. (1966). Watts, the disadvantaged and art education. *Art Education, 19*(3), 16-20.

Robbins, W. (1966). The Museum of African Art. *Art Education, 19*(2), 12-16.

Logan, F. (1966). Art education, U.S.A. *Art Education, 19*(5), 4-11.

Rose, H. (1966). 'Head Start' for the culturally deprived. *Art Education, 19*(6), 19-21.

Spiegal, H. (1966). Teaching art for the Job Corps. *Art Education, 19*(6), 22-24.

Lewis, H. (1967). Disadvantaged college youth. *Art Education, 20*(5), 12-16.

Evry, A. (1967). A summer program for culturally deprived children. *Art Education, 20*(7), 24-27.

Foster, R. (1967). From whose perspective? *Art Education, 20* (Special issue), 12-14.

Wasserman, B. (1968). Congolese art and artifacts. *Art Education, 21*(3), 8-11.

Cohen, H. (1968). Design and alienated youth. *Art Education, 21*(6), 24.

Albinson, W., & Kent, B. (1968). Present and future urban forms. *Art Education, 21*(6), 12-15.

Katz, F. (1968). The longest hour. *Art Education, 21*(4), 20-23.

Johnson, P., & Defer, R. (1968). James Washington speaks. *Art Education, 21*(7), 8-13.

Barclay, D. (1968). Introduction to the series: Art education for the disadvantaged child: Part one. *Art Education, 21*(7), 4.

Ianni, F. (1968). The arts as agents for social change: An anthropologist's

view. *Art Education, 21*(7), 15-20.

Westby-Gibson, D. (1968). Art education for the disadvantaged child: Part two. New perspectives for art education: Teaching the disadvantaged. *Art Education, 21*(8), 22-24.

Roman, M. (1968). The arts as agents for social change: A psychologist's viewpoint. Art education for the disadvantaged child: Part three. *Art Education, 21*(9), 23-27.

Deutsch, C. (1969). Effects of environmental deprivation on basic psychological processes. *Art Education, 22*(1), 18-20.

Cohen, H. (1969). Part five in the series on art education: Learning stimulation. *Art Education, 22*(3), 2-8.

Povey, J. (1969). African art in the classroom. *Art Education, 22*(4), 13-15, 26.

Cohen, E. (1969). Color me Black. *Art Education, 22*(4), 6-9.

Nearine, R. (1969). Hope in our time: Some explorations into competency education: Part six: Art education for the disadvantaged child. *Art Education, 22*(5), 7-8.

Pittsburgh Board of Education. (1969). Bibliography of African Art. *Art Education, 22*(5), 12-13.

Barclay, D. (1969). Dissemination and implementation of research for the disadvantaged child: Summary statement to the series on art education for the disadvantaged child. *Art Education, 22*(5), 23-24.

McFee, J. (1969). Urbanism and art education in the USA. *Art Education, 22*(6), 16-18.

Cohen, H. (1969). In support of human behavior. *Art Education, 22*(7), 10-13, 21, 40.

Grigsby, E. (1969). GDAT: The "Give a Damn" art teacher of Arizona State. *Art Education, 22*(7), 14-18.

Newman, A. (1970). Promoting inter-cultural understanding through art. *Art Education, 23*(1), 18-20.

Armstrong, C. (1970). Black inner-city child art: A phantom concept? *Art Education, 23*(5), 16-21, 34.

Grossman, M., & Torrance, P. (1970). A creativity workshop for disadvantaged children. *Art Education, 23*(5), 32-33.

Hudson, R. (1970). Afro-American art: A bibliography. *Art Education, 23*(6), 20-25.

Packwood, M., & Woolward, R. (1970). Art services for rural schools. *Art Education, 23*(8), 31-33.

Lanier, V. (1970). Art and the disadvantaged. *Art Education, 23*(9), 7-12.

Monteverde, M. (1972). A bibliography of Pre-Columbian art and archaeology. *Art Education, 25* (2), 10-16.

Toyoshima, N. (1973). An annotated bibliography of arts of the Far East: The arts of China, Korea, and Japan. *Art Education, 26*(3), 16-21.

Chalmers, F. G. (1974). A cultural foundation in the arts. *Art Education, 27*(1), 21.

McFee, J. (1974). New directions in art education. *Art Education, 27*(8), 10-15.

Mutchler, B. I. (1975). Art heritage curriculum. *Art Education, 28*(2), 10-11.

Whitesel, L. (1975). Women as art students, teachers, and artists. *Art Education, 28*(3), 21-26.

Acuff, B. (Ed.). (1975). Women's issue. *Art Education, 28*(7).

Feldman, E. (1976). Art and the image of self. *Art Education, 29*(5), 10-12.

Mutchler, B. I. (1976). American art heritage. *Art Education, 29*(5), 19-21.

Lovano-Kerr, J., & Zimmerman, E. (1977). Multi-culture teacher education program in the arts. *Art Education, 30*(1), 34-38.

McIntosh, J. (1978). After the melting pot. *Art Education, 31*(6), 16-18, 20-22.

Rosenberg, H. (1979). The art of the popular film adds depth to multi-cultural studies. *Art Education, 32*(2), 10-14.

Bolanos, P. (1980). Agents of change: Artists and teachers. *Art Education, 39*(6), 49-52.

Nadener, D. (1981). Art and cultural understanding: The role of film in education. *Art Education, 34*(4), 6-8.

Bersson, R. (1981). Cultural democracy in art education — Elitism rebutted. *Art Education, 34*(6), 35.

Dobbs, S. (1981). Community and commitment: An interview with Ruth Asawa. *Art Education, 34*(5), 14-17.

Korzenik, D. (1982). A blend of Marcus Garvey and the 92nd Street Y: An interview with Elma Lewis. *Art Education, 35*(2), 24-26.

Geahigan, P., & Geahigan. G. (1982). An annotated bibliography of reference sources for art education. *Art Education, 35*(3), 35-39.

Rosenblum, P. (1982). Seeing and insight: An interview with Jacob Lawrence. *Art Education, 35*(4), 4-5.

Young, B. (1984). Afro-American artists and the Brandywine workshop. *Art Education, 37*(2), 6-8.

Congdon, K. (1984). Art education in a jail setting. *Art Education, 37*(2), 10-11.

Marigliano, G. (1984). The Federal Art project: Holger Cahill's program of action. *Art Education, 37*(3), 17-19.

Heidt, A. (1984). Drawing. A sixty-hour high school credit course in art for inmates. *Art Education, 37*(3), 26-30.

Corwin, S. (1984). Urban artistic oases. *Art Education, 37*(3), 32-33.

Chalmers, G. (1984). Cultural pluralism in British Columbia. *Art Education, 37*(5), 18-21.

Andrews, M. (1984). A multi-cultural art implementation project. *Art Education, 37*(5), 22-23.

Nadener, D. (1984). Developing social understanding through art criticism. *Art Education, 37*(5), 24-26.

Bersson, R. (1984). For cultural democracy in art education. *Art Education, 37*(6), 40-43.

Congdon, K. (1985). A folk group focus for multi-cultural education. *Art Education, 38*(1), 13-16.

Young, B. (1985). Visual arts and Black children. *Art Education, 38*(1), 36-38.

Olorukooba, B. K. (1985). An analysis of the function of the arts in primary schools in Nigeria. *Art Education, 38*(4), 13-16.

Kantner, L. (1985). The Journal of Multi-Cultural Research in Art Education. *Art Education 38*(4), 23.

Desmond, K. (1985). African elegance at the Canton Art Institute: An exhibition review and participatory learning strategies. *Art Education, 38*(4), 17-20.

Kelmonson, L. (1985). A sense of Mexico. *Art Education, 38*(4), 21-22.

Kellman, J. (1985). Meditations [on American Indian culture]. *Art Education, 38*(5), 33-37.

Freyberger, R. (1985). Integration: Friend or foe of art education. *Art Education, 38*(6), 6-9.

Court, E. (1985). Margaret Trowell and the development of art education in East Africa. *Art Education, 38*(6), 35-41.

Congdon, K. (1986). An analysis of the folk artist in education program. *Art Education, 39*(2), 33-36.

Bersson, R. (1986). Why art education lacks social relevance: A contextual analysis. *Art Education, 39*(4), 41-45.

Wilson, W., & Korzenik, D. (1986). Seeing myself in the context of my community: An international student reflects on studying art and art education in the United States. *Art Education, 39*(5), 36-40.

Blandy, D., & Congdon, K. (1988). A multi-cultural symposium on

appreciating and understanding the arts. *Art Education, 41*(6), 20-24.

LaDuke, B. (1988). Nigeria: Princess Elizabeth Olowu, zero hour. *Art Education, 41*(6), 33-37.

Smith, P. (1988). The Hampton years: Lowenfeld's forgotten legacy. *Art Education, 41*(6), 38-42.

Contributors

Robert L. Adams, Ph.D., Administrative Assistant, Dean, School of Education, Department of Art and Art Education, Alabama A & M University, Normal, Alabama

Carmen Armstrong, Ed.D., Professor of Art, Northern Illinois University, DeKalb, Illinois

W. Lambert Brittain, Ed. D., died on April 22, 1987; at the time of his death he was Professor of Human Development and Family Studies at Cornell University, Ithaca, New York

Vesta A. H. Daniel, Ed.D., Associate Professor of Art Education, The Ohio State University, Columbus, Ohio

Murry Norman DePillars, Ph.D., Dean, School of the Arts, Virginia Commonwealth University, Richmond, Virginia

Paulette Spruill-Fleming, Ph.D., Associate Professor of Art, California State University, Fresno, California

Pamela Gill Franklin, Ph.D., Fairfax County Public Schools, Springfield, Virginia

Eugene Grigsby, Jr., Ph.D., Professor Emeritus of Art, Arizona State University, Tempe, Arizona

Joanne Kurz Guilfoil, Ph.D., Assistant Professor of Art Education, Eastern Kentucky University, Richmond, Kentucky

Esther Page Hill, Ph.D., Associate Professor of Art Education, The University of North Carolina at Charlotte

Adrienne Walker Hoard, Ed.D., Associate Professor of Art, University of Missouri — Columbia, Columbia, Missouri

Barbara Loeb, Ph.D., Assistant Professor of Native American Art History, Oregon State University, Corvallis, Oregon

Oscar L. Logan, Ph.D., Associate Professor of Art Education, Alabama A & M University, Normal, Alabama

Judith Mariahazy, is an Art Education student at Arizona State University, Tempe, Arizona

Lee A. Ransaw, Ph.D., was a Distinguished Scholar of the United Negro College Fund and is presently Professor and Chairperson of the Fine Arts Department at Morris Brown College, Atlanta, Georgia

Bradley Smith, retired Professor of Art Education, Tyler School of Art, Temple University, Philadelphia, Pennsylvania

Mary Stokrocki, Ph.D., Associate Professor of Art Education, Cleveland State University, Cleveland, Ohio

Elizabeth Ann Shumaker, Graduate Student, The Ohio State University, Columbus, Ohio

Patricia Stuhr, Ph.D., Assistant Professor, The Ohio State University, Columbus, Ohio

Leo F. Twiggs, Ph.D., is Executive Director of the Stanback Museum and Planetarium, and Chairman of the Art Department at South Carolina State College, Orangeburg, South Carolina

Bernard Young, Ph.D., Associate Professor of Art, Arizona State University, Tempe, Arizona